Lacan was in close contact with the Surrealists and, early in his career, exchanged ideas with Salvador Dalí. This book offers a detailed reading of Dalí's "paranoiac-critical" tour de force, *The Tragic Myth of Millet's Angelus*, in which he demonstrates a method of interpretation that involves the projection and analysis of paranoid fantasies. The author later discusses the aesthetic dimension of the disintegrative death drive explored in Georges Bataille's *Eroticism* and in Anton Ehrenzweig's *Hidden Order of Art*, both of which inspired Robert Smithson. Iversen also takes up a postwar-era narrative that examines Maya Lin's Vietnam Veterans Memorial and Robert Smithson's *Spiral Jetty*. *Beyond Pleasure* shows that the aesthetics of Freud's theory continue to resonate in the contemporary art world.

Beyond Pleasure

Beyond

Pleasure

Freud, Lacan, Barthes

MARGARET IVERSEN

The Pennsylvania State University Press | University Park, Pennsylvania

Published with the assistance of the
Getty Foundation.

Library of Congress
Cataloging-in-Publication Data

Iversen, Margaret.
 Beyond pleasure : Freud, Lacan, Barthes /
Margaret Iversen.
 p. cm. — (Refiguring modernism)
Includes bibliographical references and index.
ISBN-13: 987-0-271-02971-7 (cloth : alk. paper)
ISBN-10: 0-271-02971-4 (cloth : alk. paper)
1. Psychoanalysis and art—Case studies.
2. Art, Modern—20th century—Psychological
aspects.
I. Title.

N72.P74194 2007
701'.15—dc22
2006035524

What I look at

is never what

I wish to see.

—Jacques Lacan

The punctum,

then, is a kind of

subtle beyond—

as if the image

launched desire

beyond what

it permits us

to see.

—Roland Barthes

Contents

Illustrations

12 "Woman and Cherries." Postcard published in Salvador Dalí, *The Tragic Myth of Millet's Angelus: Paranoiac-Critical Interpretation*, trans. E. R. Morse (St. Petersburg, Fla.: The Salvador Dali Museum, 1986). © Salvador Dalí, Gala-Salvador Dalí Foundation, DACS, London, 2006

13 "Ste Catherine, donnez-moi un petit mari." Postcard published in Salvador Dalí, *The Tragic Myth of Millet's Angelus: Paranoiac-Critical Interpretation*, trans. E. R. Morse (St. Petersburg, Fla.: The Salvador Dali Museum, 1986). © Salvador Dalí, Gala-Salvador Dalí Foundation, DACS, London, 2006

14 Michelangelo, *Moses*, c. 1512. Marble. San Pietro in Vincoli, Rome. © 1990. Photo: Scala, Florence. Courtesy the Ministero Beni e Att. Culturali

15 Leonardo da Vinci, *Virgin and Child with Saint Anne*, c. 1515. Oil on wood, 1.68 x 130 cm. Louvre, Paris. Photo: Réunion des Musées Nationaux/Art Resource, New York

16 Man Ray, *Slipper Spoon (de la hauteur d'un petit soulier faisant corps avec elle)*. Photograph published in André Breton, *L'amour fou* (Paris: Gallimard, 1937). © Man Ray Trust/ADAGP, Paris, and DACS, London/Tel-image, 2006

17 Robert Smithson, detail of *Non-Site: Line of Wreckage (Bayonne, New Jersey)*, 1968. Painted aluminum, broken concrete; framed map and three photo panels. Cage: 59 x 70 x 12 ½ in.; all panels: 3 ¾ x 49 in. Milwaukee Art Museum, Purchase, National Endowment for the Arts matching funds, M1969.65. © Estate of Robert Smithson/VAGA, New York/DACS London, 2006. Image courtesy James Cohan Gallery, New York

18 Robert Smithson, *The Fountain Monument* (side view). Photograph published in Robert Smithson, "A Tour of the Monuments of Passaic, New Jersey," *Artforum* (December 1967). © Estate of Robert Smithson/VAGA, New York/DACS, London, 2006. Photo: James Cohan Gallery, New York

19 Robert Smithson, *Yucatan Mirror Displacement, Number 6*, 1969. One of nine original slides. © Estate of Robert Smithson/VAGA, New York/DACS, London, 2006. Photo: James Cohan Gallery, New York

20 Robert Smithson, *Spiral Jetty*, April 1970 (Great Salt Lake, Utah). Black rock, salt crystals, earth, red water (algae), 3 ½ x 15 x 1500 ft. © Estate of Robert Smithson/VAGA, New York/DACS, London, 2006. Courtesy James Cohan Gallery, New York. Collection of DIA Center for the Arts, New York. Photo: Gianfranco Gorgoni

21 Richard Wilson, *20:50*, 1987. Steel, used sump oil, dimensions variable. Saatchi Gallery, London. Reproduced courtesy of the artist. Photo: Anthony Oliver

22 Frédéric-Auguste Bartholdi, *Liberty Enlightening the World*, 1886 (New York)

23 Maya Lin, Vietnam Veterans Memorial, 1983. Black granite, 152 m in length, 0–3 m in height. The Mall, Washington, D.C. Photo: Maya Lin. Courtesy of the artist

24 Edwin Lutyens, Memorial to the Missing of the Somme, 1924. Thiepval near Albert, Somme, France. Photo: Imperial War Museum, London

25 Edwin Lutyens, Cenotaph, 1919–20. Whitehall, London. Photo: Imperial War Museum, London

26 Richard Serra, *Shift*, 1970–72. Cement, six rectilinear sections, each 18 x 2.4 m. Collection of the artist, King City, Ontario. Photo provided by the artist

27 Tony Smith, *Die*, 1962. Steel painted black, 183 x 183 x 183 cm. Collection of Whitney Museum of American Art, New York. Photo: Whitney Museum. © ARS, New York, and DACS, London, 2005

28 David Octavius Hill and Robert Adamson, *Elizabeth Johnson, The Beauty of Newhaven*, c. 1844–48. Salted paper print from a calotype negative. Inv. no. 67:390. Victoria and Albert Museum, London. Photo: Victoria and Albert Museum, London/Art Resource, New York

29 Karl Dauthendey, *The Photographer Karl Dauthendey with his betrothed Miss Friedrich after their first attendance at church*, 1857. Photograph published in Helmuth Theodor Bossert and Heinrich Guttmann, *Aus der Frühzeit der Photographie, 1840–70. Ein Bildbuch nach 200 Originalen* (Frankfurt, 1930), fig. 128

30 Diagrams from Jacques Lacan, *The Four Fundamental Concepts of Psycho-Analysis* (London: Penguin Books, 1977), 91, 106. © Jacques Lacan, *Les quatre concepts fondamentaux de la psychanalyse*, Séminaire t. 11 (Paris: Seuil, 1973)

Acknowledgments

There are many people whose conversation and encouragement over the years have made this book possible. Many of their names crop up regularly in the notes, since their work often bears on the subject of this book: Parveen Adams, Diarmuid Costello, Mark Cousins, Briony Fer, Mark Godfrey, Stephen Harris, Mary Kelly, David Lomas, Stephen Melville, Mignon Nixon, and Peter Wollen. My longtime colleagues at the University of Essex in the Department of Art History have consistently provided intellectual stimulus and specialists' expertise. In this context, I must particularly mention Dawn Ades, Neil Cox, Valerie Fraser, Jules Lubbock, Michael Podro, Thomas Puttfarken, and Margherita Sprio. In the Literature Department, thanks go to Peter Hulme, Shohini Chaudhuri, and the late Francis Barker. I also owe a debt of gratitude to my former Ph.D. students, in whose work I now find inspiration. These include Claire Bishop, Christine Conley, Patricia Hurrell, Oliver Ronca, Dorothy Rowe, and Beth Williamson. The University has provided generous support in the form of sabbaticals and travel grants. I have also benefited from research time funded by the Arts and Humanities Research Council. The helpful members of the staff at Penn State University Press deserve praise, especially manuscript editor Laura Reed-Morrisson and the former Art History and Humanities Editor, Gloria Kury. Finally, I would like to thank my family for being so supportive and patient; my gratitude and love go to Jules Lubbock and Benjamin Lubbock. I dedicate this book to my wonderful mother, Violet Iversen.

1 Introduction

From Mirror to Anamorphosis

It is natural to assume that the interest we take in art has to do with beauty and pleasure, and an august tradition of philosophical aesthetics backs up that assumption. The most influential contribution to philosophical aesthetics, Immanuel Kant's *Critique of Judgment* (1790), argued that we call something "beautiful" when our faculties, both cognitive and sensory, entertain the form of an object in a pleasurable, harmonious free play. Of course, Kant acknowledged that some aesthetic encounters are mixed with pain. Huge mountains or violent storms are more likely to defeat our mental faculties as we struggle to come to terms with them. But this initial humiliation is followed, on Kant's account, by an uplifting realization that we are not restricted to earthbound ideas derived from these faculties: we also have the capacity to entertain ideas of reason—totality, infinity, and morality. Although we call the objects that inspire these ideas sublime, the term really refers to the capacity of our minds to think these high abstract ideals. As Kant put it, while the beautiful "carries with it directly a feeling of life's being furthered," the sublime "is produced by the feeling of a momentary inhibition of the vital forces followed immediately by an outpouring of them that is all the stronger."[1] The sublime is thus balanced on the threshold between an acknowledgment of human limitation and an assertion of moral freedom or, as Kant poetically declared, between "the starry heavens above me and the moral law within me."[2] On reflection, we would also want to acknowledge that

certain works of art (for example, depictions of Christ's Passion or Titian's *Flaying of Marsyas*) are more likely to inspire the tragic emotions of pity and fear, as described by Aristotle, rather than unalloyed pleasure.[3] Indeed, there is a wealth of literature on these two aesthetic responses beyond pleasure, the feeling of sublime and tragic emotions. This book sets out to excavate a lesser-known tradition of writing on art that descends from Sigmund Freud's essay *Beyond the Pleasure Principle* (1920).

In its reformulation of aesthetics, psychoanalytic art theory has tended to privilege pleasure and, like its philosophical counterpart, it has also found it necessary to develop a theory of aesthetic experience beyond pleasure. Although Freud tended to be dismissive of the tradition of philosophical aesthetics, he followed it to the extent that he thought that artistic creation and our experience of art are bound up with an indirect satisfaction of what he called the pleasure principle.[4] His understanding of "pleasure," however, is quite different from Kant's notion of the mind's free play. Before turning to a discussion of *Beyond the Pleasure Principle* and its bearing on our understanding of the experience of art, we will have to pause briefly to consider the psychoanalytic conception of pleasure and Freud's theory of art as involving the sublimation of more visceral forms of pleasure.

It turns out that defining pleasure psychoanalytically is far from straightforward. Freud proposed that the mental apparatus is regulated by an economic system aimed at reducing high levels of tension that are felt as unpleasurable. Pleasure, then, is nothing more than the elimination of unpleasure, or the sensation of discharge. Yet the complete reduction of tension would lead to a state comparable to death. Freud did not shrink from that conclusion; he postulated a principle of inertia, later called the Nirvana principle, stating that the psychical apparatus avoids excitation and aims to reduce tension to zero. He then had to propose a principle countering that tendency, called the principle of constancy; it regulates levels of tension and maintains them at an optimum low level by avoiding external excitations and discharging internal ones. Both principles are, rather contradictorily, associated with pleasure, although they tend toward what are qualitatively very different states—one comparable to death and the other to the furthering of the feeling of life that Kant associated with beauty.

In Freud's early work, the pleasure principle is set in opposition to the reality principle. This model posits psychic functioning as a struggle between the urgent need to satisfy instinctual drives (and to discharge tension by the shortest possible route) and the realization that, given external constraints, moderation, postponement, and detour may offer a more prudent approach.[5] These two principles come into conflict, causing frustration, repression, and sometimes psychical dysfunction. But in so far as self-preservation or self-love (primary narcissism) is a fundamental instinct, this opposition between instinct and the prudential reality principle becomes difficult to sustain. Jean Laplanche has attempted to resolve this problem by arguing that we should understand the reality principle as linked to the emergence

of the ego, which binds energy and regulates the free circulation of unconscious desire. On this account, the reality principle merges with the pleasure principle, as both aim to avoid excessive pleasure. Laplanche's reading assigns the pleasure principle to a secondary, homeostatic process, while the primary, fundamental drive to ecstatic enjoyment (*jouissance*) and "Nirvana" would be properly regarded as an instinct beyond pleasure.[6] There is also the complication, discovered by psychoanalysis, that what might be felt by the individual as pain—a psychosomatic cough, say—may in fact be a disguised satisfaction of a wish. Conscious distress may be a "symbolic" way of deriving unconscious satisfaction and pleasure.[7] Freud speculated that our experience of tragic drama is of a similar kind: we derive pleasurable unconscious satisfaction when our hero murders his father and marries his mother, while at the level of consciousness, we recoil in horror and feel pity and fear.[8]

Freud's attempt to elaborate a general account of art's relation to the instincts is the theory of sublimation—a term he introduced. Seeking the ultimate motivation behind artistic or intellectual activities that appeared to have no obvious yield of pleasure, he proposed that they represent a transformation of sexual instinct. A portion of sexual energy or libido is diverted, transformed, and channeled into other, culturally valued forms of activity, such as scientific research or art. The aim is displaced in a process facilitated by the fact that human sexuality has no natural object or aim.[9] The artist or researcher manages to evade neurosis and associated symptoms brought on by repression because he or she has a talent for sublimation. The activity, however, is often marked by repression.[10] Freud's famous essay on Leonardo da Vinci presents a sort of "case study" of just this psychic mechanism at work. Leonardo's intense curiosity and obsessive research, together with an apparent lack of sexual activity, point in the direction of sublimation.[11] Freud's admittedly speculative suggestion is that the overly close relationship between the baby Leonardo and his abandoned mother led him to identify with the mother and to love, in an idealized way, boys like his former self. His ambivalent relationship with his mother can be detected, Freud thinks, in the seductive smile on the faces of the women in his *Virgin and Child with Saint Anne* and his portrait of the *Mona Lisa*. Freud held to the theory of sublimation throughout his career, from the *Three Essays on the Theory of Sexuality* (1905) to *Civilization and Its Discontents* (1930), where sublimation is regarded as one of several paths to relative happiness—along with intoxication, religious delusion, and madness.[12]

There is something dispiriting about this theoretical reduction of art to a diverted form of mainly sexual energy.[13] Particularly disagreeable is the close link Freud makes between the suppression of perversion and sublimated cultural activities.[14] One would almost prefer an expression of the desublimated drive itself as being more honest and courageously transgressive. Proponents of the abject and *informe* in art clearly take this view. One particularly good example of this trend is the case against

critic Clement Greenberg advanced by Rosalind Krauss in *The Optical Unconscious.* Greenberg is accused of sublimating Jackson Pollock's "art of violence, of 'howl'" by lifting the drip paintings off their low, horizontal axis on the floor (where Pollock made them) and rendering them vertical, sheerly optical, and transcendent instead.[15] The exhibition curated for the Pompidou Center by Krauss and Yve-Alain Bois, titled *Formless,* was an attempt to formulate something like a desublimating aesthetic.[16]

The difficulties we have already encountered in Freud's account of pleasure are not resolved in his highly speculative *Beyond the Pleasure Principle.* If anything, they are exacerbated. Yet the essay may offer a welcome alternative to the notion of sublimation. While Freud was writing the first draft, he was also writing "The 'Uncanny,'" which is in large part a reading of E. T. A. Hoffmann's tale "The Sand-man," along with an account of its peculiar effects upon the reader, involving dread or fear. The "Uncanny" essay has a complex history. Although it was published in the autumn of 1919, Freud wrote about it in a letter to Sandor Ferenczi in May of that year, saying that he "has dug an old paper out of a drawer and is rewriting it." And in the footnotes to "The 'Uncanny,'" Freud describes *Beyond the Pleasure Principle* as already completed, although it was not published until the following year. In any case, we gather that the papers are closely linked. Perhaps the full significance of the uncanny was recognized by Freud only at the time of writing *Beyond the Pleasure Principle,* and that is what prompted him to retrieve the essay from the drawer. "The 'Uncanny'" mentions some of the material that was to appear in the first parts of *Beyond the Pleasure Principle*—such as "repetition compulsion," a force powerful enough to override the pleasure principle—but it does not mention the death drive. It seems likely, then, that in the interval of a year between the publication of the two essays, Freud reformulated his metapsychology.[17]

The first parts of *Beyond the Pleasure Principle* concern instances when the pleasure principle is temporarily put out of action. This happens in cases of trauma, when, for example, people have a recurrent nightmare about some painful event in their lives. In fact, Freud's observation of shell-shocked soldiers during World War I led him to reconsider his theory of instinctual life. The soldiers' dreadful nightmares could not satisfactorily be understood in terms of a "disguised fulfillment of a repressed wish." Trauma is an influx of unbound energy capable of puncturing the organism's psychic "protective shield." A traumatic event causes the psyche to shut down its normal, homeostatic function in order to attend to the urgent task of binding. The job of binding is done compulsively, repetitiously, painfully. The recurrent nightmare, then, is supposed to be rehearsing the traumatic event in order to deal with the unbound energy attached to it. The nightmares are attempting to master an overload of stimuli. But if repetition compulsion is supposed to be therapeutic, then why is it relentlessly repetitious? This quandary is perhaps resolved by proposing that the unbound energy of trauma is unbindable, because the moment when one could have

defended against the trauma was missed. As Cathy Caruth observes, Freud stressed that the determining factor in trauma is fright, or lack of preparedness: "The shock of the mind's relation to the threat of death is thus not the experience of the threat, but precisely the *missing* of this experience, the fact that, not being experienced *in time,* it has not yet been fully known."[18] Could repetition compulsion be a vain effort to develop anxiety, and thus preparedness, retrospectively? In any case, repetition would seem to figure as the hallmark of whatever cannot be assimilated or subdued.

The repetition of distressing experiences, which may be aimed at mastering the material, brings no pleasure, but this function cannot be said to be in conflict with the pleasure principle. Yet there seems to be another sort of repetition compulsion summed up by Freud as the fateful, perpetual "recurrence of the same thing."[19] The later sections of the essay develop this thought and introduce a radically new dualism at the level of the drives. Eros, or the life instinct, is said to be aimed at binding energy and maintaining vital unities. But Freud, who always adhered to a conflictual model of the psyche, thought that there must be another, contrary instinct that seeks to dissolve those unities and bring them back to their primeval, inorganic state. The death instinct (*Todestrieb*) is now seen to lie behind this tendency to reduce tension to zero: it is bent on returning the living organism to the inorganic matter whence it came. It is also associated with self-destructiveness and aggression, thus providing another explanation for repetition compulsion. While one can readily understand artistic creativity in terms of binding and the creation of vital unities, it is perhaps harder to see any aesthetic application for this new disintegrative death drive. Yet while he worked on the essay, Freud was clearly struck by the relevance of Hoffmann's tale of a young man's infatuation with a life-sized automaton and his compulsive, "mechanistic," self-destructive behavior.[20]

Together, *Beyond the Pleasure Principle* and "The 'Uncanny'" inaugurated a tradition of writing on art first picked up by the Surrealists. André Breton's surrealist understanding of trauma contributed to his conception of the "encounter" and the object found as if by chance, described in *Mad Love* (1937) and elsewhere. Those ideas were, in turn, elaborated by Jacques Lacan in *The Four Fundamental Concepts of Psycho-Analysis* (1973), where he introduced the concept of the "missed encounter."[21] In effect, Lacan gave a surrealist and, hence, aesthetic twist to his reading of *Beyond the Pleasure Principle*. Roland Barthes's *Camera Lucida* (1980) carries forward that tradition. As I argue in Chapter 7, Barthes's traumatic theory of photography is deeply indebted to his reading of *The Four Fundamental Concepts*. (We shall see that the photographic "punctum" is, in fact, a species of missed encounter.) *Camera Lucida* was crucial to this book's formulation because, following Barthes, I took a path back to Lacan's *Four Fundamental Concepts,* and from there was led to the Surrealists and Lacan's encounter with them in the 1930s, and thence finally to Freud in the 1920s. I also branched off into a few alternative developments of Freud's notion of the death drive in, for exam-

ple, Georges Bataille's *Eroticism*, Anton Ehrenzweig's *Hidden Order of Art*, and Robert Smithson's use of both. This book traces, then, some of the contours of a tradition of twentieth-century art that touches on the traumatic core of human "being."

Though this intellectual tradition spans the twentieth century, my initial interest in aesthetics beyond pleasure was prompted by a reaction to a specific dominant conception of the image widely promulgated in the 1970s and 1980s.[22] The acceleration of technologies of photographic and digital reproduction and the consequent de-realization of the world revived the use of the ancient term "simulacrum" to describe a likeness that does not refer back to an original and so cannot be called a copy.[23] By invoking Lacan's conception of the traumatic real, I have sought to provide an alternative to theories of the simulacral nature of representation and art in postmodern society. In this effort, I also follow Barthes. His book on photography sought, in part, to resist what he saw as the ever-diminishing value of a simulacral image-world. In my concluding chapter, I make a case for extending Barthes's insight into photography to other art practices. I have not been alone in exploring this body of material. Books that have been particularly important for me include Slavoj Žižek's interpretations of Hitchcock's films (viewed awry) and his subsequent writings; Rosalind Krauss's revision of modernism in *The Optical Unconscious;* Hal Foster's reading of Surrealism through Freud's "The 'Uncanny'" and *Beyond the Pleasure Principle* in *Compulsive Beauty* and his writing on contemporary art collected in *The Return of the Real;* Parveen Adams's Lacanian readings of art and film in *The Emptiness of the Image;* and Briony Fer's exploration of the anxieties latent in modern and contemporary art in her *On Abstract Art* and *The Infinite Line*.[24] What follows is a preliminary outline of the shift that has occurred in psychoanalytic aesthetics—a shift brought about by the reception of Lacan, Barthes, and these authors.

After *Camera Lucida*, art theory informed by psychoanalysis underwent a sea change. A model of the spectator's relation to the work of art based on the figure of the mirror was replaced by a model that invokes the anamorphic image, the stain, and the blind spot. While the mirror model—which Lacan introduced in his celebrated article on the "mirror stage" of infantile development—emphasized the spectator's identification with a coherent form, the anamorphic moment of art criticism turns its attention to what is necessarily expelled in that exercise. As we shall see, the formation of an illusory unified ego has a certain unconscious cost.[25] Lacan's conception of the mirror phase of infantile development is by now very familiar. It only exists as a verbal description, but is no less visually striking for that. The infant of about six to eighteen months, recognizing its mirror image, presents, for Lacan, a "startling spectacle": "Unable as yet to walk, or even to stand up, and held tightly as he is by some support, human or artificial, he nevertheless overcomes, in a flutter of jubilant activity, the obstructions of his support and, fixing his attitude in a slightly leaning-forward position, in order to hold it in his gaze, brings back an instantaneous aspect of the image."[26]

Lacan draws a number of important inferences from this observation. The jubilant response indicates that the child perceives the image as an Ideal-I, that is, as better coordinated and more coherent. The image is illusory, or deceptive, because it does not reflect back the child's real helplessness and dependence owing to the prematurity of human birth. In other words, its beautiful totality belies real bodily fragmentation. The child's identification with the image means that his or her emergent ego will be an alienated one, an object outside. This primary identification acts as a template for a whole series of future identifications that will further shape and maintain the deluded ego. The "mirror" need not be literal: it is also a metaphor for any such identification—with an older sibling, for instance. Finally, the value the infant sets on the image involves a sacrifice of its own being, a sort of suicide in the manner of Narcissus. The mirror, in Lacan's account of this developmental stage, does not reflect back an already constituted self. Rather, it creates a reasonable facsimile or simulacrum of a self. As Mikkel Borch-Jacobsen so succinctly stated, "the double comes first."[27]

In order to sustain this ideal image of the self, the child has to expel all those impulses and objects that cannot be assimilated into the beautiful, coherent picture. These expelled bits, which are further alienated by the introduction of language and "symbolic castration," are what Lacan later calls the "real."[28] The formation of the ego thus alienates the subject's real body and drives. As death is one of the realities marginalized by the defensive ego, Lacan later figured its underside as an anamorphic skull. He introduced this figure in *The Four Fundamental Concepts,* where he used the perspectively distorted death's head floating in the foreground of Hans Holbein's famous painting, *The Ambassadors* (1533), to figure the blind spot in conscious perception. Several references to anamorphosis appear in *The Four Fundamental Concepts,* where it is used to describe what the geometral (conscious) model of vision necessarily elides. The real, in the scopic field, is formed when vision is split between conscious sight and what is expelled.[29] The eye would then be master of all it surveyed, were it not for the gaze, a spot or void left behind by this splitting. This spot is said to "look back at me": it is an intimate part of myself, projected outside.

Why did Lacan invoke death in the context of art? We can offer a preliminary answer to this question while attending to the crucial transition, from mirror to anamorphosis, that took place in art theory. During the 1970s and early 1980s, much art theory was dominated by a fertile strand of film theory, which amalgamated Lacan's notion of a particular stage of infantile development—when the infant's mirror image constitutes for it a rudimentary ego—with a critique of ideology. The French political theorist Louis Althusser originally made the connection between this Lacanian "imaginary" register and ideology. Althusser understood the mirror as a metaphor for ideological formations.[30] Film theorists who followed his lead argued that the filmic image and the narrative of classical Hollywood movies were complicit in the

formation of subjects who, captivated by the image, would identify themselves with idealized film characters and reproduce their social roles. The cinematic apparatus was thought to play a most important role in this process. The spectator, identifying with the point of view of the camera, would experience himself as at the center and in control of the represented world—yet all the while, he would be firmly locked into the camera's trajectory. For these film theorists, the image projected on the screen acts as a mirror in which the subject (mis)recognizes the representation as a reflection of his or her real relation to the world. In effect, it rehearses the mirror stage of infantile development by reinforcing the general illusion of self-mastery, thus making the subject vulnerable to ideological indoctrination.[31]

This argument about the role of visual imagery in the formation of subjects who mistakenly regard themselves as free and autonomous beings posed a serious problem for the psychoanalytic critic of visual art, for it was not just advertising imagery and Hollywood cinema that were criticized in these terms, but also the dominant system of representation in the West since the Renaissance—the apparatus of perspective.[32] Any alternative, and less iconoclastic, psychoanalytic approach to visual art had to understand the force of this critique and confront it head-on. As we shall see, the resolution of the problem was found in a return to and closer reading of Lacan's writings. While the Althusserian theory postulated a seamless "interpellation" of the subject in ideological formations, its psychoanalytic model, Lacan's mirror stage, is a conflicted domain fraught with anxiety and paranoia. For Lacan, the major problem of modern culture (and the source of resistance to the psychoanalytic treatment of mental illness) is that we are held spellbound by our egos. As he argues in his article "Some Reflections on the Ego," people are locked into "the stability of the paranoiac delusion system," and when that system is threatened, aggression is understandably unleashed. Although the mirror stage has a positive and necessary role in the maturation of the individual, the ideal body image can easily become rigid and defensive, especially as it retroactively conjures up a fantasy of one's original condition as a "body in bits and pieces." Lacan spells out the consequences: "Here we see the ego, in its essential resistance to the elusive process of Becoming, to the variations of Desire. This illusion of unity, in which a human being is always looking forward to self-mastery, entails a constant sliding back again into the chaos from which he started; it hangs over the abyss of a dizzy Ascent in which one can perhaps see the very essence of Anxiety."[33]

If the illusion of coherence offered by the ego gives stability to the sense of self and world, then its fictionality and externality also make it extremely susceptible to subversion. The projected object world of this anxious subject has the same idealized rigidity. Just as the ideal ego reflected in the mirror or in the pages of glossy magazines is more sharply focused, composed, and unified, so, too, the view of space and the disposition of objects in it conform to an ideal order superimposed on what would presumably be a more fluid perceptual field of experience. As Lacan notes, "We are

led to see our objects as identifiable egos, having unity, permanence, and substantiality."[34] Yet the simulacral nature of these objects, from which ambiguity and fragmentation have been expelled, means that they are as fragile as glass. Our satisfaction in imaginary coherence, then, has a permanent undertow of anxiety. This thought can be clarified by setting it in relation to our experience of a few paintings.

It seems fair to say that certain works of art are organized in such a way as to give the spectator a sense of satisfaction in an illusion of visual mastery and control, providing a pleasurable confirmation of his personal integrity and the stability of his world. This, I think, helps explain one's profound satisfaction in viewing, for example, a Piero della Francesca fresco or painting in which figures, objects, and architecture are transformed into a harmonious arrangement of geometric solids.[35] It has also been argued that systematic perspective construction, especially one in which the viewpoint is aligned with the spectator's point of view, gives the spectator satisfaction in a representation that has what Lacan later called a "belongs to me" aspect.[36] This effect, it has been suggested, is equivalent to the alignment of the cinema viewer's eye with the camera's look. Yet if we take into account the ambivalence of the mirror stage, we might also be able to explain the real sense of disorientation and estrangement a viewer may experience when confronted by the paintings of an extreme perspectivist like Uccello. They recall Lacan's description of the peculiar stagnation of the flow of experience when stability turns to stasis. He describes this stasis as "the assumption of the armor of an alienating identity, which will mark with its rigid structure the subject's entire mental development."[37] In Chapter 3, on Dalí and Lacan, we shall discuss at length this proximity (within the imaginary domain) of satisfaction in an apparently stable world and a worrying de-realization of it.

Film and art theory's importation of Lacan's concept of the imaginary founding of the subject of ideology had an unfortunate consequence: it gave visual imagery in general a bad name. A too-literal understanding of Lacan's imaginary register was partly to blame. The imaginary is a function of narcissistic identification in general, which can take place in art, film, literature, or any other medium. Nevertheless, in order to prevent imaginary identification, artists overlaid the image with text or dispensed with images entirely. They aimed to interrupt the spectator's imaginary enthrallment and so release him or her for more critical reflection. The transparency of the image could be countered by the introduction of a certain textual opacity. For example, artists influenced by feminism used strategies of defamiliarization to examine the part that images of women play in the formation of feminine subjects or in the psychic economy of patriarchy. Laura Mulvey's famous feminist-psychoanalytic critique of the patterns of identification and objectification in classical Hollywood cinema, "Visual Pleasure and Narrative Cinema," is contemporary with both Mary Kelly's monumental inquiry into maternal femininity, *Post-Partum Document*,

and the early "film stills" of Cindy Sherman displaying femininity as an imaginary construction—a flimsy tissue of costume, makeup, pose, and *mise-en-scène.*[38]

In the fields of art history and theory, critics adopted semiotic strategies to break up the image and facilitate a "reading" of works of art. This undoubtedly had to do with art historians' and critics' reception of Lacan through the filter of film theory. The impasse of iconophobic art and criticism was based on a tendentious understanding of Lacan's mirror-stage article, one that took account of the satisfactions of the imaginary domain—the child's jubilation in its mirror image—but not its threat. Because, for Lacan, the ego is an object "outside," it is capable of reversing its friendly aspect and confronting the subject as a rival. The mirror, as we have seen, is very far from being a straightforward confirmation of the ego. In the 1950s, Lacan was already playing on the figure of the mirror: "In becoming fascinated by a mirror, and preferably by a mirror as it has always been since the beginning of humanity until a relatively recent period, more obscure than clear, mirror of burnished metal, the subject may succeed in revealing to himself many of the elements of his imaginary fixations."[39]

How is the mirror of burnished metal different from a modern one? Lacan must be indicating a number of things here, including the way in which the metal mirror returns a blurred and evanescent reflection, "more obscure than clear," that may resolve into unexpected, anamorphic projections of the self. These suggestions seem to me to leave the door open for an analogy between Lacan's mirror of burnished metal and the work of art, which may be an occasion for projection and reflection. (This line of argument is pursued in detail in Chapter 3 on Dalí and paranoia-criticism, which draws attention to the contact between Lacan and Dalí in the 1930s. If the mirror is imagined as burnished metal, it already creates anamorphosis-like effects. The subsequent chapters dispense with the mirror model altogether, though, in favor of what I have described as the anamorphic model of psychoanalytic art criticism.)

The image as a linchpin in processes of ego-formation and ideological interpellation seems to me, even now, to make sense of much commercial cinema and advertising. But there have always been those who, however persuaded by the theory, were reluctant to approach the objects of their study—art or film—from such a relentlessly negative and iconoclastic standpoint. They hesitated, for example, to sacrifice practically the whole of art history on the altar of such an austere cultural politics. Even Mulvey's pioneering essay attempted to rescue Hitchcock from censure: she pointed out the way he lures the masculine spectator of *Marnie* and *Vertigo* into identification with what turn out to be perverse heroes. Objections to the particular interpretation of Lacan that underpinned the film theory were also voiced. As early as 1975, Jacqueline Rose tried to resituate the concept of the imaginary in its psychoanalytic context, calling into question "the use of the concept to delineate or explain some assumed position of plenitude on the part of the spectator in the cinema."[40] Somewhat later, Joan Copjec argued persuasively that film theory's appropriation

of Lacan tended to disregard his stress on the instability of the imaginary register, which is fraught with rivalry and aggression.[41] Both Rose and Copjec refer to Lacan's later formulation of "the gaze" in order to make their case, but I would argue that the conflicted and latently paranoid character of imaginary identification is already present in the mirror stage essay and even earlier. Lacan's doctoral dissertation, it should be remembered, concerned a paranoid young woman who indirectly punished herself by stabbing an actress who was her ego ideal.[42]

The demise of the mirror model of psychoanalytic art theory was no doubt partly precipitated by these critiques and by an unease about treating art as what Althusser termed an "ideological state apparatus." It was certainly aided by the publication, translation, and dissemination of Lacan's *Four Fundamental Concepts of Psycho-Analysis.* By the mid-1980s, the figure of the mirror had given way to the anamorphic image. In particular, the figure of the anamorphic death's head floating in the foreground of Holbein's *Ambassadors,* as analyzed by Lacan, seemed to offer an alternative paradigm for art theory (fig. 1).[43] This new paradigm was considerably more favorable to a positive reception of the image in visual art. In the earlier scheme, the image was held responsible for enhancing the ego and propping up its ideological supports; according to the later paradigm, the work of art could both point to that alienating image and suggest what lay behind it. If, for instance, the two rather self-satisfied ambassadors might at first seem to offer themselves as objects of identification fit to enhance my fictional sense of psychic integrity and visual mastery, then that satisfaction would be troubled by the unintelligible stain in the foreground and totally undermined when the perspectively skewed skull came into view (fig. 2). It is unwise to take Lacan's reading of Holbein's painting too literally, however. Rather, the distended skull in the foreground should be understood as figuring for Lacan something about the nature of art in general. The suggestion is that art, the beautiful illusion, contains within itself a seed of its own dissolution. The inclusion of an anamorphic stain points to the fact that "what we seek in the illusion is something in which the illusion as such in some way transcends itself, destroys itself, by demonstrating that it is only there as a signifier."[44] Just at the moment when painting mastered perspective construction and attained a perfect illusion, one encounters, according to Lacan, "a sensitive spot, a lesion, a locus of pain, a point of reversal of the whole history" with the development of anamorphosis.[45]

To put it plainly, art's beauty or appeal to the imaginary is empty and may be one step away from horror. Indeed, for Lacan, one of the functions of the imaginary is to veil horror (or what he calls the "real"). Lacan uses the term to designate one of the dimensions of psychic life, but the real is harder to define than the imaginary or symbolic dimensions. In fact, it is defined only negatively—that which is foreclosed, cast out in the traumatic formation of the subject through its insertion in the imaginary and symbolic orders. As such, it can also be understood as the catalyst of a trauma

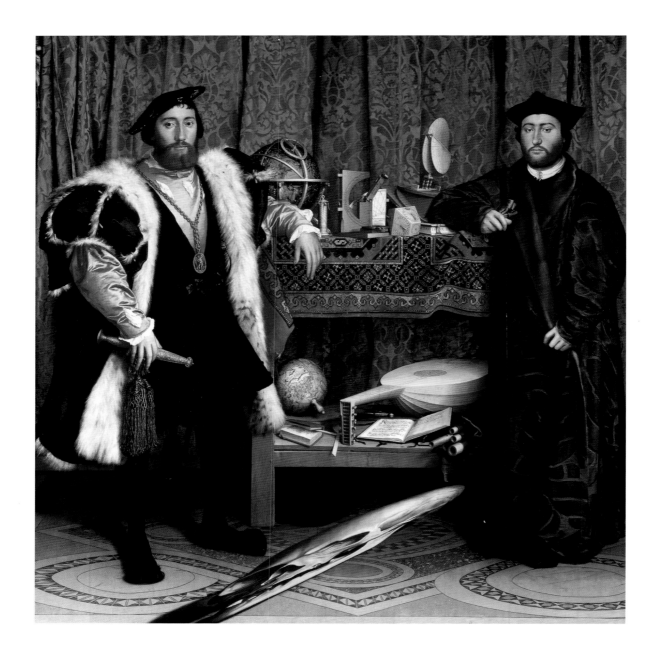

that is blanked by the subject and erupts in traumatic returns.[46] It is the missed encounter with the real, such as what Freud calls the "primal scene," that later precipitates a trauma.[47] Lacan illustrated the relation of the imaginary to the real with another exemplary anamorphic image. It is invoked most pertinently in the midst of a discussion of Sophocles' tragedy *Antigone* in Seminar VII (1959–60), *The Ethics of Psychoanalysis.* The object is an upright cylinder of polished metal that mirrors anamor-

phically distorted shapeless blobs of color spread out at its base. From this shapeless mass, there rises up in the cylinder a beautiful image of the Crucifixion of Christ after Rubens.[48] Lacan writes, "A marvelous illusion in the form of a beautiful image of the passion appears beyond the mirror, whereas something decomposing and disgusting spreads out around it."[49] The device seems designed to demonstrate the proximity of beauty and death. Similarly, our fascination with the figure of the beautiful Antigone, Lacan argues, has to do with her implacable death drive—her determination to bury her brother's decomposing body despite prohibition and the inevitable consequences. Lacan reinterprets Aristotle's conception of catharsis in tragedy to mean that we are purged of everything belonging to the order of the imaginary.[50] Antigone's intransigence is beyond ordinary forms of intelligibility or visibility. She is anamorphic.[51] The beautiful, on this view, cuts through the knot keeping the subject enslaved by his or her ego. It enables us to recognize and to live with our subjective void. There is a perverse sort of pleasure mixed with pain in this recognition, which Lacan called *jouissance*.[52] In this seminar, Lacan redefines sublimation as a way of approaching the real, circling around it rather than avoiding it. As he says, "a work of art always involves encircling the Thing"—the unattainable sublimated object of desire.[53]

As this example illustrates, the anamorphic paradigm of psychoanalytic art theory constitutes the basis of an aesthetic theory beyond pleasure, one that ultimately involves an encounter with the pain of irretrievable loss and the inevitability of death. The smooth running of the pleasure principle is disrupted by something internal to the system itself, and we are forced to take account of that reality. The chapters that make up this book are all guided by this thought. I have organized the material under a number of key concepts. Each concept is elaborated in the context of a "case study," that is, a particular work of art or body of work. This makes it sound as though the theory is "applied" to these works of art, but as we shall see, the situation is not so simple. Is Breton's *Mad Love* theory or art? The same might be asked of other key texts here—Dalí's *Tragic Myth of Millet's Angelus,* or Robert Smithson's "Spiral Jetty" essay, or indeed, Barthes's *Camera Lucida.* And what about Lacan's intricate prose? Part of my project is to demonstrate the permeability of boundaries between psychoanalytic theory, art theory, and art practice.

Freud himself enabled this permeability with his profound interest in literature and the arts of antiquity, not to mention his several excursions into art theory. His essay on the uncanny is a reading of a short story, yet the concepts he deployed there (such as doubling, making strange, repetition compulsion, and the blurring of the boundary between the animate and the inanimate) are equally available for the interpretation of works of visual art. Chapter 2 puts "The 'Uncanny'" to work in an analysis of the paintings of Edward Hopper. My reading of his paintings concerns the dissolution of boundaries—that is, uncertainty about whether something is animate or inanimate, fantasy or reality—that accompanies the uncanny surfacing of

1

Hans Holbein the Younger, *Jean de Dinteville and Georges de Selve* (*The Ambassadors*), 1533

the death drive in life. I particularly focus on what I call the "blind field" of Hopper's paintings: the space implied by the composition, but not shown, which incites an anxious reverie in the spectator.

Unlike Frued, Lacan was actively engaged in the radical artistic movements of his time. At the time he was writing about paranoia and the mirror stage, he was in close contact with the Surrealists and especially interested in the work of Dalí. Chapter 3 is an account of the intellectual exchanges that took place between the two during the 1930s. It offers a detailed reading of Dalí's paranoiac-critical *tour de force, The Tragic Myth of Millet's Angelus.* The book is a demonstration of how an image can act as "a mirror of burnished metal," eliciting the projection of paranoid fantasies that are then subjected to analysis. The insights discovered in this way provide the basis for a highly original interpretation of the work of art. Dalí also links the Lacanian mirror image with the idea of the simulacrum: his fantastical works of art were painted so as to produce powerful reality-effects, casting doubt on what ordinarily passes for reality.

Surrealism's great contribution to aesthetics beyond pleasure is also acknowledged in Chapter 4. It concerns "the encounter" as it was introduced by André Breton in *Mad Love* and adopted by Lacan in *The Four Fundamental Concepts.* The chapter serves to broach some Lacanian concepts in a way that links them immediately to art practice and criticism. My argument shows that Lacan used the surrealist concept of the *trouvaille*—the object found as if by chance—in his formulation of the *objet petit a,* the object-cause of desire. The subject's glancing encounter with this object prompts an indirect awareness of the real beyond symbolization. Because, as I will show, Lacan learned so much from Dalí, Breton, and Surrealism generally, psychoanalytic theory cannot simply be "applied" to art. Rather, Lacanian theory itself is thoroughly imbued with a surrealist aesthetic.

The last three chapters turn to more recent theoretical and artistic contributions relevant to my theme. In Chapter 5, I argue that Robert Smithson's work continues to have a powerful resonance for contemporary artists and critics because he anticipated many of the present generation's concerns. Anton Ehrenzweig's *Hidden Order of Art* and Georges Bataille's *Eroticism* form the background for a reading of *Spiral Jetty* as a stage for a ritual performance that gives temporary sway to the death drive. Chapter 6, on Maya Lin's Vietnam Veterans Memorial in Washington, sets the work in relation to Freud's article "Mourning and Melancholia." The design of the memorial, I argue, instead of disavowing loss in the manner of the fetish, encourages remembering and a kind of "anti-mourning" because the reflections in the wall appear as shadowy revenants. It is also obviously informed by the tradition of monumental earthworks and is thus related to *Spiral Jetty* and its aesthetic concerns.

The Lacanian register of the traumatic real is foregrounded in my reading of Barthes's *Camera Lucida.* In Chapter 7, I argue that the book is deeply influenced by his reading of Lacan's *Four Fundamental Concepts.* The idea of the photograph's

2
Detail of *Jean de Dinteville and Georges de Selve* (*The Ambassadors*)

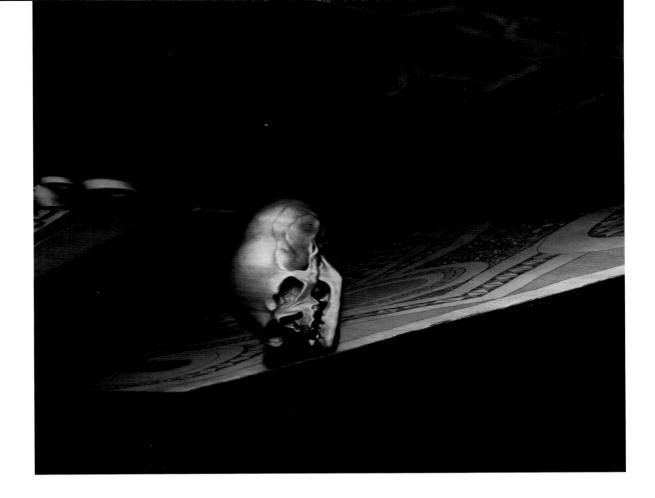

wounding punctum derives, at least in part, from Lacan's account of the missed encounter with the real. The book is a meditation on the essential nature of photography as a "that-has-been." For Barthes, the photograph indexically certifies the past existence of the object, tying it to loss and mourning. Barthes's text was of crucial importance for the shift in art theory I have described and is, in my view, a masterpiece of aesthetics beyond the pleasure principle. My concluding chapter, "After *Camera Lucida*," attempts to assess the book's impact on the theory and practice of photography as well as on other contemporary art practices. I argue that the theoretical shift from mirror to anamorphosis in art theory was manifested in art practice as a shift from a critical recycling of the photographic image as superficial simulacrum to a practice that values its indexical character. It is obvious why photography-based media should be held responsible for the proliferation of de-realizing simulacra, but Barthes's text ensured that photography has also come to be seen as the privileged site of the return of the real.

2 Uncanny

The Blind Field in Edward Hopper

Rachel Whiteread's large work, *Ghost* (1990), is the plaster cast of the interior space of a very ordinary Victorian sitting room (fig. 3). What we see is a space that is filled, negated—one to which we cannot return. Because the cast bears the traces of the demolished room that gave it shape, it evokes in another medium the pathos of the photograph as understood by Barthes. *Ghost* is an indexical imprint of a "that-has-been"; it bodies forth the presence of something that is no longer present.[1] Of course, its monumental, mausoleum-like whiteness and simplicity also contribute to this sense of an irrecoverable past or an impenetrable psychic space. But all this does not adequately account for the deeply ambivalent character of the work. One critic got the measure of this ambivalence perfectly, noting that it "elicits opposing emotional responses, inducing viewers to vacillate between comforting and sinister thoughts. To the nostalgic, it suggests the bare trimmings of a cozy, old-fashioned room, and serves as a screen onto which to project memories of old domestic rituals. Alternatively, and more bleakly, *Ghost* may appear oppressive, airless, dingy and macabre."[2] In other words, it is an uncanny object, ambivalently familiar and unfamiliar, intimate and strange. As Freud succinctly put it, "The uncanny is that class of the frightening which leads back to what is known of old and long familiar."[3]

Whiteread's *Ghost* (and all her sculpture) is uncanny because it not only triggers once familiar and now "unrecallable memories," but also reproduces a sensation

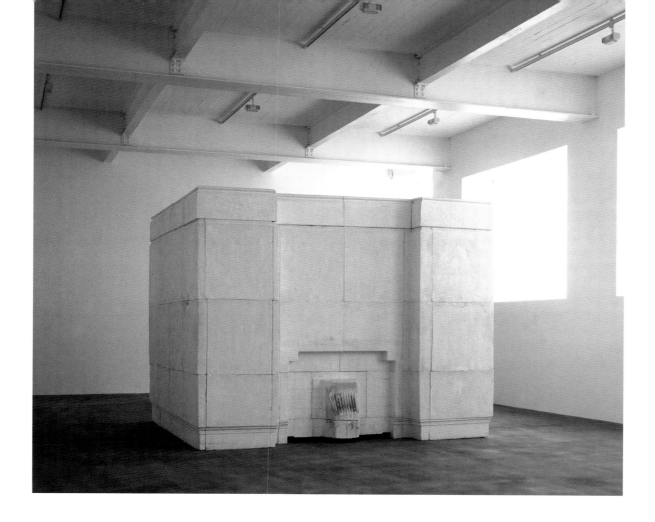

in the viewer of what it is like for those memories to return, unbidden.[4] By rendering voids solid, the sculpture creates a sense of suffocating over-presence. Intimate, domestic spaces, especially those inhabited by children, are turned into opaque or semitransparent blocks.[5] Asked in an interview why she made casts of furniture, Whiteread replied, "This was at first an autobiographical impulse, using something familiar, to do with my childhood. The first cast from furniture was called 'Closet,' taken from the space inside a wardrobe."[6] *Closet* (1988) is a plaster cast covered in black felt, an addition she did not repeat, perhaps because it is essential for the sense of suffocating over-presence that these spaces appear filled with a solidified liquid substance (plaster, rubber, resin). Speaking of *Ghost* in the same interview, Whiteread remarked, "I had an idea of mummifying the sense of silence in the room—a silence that is absolutely concrete, it completely smothers you." Several critics have noted her work's evocation of Pompeian archaeological plaster casts of the hollows left in the volcanic ash by dissolved organic bodies; some make the connection from

there to Freud's analysis of the Pompeian fantasy *Gradiva*.[7] The analogy is inexact, for the Pompeian plaster casts recreate the lost positive forms of the volcano's victims. There is a connection, however. The casts from Pompeii are literally traces of people buried alive, while Whiteread's filled spaces conjure up that uncanny fantasy in a metaphorical way.

I do not propose, in this chapter, to summarize or analyze Freud's text "The 'Uncanny'" (1919). Yet I do want to keep in close touch with it, so that the term does not deteriorate into meaning anything vaguely weird or spooky. There is a very large bibliography in literary studies of commentaries on and extensions of the essay, but surprisingly little concerning the visual arts—if you discount critical writing on Surrealism.[8] One exception is the art and writing of Mike Kelley, whose particular take on the uncanny centers on the encounter with dolls, wax figures, automata, and mannequins.[9] Another notable exception is Anthony Vidler's influential book *The Architectural Uncanny*, which associates the idea of the uncanny with the effects of urban alienation, thereby broadening the term beyond the scope of Freud's essay.[10] Freud's understanding of the uncanny is best summed up in the formula he borrows from the philosopher Schelling: "'*Unheimlich*' is the name for everything that ought to have remained . . . secret and hidden but has come to light." Freud reframes this idea in terms of his psychoanalytic model: the uncanny arises when "infantile complexes which have been repressed are once more revived by some impression, or when primitive beliefs which have been surmounted seem once more to be confirmed."[11] Most of the essay is taken up with a detailed reading of "The Sand-man" (1817), in which the uncanny effect is thought to turn on Nathaniel's childhood dread of the Sandman, who, he is told, puts sand in children's eyes so that they pop out. In the grown-up Nathaniel's frenzied imagination, the Sandman reappears throughout the story in various guises. Uncanniness is thus tracked down to castration anxiety. This would be a disappointingly reductive result, if Freud's essay did not suggest much more at work.

I want to use the concept of the uncanny, as developed by Freud and figured by Whiteread, as a means of countering what seems to me a prevalent but mistaken reading of Edward Hopper's painting as sentimentally nostalgic. For instance, describing his famous 1925 painting of a Victorian Gothic mansion, *House by the Railroad* (fig. 4), Gail Levin observes: "This solitary house seems to recall America's more innocent past—a simpler moment that has been left behind by modern urban life and its complexities. Hopper has presented us with a glimpse back in time, as though seen by chance while passing through on the way to some other place. *House by the Railroad* seems to embody the very character of America's rootless society."[12] What sort of gaze is assumed here? A nostalgic one, I suggest, which sees the house as a picturesquely decrepit monument gesturing toward a more authentic past in the midst of a degraded, alienated, "rootless" present. The passenger on

3
Rachel Whiteread,
Ghost, 1990

the train speeds into the future, casting a wistful glance backwards. Of course, only the rootless can be nostalgic. Or, to put it more emphatically, a condition of such nostalgic yearning is that the past be *safely* lost. This suggests why Levin's view of Hopper's painting must be mistaken. The house does not fade into the misty distance. On the contrary, it looms up all too closely, too powerfully. The past here returns uncannily.

What a nostalgic view of the past lacks is a sense of the violence of repression or, in this particular case, the violence of rapid industrialization and modernization that has doomed this architecture. Hal Foster's account of the surrealist and Benjaminian "outmoded" in his book *Compulsive Beauty* may be pertinent here. The auratic quality of outmoded things, such as the arcades in Paris, resides in their recalling an intimate relation with childhood—ultimately, one's closeness to the mother's body, the original lost object. But, Foster notes, "once repressed, the past, however blessed, cannot return so benignly, so auratically—precisely because it is damaged by repression. The daemonic aspect of this recovered past is then a sign of this repression, of this estrangement from the blessed state of unity."[13] The uncanny return of the past might be considered a kind of denatured nostalgia. *House by the Railroad,* then, can be seen as a once cozy, *heimlich,* maternal home, now crossed by repression represented by the railroad tracks. The spectator, positioned low (a child's-eye view?), gazes across the tracks at the weirdly transformed, forbidding house. Set in broad daylight, it is nonetheless the darkest painting of a house I know.

Hopper was a deeply pensive and taciturn man, almost incapable of making a direct statement about his art. He did stress, however, the importance of painting from memory.[14] His procedure was apparently strictly academic; he made studies from models and preliminary sketches, but the painting itself was done in the studio. This academic practice is intended to modify mimetic reference in the service of idealization. For Hopper, however, painting from memory allowed the motif to become saturated with unconscious reverie. A statement by the artist makes this clear: "So much of every art is an expression of the subconscious, that it seems to me most all of the important qualities are put there unconsciously, and little of importance by the conscious intellect. But these are things for the psychologist to untangle."[15]

I am not a psychologist, but I want to take up the challenge of making more explicit Hopper's suggestion that his paintings are saturated with unconscious reverie and addressed to an unconscious spectator. By keeping the "Uncanny" essay and the closely related text, *Beyond the Pleasure Principle,* in play, I hope to avoid a narrow interpretation of the uncanny that ties it too closely to castration anxiety. Instead, I aim to give wider scope to the uncanny as the surfacing of the death drive in life. Hopper's paintings and remarks suggest the appropriateness of this material, and all the critical literature at least recognizes in his work a certain negativity: "desolation," "alienation," "loneliness," "sadness," "silence," and "stillness" try to capture the

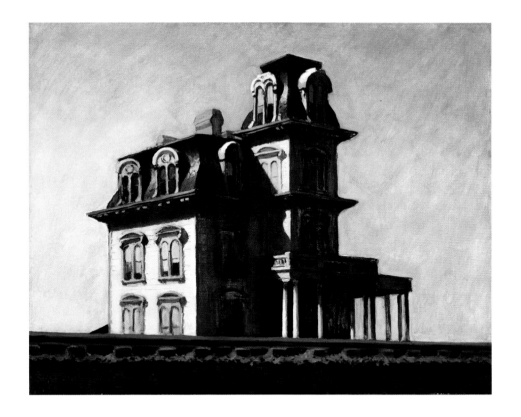

4
Edward Hopper,
*House by the
Railroad*, 1925

mood. Yet his work is completely untheorized, and the literature shows a tendency to sentimentalize his work. Terms like "sadness" and "loneliness" do not seem adequate to paintings that are deeply unsettling and sometimes even menacing.[16] Hopper is most often described as a Realist painter of the American scene in the tradition of Thomas Eakins. Yet formative early visits were made to Paris and other European cities (1906, 1909, and 1910), where he absorbed the lessons of the Impressionists and Post-Impressionists, particularly Degas, Manet, and Sickert. He also developed a taste for Decadent poetry. Although he was a lifelong and implacable opponent of abstraction, he was not necessarily a Realist—or even an antimodernist.

This character of Hopper's paintings can be foregrounded by juxtaposing a few of them with some stills from Hitchcock's *Psycho* from 1960 (fig. 5). *Psycho* begins with the camera moving slowly over a cityscape and then zeroing in and entering one partially open window. This apparently arbitrary intrusion is also characteristic of Hopper's cityscapes, where the open windows of apartment buildings reveal embryonic narratives. In the hotel room in *Psycho,* we find Marion and her lover snatching an hour together during her lunch break. The mood is one of brooding desire and frustration. Hopper, too, is a master of everyday scenes of thwarted relationships and

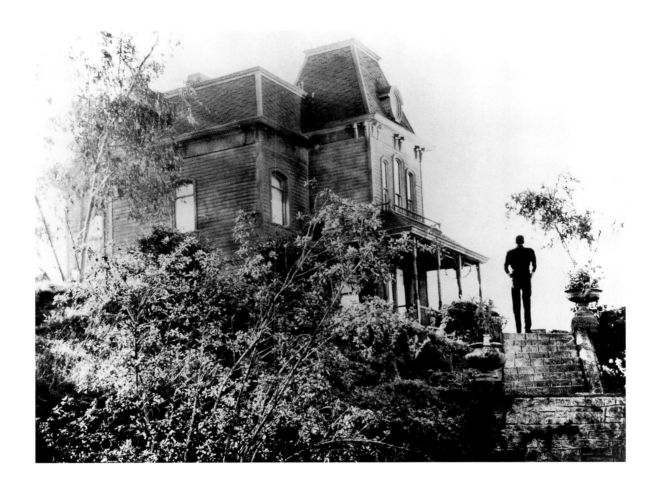

anonymous hotel rooms. They have a kind of leaden banality, as they must if they are to become uncanny. Film theorist Pascal Bonitzer notes that "Hitchcockian narrative obeys the law that the more a situation . . . is familiar or conventional, the more it is liable to become disturbing or uncanny."[17] This proximity of the familiar and the unfamiliar is the very hallmark of the Freudian uncanny. It involves the return of something that was very familiar in infancy or childhood, but is made strange or distorted by repression and the return of the repressed. As Freud put it, "this uncanny is in reality nothing new or alien, but something which is familiar and old-established in the mind and which has become alienated from it through the process of repression."[18]

This strangeness can be more or less exaggerated but, as Jean Laplanche and J.-B. Pontalis have pointed out, there is a continuum between the poles of reverie and primal fantasy, or to put it another way, between Marion's neurotic world and Norman's psychotic one.[19] Here again, *Psycho* helps draw out the deeply disturbing aspect of Hopper. The resemblance between the old Bates house and *House by the Railroad* is

striking and has been noted by other commentators.[20] Hitchcock acknowledged his use of Hopper's painting; he recognized the deeply disquieting quality of the work and used it. But the influence was not all one-way. Hopper was an avid movie enthusiast and seemed to have invented a classic film noir shot decades before the genre was invented. The "Expressionist" etching *Night Shadows* (1921) is "shot" from above and shows a lone man in a street crossed by harsh light from street lamps that cast long shadows. He also painted the interior of a movie theater, *New York Movie* (1939), in which viewing a film and the usherette's internal reverie (and our attention to the painting) are implicitly associated.

While my juxtaposition of Hopper and Hitchcock may effectively counter the view of Hopper as a sentimental Realist and highlight the filmic quality of Hopper's paintings, it perhaps has the disadvantage of tempting us to narrativize the paintings—a temptation yielded to completely in the catalogue of the retrospective at the Whitney, *Edward Hopper and the American Imagination*. The catalogue, published in 1995, is almost entirely made up of stories and poems spun around Hopper paintings and "Hopperesque" fiction. As John Updike remarked in his review, "Hopper himself put the temptation there . . . he seems on the verge of telling a story." But attempts to spell out the drama just "slide off the paintings."[21] He might also have mentioned that Hopper worked as an illustrator in order to make a living until the mid-twenties, that is, until he was forty-two. He despaired of magazine editors who wanted anecdotal scenes with people "grimacing and posturing."[22] Hopper's paintings are like film stills, suspended narratives that simultaneously incite our desire to narrate and frustrate it. His best paintings preserve a measure of illegibility.

Hopper's work has been subject to another kind of reductivist interpretation, one that is just the opposite of narrativization. This is best exemplified by the poet John Hollander's essay "Hopper and the Figure of Room." In fact, he begins by attacking narrativization, noting that a painting that left Hopper's studio called simply *Seventh Avenue Shops* has since acquired the title *Early Sunday Morning*, turning it into a slightly sentimental genre painting. But he himself provides Hopper with a career narrative of a very recognizable modernist genre. Hollander speaks of "the gradual emptying out of Hopper's interior spaces over a period of thirty years" and of "the dissolution of objects and details which could play any narrative role."[23] Hopper's famous "lightfalls," or trapezoids of light, he says, create "out of enclosed space, meditative room." In *Morning Sun* (1952), for example, "the interrupted parallelogram has become a formidable presence, an image of the meditative gazer's mind as the cast shadow on the bed is of her body." Hollander concludes that, despite himself, Hopper was an abstractionist: "the lightfalls come to occupy Hopper's room as the detritus of anecdote is brushed aside by the act of painting itself." Hollander persuasively argues that lightfalls represent the mind of the figure depicted, so the deep perplexity of the man in *Excursion into Philosophy*, for example, is manifested by the

5
Film still from Alfred Hitchcock's *Psycho*, 1960

complex crisscrossing of lightfalls in the room. The essay reaches its climax with the painting *Sun in an Empty Room* (1963), which has come to be seen as Hopper's last painting (although it isn't), and in which is told, according to Hollander, "the total parable of the relation of the internal and the external in the vision of the sublime."[24] The meaning of Hopper, on this account, is a speculative meditation on the nature of consciousness combined with Abstract Expressionist reflexivity about the act of painting, and, to crown it all, a triumphant reconciliation of American Realist and Abstract traditions.

It goes without saying that Hollander's meditative room excludes the unconscious. My view of Hopper is rather different. While Hollander's Hopper is all light, consciousness, and reflexivity, my Hopper is noirish, full of shadows and uncanny scenes. I am reminded of Freud's irritation with traditional aesthetics expressed in the opening paragraphs of "The 'Uncanny.'" "As good as nothing is to be found upon this subject in comprehensive treatises on aesthetics," he complains, "which in general prefer to concern themselves with what is beautiful, attractive and sublime—that is, with feelings of a positive nature—and with circumstances and objects that call them forth, rather than with the opposite feelings of repulsion and distress."[25] Freud often broached this issue of an aesthetic beyond the pleasure principle, particularly in his discussions of our response to tragedy. But his solution to the riddle of what interest we take in tragedy, reiterated in *Beyond the Pleasure Principle,* is disappointing. In tragedy, a series of calamitous events is received by the audience with horror. But tragedy surreptitiously serves the pleasure principle, for what is enacted on the stage, say in *Oedipus Rex,* is in fact a repressed infantile wish—murdering Father and marrying Mother. Is the uncanny, then, simply a variant on this well-worn formula of unpleasure for one system, pleasure for another? Not in so far as "The 'Uncanny'" is read through *Beyond the Pleasure Principle,* for, as Freud goes on to remark, such speculations on tragedy are of "no use for *our* purposes, since they presuppose the existence and the dominance of the pleasure principle."[26] Furthermore, it is hard to see how Hoffmann's "Sand-man," the story of demonic possession, castration, and death that is the centerpiece of Freud's "Uncanny" essay, could be plausibly interpreted as a disguised fulfillment of a repressed wish. In Freud's revised model of psychic functioning, the dream, literature, or art can be something other than compensatory pleasure; it can give form to inchoate ideas, primitive fears, anxieties, and childhood traumas.

Unfortunately, Freud does not really say much about what interest we do take in the uncanny if it is not pleasure, but he perhaps inadvertently suggests one when describing the type of person completely insensible to uncanny phenomena. In such a person, infantile beliefs have been so effectively surmounted that "the most remarkable coincidences of wish and fulfillment, the most mysterious repetition of similar experiences . . . the most deceptive sights and suspicious noises—none of

these things will disconcert him or raise the kind of fear which can be described as 'a fear of something uncanny.' The whole thing is purely an affair of 'reality-testing,' a question of the material reality of the phenomena."[27] Freud does not sound very sympathetic with this imperturbable fellow, yet in the opening paragraphs of the essay, he confesses to "a special obtuseness in the matter (of the uncanny) where extreme delicacy of perception would be more in place." As the writer of "the present contribution," Freud admits, "it is long since he has experienced or heard anything which has given him an uncanny impression, and he must start by translating himself into that state of feeling, by awakening in himself the possibility of experiencing it."[28] Freud goes out to meet the uncanny, opening himself up to it. At the same time, in *Beyond the Pleasure Principle,* he risked such bold metapsychological speculation that it unsettled and continues to unsettle the whole edifice of psychoanalysis.[29]

Modalities of the Uncanny

The most revealing statement Hopper ever made about painting was not about his own work, but about that of a fellow painter he much admired—Charles Burchfield. His tribute, published in 1928, tells us a great deal about what he values in art. What Hopper particularly stresses is Burchfield's attention to the marginal or overlooked. He quotes a passage from Emerson: "In every work of genius we recognize our own rejected thoughts; they come back to us with a certain alienated majesty."[30] These rejected thoughts are bound to remind us of "repressed thoughts" that return with an uncanny aura. The attention to the overlooked might also remind us of Freud's remark about the psychoanalyst who "is accustomed to divine secret and concealed things from unconsidered and unnoticed details, from the rubbish heap, as it were, of our observations."[31] Hopper catalogues some of Burchfield's motifs, many of which overlap with his own:

> No mood has been so mean as to seem unworthy of interpretation. The look of an asphalt road as it lies in the broiling sun at noon, cars and locomotives lying in God-forsaken railway yards, the steaming summer rain that can fill us with such hopeless boredom, the bland concrete walls and steel construction of modern industry, mid-summer streets with the acid green of closecut lawns, the dusty Fords and gilded movies—all the sweltering, tawdry life of the American small town, and behind all, the sad desolation of our suburban landscape. He derives daily stimulus from these, that others flee from or pass with indifference.[32]

What particularly interests me in this passage is its evocation of melancholy. It describes scenes full of blanks and voids—an asphalt road, a concrete wall—and calls up moods of hopeless boredom and sad desolation suggesting some inef-

fable, traumatic loss. Hopper links one of Burchfield's paintings to the experiences of childhood: "*March is* an attempt to reconstruct the intimate sensations of childhood, an effort to make concrete those intense, formless, inconsistent souvenirs of early youth whose memory has long since faded by the time the power to express them has arrived, so close to dreams that they disappear when the hand tries to fix their changing forms."[33] Again, Hopper emphasizes formless and fugitive phenomena that resist symbolization. There is also the suggestion of a temporal delay characteristic of trauma between the unassimilable experience and the possibility of its representation. Hopper does not inquire into why these early scenes and dreams should be so fleeting, but, according to psychoanalytic theory, their proximity to repressed material sucks them, so to speak, into the unconscious. A painting of a scene that touches on that material will be perceived as uncanny.

Freud describes several modalities of the uncanny, all of which concern the evocation, either in life or in literature, of repressed thoughts or infantile experience. I want to consider first of all the phenomenon of involuntary repetition, although I will return to some of the other modalities later on. Freud offers as an example of repetition compulsion an episode from his own experience: "When walking, on a hot summer afternoon, through deserted streets of a provincial town in Italy which was unknown to me, I found myself in a quarter of whose character I could not long remain in doubt."[34] He hastens away from the red-light district only to be led back again and then again by another detour. The reason such an experience is uncanny is because the repeated behavior seems "fateful and inescapable." The psychoanalyst recognizes in such instances "the dominance in the unconscious mind of a 'compulsion to repeat' proceeding from the instinctual impulses and probably inherent in the very nature of the instincts—a compulsion powerful enough to overrule the pleasure principle, lending to certain aspects of the mind their daemonic character, and still very clearly expressed in the impulses of small children."[35] Although it is not mentioned in this essay, in *Beyond the Pleasure Principle,* it is the death drive that has a demonic character and overrides the pleasure principle. Freud's formulation of the drive is notoriously obscure. What is clear, however, is that it was prompted by the observations that shell-shocked soldiers he treated during World War I repeatedly dreamt of their traumatic experiences; that his grandson invented a game that, in fantasy, repeated the painful experience of separation from his mother; and that people in analysis contrive to repeat as contemporary experiences childhood events such as the conflicts of the Oedipal scenario and its dissolution. These and other observations lead Freud to conclude that libidinal, pleasure-seeking drives constitute only that portion of the instincts (now termed Eros) that generally has to do with establishing greater unities and binding together, while the death drive endeavors to undo connections, to disassimilate and to destroy, eventually reducing complex organic things back to their original, molecular, inorganic state.[36]

Freud's unsuccessful flight from a red-light district sounds more like a case of the pleasure principle overriding the reality principle, although it does display the automatization characteristic of repetition compulsion, which is, as it were, halfway to the inorganic. But in fact, Freud thought that Eros and Thanatos were intertwined. The death drive only makes its appearance either defensively projected outward as aggression or "tinged with eroticism."[37] There is a Hopper painting that perhaps evokes something of Freud's uncanny experience, now glossed as a manifestation of the death drive tinged with eroticism: *Summertime* (1943). A young woman in an improbably sheer white dress stands invitingly in the granite portico of a city apartment building. The scene reminds me of Norbert Hanold's noonday "bodily apparition" of Gradiva in the streets of Pompeii, as described by Jensen and analyzed by Freud.[38] The brilliant white light puts the interior, seen through a door, in blackest shade and makes on the steps behind the woman a crumpled, anamorphic shadow. The temporality of repetition cannot be represented, except perhaps in the repetition of architectural elements, but there is a Magritte-like surrealism in the hot breeze that lifts the curtains in one of the windows, opening a black gap. I want to argue that a great many of Hopper's paintings can be elucidated in terms of this uncanny surfacing of the death drive.[39]

What I am calling Hopper's figuration of the death drive sometimes takes the form of a gap or void. There are several examples of people looking at empty stages. David Anfam remarks, "It is difficult to ignore the implication that the void, before which spectators come to deliberate interminably, has symbolic potential. In his last painting, *Two Comedians*, the long awaited performance finally materializes. Edward and his wife Jo take their last bows beside artificial foliage and darkness."[40] Anfam does not mention the motif of the tunnel, of which there are at least two examples: *Bridle Path* (1939), in which a white horse rears up, spooked, at the entrance to the underpass in Central Park, and *Approaching a City* (1946), in which the spectator is in the position of a train about to enter a tunnel at the periphery of New York. The most striking void in Hopper's *oeuvre* is the figurative one into which the young woman in a coin-operated restaurant, *Automat* (1927), peers as she drinks a cup of coffee (fig. 6). The title obviously identifies the setting as a coin-operated restaurant, but it also clings to the figure. Most of the canvas is taken up by a thinly painted dark window that reflects the ceiling lights of the interior. The steep recessional convergence of these reflections suggests a vertiginous lure. Seated near the door, the woman will soon put on her other glove and disappear into the night. A painting done the previous year, called *Sunday*, shows a similar use of the window motif. A seated man in shirtsleeves does not seem to be enjoying his day off; behind him, two black windows read as the blankness in the man's eyes writ large. And again, in *Hotel Window* (1955), an elderly woman in an anonymous hotel lobby gazes into a black window.

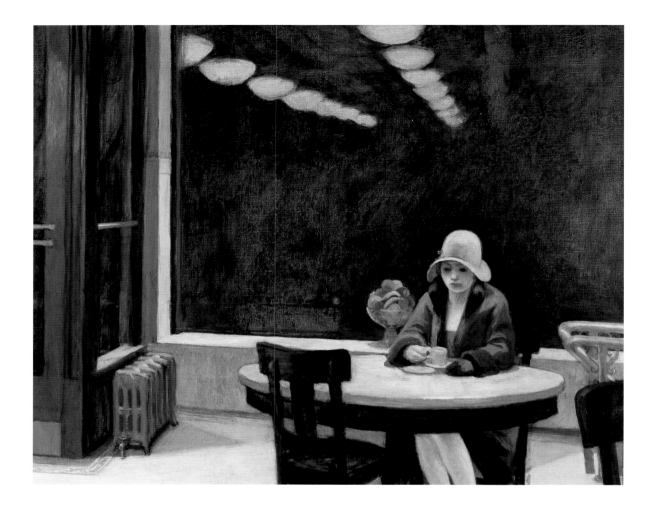

Other critics have observed the prevalence of the theme of death in Hopper's work. Even Hollander has to admit, in a footnote, the gloominess of a late work called *Chair Car* (1965), which depicts the interior of a train carriage: "With its closed off back wall, the flaglike lightfalls, and the strange dispositions of the figures, this has always seemed to me a version of Charon's ferry."[41] The poet Mark Strand consistently reads Hopper's paintings in this light. His reading of *Gas* (1940) is typical. The woods in the background are "nature's dark side, heavy and brooding" and "the illuminated Mobilgas sign with its small, red, winged horse only underscores, with ironic detachment, the impossibility of our escaping what seems like our mortal destiny."[42] My concern, however, is not simply with death as subject matter, but rather with the evocation in Hopper's work of a disturbing death drive and its contribution to a sense of uncanniness produced in the spectator.

I now want to turn to some of the other modalities of the uncanny and their pertinence to Hopper's painting. One that figures in Hoffmann's tale "The Sand-man" was the living doll, Olympia. According to Freud, children do not strictly distinguish between the animate and the inanimate or between fiction and reality, and so they are inclined to think that their dolls or stuffed animals are alive. As adults, then, the sight of a lifelike automaton—or automatic human behavior—reactivates the infantile belief that we thought we had surmounted. Freud borrowed this modality from Ernst Jentsch, whose "On the Psychology of the Uncanny" was published in 1906. Jentsch understood the uncanny as bound up with a feeling of uncertainty, particularly in regard to whether something is animate or inanimate. He mentions wax figures, life-size automata, panopticons, and panoramas. But the sensation may equally well be stimulated when we have occasion to doubt that a human being is anything more than an elaborate mechanism.[43] Jentsch's article is of considerable interest, but Freud was completely justified in distancing himself from it, for Jentsch insisted that the feeling of the uncanny is particularly strong in primitive peoples, children, women, the uneducated, and anyone with a nervous disposition. Freud, however, took the uncanny to be a fully "grown-up" phenomenon that occurs when some experience triggers ideas and feelings from childhood that we thought we had discarded, feelings that reassert themselves in our minds. By definition, then, only the enlightened adult is susceptible to uncanny sensations.

Hopper offers a very striking example of this modality of the uncanny. *Chop Suey* (1929) depicts a china doll in a Chinese restaurant who has a fixed stare, rigid posture, pale skin, and a painted mouth. There may also be a suggestion of the body's commodification and reification in the fashionable flapper's mannequin-like appeal. The double, another important modality of the uncanny, also appears here. A nearly identical woman sits opposite the first at the table. Freud explains that the double is uncanny because in infancy, primary narcissism, part of Eros, creates a double as an insurance against the destruction of the ego—which later, once it has been repressed, returns and reverses its aspect, becoming "an uncanny harbinger of death."[44] Hopper's ubiquitous shadows cast by objects or figures are, of course, another sort of double.

Because the German *unheimlich* is, in part, a negation of "homey" or "cozy," an obvious theme of the uncanny is the haunted house. Yet Freud was somewhat dismissive about this category; it can be just gruesome, rather than uncanny. Ghosts, it turns out, have a lot in common with doubles, as both are rooted in primary narcissism. People are unconsciously convinced of their own immortality, so the idea persists that the dead return in some form. Ghastly ghosts are, again, the repressed, distorted, and returned form of this idea. Hopper actually gave the title *Haunted House* to a watercolor of a house in Gloucester, Maine, deserted and boarded up. But it is the Gothic monstrosity, *House by the Railroad*, that sticks in the mind as disqui-

6
Edward Hopper,
Automat, 1927

etingly *unheimlich*. The *unheimlich* Victorian Gothic is a frequent motif in Hopper, but perhaps even more common is the New England Cape Cod cottage. There are biographical explanations for this; he and his wife spent six months of the year in a New York City apartment in Washington Square, and six months in Truro, Massachusetts, on the Cape. But what is crucial is Hopper's treatment of the cottages, which are usually depicted as the very image of rose-trellised domestic bliss. The artist Raphael Soyer visited the Hoppers' Cape Cod cottage one day in late summer and found the artist had produced no paintings. Hopper explained that he was "waiting for November, when the shadows are longer and the landscape is more interesting, in fact, beautiful."[45]

The Blind Field

I am painfully aware that, although I began with a thesis about the uncanniness of the experience of Hopper's paintings, I have slipped into a catalogue of uncanny motifs—the surfacing of the death drive, uncanny lifelike dolls, doubles, haunted houses. This is entirely unsatisfactory, because it suggests that the motifs themselves, their pure narrative content, create the uncanny effect, not the actual encounter with particular paintings. It must be said (and other writers have already done so) that Freud himself disregards the formal uncanniness of "The Sand-man" and that this precedent has hampered subsequent psychoanalytic art criticism.[46] I have already mentioned in passing, however, two unusual, closely related formal features that structure the nature of the encounter with Hopper's paintings: the film-still quality and the view from the passing vehicle. The film-still quality has partly to do with the suspended narrative, but just as much to do with what one can only describe as Hopper's "camera angles" and views into windows that one would call "crane shots" in cinema. Of course, many artists had already integrated photographic formal inventions into painting; Degas, whom Hopper particularly admired, is a perfect example. The effect of cropping objects in the foreground with the frame is essentially a photographic device. Film theorists have developed the idea to accommodate their medium. André Bazin, for instance, noted how the edges mask the surrounds and show only a portion of reality: "What the screen shows us seems to be part of something prolonged indefinitely into the universe."[47] It leaves even what is centered open and incomplete. Pascal Bonitzer explores this effect in his book *Le champ aveugle*, giving it a psychoanalytic spin. He observes that "the cinema simply wants what takes place off-screen to have as much dramatic importance—and sometimes even more—as what takes place inside the frame." What is it, he asks, about a film still that immediately strikes one? It is that "the trajectories of the image, the frozen movements, the gazes and the vanishing lines of the set seem to be attracted, drawn by a center of gravity situated outside the frame." This partial view, he concludes, is like a lost part object, cause of desire, and so sustains our desire through the desire to see.[48] Yet

this is not an effect restricted to cinema. Meyer Schapiro comments perceptively on this phenomenon in painting, where foreground objects are apparently arbitrarily cropped: "Such cropping . . . brings out the partial, the fragmentary and contingent in the image. . . . The picture seems to be arbitrarily isolated from a larger whole and brought abruptly into the observer's field of vision. The cropped picture exists as if for a momentary glance."[49] Unlike Bonitzer, though, Schapiro does not consider how this formal invention stimulates the spectator's desire, which is what particularly interests us here.

Hopper always included a blind field in his paintings. He said of *Manhattan Bridge Loop* (1928), for example, that its long uninterrupted horizontal lines were intended "to make us conscious of the spaces and elements beyond the limits of the scene itself."[50] But the blind field is not just on the periphery of a painting; it infiltrates the whole composition, as Schapiro's remarks make clear. The famous painting *Office at Night* (1940) is exemplary in this respect (fig. 7). Its cropping recalls Degas, and its very high "camera angle" effectively tilts the floor and desk forward. Early sketches for it show that the scene was originally framed by and viewed through an open window. Hopper was unusually forthcoming about this painting in a letter: "The picture was probably first suggested by many rides on the 'L' train in New York City after dark and glimpses of office interiors that were so fleeting as to leave fresh and vivid impressions on my mind."[51] There seems to be a *non sequitur* here. The fleeting glance from a passing vehicle and the arbitrary cropping by the window, temporal and spatial blind fields, somehow combine to make the scene vivid rather than, as one might expect, obscure. Why? Because the spectator's own reverie, enhanced in Hopper's case by the movement of the train, latches onto a scene encountered by chance—in the same way that Freud's unconscious fantasy was stirred by a botanical monograph he saw while passing a bookshop window or, as we shall see in Chapter 4, the way that André Breton's attention was drawn to a wooden spoon in a flea market.[52] There is also, of course, an element of unauthorized looking, spying at what the grown-ups get up to at night. Hopper remarked about a related painting that retained the open window framing, *Room in New York* (1932), that "it was suggested by glimpses of lighted interiors seen as I walked along the city street at night."[53]

Feminist criticism of *Office at Night* has focused on the gender/power relationship between the two figures. Linda Nochlin suggests that the painting pivots on "the unasked and unanswerable question of whether the woman will stoop over to pick up the piece of paper half hidden behind the desk," but the alienation and sterility of the workplace may mean that they never make contact.[54] Victor Burgin has noted that the posture of the woman in *Office at Night* is phantasmatically sexy and anatomically impossible, showing breasts and buttocks simultaneously. He argues that this excessively eroticized secretary threatens to subvert "the organization of sexual-

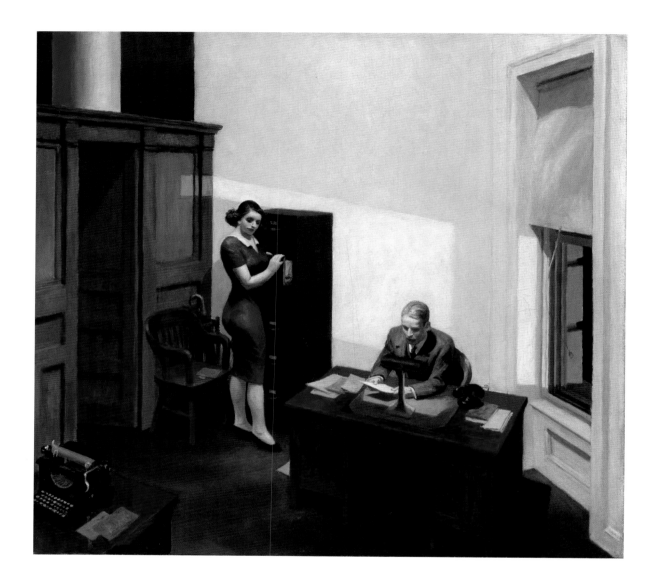

ity within and *for* capitalism" and to distract from productive labor. Yet the formal tightness of the painting and the man's refusal to look up from his work stabilizes the erotic threat and provides a patriarchal "moral solution." The male viewer, according to Burgin, can enjoy the woman's body voyeuristically, while at the same time identify with the probity of the boss.[55] Ellen Wiley Todd thinks that neither Nochlin nor Burgin gives the secretary her due of power and dominance in the scene.[56] (In this respect, she seems to me related to the contemporaneous *femme fatale* of film noir.) But this stress on the sexual tension between the two figures, or on the response of some hypostatized male viewer, short-circuits attention to one's own response to the

work. In my view, the spatial and temporal blind fields of the painting incite a specu-lation and free-associative reverie that may lead off onto that other scene—a trau-matic primal scene glimpsed or imagined in infancy. This would account for some of the enigmatic painting's peculiar vividness.

We have seen in the analysis of *Office at Night* two apparently conflicting mo-ments of reception: a vivid impression, saturated with meaning, and then a dis-persion of questions and connections leading off into the blind field. Moments of density or fusion alternate with moments of de-fusion or dissemination. In his book *Cracking Up*, the analyst Christopher Bollas has suggested that the two basic opera-tions of dreamwork, condensation and displacement, should be understood as two fundamental moments in the dialectic of the unconscious.

> Unconscious mental life operates according to an oscillation that ensures its continuous . . . function, as on the one hand unconscious work brings together through condensation otherwise disparate ideas, and on the other hand the process of free association then deconstructs these condensa-tions. When Freud asked the analysand to free-associate to the dream, he frequently stressed that in so doing the patient dispersed the manifest con-tent of the dream. What was created by an act of condensation—the dream event—is destroyed by the work of free association. Both processes, how-ever—bringing together and cracking up—are important features of the un-conscious and constitute its dialectic.[57]

The vivid experience of a Hopper painting has not only to do with certain mani-fest visual features, such as the elimination of detail and the saturation of colors, but also with a condensation of meaning. That very density of meaning, however, propels the spectator in a multitude of directions, driven by a free-associative ac-tivity that Bollas, with a nod to Nietzsche, calls "creative destruction."[58] Although he does not draw out the connection, Bollas's dialectic of the unconscious exactly parallels Freud's distinction between Eros and the death drive. The concept of the free-associative blind field of art might, then, be a step toward a psychoanalytic aes-thetic beyond the pleasure principle. But this "free-associative" blind field appears to be generated more by Hopper's suspended narratives than by any formal features. Are his paintings compositionally uncanny? How do they address the unconscious spectator?

The composition of a painting may suggest a subjective point of view that points to the implied presence of someone situated in the space in front of the scene. That is to say, some works of art depend, structurally, on the implicit presence of a specta-tor or an "actor" of some kind in the spectator's space. The outward gaze of a figure offers one way of establishing the presence of an implied spectator in the blind field

7
Edward Hopper,
Office at Night, 1940

of the painting, but a steep or oblique point of view is also effective. Degas's frequent use of oblique perspectives suggests that he intended the point of view to be experienced as subjective, and this is underscored in *L'Absinthe*, for example, by props (a table and newspaper in the lower left-hand corner). Alois Riegl pursued this theme at length in his book *The Group Portraiture of Holland*, originally published in 1902, where he argued that the coherence of a painting such as Rembrandt's *Syndics* depends on the figures' intense attention to someone near the spectator's position.[59] A dramatic scenario is thus implied, similar to the one Manet contrived in *A Bar at the Folies-Bergère* (1881–82). Yet the Manet painting, as T. J. Clark has argued, does not involve us in a reciprocal exchange of looks. The barmaid's blasé face of fashion resists that possibility.[60] Yet Clark's analysis does not fully draw out the way Manet's composition *effaces* the spectator who is initially solicited and then intercepted by the impertinent presence of the top-hatted gentleman in the mirror. In order to "see" the image in the mirror, the viewer is forced to vacate his position of mastery.[61] It is, so to speak, a more "naturalized" version of the effect of the anamorphic death's head in Holbein's *Ambassadors*.

But Manet's painting is not uncanny. Nor does the decentering of the spectator have the full force implied by Holbein's death's head, so the intercepted subjective view is clearly not sufficient for an uncanny impression. Slavoj Žižek's discussion of Hitchcockian montage in *Looking Awry* throws some light on what else is required. Hitchcock typically alternated a subjective tracking shot of a person approaching a thing—say, Lilah's view as she approaches the strange house in *Psycho*—with an objective shot of the character, that is, of Lilah climbing toward it. To insert a neutral objective shot of the house in this sequence would undo the uncanny effect, because we would be assured that her subjective view is simply deluded. Similarly, a subjective shot from the house, say, of Lilah spied from behind twitching curtains would locate another person who may be frightening, but is not particularly uncanny. Žižek suggests, following Lacan, that the effect of the scene has to do with the notion that "it is already the house that gazes at Lilah." This invisible or blind gaze has caught Lilah and filled her, and us, with anxiety.[62] Such a deanthropomorphized gaze can either affirm our existence (when it refers back to the mother's benevolent gaze) or it can, by the same token, negate it (as in, for example, the paranoid's subjection to a persecuting gaze). The old house in *Psycho* and, I would argue, the one in Hopper's *House by the Railroad* subject the viewer to an annihilating gaze.

Another aspect of the blind field is its temporality. The scenes represented in *House by the Railroad* and *Office at Night* suggest an implied spectator on a train, rushing through time. What we carefully explore in the painting, then, has the status of an afterimage, or memory. Like the scene that plants the seed of trauma, the representation of the scene is only possible after the irrecoverable event. But why do just

these scenes "stick"? Can paintings have the structure of what Freud called "screen memories"? Screen memories are recollections that adults have of their childhood. Freud observed that the earliest recollections of our childhood are often "concerned with everyday and indifferent events which would not produce any emotional effect even in children—but which are recollected (too clearly, one is inclined to say) in every detail." The reason why one has such a vivid recollection of a relatively banal event is that it is a mnemic image: not of the relevant experience itself, which is resisted, but of another image closely associated with the first. It is, as he says, "a case of repression accompanied by substitution of something in the neighborhood (whether space or time)."[63] Freud concludes that memories *from* our childhood may be a misnomer, as "memories relating to our childhood may be all we possess." The banal becomes uncanny when it is "too clear," given the apparent insignificance of the scene. On this account, the peculiar effect of Hopper's paintings derives from their indirect representations of unrecallable memories, banal but too-clear screen scenes of traumatic events.

Rachel Whiteread's *House*

I want to conclude by setting one more house alongside Hopper's *House by the Railroad* and the old Bates house in *Psycho*. There is a large and thoughtful literature on Whiteread's celebrated temporary monument, *House* (fig. 8), completed October 25, 1993 and destroyed on January 11, 1994. It is the concrete cast of the interior of a Victorian terrace house that was set for demolition, produced in situ on Grove Road, Bow, East London, close to the infamous Enterprise Zone of Docklands. Its construction involved spraying the interior space with a reinforced concrete skin and then removing the building-mold. The issue of nostalgia was a sensitive one for the reception of *House*. There was a temptation for some to read it as a monument to a long-lost, homogeneous working-class community—an interpretation that would play straight into the hands of those wishing to stir up the area's bitter history of racial hatred, directed first at the Jewish community settled there and then at immigrants from the Indian subcontinent. Doreen Massey and others have insisted that nostalgia cannot just be dismissed, for it is a symptom of our sense of what is lost in Enlightenment modernity.[64] Yet Mladen Dolar historically locates the uncanny, not nostalgia, as the underside of Enlightenment and scientific rationality. For him, Frankenstein's monster returns as modernity's repressed other.[65] Similarly, Terry Castle calls the uncanny the "toxic side effect" of the Enlightenment.[66]

There would seem to be a worrying conflation here of nostalgia and uncanniness, which brings us back to our starting point and the diverse reactions to Hopper's *House by the Railroad*. Nostalgia runs imperceptibly into uncanniness. This conflation repeats exactly the peculiar relation of the *unheimlich* to its near opposite, *heimlich*. As Freud pointed out, the root term has a range of meanings, running

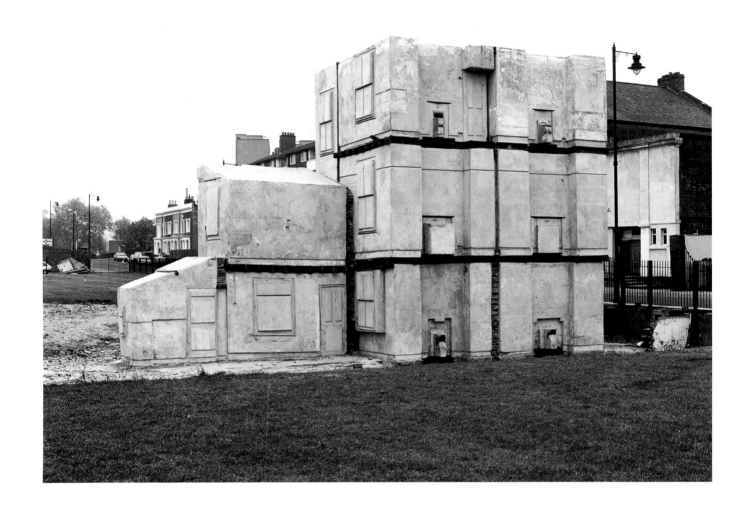

from homely, cozy, or intimate to hidden, secret, and concealed: "Thus *heimlich* is a word the meaning of which develops in the direction of ambivalence, until it finally coincides with its opposite, *unheimlich*."[67] If nostalgia is the desire for the *heimlich* object, then that object is likely to prove highly unstable. As I have already suggested, however, nostalgia longs for a past safely lost that may yet serve as an ideal for the future. The uncanny, in contrast, returns unbidden in the present. In a number of ways, *House* presented itself as this uncanny object. First, it was the cast of the interior space, so that what appeared was not a simulacrum of a house but a strangely

defamiliarized object relating to a house. Everything was reduced to the same inert substance. The simplification of forms bordered on abstraction. Whiteread took pains to remove architectural details, including the whole interior staircase, so that the sculpture would not be too articulated, too intimate. The roof void was not filled, so it had a flat, "modernist" top. The windows were "blind." Second, the white concrete absorbed color from wallpaper, stains from walls, and soot from hearths, suggesting something not altogether wholesome about its history. Third, the sculpture attracted hostile vandalism, including a splash of red paint and a spray-painted skull and crossbones, in a dreadful repetition of forms of racial harassment. Finally, it was ruthlessly destroyed by the local council in a repetition of the wholesale bulldozing of buildings and displacement of people carried out in the area. Yet despite these precautionary features and ominous repetitions, the effect of *House* is still ambivalent. No object, it seems, can be unequivocally uncanny or nostalgic. Perhaps this helps explain why Hopper's *House by the Railroad* can figure both in Gail Levin's nostalgic narrative of America's simpler, more innocent past and in Hitchcock's uncanny narrative in *Psycho,* where a dreadful past irrupts violently amid the apparent banality of the present.

8
Rachel Whiteread,
House, October
1993-January 1994

3 Paranoia

Dalí Meets Lacan

In the last chapter, we saw that one of Freud's modalities of the uncanny, the double, has its roots in narcissism and the consolidation of the ego. The double becomes uncanny when this original guarantor of personal integrity returns from repression as a harbinger of death. The ambivalence of the double is also at the heart of Lacan's conception of the ego as a mirror image. In both cases, the very need to conjure a double points to an underlying insecurity. This latent insecurity and the formation of the ego as an other, outside, makes the subject prone to paranoia. This chapter centers on the theme of paranoia as it was pursued in the 1930s by Lacan and Dalí, sometimes in collaboration.

One of the most brilliant examples of psychoanalytic art criticism is Salvador Dalí's interpretation of Jean-François Millet's *Angelus* (1858–59), now at the Musée d'Orsay in Paris (fig. 9).[1] What makes it of special relevance in the context of this book is that it was written at the height of a period of intellectual collaboration between Lacan and Dalí. The 1930s were particularly fertile years for exchanges between the Surrealists and the then newly qualified psychiatrist.[2] If Dalí was Lacan's main surrealist interlocutor when his work revolved around the mirror and paranoia, then Breton become increasingly important to Lacan when he later came to formulate his conception of the *objet petit a* and the missed encounter with the real. We shall see in the next chapter—on Lacan and Breton—that even in the mid-1960s Lacan

was still feeding his imagination and rethinking psychoanalysis by drawing on his initial encounter with the Surrealists in the 1930s. In addition, these two chapters serve to fill out some of the psychoanalytic and art-theoretical history of the models that I elaborated in the Introduction for conceiving of the subject's relation to the image—mirror and anamorphosis.

Le mythe tragique de l'Angélus de Millet is Dalí's detailed study of a painting of an apparently banal rural scene showing a peasant couple pausing in a field for evening prayer in the midst of their labors. For his interpretation, Dalí deployed what he called his "paranoiac-critical method," which involved the simulation of paranoid psychosis, with its typical perceptual hyperacuity and rigorously logical style of

thought. The technique exaggerated what is the necessarily hypothetical, interpretive, and speculative nature of any study of art. Yet art history is not alone in this. With unusual candor, Freud acknowledged an uncomfortable similarity between paranoid thought and the hypothetical constructions of psychoanalytic interpretation, admitting that "the delusions of patients appear to be the equivalents of the constructions which we build up in the course of analytic treatment."[3] Lacan, on the other hand, compared the analysand's projections with paranoia. In an article called "Aggressivity in Psychoanalysis" (1948), he described the technique of analysis as an inducement of paranoia. It is necessary, he claimed, to induce paranoia in the subject when analysis gets stalled by the ego's resistances: "Far from attacking it head-on, the analytic maieutic adopts a roundabout approach that amounts to inducing in the subject a controlled paranoia. Indeed, it is one of the aspects of the analytic action to operate the projection of what Melanie Klein calls *bad internal objects,* a paranoiac mechanism certainly, but one that is highly systematized, filtered, as it were, and properly checked."[4]

"Controlled paranoia" perfectly describes Dalí's technique of interpretation, and Lacan's reference to the projection of bad internal objects is also pertinent. In Lacan's vocabulary, these objects may be "imagoes of the fragmented body" or images of the severe parent, the Punisher. Lacan continues, "We must turn to the works of Hieronymus Bosch for an atlas of all the aggressive images that torment mankind."[5] And he no doubt had Dalí's paintings in mind, too. In Seminar XI, Lacan wrote: "Distortion may lend itself . . . to all the paranoiac ambiguities, and every possible use has been made of it, from Arcimboldo to Salvador Dalí."[6] The imago projected in the paranoiac interpretation of *The Angelus* is an archaic, seductive, predatory, monstrous, anamorphically distorted mother, the maternal counterpart of those bad, cannibalistic father imagoes Dalí also explores—Saturn, Abraham, and William Tell.

The paranoid projection of imagoes is of prime importance for the paranoiac-critical method of interpretation, as is the characteristic formal aspect of paranoiac thought. Lacan considered "the formal envelope of the symptom" to be most telling. In an article he published in the surrealist journal *Minotaure* on the style of paranoia, he observed that the productions of paranoiacs are marked by "an original syntax" featuring repetition, multiplication, and splitting.[7] We will find in Dalí's analysis of *The Angelus* that the dreaded maternal imago and her cowering son have many faces, are multiplied a hundred times, and sometimes serve as doubles of Dalí. Lacan often stressed the power of these imaginary forms. In his 1936 article "Beyond the Reality Principle," for example, he credits Freud with having discovered the "psychic reality" of the imaginary realm. He lists some of those imagoes introjected by the subject, determining his or her behavior and personality, and they could serve as a roll call of Dalí's subjects: "the image of the father or the mother, of the all-powerful adult, tender or terrible, beneficent or punishing, the image of the brother, rival child, self-

9
Jean-François Millet,
The Angelus, 1857

reflection or companion."[8] Incidentally, the conjunction of "parental" imagoes with multiplication and repetition recalls irresistibly the work of a later celebrated artist, Andy Warhol, with his repeated and often giant projections of Marilyn Monroe, Elizabeth Taylor, and Jackie Kennedy, on the one hand, and Chairman Mao and "Most Wanted Men," on the other.

The Tragic Myth was not published until 1963, but it was written in the 1930s and got lost during the German occupation.[9] It therefore coheres with the body of work undertaken at the moment of Dalí's most productive exchange with Lacan. Indeed, Lacan's article of 1933 in *Minotaure* on the style of paranoia appeared alongside a brief "paranoiac-critical" account of Millet's *Angelus* by Dalí. As I have already indicated, both were deeply interested at the time in paranoia. Yet *The Tragic Myth* owes as much, if not more, to Dalí's acute understanding of Freud. I have found no psychoanalytically informed, detailed analysis of it.[10] Haim Finkelstein treats it at length, but his account amounts to little more than exposition and a rather dismissive assessment of its worth. He regards Dalí's wonderful essay "Objets psycho-atmospheriques-anamorphiques" (1933) as an allegory of Dalí's critical strategy.[11] In that essay, Dalí suggests that when a brilliant, distant star one is dreamily contemplating loses its luster as soon as one realizes that it is only the tip of a burning cigarette, one can compensate by elaborating a fantastic myth about that cigarette—how it came to be, who is smoking it—that will restore to it all its magic and mystery. Finkelstein concludes that "paranoia-criticism is merely the climate that allows Dalí to experience his freedom to tell and suggest, unhindered by any dictates other than those of imagination."[12] I propose to take Dalí's text a good deal more seriously, considering its form, its language, its argument, its precedents, and its implications. I also want to inquire briefly into the connection between paranoia and certain masculine pathologies of the ego. I begin with a brief synopsis of *The Tragic Myth* that sets it in relation to Freud's *Interpretation of Dreams*. A section arguing for the interpretive relevance of Freud's essay "The Moses of Michelangelo" follows, and finally, I will consider the Lacanian context of the book's formulation.

Paranoid Criticism

The rigorous exposition of the argument in Dalí's *Tragic Myth,* the clarity of its prose, and its scholastic division into three sections and subsections mimes, I think, Freud's literary mastery. In particular, frequent reference is made, in both style and content, to *The Interpretation of Dreams.*[13] Dalí freely uses the language of dream interpretation, including such terms as "latent content," "condensation," and "displacement." The descriptions of his paranoid interpretive delusions—what he terms the "delirious phenomena"—alongside the contexts of their occurrence are the equivalents of Freud's exposition of the manifest content of a dream together with the events of the

preceding day. Like Freud, he then breaks down these texts into brief sections, free-associates to them, and submits them to interpretation. For the sake of compression, my exposition brings together the "delirious" and critical moments of the technique. Another similarity is the self-reflexive nature of both texts; the key dreams in Freud's book are his own, so interpretation is equally self-analysis. Furthermore, self-analysis, for both, is not an end in itself but the key to discoveries about the nature of the unconscious mind in general. Another point of comparison is the apparent banality of their objects of study, which nonetheless are popularly valued. Freud posed the question, for instance, of why "lay opinion" attaches such importance to dreams, even when their content is apparently so unintelligible and absurd. This sort of discrepancy also concerned Dalí, who had long been intrigued by the saccharine image of *The Angelus* and marveled at the extraordinary proliferation of popular reproductions. He asks, "How then can we reconcile the obsessive unanimity, this undeniable violence exercised on the imagination, the power, the absorbing and exclusive efficaciousness in the kingdom of images; how to reconcile, I say, this power, the fury, even in reproductions, with the miserable, quiet, insipid, stupid, insignificant, stereotypical and conservative to the dreariest extent, aspect of Millet's *Angelus*?" (*TM*, 33–35).

Dalí answers this question by arguing that *The Angelus*, like the dream, is an image charged with psychic significance; it is enigmatic and troubling because "*quelque chose se passe*" [something is going on] (*TM*, 35). He declares that the painting is "the densest, the richest in unconscious thought that has ever existed" (17). In other words, the painting is a kind of externalized unconscious. Like a brief dream, the apparently simple image yields, upon analysis, a wealth of meaning. Although Dalí treats the image as though it were his own dream, he clearly understands it as a repository of popular unconscious thought.

Clues leading to the painting's latent content are given as a series of chance occurrences and hallucinations over the summer. Dalí then patiently unpacks the significance of these phenomena, accompanied by anxiety. Paranoiac-critical activity is summed up as "a spontaneous method of irrational knowledge based on the interpretative-critical association of delirious phenomena."[14] We should bear in mind, however, that like the two sides of the analytic encounter—projection and interpretation—both the delusional and critical moments have a paranoiac quality.

One day in June 1932, suddenly and inexplicably, an instantaneous image of *The Angelus* presented itself to Dalí's consciousness—visually unchanged, but imbued with a strange, overwhelming emotional coloration. This was the "initial delirious phenomenon." It was followed by a series of secondary delirious phenomena. Idling on the beach one summer day, he made a sculpture of two small stones and magnified them to monumental proportions in his imagination. One stone was round and smooth, "almost fleshy," and the other eroded, "riddled with holes" (*TM*, 45), and

skeletal (*decharnée*). This coupling evoked the image of *The Angelus*. Dalí's delusion enabled him to see the man as insubstantial, shadowy, *"informe"* (21).[15] The sculpture seemed to Dalí a "just" representation of *The Angelus*. While the male figure is not actually perforated (except for the fork of his legs) or diminutive, Dalí interprets his pose as threatened or defensive for, in popular iconography, the positioning of his hat connotes both arousal and shame. The woman's head, on the other hand, bends forward expectantly, aggressively. In a later book, Dalí comments on the oddity of the composition, with a yawning "dead space" between the figures.[16] This composition, together with the twilight and the monumentality of the couple in *The Angelus*, recall great standing stones, remnants of a dark and terrible prehistory and a presentiment of death. For Dalí, the image suggests mother and son locked in an atavistic pre-Oedipal and Oedipal drama and not, or at least not primarily, husband and wife. One of the many folkloric exhibits proffered by Dalí to support his interpretation is a nineteenth-century American cartoon (fig. 10). The drawing shows a phallic mother reducing her husband to a mere tool of reproduction, while a huge son/sun peers smiling over the horizon, briefly triumphant, but destined to descend to the ranks of merely instrumental husbands (7/iii–v).

Another secondary delirious phenomenon takes place immediately following the revelatory automatic sculpture of stones on the beach. On the way home, Dalí crosses a meadow, dotted with pools of stagnant water, where green frogs and grasshoppers leap about. The insects and frogs are the same color as the grass, and this makes him reflect on the possibility of mimetic adaptation, a thought no doubt retrospectively heightened by his reading of Roger Caillois's celebrated essay on the topic.[17] Dalí imagines an antediluvian nature with its permeable membrane (*l'espace d'osmose*) between the animal and vegetable kingdoms, the organic and the inorganic. A sudden collision with a fisherman on the path, which he likens to a battle

for supremacy between beasts, then sparks off a vision of *The Angelus*. The collision might easily have been avoided, but as Dalí notes, "our movements happened to be identical and correspondent like those of a man and his image in a mirror" (*TM*, 47). His discussion of this event makes use of Freud's conception of the *acte manqué*—bungled action, or parapraxis. Behind the "mask of clumsiness," claimed Freud, a person often "pursues sexual aims."[18]

Under the head of this secondary delirious phenomenon, Dalí lists six more associated delusions, a few of which are particularly pertinent. An oft-repeated reverie takes him, accompanied by Gala, to the Museum of Natural History in Madrid, where colossal models of *The Angelus* couple loom in the center of the vast shadowy hall of insects. As they leave, Dalí is moved to sodomize Gala. He later explains that this reverie relates to his adolescence, when he lived in terror of the act of love, which he understood to be a violently ferocious coupling (*TM*, 51, 81/77). He adds, "The circumstances of this act are clearly connected to my infantile sexual theories" (51). The unmistakable reference here is to Freud's notion of the primal scene and, more particularly, to the traumatic episode in Freud's case history of the Wolfman, who had witnessed as a child his parents' *coitus a tergo*.[19] The archaic fears of impotence, violence, and death figured in Dalí's delusions were revived by his passion for Gala—and so, it turns out, *The Angelus* figures are not only mother and son but also Gala and Dalí. The maternal identity of the woman is reasserted, however, in Dalí's "experimental fantasy" of dipping *The Angelus* halfway into a container of warm milk. The painting is dunked longitudinally, submerging the male figure. The interpretation of this phenomenon is aided by Dalí's recollection of the fascination and repulsion he felt as a child on seeing an illustration of baby kangaroos apparently half-submerged in milk in their mother's pouch: "The submersion of the figure in the *Angelus,* that is to say, *me,* in the maternal milk cannot be interpreted . . . other than as a fear of being absorbed, annihilated, eaten by the mother" (57). The ambivalent relation of the infant to the mother's body is clearly behind both of these fantasies, as well as the one prompted by Dalí's passing a shop window that displays a full coffee service, decorated with the repeated *Angelus* image inscribed in roundels (fig. 11). The anguish he suffers, we learn, is caused by the notion that the large "mother" pot, by introducing her substance into the baby cups, gives them life but is also capable of reabsorbing their vital substance. In short, "the mother devours her sons" (65).

A final related event: Dalí pulls out of a drawer a fragment of a color reproduction of a painting of a cup of cherries, and for a few seconds, he confuses it with his postcard of *The Angelus*. The repetition and coloration of the cherries relates back to the repeated roundels on the (baby) cups and so also to the vulnerable (edible) male figure in the image (*TM*, 73ff/111ff). For Dalí's exaggerated sensitivity, the cherries awaken aggressive, cannibalistic drives and are charged with erotic symbolism: "The idea of cherries immediately prompts, with a unanimous ferocity, the phantasm of

10

American Folkloric Cartoon (Hard Times on the Farm), nineteeth century

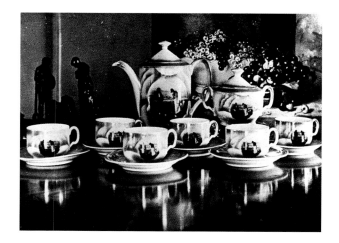

11
Angelus coffee
service

blinding and annihilating teeth" (73). This theme, Dalí observes, is obsessively reiterated in popular thought, as exemplified by numerous picture postcards showing a voracious young woman toying with a pair of cherries suspended between her teeth (fig. 12). The combination of avid sexuality and piety puts Dalí in mind of the mystical ecstasy of St. Theresa and of picture postcards of hopeful virgins praying for *un petit mari,* a "little husband" (fig. 13). The woman's attitude also evokes that of the female praying mantis, which is said to devour her mate after sex. The praying mantis was an insect dear to the Surrealists. In an article in *Minotaure* of 1933, entitled "On the Terrifying and Edible Beauty of Modern Style Architecture," Dalí reproduced photographs of art nouveau ironwork looking distinctly like giant praying mantises. He headed the page, "Have you seen the entrance to the Paris Metro?"[20]

Dalí concludes that *The Angelus* represents a temporal condensation. Unlike Watteau's *Pilgrimage on the Island of Cythera,* which serializes sequential action in the space of the painting, Millet solves the problem of representing a temporal series "oneiricly" (*TM,* 79/123). That is to say, it is like the palimpsest that is the dream-image. The first phase, the one that is manifestly represented, is all expectation and immobility, but anticipating imminent forward movement. The second phase, incestuous *coitus a tergo,* Dalí sees doubly displaced onto the wheelbarrow (which has popular erotic connotations) and the two sacks coupling in it. In the third phase, the mother devours her son. Dalí's "paranoid delusions" concerning *The Angelus* are, of course, intensely personal and relate to his adolescent fear that he would die in the sexual act—a fear that was reactivated by his passionate attachment to Gala but reached back to an archaic dread of being devoured by his mother. While this fear may be personal, it is far from eccentric. Dalí is only unusual in his ability to dredge up unconscious fantasies and in his hyperacute

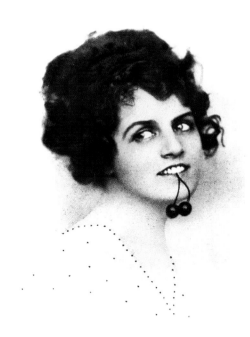

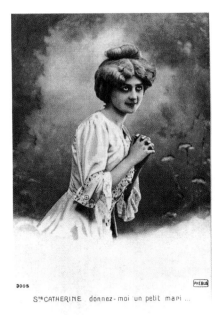

12 *(left)*

"Woman and Cherries" postcard

13 *(right)*

"Ste Catherine, donnez-moi un petit mari" postcard

sensitivity to possible resonances in Millet's paintings. It is a question, as he puts it, of being "poetically perverted enough" to elicit the unconscious symbolic content of the everyday (63/96).

Freud's "Moses of Michelangelo"

I have briefly considered Freud's *Interpretation of Dreams* as a model for Dalí's critical procedure, yet Freud also turned his hand to analyzing works of art, and Dalí admired the results. He makes explicit reference to Freud's essay on Leonardo da Vinci, which is relevant in several respects, but even more interesting are his implicit references to Freud's more obscure "The Moses of Michelangelo."[21] I am convinced that Dalí must have been familiar with the main lines of its argument and its illustrations when he wrote *The Tragic Myth*. Freud opens the essay with a description of his encounter with the work (fig. 14). After declaring his merely amateur knowledge of art, Freud confides, "Nevertheless, works of art do exercise a powerful effect on me, especially those of literature and sculpture, less often of painting."[22] He says of Michelangelo's *Moses,* "No piece of statuary has ever made a stronger impression on me than this. How often I have mounted the steep steps from the unlovely Corso Cavour to the lonely piazza where the deserted church stands, and have essayed to support the angry scorn of the hero's glance!"[23] Note the suggestion here of paranoiac persecution. In his biography of Freud, Ernest Jones raised some intriguing

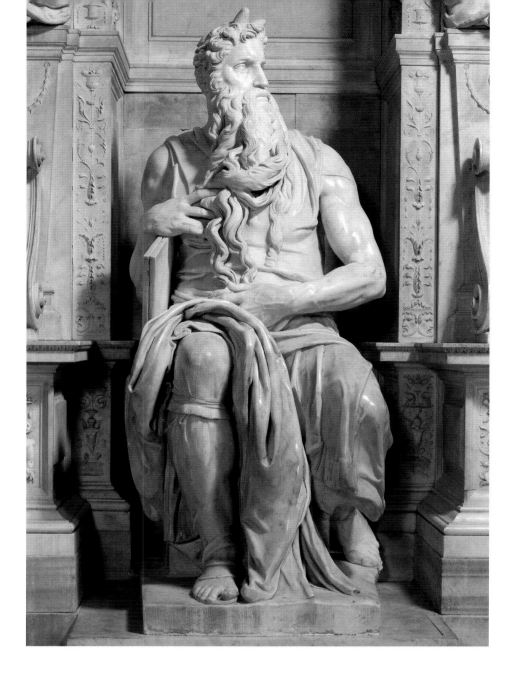

questions about Freud's response to the statue.[24] It seems likely that Freud must have identified with the lawgiver's rage at his faithless people at a time when he himself was reacting to the dissent of his own followers, notably Carl Jung. Yet in the passage I have just cited, Freud positioned himself as one of the cowering mob before the enraged Moses, expressing the other side of the ambivalence between identification and dread in relation to the father.

Beyond **Pleasure**

What is remarkable about Freud's essay is the way in which it poses the question of the interpreter's own response to the work of art. It makes an effort to explain the statue's emotional charge of anguish or dread. Freud attempted to explore the spectator's subjective relation to the work, using his own response as a starting point. For both Freud and Dalí, what requires explanation is the specific quality of the encounter with the work. Their procedures, however, are apparently completely at odds. While Dalí collects reveries associated with *The Angelus*, Freud turns to the authorities—the art historians, whose views, it emerges, sharply diverge. Yet, as in Dalí's case, a sort of interpretive palimpsest is built up. Some interpreters of Michelangelo's *Moses* read his expression and posture as a moment of self-control just before he unleashes his rage against the faithless people dancing around the Golden Calf. Others see him overwhelmed and even paralyzed by emotion. For another, his look is one of unbridled passion.[25] Freud used the puzzlingly contradictory responses of the authorities to unravel the enigma of Michelangelo's *Moses*. Like delusional projections, Freud implies, their observations pick up real aspects of the work. The discrepancies he finds among the various interpretations throw light on the statue's ingenious invention.

Another interesting parallel between Freud's and Dalí's procedures is their attention to insignificant details, which is also characteristic of paranoid perception. Freud utilized the technique of the Italian physician and connoisseur Giovanni Morelli, who discovered that correct attributions could be made by examining the rendering of fingernails or earlobes. Dalí certainly attended to marginal details, too—hat, sacks, basket, and pitchfork—and ascribed great significance to them. Yet he went further and contemplated what would normally be disparaged, such as his purely subjective reveries, trashy erotic postcards, and, in the context of the Parisian avant-garde, the apparently sentimental and pious painting by Millet.

What finally convinces me of Dalí's debt to Freud's *Moses* essay is Freud's reconstruction of a series of moments betrayed in details of Michelangelo's sculpture.[26] By minutely examining the position of the tablets, the hands, and the beard, Freud hypothesized that the action represented in the sculpture was preceded by Moses's rising up and violently tugging at his beard, a gesture Freud sees as an attack upon the distant revelers turned against Moses himself. This action, Freud suggests, was checked just as the precious tablets began to slip. Moses then let go of his beard, dragging a lock of hair across his body. The various interpretations of the statue are thus "vindicated," as they each turn out to contain a grain of truth. The calm initial position and the moment of rage are implied by the details represented in the final stage. In a striking phrase, Freud remarks, "It almost seems as if they [the art historians] had emancipated themselves from the visual image of the statue and had unconsciously begun an analysis of the motive forces behind it."[27] In other words, their delusions, sparked by apparently insignificant details, helped Freud understand the

statue, just as Dalí's own delusions enabled him to imagine the subsequent phases of action implied in *The Angelus*.

For anyone reading "The Moses of Michelangelo" in tandem with Dalí's book, Freud's conclusion is somewhat surprising. He declares that the statue is so powerful because, by a superhuman act of will, this Moses, unlike the historical one who broke the tablets, "will remain sitting like this in his wrath forever."[28] In a Kantian vein, Freud applauds Michelangelo's evocation of such sublime self-control, allowing reason to rule over the passions. The statue's aesthetic and emotional impact relates to the viewer's response to this sublimity, which produces a pleasure mixed with pain. Moses is an ideal patriarch, "a concrete expression of the highest mental achievement that is possible in a man."[29] One might rather have expected Freud to conclude, especially in view of the personal anguish he expresses at the beginning of the essay, that the power of the statue lies in the very primitive violent gesture, the naked paternal aggression, that simmers just below the surface. Could it be that those traces of rage—details on the threshold of visibility—are picked up at the level of the unconscious and reverberate there as part of our experience of the work? From a Dalían perspective, Moses is a terrifying father imago, made all the more bestial by the horns on his head (curiously not mentioned by Freud). To illustrate this point, a large reproduction of the Moses statue at the Teatro Museo Dalí in Figueres, Spain, is surmounted by a stuffed rhinoceros head adorned with an octopus "beard."[30]

The aim and procedure of Freud's "Moses of Michelangelo" make it, I think, a probable model for Dalí's *Tragic Myth*, although there is one obvious difference: Dalí's interpretation is dominated by a threatening maternal, not paternal, imago. That sexually alluring and threatening female figure is, however, at the center of Freud's other great study of visual art, "Leonardo da Vinci and a Memory of His Childhood." Dalí is predictably interested in the most speculative, exploded portions of that essay, zeroing in on Freud's excursus on the ancient Egyptian phallic vulture goddess, Mut, and the vulture-like form adumbrated in the robes of the Virgin in Leonardo's *Virgin and Child with Saint Anne* (fig. 15). Dalí also attends, though, to an undeniable feature of Leonardo's fantasy: the oral character of his infantile screen memory. "While I was in my cradle," Leonardo says, "a vulture came down to me and opened my mouth with its tail, and struck me many times with its tail against my lips." According to Freud, this tail represents both the breast and fantasized penis of the mother.[31] Dalí makes oblique, inverted reference to this, recalling a "false memory" from earliest infancy of his mother sucking and devouring his penis (*TM*, 57/88). With acute psychoanalytic insight, Dalí sees that the wished-for fantasy of devouring the mother (figured in Leonardo's false memory) can easily flip over into an anxiety about destroying the object and a fear of in-kind retribution. Melanie Klein called this process "projective identification." Dalí again inverts Leonardo's fantasy when he associates the Mona Lisa with "the devouring sphinx of Oedipus Rex." For all "Oedipal protagonists," he

declares, she represents "the sphinx to whom every son addresses his anxiety" (105). He also reproduces Marcel Duchamp's altered Mona Lisa with a distinctly Dalían mustache, an identification heightened in his own self-portrait as Mona Lisa. Just as Freud oscillated between identification and dread in relation to Michelangelo's Moses, so too did Dalí in relation to this maternal imago.

Oral-sadistic, cannibalistic fantasy in Dalí's interpretation of *The Angelus* is particularly prominent in the episodes involving the cherries and the praying mantis. Yet the milky kangaroo pouch and the threatening liquid substance of the *cafetière* seem to demand a different sort of theorization. This is provided by Julia Kristeva, an analyst deeply influenced by Melanie Klein and Georges Bataille. In her *Powers of Horror,* she uses the term "abjection" in relation to the maternal element that is abjected, or expelled, in the formation of a separate self. The maternal substance is desirable, but to succumb to it means self-annihilation. It is therefore abjected and becomes, in the process, an object of disgust.[32] Dalí associates the kangaroo pouch with another ghastly image: baby toads half-emerging from the back of their mother. It is a question here of annihilation by fusion with the mother, a prospect both profoundly desirable and horrible. The erosion of the boundary between mother and baby is, for Dalí, contagious, spreading to other categorical divisions like that between the animal and vegetable kingdoms. As we shall see, the paranoiac ego, as formulated by Lacan, defends against this abolition of difference. Paranoia, it appears, has two faces: a controlled inducement of paranoia sparks perceptions providing fertile material for interpretation, but this material may also provide a powerful motive for the ego's defensive strategies.

Dalí Meets Lacan

In the general theoretical section of his major paper on paranoia, the Schreber case history, Freud relates the illness to a fixation at the narcissistic stage of infantile development. During that stage, a halfway house between auto-eroticism and object-love, the individual takes himself or the image of himself as his love object. This "homosexual" phase is usually passed through to a heterosexual object choice, in which case, the homosexual currents are not abolished but rather "deflected" into social virtues such as friendship and *esprit de corps.* It is possible, therefore, for this sublimated energy to "flow backwards" in later life and to regain its fully erotic character. Freud proposed that behind male paranoia lies a wishful fantasy of loving a man and that all the familiar forms of the illness are various ways of contradicting the proposition, "I (a man) love him (a man)." For example, the delirium of persecution inverts the affect from love to hate and projects the feeling onto an external object: "he hates (persecutes) me."[33]

Certainly, these aspects of paranoia—feelings of persecution, fear, and anxiety—were aroused in Dalí by his encounter with *The Angelus* painting. A quite differ-

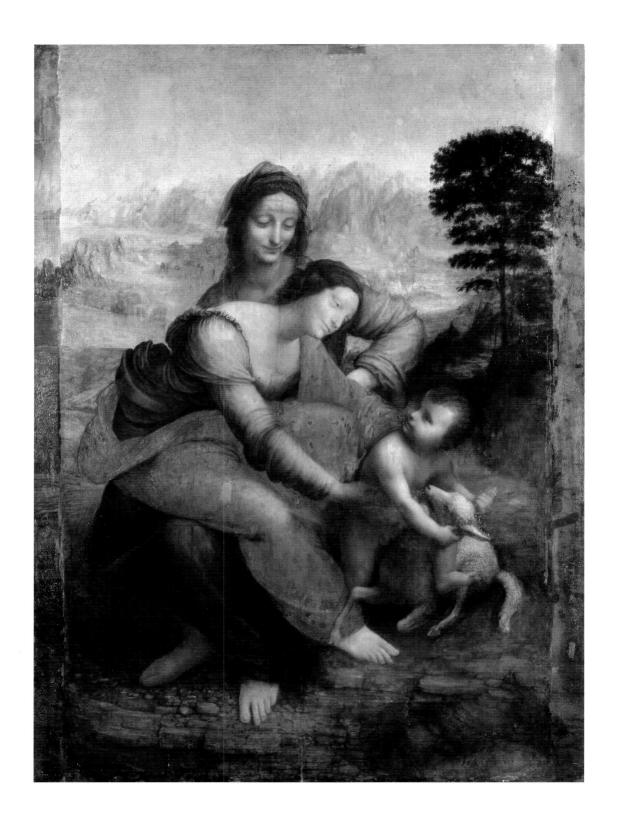

ent feature of paranoia, however, particularly recommended it to him as a method: its "objective and communicable hyperacuity."[34] In *The Psychopathology of Everyday Life*, a book well known to the Surrealists, Freud observed how paranoiacs interpret everything—accidents, slips of the tongue, lapses of memory—as significant.

> Everything he observes in other people is full of significance, everything can be interpreted. . . . In paranoia many sorts of things force their way through to consciousness whose presence in the unconscious of normal and neurotic people we can demonstrate only through psychoanalysis. In a certain sense, therefore, the paranoiac is justified in this, for he recognizes something that escapes the normal person, but the displacement onto other people of the state of affairs which he recognizes renders his knowledge useless.[35]

It is not surprising, Freud concludes, that the paranoiac is so convinced by his interpretations: *"There is in fact some truth in them."*[36] Lacan went further than Freud, insisting that knowledge itself is paranoiac—a view with which Dalí would have concurred, I am sure.

The story of Dalí's meeting with Lacan bears retelling, punctuated as it is with telltale signs of everyday paranoia. According to Dalí, Lacan telephoned him shortly after Dalí published an essay on paranoia in *Minotaure*.[37] He is probably referring to "Interprétation paranoïaque-critique de l'image obsédante *L'Angélus* de Millet" (1933) that appeared in the magazine's first issue (although this is far from clear, as Lacan's essay on style was printed immediately following it, so one would have thought that they had already met by this point). Dalí was determined that the meeting should be serious, because even some of his surrealist colleagues regarded him as whimsical. Prior to receiving his guest in his home, he was working on a small copperplate and, bothered by the reflection of his own face in the polished metal, he placed a piece of white card on the end of his nose in order to diffuse the light. After the interview—an intense two-hour discussion—Dalí "puzzled over the rather alarming manner in which the young psychiatrist had scrutinized (his) face."[38] Only later, when he went to wash his hands, did he notice the card still affixed to his nose. The story from Lacan's side, as mediated by Elisabeth Roudinesco, has it this way: "As a provocation, he wore an adhesive plaster on his nose and expected a surprised reaction from his visitor. Lacan did not flinch."[39]

A thorough account of their relationship has yet to be researched, but most important is the flurry of related publications that appeared during the 1930s.[40] It is worth reviewing these implicit exchanges in some detail in order to follow the shared formation of their thoughts on paranoia. Dalí's focus on paranoia was original. When he joined the Surrealists in 1929, their favorite mental illness was hysteria, and they tended to privilege phenomena such as hallucinations, dreams, and automatism.

In the 1930 essay "L'âne pourri" ("The Rotten Donkey"), Dalí argued that while phenomena such as hallucinations and dreams have only an evanescent reality, the paranoiac can pick up minute indications and make connections that, as Freud often observed, display a subtlety and quickness of mind and also contain an undeniable kernel of truth. It was this concrete, objective quality of the irrational phenomena in paranoia that appealed to Dalí: "It suffices that the delirium of interpretation be able to connect up the meaning of heterogeneous images which cover a wall for it to be already impossible for anyone to deny the reality of this connection."[41] Paranoid perception may be likened to Leonardo's technique of conjuring up images in damp stains or in clouds, but the experience is more intense. The properly double image is more acutely paranoiac: "It is by a clearly paranoiac process that it is possible to obtain a double image, that is, the representation of an object which, without any figurative or anatomical modification, is at the same time the representation of another absolutely different object."[42] An image is capable of being more than double, as demonstrated by Dalí's painting *Invisible Sleeping Woman, Horse, Lion, etc.* (1930), but a strictly reversible image has a quality that, as we shall see, links it to the ambivalence of paranoia.

Dalí's preference for the concrete, objective quality of paranoid delusion is obviously connected to his characteristic hyperrealistic style of painting. However fantastic his images may be, their perspective, modeling, and so on produce an undoubted "reality effect." In "The Conquest of the Irrational" (1935), he explained that the only way to create "images of concrete irrationality" is to use the pictorial means of Velázquez and Vermeer, and he described his style as "instantaneous and hand-crafted colour photography."[43] Given his reference to photography, here and elsewhere, and his quest for a reality effect, it is interesting that in "The Rotten Donkey," Dalí calls the productions of paranoid thought "simulacra." The simulacrum is a species of image defined precisely by its reality effect, that is, its superficial likeness (as opposed to any essential, internal relation to a model).[44] As we shall see in the concluding chapter, the simulacral nature of photography became, for a group of philosophers, artists, and critics in the 1970s and early 1980s, a means of undermining the distinction between model and copy, original and reproduction. While mimesis claims to represent the real faithfully, the simulacrum undermines the very notion of a stable reality, which accords well with Dalí's aim of making all the possible readings of his double or multiple images equally valid: "It would be curious to find out what it is that the image under consideration really represents, what is the truth; and right away doubts are raised in our minds regarding the question of whether the very images of reality itself are not merely products of our own paranoiac capacity."[45] David Lomas has persuasively argued that Dalí can claim to have anticipated the clutch of French thinkers—such as Jacques Derrida, Gilles Deleuze, and Jean Baudrillard—who were interested in the simulacrum's challenge to the Platonic hierarchy of original and copy.[46]

In 1930, André Breton and Paul Éluard published a volume called *The Immaculate Conception,* which contained pieces written to simulate a variety of different mental disorders. One, called "In Simulation of the Delirium of Interpretation," is written through the eyes of someone who sees himself and the whole world as bird-like.[47] That text and "L'âne pourri," along with other surrealist experimental writing, were the inspiration for a study co-authored by Lacan called "Écrits 'inspirés': Schizographie" (1931), which attended closely to the letters of a patient diagnosed as paranoid.[48] Lacan's dissertation, *De la psychose paranoïaque dans ses rapports avec la personnalité,* was published the following year. As the title suggests, it critiques the psychiatric clinical practice of abstracting the psychosis from the patient's personality, life history, and system of meaning. It contains a case study, written in novelistic form, of a patient (though one not analyzed by Lacan) code-named Aimée. Instead of regarding her illness as an organic condition, Lacan inquires into the meaning of her behavior. In Aimée's case, it is a knife attack on an actress whom Aimée accuses of wanting to kill her child. Lacan, following Freud's thesis on the connection between repressed homosexuality and paranoia, claims that Aimée's homosexual attachment to her ego ideal (originally her sister, now represented by the actress) was met with indifference and interpreted as persecution. Her love was projected in an inverted form onto the actress. By attacking the externalized ideal she was, in an indirect way, attacking herself. Aimée had written two unpublished novels, which, Lacan said, allowed him "to understand the connection between the delirium and her personality."[49]

Dalí read this study and paid tribute to it in his essay published in the first number of *Minotaure,* "Interprétation paranoïaque-critique de l'image obsédante *L'Angélus* de Millet." He declares that we are indebted to Lacan's book "for giving us, for the first time, a global and homogeneous conception of the paranoiac phenomena beyond any mechanistic afflictions (*miseres mécanistes*) in which psychiatry is today mired." He notes that "the work of Lacan conveys perfectly the objective and 'communicable' hyperacuity of the phenomenon, thanks to which the delirium has a tangible and incontrovertible character which places it at the antipodes of the stereotype of automatism and dream." While the two "passive" phenomena may be susceptible to interpretation, "the paranoid delirium constitutes already in itself a form of interpretation."[50] Dalí refers in this context to the "visage paranoïaque" published in the journal *Le surréalisme au service de la révolution.*[51] Here and later, in his *Unspeakable Confessions,* Dalí relates how he took a snapshot of a tribal village from a drawer and saw instead a Picasso head. When Breton saw it, he even recognized it as a portrait of the Marquis de Sade, complete with powdered periwig.[52]

Following Dalí's *Angelus* article in *Minotaure,* we find Lacan's "Le problème du style et la conception psychiatrique des formes paranoïaques de l'expérience," to which I have already alluded. The problem of style, as Lacan sees it, is the antago-

nism between an attempt at realist representation and "the superior power of signi-fication." The direction being taken by psychiatric research (that is, his own studies of the writings of psychotics) offers new data on the problem of style. Before directly addressing this issue, however, Lacan launches an attack on the ascendancy of posi-tivistic science in psychiatry that leads to what he calls "mechanistic psychophysics" and, implicitly comparing it to a paranoiac delusion, he calls it "a systematic misun-derstanding of human reality." Reiterating the position he outlined in his disserta-tion, Lacan favors an approach that, he says, "would not detach the local reaction . . . that one isolates as a mental problem from the totality of the lived experience of the patient."[53]

Like Freud and, more emphatically, the Surrealists, Lacan stresses the originality and creativity of certain forms of neurosis and psychosis: "Certain of these forms of lived experience, called morbid, seem particularly rich in symbolic modes of expres-sion, which, although fundamentally irrational, nonetheless carry an eminently in-tentional signification and a high tension communicability" (*d'une communicabilité tensionnelle très élévée*). In other words, the symptoms of paranoiacs resemble the products of imaginative creativity because, in both cases, the field of perception is imprinted with a personal signification that can carry, even for others, the conviction of reality. Even our rationalistic society, says Lacan, could be fascinated by the per-sonality of the undoubtedly paranoiac Jean-Jacques Rousseau. Lacan concludes the essay with the affirmation that one might conceive of the lived experience of para-noiacs and their specific conceptions of the world as governed by an "original syn-tax," which seems to us "indispensable to an understanding of the symbolic value of art and particularly to the problem of style." The style, or individual syntax, of para-noia has a particular formal character: "The delusion proves in fact to be very fertile in fantasies of cyclical repetition, of ubiquitous multiplication, of endless periodic return of the same events, and doubles and triples of the same characters, some-times in the form of an hallucination of a splitting of the person of the subject."[54] To use a term that he would later adopt, Lacan is here stressing the importance of the role of the "signifier" in psychic life. "These problems," he concludes, "will always remain beyond the grasp of any form of anthropology that has not yet freed itself from the naive realism of the object." Lacan's interest in style also points toward his later claim that the subject avoids being entirely submerged in the universality of language by maintaining a unique, elusive object of desire.[55]

Lacan's early interest in paranoia, as well as his exposure to Alexandre Kojève's lectures on Hegel's dialectic of consciousness, led him (in the mirror stage and ag-gressivity articles) to set out the theory of the ego as essentially paranoiac.[56] As we shall see, one reason why Dalí advanced paranoia as the key psychosis is connected to the unusual circumstances of his childhood. His account of his childhood pro-vides what amounts to a lucid anecdotal exemplar of Lacan's conception of the ego

as double and alienated. Lacan thought that a coherent self-image is both fictional and lined, so to speak, with our original infantile distress, expressed as imagoes of the fragmented body. These are inevitably unleashed in the fraternal rivalry that is set up by the identificatory process—for that double almost certainly does desire the object of my desire.[57] As Peter Dews notes, "the oscillation between love and aggression, fascination and rivalry, which is characteristic of many human relationships is a consequence of the ontological precariousness of the ego."[58] Jacqueline Rose sums up the situation succinctly: "Paranoia is latent in the reversibility of the ego's self-alienation."[59] One can easily see how, in Lacan's view, jubilant (mis)recognition in the mirror can easily flip over into an image of a hostile rival in a manner uncannily like Dalí's paranoiac double image.

Although Lacan's understanding of the ego, with its inbuilt rivalry and aggression, was intended by him as an ungendered theory, the picture that he paints of man as "rival to himself" has undeniable overtones of a well-known masculine pathology.[60] Anika Lemaire's account of the imaginary order that sustains the ego makes this clear: the structure "dictates the constitutional aggressivity of the human being who must always win his place at the expense of the other and either impose himself on the other or be annihilated."[61] The masculine character of the Lacanian ego is particularly pronounced in the 1953 article "Some Reflections on the Ego," where he observes the close relation between Homo psychologicus and his machines, particularly his motorcar. "We get the impression," he writes, "that his relationship to this machine is so very intimate that it is almost as if the two were actually conjoined: its mechanical defects and breakdowns often parallel his neurotic symptoms. Its emotional significance for him comes from the fact that it exteriorized the protective shell of his ego, as well as the failure of his virility"—when the car breaks down, I presume.[62] In another context, Lacan figures this situation by analogy with Roger Caillois's characterization of display and intimidation in the natural world: in order to obscure a vulnerable body, the whole animal swells up and gives himself "something like a mask, a double, an envelope, a thrown-off skin, thrown off in order to cover the frame of a shield."[63] The car is the modern male's shield. Dalí uses an even more mundane metaphor for the ego in *The Secret Life of Salvador Dalí*. There he declares that when he smiles, he never exposes "horrible and degrading spinach" clinging to his teeth, for the simple reason that he does not eat spinach. He goes on: "I detest spinach because of its utterly amorphous character. . . . The very opposite of spinach is armor. That is why I like to eat armor so much . . . , namely shellfish."[64] Spinach is obviously another form of the abject substance coded as feminine, like warm milk, against which the armor or exoskeleton of the paranoiac masculine ego defends. Dalí is particularly lucid about the nature of repugnance in an early piece he wrote called "Love" (1930). The text suggests that Dalí had been reading Freud's *Beyond the Pleasure Principle*, which was translated into French in 1927, as well as Bataille's re-

flections on "The Big Toe."[65] Repugnance, he claims, is "a symbolic defense against the intoxication of the death wish. One experiences repugnance and disgust for what deep inside one wishes to get closer to, and from this comes the irresistible 'mordid' attraction."[66]

In *The Unspeakable Confessions*, Dalí relates how throughout his life, he was haunted by an older brother, also called Salvador, who died at the age of two, just over nine months before Dalí's own birth. Dalí writes, "I deeply experienced the persistence of his presence as both trauma—a kind of alienation of the affections—and a sense of being outdone. All my efforts thereafter were to strain toward winning back my right to life, first and foremost by attracting the constant attention and interest of those close to me by a kind of perpetual aggressiveness."[67] Dalí felt persecuted by the affection of his parents, which he believed was not really intended for him. Paraphrasing Shakespeare, he wrote: "He was the wisely loved; I was but loved too well. In being born, my feet followed in the footsteps of the adored departed, still loved through me, perhaps even more than before." When his father looked at him, Dalí says, "he was seeing my double as much as myself." The son was "choked by the corset of the image of the other that was being forced on me."[68] I believe that Dalí could not have written this without a clear understanding of Lacan's mature conception of the paranoid ego, which he may have had a hand in shaping. As Borch-Jacobsen has pointed out, that conception has to do with identification with a like, with self-love/hate, and not, as in Freud, with repressed homosexual desire returning in a projected, inverted form.[69] Dalí felt his place usurped and so struck out in an aggressive and self-destructive way at his absent sibling rival. Narcissistic identification inevitably leads to competitive aggression—or, as that great paranoiac Rousseau observed, *amour propre* brings the downfall of all peaceable society. The special circumstances of Dalí's childhood are only a more palpable case of the primary identification that structures the subject as a rival to himself. In view of this background, imagine how dismayed and elated Dalí must have been when, at his request, the Louvre X-rayed *The Angelus* and found, at the peasants' feet, an object Dalí takes to be a small, overpainted coffin (*TM*, 8/vii). The couple thus revert to husband and wife, mourning inconsolably over the loss of their first-born Salvador.

Lacan argued in his dissertation that we should cease viewing the paranoiac in the third person. This is fundamentally what I am advocating for a psychoanalytical approach to visual art. *The Angelus* may seem, at first, to be the very image of peace and tranquility. Yet Dalí's dynamic encounter with the work and his paranoiac hyperacuity have, I think, picked up a real resonance there. Does this have wider implications? Is the coherence and perfection of the beautiful haunted by disintegrative drives? Is it, like the mirror image, lined with aggressivity and imagoes of the fragmented body? Dalí was intent on making us reflect on these questions: "The irrational spurts constantly from our minds and the shock of reality, but we do not

perceive it, for we are so deeply conditioned to recognize only good sense, reason and acquired experience. . . . We have forgotten the ways of truth. We have eyes yet see not, ears yet hear not."[70]

Above all, the paranoiac-critical method is dedicated to destabilizing our interpretations of artworks and of the world in general. Most models of interpretation propose a reading that will stick once and for all. For Lacan, this attitude represents a sort of "stagnation," which is characteristic of the subject's constant "paranoid" efforts to firm up the ego and steady the world. This effort "is akin to the most general structures of human knowledge: that which constitutes the ego and its objects with attributes of permanence, identity, and substantiality."[71] Yet paranoia's ambivalence extends to its value for art history. It can either be the agent of creativity, destabilization, and the disruption of disciplinary boundaries, as in Dalí's art criticism, or a powerful motive for defending against threats to the coherence and authority of the discipline—as in his hatred of spinach.

4 Encounter

Breton Meets Lacan

I trust that my account of Dalí and paranoia has dispelled any lingering impression that a model of the subject's relation to the image, properly based on Lacan's mirror stage article, has to do with unalloyed confirmation of the ego. Although film and art theory in the 1970s adapted Lacan's mirror stage to explain the way in which images enhance an illusory sense of personal autonomy and visual mastery, in fact, Lacan gave equal weight to that illusion's precariousness. The mirrored ego is highly ambivalent—sometimes lucid and affirmative, sometimes threateningly subversive. In the last chapter, I made use of Dalí's and Lacan's shared interest in paranoia in order to draw out some of the more unsettling aspects of our psychic relation to images. I now want to turn to Lacan's relation to another celebrated Surrealist: André Breton. This chapter will amplify Lacan's "anamorphic" conception of the subject's relation to the image by establishing a connection between it and Breton's idea of the chance encounter.

In *The Four Fundamental Concepts of Psycho-Analysis,* Lacan introduced the idea of the "missed encounter." He derived the term from *la rencontre,* a key surrealist concept advanced by Breton that had repercussions in the work of Walter Benjamin, another writer significant to twentieth-century art theory.[1] Like anamorphosis, the encounter has the virtue of being already embedded in the history and theory of art. It is not a psychoanalytic category that has to be applied to art. As we shall see,

the Bretonian encounter, by virtue of its fortuitous, accidental character, bypasses one's consciousness and intentionality, thereby giving some access to an otherwise imperceptible reality. In *Mad Love,* Breton said of his found objects, "It is really as if I had been lost and they had come to give me news about myself."[2] Lacan described his psychoanalytic practice in much the same way. In the first seminar of his *Four Fundamental Concepts,* he compared himself to an artist close to the Surrealists, Picasso, who famously declared, "I do not seek, I find."[3] Encounters can be with people or objects and usually take place on the street. A Paris flea market is, after all, one of the few places you might actually stumble across "the encounter of a sewing machine with an umbrella on a dissecting table."[4]

I also attend to the notion of the encounter in order to emphasize here what has been a guiding principle for the writing of the following chapters. The first-person account of the experience of the work of art is central to my approach. But this is not the first person of a consciousness transparent to itself; rather, it gropes in the dark, as it were. I take as my model the paradoxical surrealist project of searching for something that can only be encountered by blind chance. Our attention is drawn to objects or texts that escape our understanding, presenting an enigmatic stain—our own shadow among the objects. The feminist literary theorist Jane Gallop made an eloquent plea some time ago for this type of psychoanalytic art criticism. Gallop made a distinction between a type of criticism that seeks to uncover latent subject matter linked to the sexuality of the artist and another type, "which barely exists at all," involving "an erotics of engagement, a sexuality that is not in the object, however deeply hidden, but in the encounter."[5] The aesthetic experience, she argued, should be understood along the lines of Freud's conception of sexual eroticism, which is not something that is in the object but in an intersubjective dynamic. "Objectivist" psychoanalytic art criticism fails to take into account what might be thought of as the aesthetic equivalent of the transference in analysis—that is, the dynamic relation between analyst and analysand.[6] One's feeling of being moved, overwhelmed, irritated, disgusted, or bored in relation to a work of art must be taken into account. This involves giving up a position of mastery with respect to the work of art and letting "insignificant details" float into one's visual field, in the same way that the Surrealist's distracted look lights upon the *trouvaille,* the lucky find, amidst the detritus of the flea market. My approach differs from the one advocated by Gallop in that I want to go beyond an erotics of engagement to encounter in art something that opposes and yet is intertwined with Eros—what Freud called the death drive.

The encounter may be good or bad, delightful or troubling. What sets it apart from other experiences is its unexpectedness and baffling fascination. This implies that one cannot set out to have an encounter by, for example, seeking out the bizarre or uncanny. Equally, an artist's intention to evoke such an experience is doomed to failure. One cannot aim at the encounter because, as Lacan insists, the encounter

is always missed. I will illustrate what this means by recounting an accidental revelatory experience of my own. Some years ago, I visited Paris and, following in the footsteps of the Surrealists, visited the Musée Grevin. Inside were waxwork tableaux of great moments of French history, including the death of Marat as well as Louis XVI and Marie Antoinette in prison. There was also a series of *tableaux noirs,* similar to Madame Tussaud's Chamber of Horrors. I remember thinking it a rather dusty and threadbare spectacle. Visitors are decanted from the museum via the back door, where one might expect to find a dingy alley. Instead, I found a brightly lit glass arcade of the sort I'd read so much about but thought extinct. It was like slipping into a time warp. I particularly remember an old-fashioned stationery shop called *La Plume* and a Russian tea room where I bought some finely detailed sugar babies wrapped up in a cellophane packet of four. My arcade experience has all the hallmarks of a surrealist encounter—both wonderful and unsettling—and the sugar babies, long lost, still have the weight of significance for me without any definite meaning. In this case, unconscious material opens a gap between experience and understanding. The encounter is opaque; the Grand Guignol of the waxworks museum, by contrast, manipulates the viewer with lighting and sound effects and can be readily cashed out in terms of stock emotional responses of horror and pity.

I have yet another motive for turning to the encounter in Breton's and Lacan's writing, which is to make a case for reading Lacan surrealistically. His close relationship to the group as a young man is often mentioned but rarely developed into any systematic analysis of the way Surrealism permanently inflected Lacan's thought and writing. Although Lacan's heavy intellectual baggage, apart from psychoanalytic literature, includes Hegel, Heidegger, Saussure, Merleau-Ponty, and Lévi-Strauss, among many others, it is still often possible to see him reading Freud through a purely surrealist lens. Consider, for example, the following passage from *The Four Fundamental Concepts.*

> Impediment, failure, split. In a spoken or written sentence something stumbles. Freud is attracted to these phenomena and it is there that he seeks the unconscious. There, something other demands to be realized—which appears as intentional, of course, but of a strange temporality. What occurs, what is *produced,* in this gap, is presented as *the discovery* [*la trouvaille*]. It is in this way that the Freudian exploration first encounters what occurs in the unconscious. (25)

Lacan is referring in this passage to phenomena such as forgetting, parapraxes, and flashes of wit, where a train of conscious thought is intercepted by another, unconscious train that knocks the first off the rails. But his language in this passage and others takes over that of Breton's account of the encounter as a lucky find. The *trou-*

vaille is an encounter with a highly significant and seemingly enigmatic object found as if by chance. The *trouvaille* in the context of psychoanalysis, continues Lacan, takes the subject by surprise and is valued as something like a solution to a riddle. The subject finds there "both more and less than he expected—but, in any case, it is, in relation to what he expected, of exceptional value." Finally, the *trouvaille*, which initially took one by surprise, changes character: "Now, as soon as it is presented, this discovery becomes a rediscovery and, furthermore, it is always ready to steal away again, thus establishing the dimension of loss." This passage is of key importance for my argument, especially the last sentence that stresses the dimension of loss inherent in the *trouvaille*.

The Lost Slipper

It is not necessary to cite chapter and verse from Breton to establish the connection I wish to make. A few lines on the found object from the more theoretical sections of *Mad Love*, and one example, will suffice. Both Lacan's and Breton's texts, it should be pointed out, circle around Freud's essay *Beyond the Pleasure Principle*.[7] Breton describes the *trouvaille* as a solution not found by logical means, one that differs completely from what he had anticipated: "In any case, what is delightful here is the dissimilarity itself which exists between the object wished for and the object found" (*ML*, 13). In his book *Compulsive Beauty*, Hal Foster analyzes in some detail the pas-

sages in *Mad Love* about two key *trouvailles,* a metal mask and wooden spoon, and clearly demonstrates that they do not represent simple wish fulfillments but are laced with desire, death, and repetition. He suggests briefly that Breton's conception of the found object anticipates Lacan's *objet petit a.*[8] But I would want to make a stronger claim and consider the possibility that Lacan appropriated Breton's concept in his formulation of the idea. The long passage cited above refers more generally to Freud's great *trouvaille,* the unconscious, but it is tempting to push the analogy further and argue that Lacan's phantasmatic lost object, *objet petit a*—which sets desire in motion and which, paradoxically, represents both a hole in the integrity of our world and the thing that comes to hide the hole, both the blot in the landscape and its dissimulation—is actually modeled on Breton's *trouvaille.* Lacan is, after all, particularly interested in those moments when the subject is able to catch a glimpse of the object, whether in a psychoanalytic or artistic context.[9]

16
Man Ray, *Slipper Spoon (de la hauteur d'un petit soulier faisant corps avec elle)*

The example of the marvelous slipper-spoon found by Breton in a Paris flea market is most telling (fig. 16). First, the context is one of impediment or blockage. Breton had a little unintelligible but insistent phrase, "Cinderella-ashtray" (*le cendrier-Cendrillon*), running in his mind—knocking on the window, as it were.[10] Given Lacan's development of the idea, it is highly significant that the context is linguistic and hinges on a slight phonic difference that alters the meaning of the words completely. In this respect it resembles the context of the fort/da game described in *Beyond the Pleasure Principle.* The game, invented by Freud's grandson in response to his mother's absence, involved repeating "Gone!" and "There!" while throwing away a spool attached to a string and then retrieving it.[11] In *The Four Fundamental Concepts,* Lacan suggests that the spool should not be understood as a shrunken mother made to go and come at will, but rather as representing *objet petit a,* "a small part of the subject that detaches itself from him while still remaining his, still retained" (62). The child, already separated from his mother, caught up in the net of language and subject to the Law, just manages to hang on to this remainder, this piece of the real that resists symbolization. "Fort/da" testifies to the nature of language as a system of differences that nonetheless seeks to capture a lost object in its inadequate net.

Breton wanted to see his phrase, "Cinderella-ashtray," concretely materialized, so he asked Giacometti to make him a slipper-shaped ashtray of gray glass. It was not forthcoming. On a visit to the flea market with the sculptor, however, Breton lit on a curious wooden spoon with a little boot carved under its handle and carried it off. Only when he got the object home did it transform itself into the object of his desire: "It was clearly changing right under my eyes. From the side, at a certain height, the little wood spoon coming out of its handle, took on, with the help of the curvature of the handle, the aspect of a heel and the whole object presented the silhouette of a slipper on tiptoe like those of dancers" (*ML,* 33). Like the anamorphic stain in the Holbein painting that resolves into a skull from a certain angle, the opaque, incom-

prehensible spoon is suddenly transformed into the lustrous lost object par excellence, Cinderella's glass slipper: "it is just what, in our folklore, takes on the meaning of the *lost object*" (36). It also demonstrates what Lacan calls the "metonym" of desire, which slides endlessly from object to object: the spoon's handle is propped up by a tiny carved shoe, so that the heel of the "slipper" is another shoe, and so on, *ad infinitum* (34). Breton observes in a postscript that the slipper spoon has phallic connotations, but not unambiguously. It is also distinctly vaginal, "the perfect mold of this penis," especially in view of the homophonic relation of *verre* (glass) and *vair* (squirrel fur) (36). The ambivalent presence/absence of the penis gives it that fetish-like quality of the *objet petit a,* both marking and covering over lack. As Foster puts it, "The slipper spoon is not only a fetish that combines a perception of castrative 'lack' with an image of phallic 'unity,' it is also a 'Cinderella ashtray' that conflates a figure of desire (Cinderella) with an image of extinction (ashes)."[12] Equally, it is both a worthless bit of *bric-à-brac* and a fascinating glass slipper. If the reflection in the mirror is the prototype of all images of the ego, then this contradictory, ungraspable, fleeting object is the prototype for images of the castrated, barred, split—in short, anamorphic—subject. This subject, called punningly by Lacan *le sujet troué* (the subject full of holes), uses an *objet trouvé* (a found object) to figure both the hole and the missing bit (*FFC,* 184).

Finally, Breton interprets his *trouvaille* as a sign of his desire to love and be loved. It is not, then, an object that satisfies desire but one that reveals it. It is the revelation of an absence or void. Foster says that Breton does not quite see the *trouvaille* as the object-cause of desire in the manner of Lacan's *objet petit a.*[13] Yet Breton does at times indicate that the object of desire must be permanently lost, because it is the cause of desire and thus behind rather than in front of him: "Behind ourselves, we must *not let the paths of desire become overgrown*" (*ML,* 25). These paths of desire, he warns, must not become filled up, clogged by fixations on the objects themselves, because what is important is the openness, the wait, the discovery: "Independent of what comes, doesn't come, it's the wait that's magnificent."[14] Lacan makes this same point in the discussion of the transference. The analysand becomes fascinated by the gaze (*objet petit a*) of the analyst, figured as equivalent to the hypnotist's crystal stopper. The job of the analyst is then to let the object fall, leaving the subject's point of identification empty, open, *disponible* (*FFC,* 272–73).

If Lacan formulated his idea of the object of desire with Breton's *trouvaille* in mind, then he must also have borrowed the surrealist encounter for his conception of *la rencontre manquée* (missed or failed encounter). Yet there would seem to be a mismatch here, for does not the surrealist notion imply discovery—that is, success, rather than failure? My view is that Lacan is a very good reader of Breton, and his emphasis makes explicit the uncanny aspect of both the *trouvaille* and the chance encounter. This aspect is obscured by some writers who understand the notion of

"objective chance," which governs both phenomena, in an unequivocally positive way. Breton defines chance as "the encounter of an external causality and an internal finality" (*ML,* 21). Roger Cardinal's gloss on this, in his book on Breton's *Nadja,* is as follows: "Converging at an unexpected tangent, the pleasure principle and the reality principle meet, and, in the most compelling yet unpredictable way, a desire is fulfilled."[15] Why, in that case, should *Nadja* be filled with such foreboding and even panic? Margaret Cohen, commenting on the same text and on *Mad Love,* stresses instead the disturbing uneasiness, *le trouble,* provoked by the encounter, and she connects it to the Freudian conception of the trauma in its hesitation between objective and subjective determination as well as retrospective causality.[16]

Cohen also observes that the English translation of *The Four Fundamental Concepts* is curiously insensitive to Lacan's surrealist vocabulary. By foregrounding that vocabulary, she is able to argue that Lacan recasts Freud's conception of trauma in terms of the surrealist encounter.[17] In fact, Lacan announces as much himself, referring to "the real as encounter—the encounter in so far as it may be missed, in so far as it is essentially the missed encounter—first presented itself in the history of psycho-analysis . . . in the form of the trauma" (*FFC,* 55). Cohen's discussion is a noble exception to the rule in Lacanian studies of paying mere lip service to Breton and Surrealism generally. (The "authoritative" collection of essays, *Reading Seminar XI,* makes one reference to Surrealism.)[18]

The Dream of the Burning Child

Lacan's most suggestive, extended, and baffling discussion of the missed encounter centers on the dream of the burning child (*FFC,* 57–60, 68–70). In *The Interpretation of Dreams,* Freud briefly analyzes it, offering it as an example of a dream that is fashioned around some external disturbance, such as a noise, in order to neutralize it and allow the dreamer to continue sleeping.[19] But Lacan sees something far in excess of this interpretation, and that is what attracts him to it. A bereaved and exhausted father, leaving the corpse of his son in a bed surrounded by candles, entrusts the vigil to an old man and goes to bed in the next room. The old man nods off and a candle accidentally falls, igniting the dead child's bedclothes. At that moment, the sleeping father dreams that the boy comes into the room, grasps his arm, and whispers reproachfully, "Father, don't you see I'm burning?" Freud suggested, rather unconvincingly, that the dream figured the child as still alive and so fulfilled a wish. Let the dream go on!—or I shall have to wake up and face reality.[20]

Lacan turns this around by noting two things. First, he observes that the child is laid peacefully to "rest" in a bed, perhaps preserving a simulacrum of life. But the reality of the trauma breaks through in the dream: "The terrible vision of the dead son taking the father by the arm designates a beyond that makes itself heard in the dream." In other words, the waking, conscious self is protected against the real of

death and tragic loss, but in the dream this screen is broken through. What wakes the dreamer is desire as loss.

Lacan also remarks that a noise, the falling candle, apparently triggers the dream of the burning child and really ignites the dead child. A chain of events in the world suddenly intersects with a psychic series. Curiously, Freud writes not of a noise at all, but of the glare of the fire, but it amounts to the same thing—a moment of half-conscious perception that sparks the dream, perhaps initially to prolong sleep against the disturbance from outside. But the dream is so terrible that the father wakes up in order to escape it. Margaret Cohen rightly notes that here Lacan "considers a collapse between external events and psychic reality resembling the encounter so important to Breton."[21] Instead of interpreting that collapse as a coincidence of desire and reality, she stresses another, more refined, "modern materialist" definition of chance offered by Breton: "Chance would be the form taken by external reality as it traces a path (*se fraie un chemin*) in the human unconscious" (*ML*, 25). She further points out that the verb *frayer* is used by the French translator of *Beyond the Pleasure Principle* to render Freud's term *Bahnung* (facilitation), which has to do with laying down a permanent trace of an excitation.[22] Some real excitations, whether actually external or internal ones projected outside, lay down a path that will then be repeatedly reactivated by later, perhaps inconsequential, events. The primal scene of one's parents' copulation is the paradigm of the missed encounter: it is observed by the child too early to understand or even consciously register and reactivated too late to defend against the impression. The sound of the falling candle, "the small element of reality" (*le peu-de-réalité*, says Lacan, alluding to Breton), is a moment of pure contingency, meaningless in itself but pointing toward the pure contingency of trauma.[23] What is indicated here is the uncanny conjunction of internal and external that characterizes trauma and the *trouvaille*. Freud exemplified this peculiarity in his discussion of repetition compulsion, in which he tells the story of a woman who managed three times to marry men who, although apparently healthy, proceeded to fall ill and die. Here a repetition compulsion was realized in external events over which the woman seemed to have no control.[24] Benjamin (and later Roland Barthes, as we shall see in Chapter 7) was attentive to the way the photograph could record the trace of the trauma, "the spark of contingency" with which "reality had seared the subject."[25] The camera, itself incapable of dissimulation and ruled by delayed temporality, is a device perfectly designed for precipitating a missed encounter.

By drawing out the traumatic character of the surrealist encounter, Lacan also indicates why it is always missed. The encounter can be missed in two ways. One has to do with the delayed or deferred reaction, what Freud called *Nachträglichkeit*, where childhood memory traces, particularly of unassimilable material, are retrospectively given meaning, affect, or traumatic coloring.[26] In other words, childhood sexuality is always traumatic because it is missed, which is to say, not understood.

Lacan suggests, in the case of the dream, that the words "I'm burning" might have been spoken by the son in his fever, but they only take on this retrospective traumatic character in the dream, too late, when nothing can be done—and so are doomed to endless repetition. The words "I'm burning" have also been glossed by Jane Gallop as "I'm burning with desire."[27] If this is so, the dream then bears on what might be called the trauma of paternity played out in the Oedipal scenario: namely, the son's threat to take the father's place and the father's castrating prohibition. The real that awakened the father is not, then, the slight noise, but, as Lacan says, "that which is expressed in the depth of the anxiety of this dream—namely, the most intimate aspects of the relation between father and son" (*FFC*, 68). For the waking father, the encounter is missed in a temporal sense. The subject can never be simultaneously present to himself and in possession of the lost object. The other sense in which the encounter is missed, according to Lacan, is that it is impossible. Because the object of desire is irredeemably lost, the encounter can finally only disclose a fundamental lack.

I have been emphasizing the ways in which Breton conceived of the chance encounter as always missed and how he understood the *trouvaille* as covering over a lack, but it is fair to say that he was more optimistic than Lacan. *Mad Love* is about "Eros and the struggle against Eros," love and death (*ML*, 37, 38). The latter half of the book is dominated by a poetic evocation of the reciprocal love between Breton and Jacqueline Lamba. Yet even in the midst of his exaltation at this good, apparently destined encounter, shadows cross the couple's path. In the night streets of Les Halles, fresh vegetables, "magnificent white, red, green cubes," fall at their feet, instantly transformed into "gleaming, wretched garbage" (45).[28] Or, again, a stroll by the seaside in Brittany on a summer's day is clouded by the dreadful aura of a house where, it transpires, a local attorney had recently shot his wife dead (101–2). These anamorphic stains reveal Breton's doubts about the possibility of finding the unique object—not just one of the shadowy gallery of the women in his life that opens the book, but *the* love of his life. As he puts it, "the mind chooses to believe that the loved object is a *unique* being, whereas often social conditions of life can destroy such an illusion" (7).

Hal Foster has done much to inflect the reading of Surrealism by foregrounding concepts drawn from *Beyond the Pleasure Principle* and "The 'Uncanny'"—the return of the repressed, the trauma, the compulsion to repeat, and the death drive. Yet, I would suggest, the project of his *Compulsive Beauty* is already immanent in Lacan's reading of Freud, which foregrounds those texts and sets them in relation to surrealist writers and artists. It is not accidental, I think, that commentators on the later work of Lacan, such as Slavoj Žižek or Parveen Adams, draw out Lacan's meaning using artistic, literary, and filmic texts. They are finding in Lacan the implicit aesthetic dimension that was there from the start. Lacan's privileging of Freud's work after 1920—that is, after *Beyond the Pleasure Principle*—has shifted our understanding of Freud and

so, necessarily, of Surrealism. But in rereading Surrealism, we discover that we have come full circle to a moment in the 1930s when Lacan was part of the surrealist milieu and contributing to its periodicals. It is undecidable, then, whether "Breton is proleptically Lacanian," as Foster says, or if Lacan is belatedly Bretonian.[29]

Baltimore in the Early Morning

It is one thing to interpret works of art from the standpoint of an aesthetic beyond pleasure; the work, like the surrealist art and texts that Foster treats, may demand it. It is quite another to commend such work and, further, to argue that what is really valuable in art has, paradoxically, little to do with the aesthetic pleasure we may derive from it and, further yet, that "what one looks at is what cannot be seen" (*FFC*, 182). It is a difficult case to argue, but Lacan has a stab at it on several occasions. One memorable instance follows an account of a sort of reverie he experiences looking out of a hotel window over the city of Baltimore just before dawn. A neon sign flashes the change of time every minute as cars stream through the streets. He is struck first by the thoroughly man-made, artificial nature of the landscape and then by a sense of the spectator's intermittence, or fading. He concludes, "The best image to sum up the unconscious is Baltimore in the early morning."[30] As the context of the remark makes clear, Lacan is pointing out that the unconscious is not some natural wellspring of desire. It is cultural (and indeed linguistic) through and through, a differential network of discontinuous and combinatory signifiers. The cityscape figures the unconscious as a field of flickering signifiers—just the opposite, in other words, of what Lacan calls the "mirage" of "the enveloping psyche, a sort of double of the organism in which this false unity is thought to reside" (26).[31] Lacan inverts the more Freudian image of the unconscious as a subterranean, confined space, like a basement. The unconscious, as he frequently stresses, is "outside."

Lacan's reverie in Baltimore, which owes so much to the uncanny scenes of *Nadja* and also to film noir, leads to a consideration of the subject as "spectator" of the scene. I imagine Lacan briefly illuminated by neon signs or passing headlights and then adrift in a darkened, anonymous hotel room. This offers a metaphor for the precariousness of the subject's identity caught up in the field of unconscious signifiers, the Other. The subject must negate himself as real, as Being, in order to accede to meaning. Entry into the symbolic implies, then, the fading or vanishing of the subject in the register of the real: "Hence the division of the subject—when the subject appears somewhere as meaning, he is manifested elsewhere as '*fading*,' as disappearance" (*FFC*, 218). What prevents the subject from being an echo of the Other, a simple effect of symbolic determination, is the inconsistency of the network. It is full of holes and, indeed, is structured around a hole—the unintelligible, unassimilable, traumatic real of primal repression. The subject's insertion into the structures of the symbolic order creates a split-off remainder that marks him or her as a unique being.

The vanishing subject is supported and fleshed out by the lost *objet a* and the desire it sustains. At the end of the Baltimore seminar, Lacan makes this point by invoking the encounter: "The question of desire is that the fading subject yearns to find itself again by means of some sort of encounter with this miraculous thing defined by the phantasm." Yet the approach to the object incites a *jouissance* beyond the pleasure principle. Anxiety signals that the uncanny object is too close and that the mediation of symbols might disappear. The pleasure principle, Lacan affirms, actually creates a barrier to *jouissance:* "If I am enjoying myself too much, I begin to feel pain and I moderate my pleasures. The organism seems made to avoid too much *jouissance.* Probably we would all be quiet as oysters if it were not for this curious organization which forces us to disrupt the barrier of pleasure or perhaps only makes us dream of forcing and disrupting this barrier."[32] Quiet as oysters, happy as clams, living and dying, eating and excreting in a defensive, protective shell commonly called consciousness. This is the model of human life, self-preservative and well adapted, that Lacan saw adumbrated in ego psychology and in the associated politics of the autonomous subject conceived by bourgeois individualism. His surrealist psychoanalysis aimed precisely at cracking open that shell.

Coda

I wondered for some time why the phrase "Baltimore in the early morning" worried me like one of Breton's *phrases de réveil.* David Macey used it in his book *Lacan in Contexts* for the heading of the chapter where he explores some of the surrealist context of Lacan's thought. He notes, "The image of Baltimore in the early morning might have been culled directly from the iconography of Surrealism."[33] But the chapter did not help me unpack the phrase. Then it occurred to me that one of Hopper's paintings is called *Baltimore in the Early Morning.* When I calmed down, I realized that I was in fact conflating several of Hopper's titles and images: *Dawn in Pennsylvania, Early Sunday Morning, Morning in a City, Hotel Window.* No matter; the image of Lacan in his reverie by the window is now permanently painted in my mind by Hopper.

5 Death Drive

Robert Smithson's *Spiral Jetty*

In clinical Freudian psychoanalysis, trauma precipitates illness. Yet, as we have seen, Lacan's surrealist adaptation of Freud transforms it into one of the routes the subject finds to breach constraining imaginary identifications and the alienation of the symbolic. His conception of the missed encounter with the real, inspired by the surrealist encounter, brings out the aesthetic dimension of trauma and repetition. In this chapter, we will pursue the death drive's aesthetic implications by focusing on Robert Smithson's interest in the concept as mediated by Anton Ehrenzweig and Georges Bataille. I will argue that Smithson's great work, *Spiral Jetty* (1970), is an attempt to render the death drive visible.

Unbinding

Lacan praised Freud's *Beyond the Pleasure Principle* for the same reason that most people deplore it. Its bold metapsychological speculation is often self-contradictory and counter-intuitive. Yet, for Lacan, it was important precisely because in it Freud "risked appearing lost in obscurity."[1] If that is so, then I would add that the essay exemplifies its theme: the death drive. Since its introduction in 1920, this drive has been constantly reformulated and woven into cultural narratives of the twentieth century. The death drive, according to one of its definitions, has to do with unbinding. In Freud's final formulation of the organization of the drives, binding is characteristic

of the life instincts. He wrote that "the aim of Eros," which includes self-preservation, self-love, and sexuality, "is to establish ever greater unities and to preserve them thus—in short, to bind together; the aim of the destructive instinct is, on the contrary, to undo connections and so to destroy things."[2] The ego is closely associated with the process of binding. Lacan repeatedly attacked the sovereignty of the ego, which he thought led people to greater isolation and so also to greater aggression, and he naturally turned with interest to the power of the death drive to unbind, or undo, the ego.[3]

In doing so, Lacan gestured toward an aesthetic beyond the pleasure principle, particularly, as I have already argued, with his references to anamorphosis and the missed encounter with the real. In this chapter, I want to consider the notion of unbinding from the aesthetic point of view, that is, as another avenue for developing a theory of art beyond pleasure. As I explained in Chapter 1, Freud defined unpleasure as an increase in psychic tension brought about by the free, unbound energy issuing from the drives or from external stimulation that threatens the ego's homeostatic system of bound energy. This energy seeks expression in the form of a "discharge" along established paths that lowers tension and restores psychic balance. The sensation of discharge is experienced as pleasure. This homeostatic function of the psychic apparatus was already articulated by Freud in the early "Project for a Scientific Psychology" (1895), where he described the principle of neuronal inertia—the tendency for neurons to divest themselves of excitation.[4] According to this model, we are in permanent flight from stimulus, both from within and without. Freud makes the point emphatically: "*Protection against* stimuli is an almost more important function for the living organism than *reception of* stimuli."[5]

In so far as Freud associates repetition compulsion with the work of binding, functioning independently of the pleasure principle, it is not properly *beyond pleasure* because it is ultimately in the service of restoring the ego's integrity. But the idea of repetition, in the sense of a "constant recurrence of the same thing," leads toward the conception of the death drive. Only when we wade into the murky water of section 5 of *Beyond the Pleasure Principle* do we encounter something that really challenges the dominance of the pleasure principle: the death drive. The drive is summed up in that paradoxical and bewildering phrase, "the aim of all life is death."[6] The initial formulation relates to the drive as such: "an instinct is an urge inherent in organic life to restore an earlier state of things which the living entity has been obliged to abandon under the pressure of external disturbing forces."[7] This aim, internal to the subject, is related to the cosmic principle of entropy, whereby organized forms tend to revert to less organized ones, organic life to inorganic, and so on. The death drive exerts a constant pressure to breach the protective crust of the ego. We have already noted the problem caused for Freud by the fact that the reduction of tension seems to be the goal of both homeostatic satisfaction and the death drive. To avoid confu-

sion, one needs to be clear about the very different effects these functions have on the ego. While pleasure as satisfaction diminishes tension to protect the ego from being overwhelmed by stimulation, the death drive aims to eliminate tension to the point of abolishing an individual's sense of separate existence—Nirvana.[8] Lacan reformulates Freud by assigning the binding, homeostatic function to the ego and by understanding all drives as repetitive, unrealistic, and destructive. Approaching the satisfaction of the drive, which if accomplished would be deadly, is experienced not as pleasure but as *jouissance.* Joan Copjec is very clear on this point when she writes, in Lacanian terms, that "in contrast to the ordinary pleasure that everyday objects bring, *jouissance,* attached as it is to the memory of an originally lost object—das Ding—is a painful, immoderate pleasure."[9] Although Copjec does not spell it out, what is implied here is that the approach of the Thing rekindles a memory of the undifferentiated infantile world before the separation of mouth and breast, subject and object. What is required in this context, then, is a distinction between binding as a form of pleasurable satisfaction that consolidates the ego and unbinding as painful, frenetic enjoyment that dissolves it.[10] The intensity of the experience may be painful but, as Rob Weatherill puts it, with such an experience "the alienation of ordinary life is overcome."[11]

Milner

This pressure on the distinction between pain and pleasure recurs in my reading of Smithson's *Spiral Jetty* in terms of the death drive and unbinding. Before turning to Smithson, however, I want to cite an example of another analyst who understood the potential of the death drive to unbind and appreciated its aesthetic dimension. Marion Milner was a Kleinian analyst who was particularly interested in visual art and aesthetics. In "The Role of Illusion in Symbol Formation" (1952), Milner describes in some detail the analysis she carried out of an eleven-year-old boy using Klein's play technique while under her supervision.[12] The boy grew up during the Blitz on London and had consequently been forced to mature too quickly. His rigidly defended sense of himself and his lack of engagement with the world was, argues Milner, the result of premature ego development. His early exposure to danger meant that he had to keep a firm grip on the objective world and always distinguish clearly between inner and outer, self and not self. Daydreaming of a blissful return to oceanic oneness was not an option in these circumstances, and this harsh stricture produced anxiety in the boy. In her case study, Milner betrays some impatience with the Kleinian model of object relations and its vocabulary of introjection and projection, because this way of talking "takes for granted the idea of a clear boundary."[13] What seemed at issue in the case of this child's play was precisely the obliteration of boundaries, figured in imagery of burning, melting, and boiling down. Milner's description of one of the child's elaborately staged scenarios in analysis deserves full quotation.

He would close the shutters of the room and insist that it be lit only by candlelight, sometimes a dozen candles arranged in patterns, or all grouped together in a solid block. And then he would make what he called furnaces, with a very careful choice of what ingredients should make the fire, including dried leaves from special plants in my garden; and sometimes all the ingredients had to be put in a metal cup on the electric fire and stirred continuously, all this carried out in the half darkness of candlelight. And often there had to be a sacrifice, a lead soldier had to be added to the fire, and this figure was spoken of either as the victim or the sacrifice.[14]

Milner remarks that this type of play had a dramatic ritual quality comparable to the fertility rites in primitive societies described by J. G. Frazer in *The Golden Bough*.[15] I would want to add that the scene also resembles contemporary installation/performance art, much of which is concerned with obliterating our everyday relation to our bodies and objects in the world.[16] Milner concludes her case study by suggesting that the fire represented not only a destructive fire but also the fire of Eros. What the boy was telling her, in the language of play, was that "the basic identifications that make it possible to find new objects . . . require an ability to tolerate a temporary loss of self, a temporary giving up of the discriminating ego which stands apart and tries to see things objectively and rationally and without emotional colouring."[17]

Ehrenzweig

Robert Smithson was himself a major theoretician of aesthetics beyond pleasure. His main theoretical source for the psychoanalytic conception of the death drive, or Thanatos, was Anton Ehrenzweig's very influential book *The Hidden Order of Art* (1967). In that book, Ehrenzweig discusses Milner's essay on symbol formation as well as other publications by her.[18] Smithson referred to Ehrenzweig's book frequently and used its key concept of "dedifferentiation" as a synonym for his own concept of entropy. So there is a distinct, if unexpected, link between Post-Minimal art in the United States and psychoanalytic practice in London during the 1950s and 1960s.[19] Ehrenzweig proposed a psychoanalytic theory of creative process, one indebted to Milner and to Melanie Klein, which I will briefly outline. The first phase of the process involves the splitting off and projection of unwanted bits of the self, which may appear haphazard, fragmentary, or even persecutory. This is what Klein called the "schizoid" state.[20] The next phase, which Ehrenzweig calls creative dedifferentiation, "tends toward a 'manic' oceanic limit where all differentiation ceases. The inside and outside world begin to merge and even the differentiation between ego and superego becomes attenuated. In this 'manic' stage all accidents seem to come right." In the next, "depressive" phase, the whole mess is swept into the bin.[21] Unless, that is, you are an artist, in which case you manage to reintroject and present the result in a

revised form. An artist such as Jackson Pollock, an important figure in Ehrenzweig's book, can tolerate a particularly high degree of dedifferentiation in his art: "In modern art the ego rhythm is somewhat one-sided. The surface gestalt lies in ruins, splintered and unfocusable, the undifferentiated matrix of all art lies exposed. . . . The pictorial space advances and engulfs him in a multi-dimensional unity where inside and outside merge." The ego's temporary decomposition, Ehrenzweig concludes, is necessary for artistic creativity. He associates this creative dedifferentiation with the death drive or Thanatos, but notes that "we are not engulfed by death, but are released from our separate individual existence."[22] Thanatos, in other words, "tends toward entropy, a leveling down of the difference between inside and outside and a diminution of internal tension through externalization (excreting, expelling)."[23] Milner summed up the relevance of this for creativity: Ehrenzweig, she wrote, described "the rhythm by which the ego's ordinary common-sense consciousness voluntarily seeks its own temporary dissolution in order that it may make contact with the hidden powers of unconscious perception."[24] This distinction has implications for the morphology of visual art, because dedifferentiated forms tend toward uniformity of inorganic matter, while organic forms are highly differentiated and organized.[25]

A number of themes that preoccupied Smithson, apart from dedifferentiation, are touched on here, including entropy, the interpenetration of inside and outside, and the inorganic. Ehrenzweig's book gave a psychoanalytic underpinning to Smithson's aesthetics of entropy and it also had a far wider impact. The book had a decisive influence on the development of Minimalism around the crucial years of 1966 to 1970. Smithson loaned his copy of the book to Robert Morris.[26] In the mid-1960s, Morris advocated sculpture that enabled "strong gestalt sensations." Phrases in his "Notes on Sculpture, Part 1," such as "constancy of shape" and "tendencies toward simplicity," attest to his knowledge of the literature of Gestalt psychology.[27] Donald Judd, too, advocated the use of forms that are unified and simple: "In the new work the shape, image, color and surface are single and not partial and scattered."[28] This preference was motivated by antipathy to "composition," which for them summed up the whole tradition of European art, including Cubism, David Smith, and Anthony Caro. Composition implied, for the younger generation, a balancing and harmonizing of elements that involved making what they deemed arbitrary judgments of taste.[29] The "reasonableness of the well built" object avoided all that.[30] Morris's gestalt aesthetic is tempered in Part 2 of "Notes on Sculpture," where he stresses the tension between the immediate gestalt sensation and the variable phenomenology of space, light, and point of view.[31] The experience of the work takes place in a particular place and time. Morris continued to deplore the capriciousness of tasteful composition, but in the late 1960s he radically altered his prescription for avoiding it. He now regarded Pollock as an exemplary artist because he let the qualities of his materials, such as paint's viscosity, dictate form. Minimal Art answered the problems

raised by Abstract Expressionism with the formula "construct instead of arrange." Post-Minimal art counters, "drop, hang, lean—in short, act."[32]

It is difficult to account for this shift in Morris's thinking, unless he was particularly struck by the retrospective of Pollock's work at the MOMA in 1967 or by Lucy Lippard's *Eccentric Abstraction* show of 1966, which did seem to anticipate Post-Minimalist trends. In 1967–68, Morris started making his Pollock-like cut felt wall hangings, scatter pieces of mixed materials, and installations of threadwaste with mirrors. The first sign in print of the shift is his essay "Anti Form" of April 1968, in which he begins to raise questions about the order "imposed" on the material in object-type art and the a priori value set on the well built. Letting gravity act on matter results in "forms that were not projected in advance."[33] The same year, he organized an exhibition at Leo Castelli's warehouse space called *Nine,* which included work by Eva Hesse and Bruce Nauman as well as Richard Serra's *Splashing* (1967) of molten lead. In his "Notes on Sculpture, Part 4: Beyond Objects" (1969), Morris makes reference to Ehrenzweig and formulates an explicitly anti-gestalt aesthetic.[34] By this time, he had read Ehrenzweig—or, at least, Smithson's 1968 essay called "A Sedimentation of the Mind: Earth Projects," in which Smithson makes the link between Morris's ideas on anti-form and Ehrenzweig's notion of dedifferentiation.[35] Morris now advocates an art that engages a "syncretistic," dedifferentiated scanning, "a purposeful detachment from holistic readings in terms of gestalt-bound forms."[36] The new process art becomes "an energy driving to change perception" and "an activity of change, of disorientation and shift, of violent discontinuity and mutability, of the willingness for confusion even in the service of discovering new perceptual modes."[37] Ehrenzweig's book gave a psychoanalytic grounding to ideas concerning process, materials, and the psychology of perception that initiated Post-Minimalist work.

Morris's model of form/anti-form has had a recent revival in the work of Rosalind Krauss, particularly in her exhibition catalogue *Formless: A User's Guide,* co-authored by Yve-Alain Bois.[38] The exhibition's conception basically blends equal parts of Morris's anti-form and Bataille's *informe.* Particularly prominent is Morris's antithesis between bad (or conservative) static gestalt versus good, extended, spatiotemporal experience, which he most fully elaborated in the somewhat later essay "The Present Tense of Space" (1978). In that essay, the basic opposition summed up by the paired terms "image" and "duration" leads him to deplore the effects of the "cyclopean evil eye" of photography.[39] Morris writes, "It is, of course, space- and time-denying photography that has been so malevolently effective in shifting an entire cultural perception away from the reality of time in art that is located in space."[40] Morris acknowledges that his position is paradoxical. Because the kind of work he advocates resists settling into an autonomous, consumable object and is therefore temporary and situational—that is, made for a particular time and place and so later

dismantled—it absolutely relies on photography for its dissemination. The reason this appears paradoxical to Morris is that he does not acknowledge that anti-form relies absolutely on form.[41]

Smithson figures a good deal in *Formless,* but his more nuanced reading of Ehrenzweig's psychoanalytic aesthetics meant that, unlike Morris, he always emphasized the necessary relation between the two poles of the dialectic of form and anti-form. For Smithson, the artist's job was to endure, temporarily, the suspension of boundaries between what Ehrenzweig called the self and the non-self, and then return to tell the tale: "The artist who is physically engulfed tries to give evidence of this experience through a limited mapped revision of the original unbounded state."[42] Form that has not emerged from an experience of unbounded undifferentiation is empty, but equally, "if art is art it must have limits."[43] Smithson wants art to bear the traces of its formation, and so he objects to smooth sculptural surfaces where "all chaos is put into the dark inside of art."[44] His position resembles Lacan's ambivalent attitude to the mirror image gestalt. For Lacan, it is a precondition of human culture: "This illusion of unity, in which a human being is always looking forward to self-mastery . . . is the gap separating man from nature that determines his lack of relationship to nature."[45] As he points out, imaginary anatomy has little to do with natural anatomy. Yet, as we saw in the chapter on Dalí, the mirror stage also involves a "formal stagnation," or worse, the imposition of a paranoid "defensive armor."[46] Lacan, as we have seen, looked to the potential of the death drive to breach the defensive ego, and Smithson looked to it in order to undo the rigid formalism to which both art and thought are susceptible.

New Jersey

Smithson was clearly working toward an art capable of sustaining the dialectic between containment and scattered dedifferentiation when, in the late 1960s, he presented what he called his *Non-Sites* (fig. 17). Rubble was taken from a site (usually some ruined backwater of New Jersey) and displayed in containers in the organized, institutionalized, white space of the urban gallery. The gallery space was thus made to incorporate the alien bits, but the work simultaneously pointed beyond the gallery space to some peripheral, fragmented landscape, such as an abandoned quarry. As Smithson put it, "The bin or containers of my *Non-Sites* gather in the fragments that are experienced in the physical abyss of raw matter."[47] The dialectic blurs the distinction between center and periphery, because the fragments in the gallery are inhabited by the absence of the site, and the site is virtually unlocatable. Smithson wanted to make the boundary between these two camps permeable, and the material samples, photographs, and written accounts of the experience of the site have just as much weight in this project as the site itself. This contrasts with the position taken up by Smithson's earthwork contemporaries, who tended to see the interven-

tion in the landscape *as* the work, which could then be communicated secondarily to an audience.[48]

But perhaps this site/non-site dialectic, using bins of raw matter in the gallery space, was a bit too literal an illustration of the effect Smithson was after. From the point of view of his future development, the written account of his journey through the entropic landscape of Passaic, New Jersey, may have been more productive. "A Tour of the Monuments of Passaic, New Jersey" (1967) is a remarkable literary and photographic evocation of the suburbs of New York City (fig. 18). It contrasts tellingly with Tony Smith's visit to New Jersey in the early 1950s, which has become a founding fable of postmodernism. Smith's account of his night ride on the unfinished New Jersey turnpike was related in an interview published in *Artforum* in December 1966, and it undoubtedly had an impact on Smithson's conception of the Passaic piece as the description of an encounter with a peripheral landscape. Smith's story was retold by Michael Fried in June 1967 in "Art and Objecthood," and Fried presented it as exemplifying an attitude that flouted the distinction between the phenomenal and the aesthetic, opening the way for an undifferentiated, "anything goes" kind of art practice. Smithson's "reply," "A Tour of the Monuments of Passaic," appeared in the December issue.[49]

But what kind of reply is it? In his "Sedimentation of the Mind" essay, Smithson addresses the issue directly. Having by now read Ehrenzweig's book, he thinks of Tony Smith's car ride as an experience of dedifferentiation: Smith "is talking about a sensation, not a finished work of art. . . . describing the state of mind in the 'primary process' of making contact with matter." Fried reacts adversely to this experience because he "is unable to bear this 'oceanic fragmentation.'" He "cannot endure the suspension of *boundaries* between what Ehrenzweig calls the self and the not-self."[50] Smithson would seem, then, to endorse Smith's implied model of creative experience. But what strikes me is the dissimilarity of Smith's and Smithson's journeys. The sublimity of Smith's night drive on the empty, dark turnpike is patent when compared to Smithson's downbeat noonday tour by bus and on foot. Smithson, too, encounters a highway under construction, but he stresses the utter dereliction of the site: "River Drive was in part bulldozed and in part intact. It was hard to tell the new highway from the old road; they were both confounded into a unitary chaos. Since it was Saturday, many machines were not working, and this caused them to resemble prehistoric creatures trapped in the mud, or, better, extinct machines—mechanical dinosaurs stripped of their skin."[51]

When one also takes into consideration the fact that Smithson was born in Passaic, the contrast with Tony Smith's excursion could not be more emphatic. Smith's night ride is on a truly monumental, sublime, unfinished New Jersey turnpike, rushing into an exhilarating void. Smithson's journey is a disorientating meander on the site of his own prehistory. He is concerned with the traces of the past on the landscape. In an

interview he discusses his choice of sites in New Jersey: "I think those landscapes em-
bedded themselves in my consciousness at a very early date, so that in a sense I was
beginning to make archaeological trips into the recent past."[52] The poor monuments
of Passaic punctuate a postindustrial wasteland. Even those parts of the landscape
under construction have the air of "ruins in reverse." Passaic, writes Smithson, is full of
holes—"monumental vacancies that define, without trying, the memory-traces of an
abandoned set of futures." Smithson's "Tour" seems to me to be a far more interesting
originary tale for postmodernism than the heroic night ride of Tony Smith.[53]

Bataille

Before I finally turn to *Spiral Jetty*, I want to refer to one more figure important to
Smithson and for my reading of him: Georges Bataille, a French writer associated

with Surrealism.[54] He is not frequently cited by Smithson, but a few allusions do occur, which is not surprising given both thinkers' concerns with prehistory, ancient civilizations, and contemporary art. One mention appears in Smithson's "Conversations with Dennis Wheeler" (1969/70), in the course of discussing his mirror displacements and referring to his essay "Incidents of Mirror-Travel in the Yucatan" (1969). The mirror works involve setting mirrors in landscapes so that they cut square holes in the earth, photographing them, and then dismantling them. Smithson describes them as displaced human sacrifices (fig. 19). They perform a sacrifice of matter, which "releases a certain kind of awareness. That is what George Bataille in his book called *Death and Sensuality* points out."[55] (*Eroticism,* titled *Death and Sensuality* in the Ballantine edition, was found in Smithson's library.)[56] Smithson

gets interrupted at this point, so I will have to draw out the implications of his reference to Bataille.

Eroticism, according to Bataille, has fundamentally to do with destroying the self-contained, "discontinuous" character of the participants. "We yearn for our lost continuity," he writes.[57] Yet death also destroys the discontinuous individual, pitching him "headlong into continuity" with all being. Bataille's notion of eroticism completely collapses Freud's precarious distinction between Eros and the death drive. For Bataille, the binding counterpoints to the unbinding effects of eroticism and death are our actual physical separateness as well as an inward sense of self-possession and stability—in other words, the ego. The dynamic of binding and unbinding is thus preserved, but Eros is given a self-shattering quality, while death is eroticized. Life at its most intense, at its limit, encounters death. Ecstatic pleasure borders pain. It is no wonder, then, that Freud's pleasure principle, which shuns pain, seems moribund, while the beyond of pleasure makes life intensely felt at its very limit.[58] The ritual of sacrifice is a way of experiencing that limit. Bataille observes that the sacrificial victim shows "the continuity of all existence with which the victim is now one."[59] The act of violence bestows on the sacrificial creature "the limitless, infinite nature of sacred things."[60] He closes the remarkable introduction to this book with a reflection on the relevance of this for aesthetics: "Poetry leads to the same place as all forms of eroticism—to the blending and fusion of separate objects. It leads us to eternity, it leads us to death, and through death to continuity." This is offered as a gloss on some lines of poetry by Rimbaud: "It's returned. / What? Eternity. / It's the sun matched with the sea."[61]

Smithson's mirror displacements enact the sacrifice of matter. The mirror glass cuts into the earth, dematerializing it and sometimes depositing patches of blue sky on the ground, disorienting our senses. The effect of dematerialization is, of course, compounded by its photographic reproduction. Smithson's acute sense of the way reproduction, so to speak, kills its object is clearest in another passage, where Bataille's influence is particularly marked. In "Incidents of Mirror-Travel," Smithson imagines a large-scale sacrifice of matter.[62] He is heading into a dedifferentiated landscape when an ancient Mayan god tells him to get rid of his guidebooks, saying, "You risk getting lost in the thickets, but that is the only way to make art." The horizon before him is constantly consumed: "Through the windshield the road stabbed the horizon, causing it to bleed a sunny incandescence. One couldn't help feeling that this was a ride on a knife covered in solar blood. . . . The tranquil drive became a sacrifice of matter that led to a discontinuous state of being."[63] Or should that read "continuous" state of being? Bataille's eroticism is here blended with the ancient rituals of Mesoamerican peoples. Yet this image of sacrifice also holds an allegory about the nature of representation. Smithson's art and writing displace, or destroy, materiality: "The unnamable tonalities of blue that were once square tide pools of sky have vanished

18
Robert Smithson,
*The Fountain
Monument*
(side view)

into the camera and now rest in the cemetery of the printed page—Ancora in Arcadia morte."[64] But this sacrifice, as he remarked in the interview, is not for nothing; it "releases a certain kind of awareness."

Spiral Jetty

"Et in Utah ego" is a phrase Smithson uses in the "Spiral Jetty" essay—and it can be construed as 'I [Death] am also in Utah," following Erwin Panofsky's famous article on Poussin's paintings of Arcadian shepherds.[65] The Great Salt Lake, site of the jetty, is a dead body of water, only capable of sustaining a kind of algae that stains the water red. The color is most important. Smithson highlights it with an epigraph from G. K. Chesterton on the color red, "a joyful and dreadful thing": "it is the place where the walls of this world of ours wear the thinnest and something beyond burns through."[66] Chesterton's remark frames Smithson's account of his encounter with the site and the building of the *Spiral Jetty*, but the essay, like the film, begins with a pragmatic, pedestrian account of the search for the site and the journey to it (fig. 20). As they approach the site, though, on almost indecipherable dirt roads "that glided away into dead ends," Smithson's prose slips into a mode aimed at confounding classifications and categories. Solids go liquid and confusion reigns about the distinction between inside and outside, perception and landscape:

"Sandy slopes turned into viscous masses of perception."[67] Dilapidated, abandoned oil rigs are "mired in abandoned hopes." "My dialectics of site and non-site whirled into an indeterminate state, where solid and liquid lost themselves in each other," Smithson observes.[68] On first viewing the lake, he imagines that he sees a whirlpool—a vision fueled by ancient legends that explain the lake's salty water by positing a subterranean link between the lake and the Pacific Ocean. The lake has, mythically, a dangerous vortex leading to a giant watery black hole. The image irresistibly evokes the great "closing vortex" whipped up by Moby Dick at the apocalyptic end of Melville's novel.[69] But "the sun matched with the sea" is also dangerous. Toward the end of the film, the jetty is filmed from a helicopter that maneuvers into position so that the sun is reflected in the eye of the vortex. I imagine this as a moment of convulsion like the one described in Smithson's essay: "On the banks of Rozal point, I closed my eyes and the sun burned crimson through the lids. I opened them and the Great Salt Lake was bleeding scarlet streaks. . . . Perception was heaving, the stomach turning. . . . I had the red heaves as the sun vomited its corpuscular radiation."[70] At the end of the film, the camera is focused directly into the reflected sun, causing irruptions of lens flare that look like light flooding and spilling out of the jetty's eye. A vomiting, bleeding eye is envisaged here—reminiscent of the one in *Un chien andalou,* but vast.[71]

Two artists are mentioned in this otherwise swooning passage. A reference to Pollock undoubtedly offers an homage not only to his whorls of paint but also to the mythopoetic bent of his early work, not to mention his violent death. A particular painting is invoked: *Eyes in the Heat* (oil and aluminum paint on canvas, 1947). The New York poet Frank O'Hara described it vividly. It is, he wrote, "a maelstrom of fiery silver . . . which has a blazing, acrid and dangerous glamour of a legendary kind, not unlike those volcanoes which are said to lure the native to the lip of the crater . . . and cause him to fall in."[72] Next, a mirage of Van Gogh at his easel appears. He is also a painter of magnificent whorls, a painter burdened by madness who suffered a violent, self-inflicted death. Incidentally, Bataille wrote about Van Gogh in the context of sun worship and sacrificial mutilation. The self-mutilator, he argues, emulates his self-consuming ideal, the solar god, who tears out his own organs.[73]

My idea about the *Spiral Jetty,* in its earthwork, prose, and film forms, is that it enacts a symbolic ritual allowing temporary sway to the death drive. In the film, Smithson performs the rite, running like mad the length of the spiral, chased by the noisy helicopter/camera hovering above him like some prehistoric bird of prey. He gets to the innermost circle and stops at the center of the labyrinth, where he survives death, like Theseus in his confrontation with the Minotaur.[74] He then turns around and walks back, clockwise, returning to his workaday world, but now better able to sustain an ethical position beyond the narcissistic ego, beyond the pleasure

19
Robert Smithson,
*Yucatan Mirror
Displacement,
Number 6,* 1969

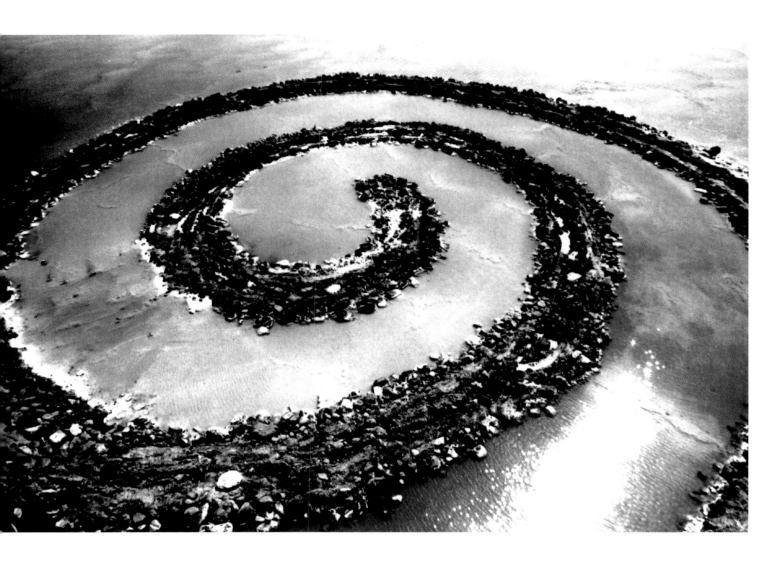

principle.[75] This about-face is a performative realization of the "depressive" moment in Ehrenzweig's conception of creativity: having suffered the vertigo of dedifferentiation, Smithson is called back to his sole, differentiated, contained self.[76] The film, however, follows this moment up with a more immediate experience of dedifferentiation for the spectator. The helicopter/camera wheels and roars, and light pulses from the jetty's core. One's bearings and sense of identity are overwhelmed in "an ecstatic blindness."[77] This is dedifferentiation made visible. A jump cut abruptly takes us to an editing suite in which we see a large photostat of the *Spiral Jetty* hanging on the wall—the final, depressive image of the film.[78] In this last sequence, the spectator is directly caught up in the ecstatic and depressive moments, unmediated by

Smithson's performance. (This analysis demonstrates why the experience of the *Spiral Jetty* is not sublime. There are two moments of the Kantian sublime, but the first is humiliating, and the second, uplifting.)

Richard Wilson's well-known installation at the Saatchi Gallery in London, *20:50*, seems to me to invite the viewer to enact the same ritual on a smaller scale. Here, the spectator is the performer (fig. 21). Walking the plank—a metal wedge cut into the midst of an apparently deep pool of black oil—one experiences the disorienting dedifferentiation of the ceiling reflected in the dark mirror surface, coupled with the heavy, dizzying smell of the oil. One then turns and retraces one's steps. The practical necessity of having an attendant on duty who makes you leave your belongings behind only enhances the sense of the installation as a journey halfway across the river Styx.

The *Spiral Jetty*, according to a popular Derridean reading, deconstructs the conventional notion of the art object because the title refers indifferently to earthwork, text, and film. Craig Owens goes further, suggesting that the work only exists as photos, film, and narrative.[79] It certainly is true that the film and text do not simply document the site-specific work, yet I think this obvious overstatement misses a crucial point. Because of the earthwork's extreme inaccessibility, all most of us are ever likely to experience of the work are the filmic, photographic, and literary versions. But these, it seems to me, have the weight and interest they do precisely because they circle around the vortex created by this great lost object. As Eva Schmidt points out, the last image of a black-and-white photograph over the editing table—drained of color and still—suggests that the jetty has already "irretrievably changed into an absence."[80] This loss is inevitably superimposed on another: Smithson's own early death in a plane crash. As Allan Kaprow noted of Pollock's death, such accidents evoke for us "the sacrificial aspect of being an artist."[81] It is made all the more acute and uncanny by the fact that Smithson symbolically performed the *Spiral Jetty* sacrifice only a few years before the accident.

Lacan claimed that the absence of ritual and rites of passage in modern life means that people end up going to the psychoanalyst to give their lives symbolic structure and meaning. This view is made most explicit in "Some Reflections on the Ego" (1953), where he refers in particular to rites of passage in traditional societies. "Such rites seem a mystery to us now," he writes; "we are astonished that manifestations which among us would be regarded as pathological, should in other cultures, have a social function in the promotion of mental stability. We deduce from this that these techniques help the individual to come through critical phases of development that prove a stumbling block to our patients."[82] Yet in the absence of religion, I would argue, cultural forms other than psychoanalysis come to fill the vacuum and take over the function of offering symbolic mediation. In fact, a link between the insights of comparative anthropology and contemporary art practice

was proposed in an exhibition at the Tate Gallery in 1995 called Rites of Passage: Art for the End of the Century. The catalogue includes essays by literary theorist Stephen Greenblatt and psychoanalyst Julia Kristeva. The latter alludes to the etymology of the word "religion," meaning "to bind" or "to make a community," and remarks: "It is very difficult to imagine a religious institution which could channel this experience without lapsing into dogmatism. Perhaps the museum is one place which can provide a context for it."[83] I cite this passage because it puts into sharp relief the sort of rite Smithson invoked in the *Spiral Jetty*. It is the very opposite of the binding, communal function of ritual that is intended to subsume individual egos to a symbolic order. The aesthetic function of the death drive is precisely to invoke what is beyond the symbolic order and imaginary fixations that constitute our reality.

21
Richard Wilson,
20:50, 1987

6 Mourning

The Vietnam Veterans Memorial

The last chapter broached the idea of a form of art that involved the spectator in a ritualized confrontation with the reality of death. This chapter takes up that theme in the context of Maya Lin's remarkable monument made for the veterans of the Vietnam War. While considerable research has been undertaken recently on the topic of monuments and memorials, very little of it has concerned what might be called their subjective dimension.[1] My aim in this chapter is to bring psychoanalytically informed conceptions of loss and mourning to bear on the subject of monuments. Freud touched on the topic when, in his "Fetishism" paper of 1927, he compared castration anxiety to the panic a grown man feels "when the cry goes up that Throne and Altar are in danger, and similar illogical consequences ensue."[2] Freud used "throne" and "altar" as metonyms, of course, for established government and religion. His use of metonymy here, which takes a part for a whole, seems pointed, deliberate. Certain fabricated objects, like throne and altar, he suggested, have a loaded significance, similar to the little boy's penis during the Oedipal crisis, when he feels threatened with castration. But the analogy is not quite right, for it is precisely the function of these objects to assure us that the body politic is intact—or that the nation is a coherent totality—although it manifestly is not. The safety of the part guarantees the integrity of the whole. In other words, they function as fetishes disavowing traumatic knowledge, and yet, by the very importance attached to their preservation, they also

"memorialize" the trauma and acknowledge the inevitability of fragmentation and loss.[3] The monument as fetish is one response to any threat to national integrity.

Fetishism and Forgetting

Neil Hertz explored this terrain in his study of representations of revolutionary France personified as a woman. He deals with what he calls "the representation of what would seem to be a political threat as if it were a sexual threat."[4] Given that conflation, it follows that assuaging the political threat may take a form similar to the management of the sexual threat of castration—that is, it may have a fetishistic character. Hertz's examples of revolution figured as a hideous, castrating Medusa are, I would argue, the flip side of the monument as fetish. Freud's essay on fetishism is of obvious interest for art theory, because it attempts to explain men's fascination with certain kinds of rather strange objects. According to Freud, the fetish functions to repudiate the unwelcome knowledge that the mother lacks a penis. The observation of this imagined lack, made during the phallic phase of infantile sexuality, makes real for the child the possibility of castration. In a defensive gesture, the sight is disavowed, and the child goes on believing in the maternal phallus by endowing another part of the woman's body (or her clothing) with importance equivalent to that of the "missing" organ. He invents a substitute object to stand in for the imagined lack and displaces his interest onto it. Yet Freud also notes that the fetish serves as a "memorial" to the horror of castration. This corresponds to the oscillation of recognition and disavowal characteristic of the fetishist, summed up by the analyst Octave Mannoni in the formula "I know, but all the same. . . . " Of course, the fetishist does not consciously articulate this formula: the "but all the same" part is the fetish.[5] The experience of the moment of recognition, Mannoni stresses, is not effaced. On the contrary, it leaves behind a *stigma indelibile,* one that is utterly ineradicable. Only the conscious recollection of the traumatic experience is effaced.[6] Mannoni also makes the point, pertinent in this context, that the structure of fetishism is repeated in later and less strictly sexual contexts, where it serves as a model of all repudiations of reality and disavowals of lack: "Disavowal of the maternal phallus delineated the first model of all repudiations of reality, and constituted the origin of all beliefs that survive the refutation of experience."[7] Because the fetish is haunted by a residual knowledge of its origin, it is a profoundly ambivalent object—either venerated or denigrated. Laura Mulvey develops this theme in her book *Fetishism and Curiosity,* where she also argues that because the fetish "stays in touch with its original traumatic real," it "retains a potential access to its own historical story."[8]

The classical Freudian account of fetishism makes it an exclusively male perversion. As such, it has had some limited use as a concept in the critique of certain representations of women in pornography, advertising, and art. Yet if we expand the concept of fetishism following Lacan's interpretation of it as the fantasy, in men and

women, of having the phallus, then all human subjects are prone to disavow lack and seek out substitute objects to plug the gap in Being.[9] It is then easier to see how collectivities, like nations, might also have an interest in setting up fetishes to cover over sources of social division and insecurity.

During the 1980s, the U.S. government embarked on an ideological project of disavowing the recent national trauma of the Vietnam War. It seemed as though protests at home and defeat abroad still figured in the nation's psyche as a threatened castration that must be disavowed. The political turmoil stirred up by antiwar protests as well as by civil rights, women's rights, and gay rights movements and all sorts of countercultural expressions that characterized the preceding two decades—not to mention the terrible roll call of assassinations—all clustered around that central trauma. George Bush Sr. made this project of disavowal explicit in his inaugural address of 1989: "The final lesson of Vietnam is that no great nation can long afford to be sundered by a memory." But the key moment of the project was the extravagant celebration of the Statue of Liberty's centennial in July 1986, when Ronald Reagan was still president (fig. 22). I want to argue that it was intended to secure the status of the monument as fetish. If this was the case, then the paradoxical consequence follows that a monument, something intended to preserve a memory, was adapted to the task of forgetting. The statue might best be described as containing the fetish and so, like the fantasy of the phallic mother, it serves as a guarantee that the Other does not lack. In short, the Statue of Liberty invests the image of the female body with a fantasy of phallic mastery, integrity, and control. The monument is to history as the fetish is to the body of the mother.[10]

I am sure that I am not alone among Americans in recognizing in the Statue of Liberty the embodiment of all my childish idealizations of my mother country as all-powerful and good—an idealization that, of course, set me up for eventual disillusionment. This recognition was brought home to me forcefully during a viewing of James Cameron's 1997 film *Titanic*. In the film, the young heroine who survives the disaster boards a boat that sails into New York Harbor under a towering, majestic Statue of Liberty. My reaction to this episode, something like grief, required explanation. In *The Sublime Object of Ideology*, Slavoj Žižek writes about the amazing submarine photographs and film of the wreck of the *Titanic* at the bottom of the sea and tries to explain their terrible fascination: "The *Titanic* is a Thing in the Lacanian sense. . . . By looking at the wreck we gain an insight into the forbidden domain, into a space that should be left unseen: visible fragments are a kind of coagulated remnant of the liquid flux of *jouissance,* a kind of petrified forest of enjoyment."[11] In other words, the corroding wreck is a Medusa's head—the sight of which, without the saving mediation of Perseus's reflective shield, was lethal and which was supposed even to have turned seaweed into a petrified forest of coral.[12] The wreck, I realized,

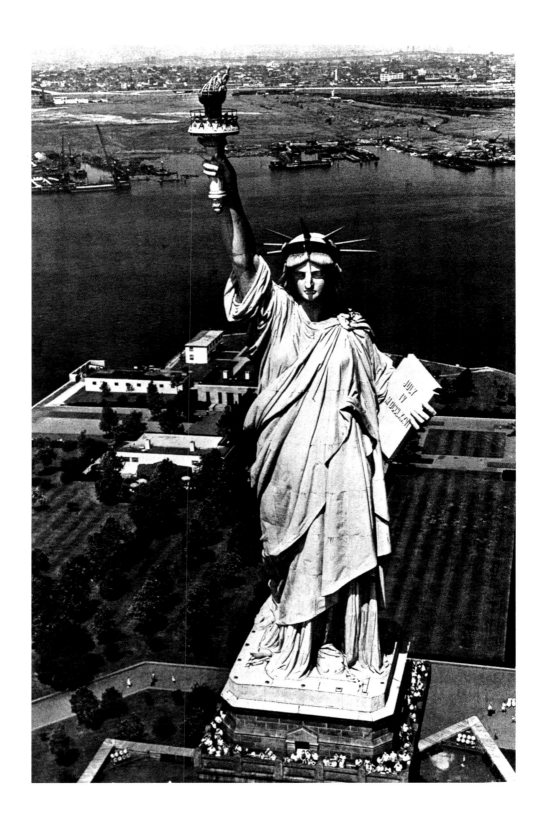

signified the ruin of any fantasy of returning to the arms of the "unsinkable" mother, while the statue whispered, "but all the same. . . ."[13] Within the logic of the film, the horror of the wreck demanded that the Statue of Liberty come to cover over the sight or to stanch the wound. But, as I have suggested, such comfort is equivocal, for that object will always mark a site of deep psychic pain.

The Wall

I have argued that the Statue of Liberty became a giant phantasmatic plug modeled to fill a perceived hole in the structure of the nation, and this offers some background for my account of a monument specifically designed to elicit remembering and mourning rather than fetishization. Maya Lin's Vietnam Veterans Memorial in Washington, D.C., intervenes in the same fraught space and time as the apotheosis of the Statue of Liberty—the United States in the 1980s—but to entirely different effect (fig. 23). Practically all of the literature on the Wall, as it has come to be called, is a retelling of the narrative of its genesis. It is, indeed, an irresistible story, so I will provide a compressed account. It centers on the figure of Jan Scruggs, a former Vietnam infantry corporal and son of a milkman, who, years after the end of the war, saw again in a nightmare the mangled bodies of his friends and resolved that their names would not be forgotten.[14] In 1979, he set up a fund to raise public contributions, and, with a few allies who joined the fund committee, he persuaded Congress to donate a prestigious plot of land on the Mall in the heart of Washington. Everything went smoothly until the winner of the anonymous open competition for the memorial's design was announced. A small but powerful minority, including Ross Perot and the secretary of state for the interior under Reagan, James Watt, disliked the austere design. No doubt the fact that the winning entry turned out to be by Maya Lin, a twenty-one-year-old Chinese American female undergraduate studying architecture at Yale, gave strength to their arm.

After considerable acrimony, a compromise was hammered out that supplemented the Wall with a hyperrealistic sculpture by Frederick Hart of three soldiers (one white, one black, and one Hispanic) and a flagpole forty feet high. Fortunately, these were eventually sited at a discreet distance from the Wall, although the critics favored using the Wall as a backdrop to Hart's sculpture and hoped to plant the flagpole at the apex where the two halves of the Wall met. Lin's critics disliked her design because it was "unheroic." For one vocal vet, Thomas Carhart, it was "a black gash of shame and sorrow, hacked into the national visage that is the Mall."[15] Of course, the perception of a dreadful "gash" and the proposed strategically sited flagpole cry out for an analysis in terms of castration anxiety and fetishization. Marita Sturken makes this case forcefully: "To its critics this antiphallus symbolizes the open, castrated wound of this country's venture into an unsuccessful war."[16] A repetition of the divisive discourse of phallus/antiphallus, male/female, pro-war

and antiwar was, however, exactly what the organizers of the memorial fund had wanted to avoid.

As a symptom, the controversy provoked by Maya Lin's design for the memorial was certainly telling. The design acted as a kind of lightning rod that attracted the still-charged atmosphere that swirls around the Vietnam War. Emotions (mostly of anger) and opposing attitudes toward the war were rekindled by the Wall and were largely displaced onto issues of aesthetics—modernism as against tradition, abstraction as against figurative art. These rather crude categories seemed to me to curtail any serious thinking about the Wall's original conception, its complex resonances and emotional power. Yet its trial by fire undoubtedly raised its public profile and sparked Americans' collective imagination. Paradoxically, it became a truly national monument precisely because it was attacked and struggled to survive in a blaze of publicity.

A Moving Composition

In fairness, the critics should not have attacked Lin's design. It was not intended to be heroic or to validate the Vietnam War. On the contrary, it was intended "to heal a nation," that is, to reconcile both veterans and those who had not fought to the tragic loss of life and to settle still-simmering resentments and hostility on both sides.[17] In short, it was meant to be therapeutic. Jan Scruggs was deeply involved in the rehabilitation of veterans when he proposed the memorial and had done research on the psychological maladjustments suffered by Vietnam veterans who had been involved in heavy combat. In 1976, he had presented his research before a Senate subcommittee in support of a counseling program for Vietnam veterans. He also recommended that a national memorial be built. He said that on returning home, the veterans had been "cast into a void." Scruggs understood that the veterans could only be rehabilitated if those who had objected to the war stopped transferring their hatred and derision onto the already battered veterans, the vast majority of whom had been drafted. Scruggs always stressed the baleful effects of the war on all Americans born after World War II —not only on the 2.7 million who served, but also those at home who experienced the bitter debates that divided generations, social classes, families, and friends. The memorial, then, was to have two functions: it would be a place of mourning for soldiers who had lost friends and for bereaved relatives, and it would invite the rest of that generation to reflect on the enormous sacrifices made by the living and the dead. In his address to Congress in 1980, Scruggs acknowledged the continuing differences of opinion about U.S. policy in Vietnam and voiced the hope that all "may unite in expressing their acknowledgment of the sacrifice of those who served."[18] This small ground for reconciliation is tersely stated in a line from a poem by Archibald MacLeish, cited by Scruggs: "We were young. We have died. Remember us."[19]

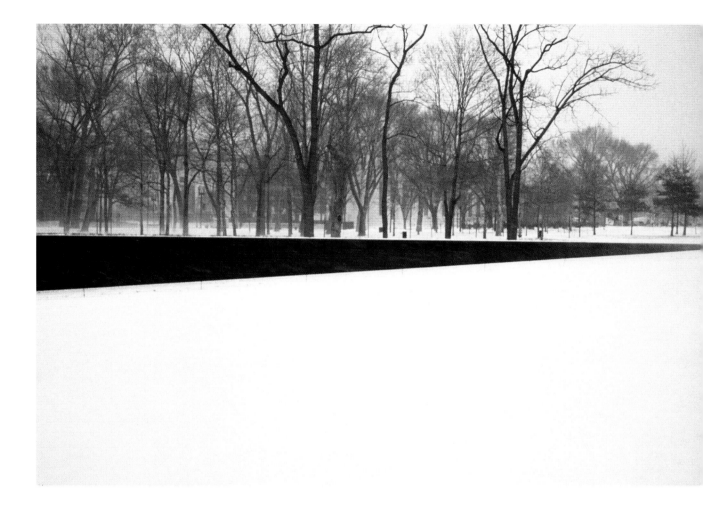

In keeping with this aim, a key design requirement for the memorial was the inscription of the more than 58,000 names of the dead and missing. Another explicit requirement was that it should not make a political statement. The criteria for judging the design competition went further, repudiating political or military content.[20] Given these requirements, plus the stipulation that the memorial respect the sensitive site between the Washington Monument and the Lincoln Memorial, it was inevitable that the successful design would have a funerary character, be abstract, and emphasize the horizontal. Maya Lin's brilliant conception was to construct a wall below grade in an excavated hollow, making use of the connotations of a grave or tomb. Her other stroke of genius was to take literally the design brief that required the memorial to be "contemplative and reflective in character."[21] The highly polished black granite reflects the passing mourners and visitors in the depths of its virtual space.

If the heartwarming narrative of "Mr. Scruggs goes to Washington," with its heroes and villains, setbacks and ultimate triumph, dominates the reception of the Wall, it is no wonder that there is little written about the actual encounter with the work beyond the anecdotal. Another obstacle to understanding it properly is that it is most often described as an object in space. It is composed of two walls of polished black granite sunk into the earth, like garden retaining walls, tapering at either end and meeting at an angle of 130 degrees in the center, where the Wall is ten feet high (or deep). The entire five-hundred-foot expanse is covered with names registered according to the day of death. This may describe the physical structure of the memorial, but Maya Lin's statement accompanying her design entry very explicitly invoked a passage, even a rite of passage. It begins, "Walking through this park, the memorial appears as a rift in the earth—a long, polished black stone wall, emerging from and receding into the earth." Further on: "The memorial is composed not as an unchanging monument, but as a moving composition, to be understood as we move into and out of it."[22] She then outlines the aspect of the design I find least satisfactory. The chronological list of names starts at the apex at the top of the right-hand wall (1959) and ends at the bottom of the left (1975), so that the war is, metaphorically, "complete, coming full circle, yet broken by the earth that bounds the angle's open sides and contained within the earth itself."[23] The suggestion seems to be that the Wall's imaginary third side is submerged, but the chevron design does not elicit a sense of this invisible closure. On the contrary, the walls point like black arrows away from the site, toward the two famous monuments on its perimeter.

Curiously, Lin made no mention of the Wall's literal reflectiveness in her statement, although she later frequently did in interviews and letters following the selection of her design—especially in response to hostile critics who disapproved of its lack of figuration or the "human element," as they said. "Surely," she countered, "seeing himself and the surroundings reflected within the Memorial is a more moving and personal experience than any one artist's allegorical or figurative interpretation could engender."[24] She meant "moving" in two senses. The affective power of the experience of the memorial is linked to its temporality.[25] In a press conference following the announcement of the winning design, Lin said, "I wanted to describe a journey—a journey which would make you experience death."[26] In an interview, she elaborated on this, calling the Wall "a very psychological memorial, meant to bring out the realization of loss and a cathartic healing process."[27] Crucial to this realization is the encounter with the dim reflections in the Wall. Yet Lin never makes explicit why these reflections should be so moving. Donald Kunze, whose reading of the monument is closest to mine, explains it as follows: "The reflected images of the visitors are blurred into specters of the dead standing behind the names."[28] Yet in some of Lin's statements, it is evident that she thought of the virtual space behind the

Wall as a metaphor for the underworld. For example, she describes the great granite slabs as "an interface between the sunny world and the quiet, dark world beyond that we cannot enter."[29]

Artistic Precedents

Before exploring in psychoanalytic terms the experience of the memorial, I want briefly to consider some art-historical reference points for the design. It was originally a project for a course at Yale School of Architecture. Important for the conception must have been the course given by Kent Bloomer and Charles Moore, "Body, Memory, and Architecture," which argued for the building of environments that involve the whole body in a "haptic," or tactile, form of reception instead of a purely visual, alienated perception—a difference summed up by the contrast between climbing a mountain and regarding it from a distance.[30] Another important source was a series of lectures delivered by Vincent Scully. In an article printed in the *New York Times,* Scully noted that Lin had already designed the monument when she heard his lecture on the Memorial to the Missing of the Somme in Thiepval, France, but had not yet written the text accompanying it (fig. 24). Scully's lecture described Edwin Lutyens's design as a staging of a walk toward a gaping maw of death, miming the experience of the soldiers on the battlefield, some of whose anonymous gravestones we encounter on passing through the arch. We recapitulate the soldiers' path, "advancing in the open toward pain, nothingness, the void: insatiable, unimaginable death."[31] Lin described her monument as "a journey from violence to serenity." The Thiepval memorial records the names of British soldiers who died in the area during World War I and whose graves are unknown—presumably because nothing remains. There are more than 73,000 names inscribed, which accounts in part for the design: the multiplication of arches, forming sixteen massive supports at ground level, increases the surface area for inscription. Writers on Lutyens's war memorials have noted his austere, aniconic, "elemental" style. Thomas Laqueur, writing on World War I memorials generally, notes the tendency to "eschew representation and the production of meaning as far as possible and resort to a sort of commemorative hyper-nominalism."[32] Anyone who has visited Thiepval, however, will be aware that the gigantic triumphal arch dominating the plain bears little formal relation to Lin's discreet monument. In her book *Boundaries,* Lin concedes this point: "Formally the two memorials could not be more different. But for me, the experience of the two memorials describes a similar passage to an awareness of loss."[33] Lutyens's apparently simple monolith of the Cenotaph in London—honoring, as its inscription reads, The Glorious Dead—is a pertinent reference point as well, especially in view of the public's spontaneous expressions of grief elicited by it and by the Wall (fig. 25). As Laqueur remarks, the meanings of World War I and Vietnam were both disputed, and the monuments to both "derive their meaning from their intrinsic lack of it."[34] The

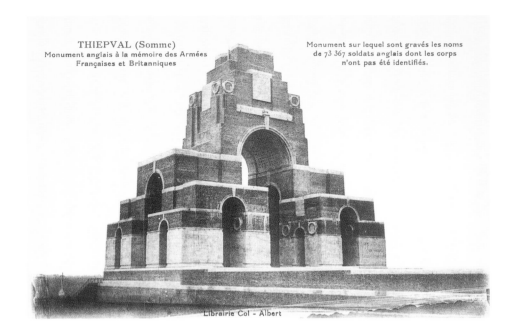

THIEPVAL (Somme)
Monument anglais à la mémoire des Armées
Françaises et Britanniques

Monument sur lequel sont gravés les noms
de 73 367 soldats anglais dont les corps
n'ont pas été identifiés.

Librairie Col - Albert

24
Edwin Lutyens,
Memorial to the
Missing of the
Somme, 1924

lack suggests that any attempt to subsume so many deaths under some trumped-up noble cause or patriotic duty would be utterly trivializing. The case of Vietnam—a war whose meaning is unclear and contested—produced an aniconic, hypernominalist, and profoundly moving monument.

Although Lin has not mentioned any sources of inspiration apart from the Thiepval memorial, another probable and more proximate forerunner for her design is the Post-Minimalist, site-specific, environmental art or earthworks of the 1970s. This has also been noted by commentators and is evident in some of Lin's statements:

> I thought about what death is, what a loss is . . . a sharp pain that lessens with time, but can never quite heal over. A scar. The idea occurred to me there on the site. Take a knife and cut open the earth, and with time the grass would heal it. . . . The grass would grow back, but the cut would remain, a pure, flat surface, like a geode when you cut into it and polish the edge.[35]

Here we have the germ of an alternative to the symbolics of castration and fetishization. A scar implies an acknowledgment of loss and a slow process of healing: a slow work of mourning, rather than a dramatic, instantaneous disavowal and substitution. In her book on melancholia, *Black Sun,* Julia Kristeva notes the difference between these two processes as motors of creativity: "If loss, bereavement, and absence trigger the work of the imagination and nourish it permanently as much as they

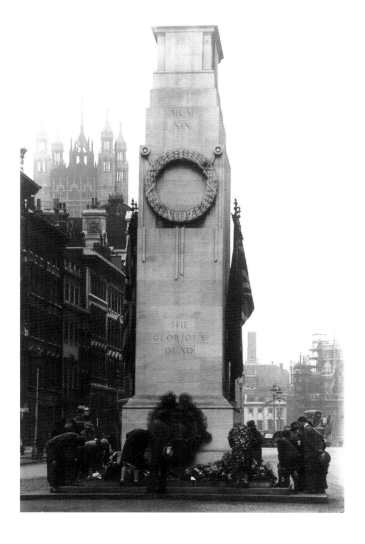

25
Edwin Lutyens,
Cenotaph, 1919-20

threaten it and spoil it, it is also noteworthy that the work of art as fetish emerges when the activity of sorrow has been repudiated."[36] Clearly, the characters or styles of art produced under the signs of these two ways of responding to loss will be markedly different.

Robert Smithson wrote about the symbolics of the scar in the landscape in 1973. Interestingly, he referred to eighteenth-century theories of the picturesque developed by Uvedale Price and William Gilpin. Smithson's article is called "Frederick Law Olmsted and the Dialectical Landscape" and discusses the "earth sculpture" that is New York's Central Park. The park was made in the 1850s but was inspired by the earlier picturesque garden. The term "picturesque" is, according to Smithson,

misleading in so far as eighteenth-century garden reformers aimed precisely "to free landscaping from the 'picture' gardens of Italy into a more physical sense of the temporal landscape."[37] Their view was "dialectical" because they were neither constrained by a one-sided idealism nor deluded by the fantasy, held by some present-day ecologists, of a harmonious relation to nature. Smithson urges latter-day reformers to consider the following quotation from Uvedale Price: "The side of a smooth green hill, torn by floods, may at first very properly be called deformed, and on the same principle, though not with the same impression, as a gash on a living animal. When a rawness of such a gash in the ground is softened, and in part concealed and ornamented by the effects of time, and the progress of vegetation, deformity, by this usual process, is converted into picturesqueness; and this is the case with quarries, gravel pits, etc., which are at first deformities, and which in their most picturesque state, are often considered as such by a leveling improver."[38] Smithson, via Price, understood the picturesque as the site of an original violence to the land perpetrated by man or nature.

Maya Lin's original thought at the site of the memorial—of a knife cutting into the landscape—also evoked an initial violent gesture. In the context of a war memorial, one naturally links this ripping of the land to the trenches and craters left in the wake of war. Some of these rather different "earthworks" are preserved as heritage sites on the Continent, memorials to war that have the character of traces, indexical signs of past events. A hollow in the ground is a negative object that insists on the past tense of the event and also the loss incurred by it. The excavated hollow on the Washington Mall, a simulated violence, may help to bring home the reality of a war that, as Scruggs observed, "rent the land of Vietnam and the American social fabric."[39]

Of course, Lin may have been familiar with the literature on the picturesque, but Smithson and his associates inform her sensibility. None of Smithson's actual earthworks, say *Spiral Jetty* or *Amarillo Ramp*, seems to have supplied a model for the Vietnam Veterans Memorial—but one by Richard Serra, dedicated to Smithson after his untimely death in 1973, does seem a possible source of inspiration. Serra's *Spin Out (for Robert Smithson)* (1972–73) is made of three steel plates in a centrifugal arrangement, set into a natural hollow so that they are partially submerged in the surrounding slopes. Perhaps his large landscape piece *Shift* (1970–72) is even closer in conception (fig. 26).[40] Rosalind Krauss has observed of this and related works that, with them, we see "the transformation of sculpture—from a static, idealized medium to a temporal and material one" by means of the idea of a "passage."[41] (If one needs confirmation of a link with Lin, Serra taught graduate courses at Yale when she was a student there.)[42] The art of Smithson, Serra, and Lin opens itself up to the experience of the visitor, who walks through it and takes in its unfolding views and retrospective realizations. It is the antithesis of the ideally autonomous object of traditional

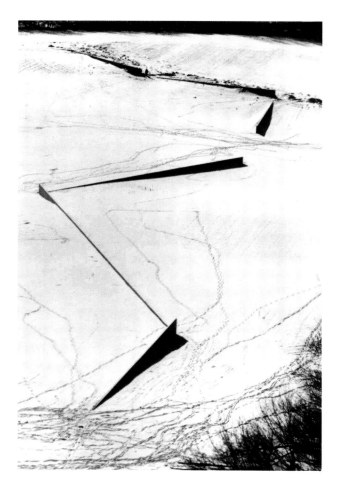

26
Richard Serra, *Shift*,
1970-72

sculpture. Its openness, I want to argue, makes it particularly receptive to affective response.

In an article called "The Revenants of Time," Jean Fisher comments on the Wall's connection with the time-based and interactive reception of Minimalism and opposes these strategies to an idealist form of Modernism: "Modernism's investment in the Ideal Object reflected its desire for a coherent subject. The tendency of the empirical and contingent self in the world towards dispersal and discontinuity—in effect, the specter of its own otherness, its death—could be forestalled by the elaboration of an ideal self in the contemplation of an Ideal Object."[43] While other writers have connected Minimalism with a postmodern deconstructive turn, Fisher recasts this idea in psychoanalytic terms to encompass the subject's encounter with death.

This may seem a tendentious reading of Minimalist and Post-Minimalist art of the 1960s and 1970s, especially in view of Anna Chave's unstinting attack on

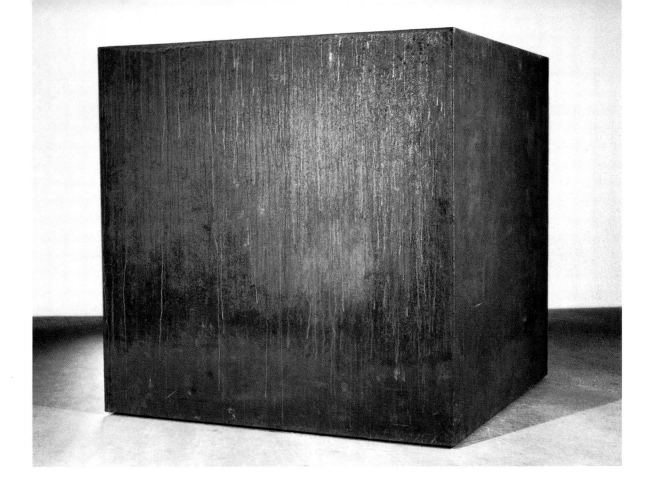

Minimalism as "the face of capital, the face of authority, the face of the father." In fact, Chave had some difficulty in reconciling her view of Minimalism with Lin's monument, and one commentator on it, deferring to Chave's "Minimalism and the Rhetoric of Power," describes Lin's work as only "superficially Minimalist." He concludes, "Lin's monument addressed the beholder, not with a rhetoric of exclusion and domination ... but with a rhetoric of inclusion and healing."[44] Chave tends to read Minimalist works not as reminders of our finitude, but as implied death threats. So, for example, Tony Smith's mausoleum-like black cube *Die* (1962) is described as "a bleak crypt presented to the viewer with succinct instructions to perish" (fig. 27).[45] It and the other works she attacks might more plausibly be interpreted as meditations on mortality in an era of U.S. history that was to be repeatedly traumatized by violent death. As we have seen, references to the death drive or Thanatos occur in the writings of Robert Morris and especially of Smithson.[46] Yet one does not want to ignore the implicit critique of high Minimalism in these artists' later work. In an interview, Serra spoke of his close relationship with Smithson and their mutual distrust of certain aspects of the work of Sol LeWitt and

Dan Flavin: "There was a presumption of didacticism, of authority. We felt that it left no room for doubt, no room for anxiety, no room for anything that would not substantiate a general proposition. We thought that closed systems were doomed to fail."[47] Lin's appropriation of Post-Minimalist sculpture picks up on its openness, doubt, and anxiety.

Mourning

I visited the Vietnam Veterans Memorial one wet February afternoon. Descending the ramp, I first noted with disbelief the thousands of densely packed names on the Wall. When the Wall reached eye level, my own and others' reflections rose up. At the low point of the passage, the joined walls towered over me, obliterating the horizon. As I slowly climbed up the opposite ramp, the trees and grass of the Mall again came into view. It was then that I started to cry. I puzzled for some time why, just at that point, I was suddenly overcome with sadness. Finally, I decided that it was because only then, emerging again into the world, did I realize that I had metaphorically passed through the valley of the shadow of death, without even knowing it. I emerged unscathed on the other side, while the shades stayed behind. I am sure that this retrospective realization of the meaning of the experience of the Wall heightened its emotional impact, miming as it does the delayed temporality of trauma. The catastrophe had already happened by the time I was able to represent it to myself.

I proposed at the outset of this chapter that the memorial was intended to serve two quite distinct purposes. Apart from being a site of mourning, it was intended to bring hostile and indifferent Americans to a realization of the sacrifice of life, limb, and mental health made by the soldiers and to share in the grief of the veterans. For us, the uncanny apparitions walking in the dim space behind the surface of the stone—ourselves among them—make loss real and connect us to the dead. If that is so, our experience is the antithesis of mourning. Mourning, according to Freud, is a slow process of undoing affective attachments: "Each single one of the memories and situations of expectancy which demonstrate the libido's attachment to the lost object is met by the verdict of reality that the object no longer exists; and the ego, confronted as it were with the question whether it shall share this fate, is persuaded by the sum of the narcissistic satisfactions it derives from being alive to sever its attachment to the object that has been abolished."[48] The function of the Wall, then, might be described as a kind of "anti-mourning." Instead of severing attachments, it establishes a cathexis by reopening an archaic psychic wound. We shall see in the following chapter that this is the same effect Roland Barthes noted when he described the shadow figures in old photographs as wounding. Unsuccessful mourning—melancholia—involves clinging to the object so closely that the ego becomes identified with it. One becomes the shadow of the lost love or, as Freud so eloquently put it, "the shadow of the object [falls] upon the ego."[49] The shadows on the Wall hint at what that feels like.

27
Tony Smith, *Die,* 1962

The reference above to Barthes's *Camera Lucida*, which is informed (as I shall argue in Chapter 7) by Lacan's *Four Fundamental Concepts*, points to another way of interpreting the appearance of the shadowy soldiers.[50] As we have seen, Lacan argued that our sense of a coherent ego requires that certain partial objects, originally thought of as part of the self, be cast out, ejected, abjected. These remainders of the real, which include intimations of mortality, are likely to return uncannily. This psychic mechanism has been adapted and redeployed by Slavoj Žižek in his analysis of the pathologies of political desire. In *The Sublime Object of Ideology,* Žižek proposes that "ideology designates a totality set on effacing the traces of its own impossibility."[51] Ideology, on this account, has the same structure as fantasy—a screen concealing the fundamental lack in being. Can anything penetrate this screen? Lacan's answer to this question is a reformulation of the Freudian conception of trauma, the missed encounter with the real.[52] The effect of the Wall on the viewer can be better understood by making use of Žižek's expanded sense of Lacan's model. Lin often commented on Americans' inability to face the reality of death: "We don't tell children about it. We say someone 'went away, passed away.' We don't admit it to ourselves. That's always disturbed me."[53] The death of so many young soldiers, she said, "was something we had just glossed over."[54] The abject dead soldiers of a lost war were, for many Americans, an unassimilable reality. An accident of history meant that the unveiling of the design for the memorial coincided with the election, in 1980, of President Ronald Reagan, whose declared mission was to make America feel good about itself again—that is, in Lacanian terms, to disguise the gap opened by the cast-out objects. Small wonder, then, that he was conspicuously absent at the memorial's dedication ceremony. Yet the abjected dead soldiers, remainders of the real, would come back in the form of an hallucinatory encounter in the Wall's dark mirror, troubling the ego-affirming image in the mirror of misrecognition held up by Reagan.

There is a danger that this newly found grief, the index of a rupture in the screen of fantasy, might set itself up as an adequate response to the war and its aftermath. As Gillian Rose warns, we are all too ready to oppose "our cherished good to public ills." It is tempting, she continues, "to see ourselves as suffering but good, and the city as evil."[55] She subtly refers to a passage in Hegel's *Phenomenology of Mind* about the "beautiful soul" who "lives in dread of staining the radiance of its inner being by action and existence." Sorrow-laden and pure, it is "an insubstantial and shadowy object."[56] Lin seems to have anticipated this danger. She designed the memorial to point beyond itself to the wider political sphere. "The angle was formed solely in relation to the Lincoln Memorial and Washington Monument," she declared, in order "to create a unity between the nation's past and present."[57] Some critics have argued that this gesture encourages one to historicize the Vietnam War in a way that defuses its critical power. Daniel Abramson, for example, complains that this

"remarkable ideological conceit" means that "these two icons of American history are given a new lease on life, revivified as the symbols which equilibrate the vertiginous trauma of the Vietnam War and bracket all attempts at historical understanding."[58] Other critics, such as Marita Sturken, read in its design an implicit critique of its neighbors. It is, she writes, "deliberately counter-pointed to the dominant memorials which surround it."[59] Both interpretations can be plausibly argued. What is crucial, however, is that the reference outward denies closure and raises questions about the relationship of the war to the entire history of the United States and its most cherished values, thereby preventing the short-circuited consolation of the beautiful soul.

But what about the veterans and bereaved relatives who come to the memorial? Certainly they do not want or need to reactivate a wound or encounter the real of their loss. I cannot speak so authoritatively about their experience, but my impression is that the names are important for them. They touch and make rubbings of the names and leave mementos near them. This tactility is another remarkable feature of the memorial. Sculpture, and especially monumental sculpture, normally exists in a space of ideality defined by an actual or notional plinth that separates it from other objects in the world. One is not encouraged to touch such an object. Part of the project of Minimalist and Post-Minimalist art, as we have seen, was to restore the object to the spectator's space and time. The traditional boundary between the spectator and the work was abolished. Lin astutely saw the appropriateness of this aesthetic for a site of mourning. As in a rite of mourning, people descend into the liminal space between the living and the dead, touch the names, and get close to the Wall as a preliminary for separation. These distraught mourners find consolation in the symbolization of their grief—the indelible letters sandblasted into the granite. They emerge better reconciled to the necessity of relinquishing the dead and, indeed, a measure of their own grief.

In this context, the reflective surface of the polished wall has another connotation. The mirror-like surface catches every passing person and cloud and so might be thought to figure consciousness. It is like the celluloid surface of Freud's "mystic writing-pad," which suggested to him, as he said, "the flickering-up and passing away of consciousness in the process of perception."[60] The indelible, opaque names correspond to the marks on the wax slab below, the equivalent of the pre- and unconscious that stores impressions and makes the clean, receptive slate of consciousness possible. The Wall, then, is a figuration of these two systems superimposed: perpetual memory held in active consciousness, a state analogous to that of a mourner whose thoughts are constantly preoccupied with the lost person. The Wall suggests itself as an object that will do some remembering for you, allowing you to take your leave. Perhaps the bereaved also take comfort from the ambiguous symbolics of the indelible scar in the landscape, which is simultaneously closure

and index of loss. A scar figures somewhere between the "ideal" closure of mourning as described by Freud, when all affective ties are finally severed, and the "open wound" of melancholia.[61]

We noted how, for Freud, melancholia involves clinging to the object so closely that the ego becomes identified with it. The ego introjects the object, and there it can be sequestered and punished for leaving. This inability to mourn is related to the hysteric's inability to forget. In the early "Five Lectures on Psychoanalysis," Freud compares the symptoms of hysterics, who "suffer from reminiscences," to a person unable to pass unfeelingly a monument to some long-forgotten disaster. Monuments are public "mnemic symbols" of traumatic experiences. Freud mentions two examples. Charing Cross, an ornate stone cross outside the railway station in London, is the last remaining memorial set up along the path of the cortege taking the coffin of the queen of a thirteenth-century Plantagenet king to Westminster. The Monument, a giant pillar in the City of London, was raised to commemorate the death and destruction wreaked by the Great Fire of London of 1666. Freud asks:

> But what should we think of a Londoner who paused today in deep melancholy before the memorial of Queen Eleanor's funeral instead of going about his business in the hurry that modern working conditions demand or instead of feeling joy over the youthful queen of his own heart? Or again what should we think of a Londoner who shed tears before the Monument that commemorates the reduction of his beloved metropolis to ashes although it has long since risen again in far greater brilliance? Yet every single hysteric and neurotic behaves like these two unpractical Londoners. Not only do they remember painful experiences of the remote past, but they still cling to them emotionally; they cannot get free of the past and for its sake they neglect what is real and immediate.[62]

Although this is intended as a metaphor to clarify the nature of neurosis to a general lecture audience, it does touch on the peculiarly ambivalent status of monuments, bulwarks against oblivion that eventually become, for the most part, invisible.[63] This ambivalence has been noted in recent controversies over the function of memorials: Do they serve as perpetual reminders of a traumatic loss, or do they help us mourn—and so forget?[64] In his book *Sites of Memory, Sites of Mourning,* Jay Winter eloquently argues for the necessity of the latter function. Rituals of separation, he writes, "are means of avoiding crushing melancholia, of passing through mourning, of separating from the dead and beginning to live again. Ritual here is a means of forgetting as much as commemoration and war memorials, with their material representation of names and losses, are there to help in the necessary art of forgetting."[65] The ancient monuments of London noted by Freud may be invisible, forgotten, but they are not

demolished. They are the physical traces of a particular past, and like the contents of the unconscious, they may still be effective even if forgotten.

The experiences elicited by the Vietnam Veterans Memorial and their role in the work of mourning raise important issues for aesthetics in general. Perhaps the most developed account of the connection between art and mourning can be found in the work of Melanie Klein, for whom all creative art is a form of mourning or "reparation" originally undertaken by the infant in the "depressive position," where the infant is wracked by guilt and full of fear of the reprisals expected as a consequence of his or her own infantile aggression.[66] The Kleinian analyst Hanna Segal, developing this theme, described art as "a narrow victory over Thanatos." In great art "the degree of denial of the death instinct is less than in other human activity. . . . There it is acknowledged as fully as it can be borne."[67] But Segal's account of art's victory over Thanatos is in terms of beautiful form triumphing over dreadful content: chaos and destruction represented in Greek tragedy, for example, is surmounted at the level of its perfect formal structure. This formulation seems to me wholly unsatisfactory. In his *Poetics,* Aristotle insists that it is precisely the very tightness and inevitability of the plot, its perfect formal structure, that heightens the powerful tragic emotions of pity and fear. Equally, in the case of the Vietnam Veterans Memorial, formal structure is what leads one on a passage through the valley of the shadow of death and out the other side.

The many connotations of the memorial, and its diverse aims of assisting both mourning and anti-mourning, are implicit in Maya Lin's design and suggested in her statements. Her synthesis of hypernominalist and aniconic World War I memorials and earthworks is inspired. Yet there is one aspect of the Wall that is deeply troubling and probably unintended: its evocation of impossible closure. I think that this accounts for a great deal of its haunting power. Lin's conception of a circular time line of names cannot possibly make the war seem complete, or finished; the shadowy soldiers will forever walk in the gloomy depths of the Wall. The "spectators," for their part, will continue to rehearse the passage though the valley "as they mediate, through their bodily movements, something uncloseable, which cannot simply be left."[68] In his essay on *Hamlet,* Lacan observed that ghosts appear "when someone's departure from this life has not been accompanied by the rites that it calls for."[69] Although Hamlet's father is biologically dead at the outset of the play, the settling of accounts for symbolic death were not observed, and so he returns as a dreadful apparition. Without ritual, "the system of signifiers proves inadequate to cope with the hole in existence," and, inversely, "the hole in the real that results from loss sets the signifier in motion." As a result, "a swarm of images" is projected. This is the situation of fetishism writ large: "This hole provides the place for the projection of the missing signifier, which is essential for the structure of the Other." Lacan interprets the ghost in *Hamlet* as just such a defensively projected signifier, functioning, as I have argued, like the Statue of Liberty in the 1980s. Ritual, like psychoanalysis, offers some

mediation. That is, it allows one to frame the lack within a symbolic structure that reconciles one to the inevitability of loss: "Ritual operates in such a way as to make this gap coincide with that greater *béance* [gap], the symbolic lack."[70]

In the case of the Vietnam War, as with the death of old Hamlet, none of the formalities was observed—undeclared and unresolved, it was a waste, a shame, and probably a crime that was followed by defeat, doubt, and guilt. There were neither parades nor any ceremonies of national recognition for surviving or dead soldiers. In the end, the veterans had to erect a memorial to themselves. The restless ghosts in the Wall eloquently testify to the specific character of that war and its lingering, painful aftermath. But the reflections, unlike old Hamlet's ghost, are not fetishistically projected compensations for loss. Rather, the negative space of the site of the Wall raises individual losses to the level of the symbolic and the social; here, people are encouraged to reflect on the limits of the nation's and their own structural coherence.

In my account of the Vietnam Veterans Memorial, I have stressed the idea of anti-mourning and the shadowy presence/absence of the reflections in the Wall. The idea of anti-mourning, however, was inspired by my reading of Barthes's *Camera Lucida*. In many ways, then, the themes of this chapter anticipate those of the next. The context of Barthes's book was partly given by the death of his mother and his search for a photograph of her that was "wounding." He wanted to find one that would keep his loss alive. Yet perhaps the act of writing the book was a way of symbolically marking her passing and letting her go.

7 The Real

What Is a Photograph?

Barthes's last book, *Camera Lucida* (1980), begins with the words "One day, quite some time ago," which clearly announce the book's status as a fiction, as art.[1] The central character is a scholar who, throwing off his academic robes—his whole culture, even—retires to his study, rather like Descartes, and meditates in the first person on photography. Or, more precisely, he meditates on his desire in relation to those photographs that somehow move him. These few instances furnish a bedrock of personal but irrefutable evidence from which he hopes to extrapolate the essence of photography in general. It is a lovely, alluring story; we want to believe it, but we ought not be completely taken in. Rather, we should ask why the book is written in this form. There are, no doubt, many answers to this question, chief among them being Barthes's avowed desire to write fiction. I propose that the book is a kind of fable about photography that, despite its apparent antitheoretical stance, was deeply influenced by the difficult, frequently impenetrable seminar given by Jacques Lacan in 1964 and published in English as *The Four Fundamental Concepts of Psycho-Analysis*. Lacan gave Barthes an inscribed copy of the book when it was published, and it survives, lightly annotated, in an archive in Paris.[2] Barthes's accessible little book effectively mediated Lacan's thinking about the real, and the function of the gaze as *objet petit a*, without too many overt references to Lacan. In this chapter, I set the two texts side by side, elucidating Lacan through

Barthes's reading of him and, conversely, interpreting *Camera Lucida* in the light of *The Four Fundamental Concepts.*

The dramatic opening gesture of eschewing all technical, semiological, sociological, and historical approaches to photography draws Barthes closer to the tradition of phenomenological description of lived experience. In fact, the book is dedicated to Jean-Paul Sartre and his *L'imaginaire*.[3] But Barthes adds something conspicuously lacking in that tradition: affect. His kind of phenomenology would be "steeped in desire, repulsion, nostalgia, euphoria" (*CL,* 21) and, I will argue, psychoanalytical through and through. *Camera Lucida* is in many ways a somber book, haunted as it is by the recent death of the author's mother (and, for us in retrospect, his own). It circles around the thought that the essence or specific character of photography is a "that-has-been"—a certificate of the presence of something that is past. A photograph weaves together presence and absence, present and past.[4] The nature of the medium as an indexical imprint of the object means that any photographed object or person has a ghostly, uncanny presence that might be likened to the return of the dead. Yet the title of the book is anything but somber. *La chambre claire,* its original French title, literally means "the light (or bright) room." It also refers, we are told, to a draughtsman's technical aid, quite unlike the dark chamber of the camera obscura, which projects an image onto paper by means of a prism (106). For those who have read the book, it might also evoke its key (though unreproduced) photograph of Barthes's mother as a child in a conservatory or winter garden.

The Real

The occasion for writing the book, according to the fiction, was given by the death of the mother and the son's melancholy search for her in a pile of old photographs. But its underlying theme is taken from Lacan's account of the encounter with the real, which is ultimately an encounter with the persistently denied fact of one's own mortality. Barthes declares that every photograph contains "an imperious sign of my future death" (*CL,* 97). Looking at an old photograph, one thinks simultaneously of a future, "he is going to die," and of an absolute past, "he has died" (96)—a recognition that collapses time and seals one's own fate. But Barthes develops this painful recognition from a negative into a positive, from dark to light, through Freud's conception of the death drive as mediated by Lacan.

The death drive is not something that had previously much concerned Barthes, although it might well be argued that his earlier aesthetics of *jouissance* or bliss in *The Pleasure of the Text* already carried something of that which is beyond the pleasure principle: "he enjoys the consistency of his selfhood (that is his pleasure) and seeks its loss (that is his bliss)."[5] The topography of instinctual drives developed by Freud in *Beyond the Pleasure Principle* sets the pleasure principle in opposition to the death drive.[6] As we have already noted, the first principle relates to the theory

enlargement, and so on) that "reveal secrets" opening up an "optical unconscious," just as the techniques of psychoanalysis reveal the instinctual unconscious. But do the stop-motion photographs of Eadweard Muybridge and Etienne-Jules Marey, or the enlarged plants of Karl Blossfeldt, give us insight into an unconscious dimension in anything like a Freudian sense? I doubt it. In her book *The Optical Unconscious,* Rosalind Krauss points out the difficulty of thinking of the visual field as having an unconscious in these terms, but she develops the idea in other ways.[20] When we understand, with Lacan, how the real appears in the visual field as the gaze, the difficulty unravels. In my view, this is what Barthes proposes in *Camera Lucida.*

Before moving on to consider the Lacanian conception of the gaze, we need to return to the psychoanalytic understanding of trauma and Barthes's appropriation of it. There is little point in pausing too long here, however, because the job has already been thoroughly done by Andrew Brown in his monograph, *Roland Barthes: The Figures of Writing,* which closes with a chapter simply called "The Trauma."[21] For Freud, the trauma is linked to what he termed the primal scene: the child witnesses or experiences something but is too young to comprehend its meaning. This unassimilable memory is preserved until, at a later date, another (perhaps innocuous) event occurs that recalls the first and floods it with sexual meaning. By a process of "deferred action," then, the childhood experience becomes traumatic. A good example of this process is given in Freud's case study known as "The Wolf Man."[22] The adult patient reported to Freud a frightening dream he had at five years old: wolves were sitting motionless in the branches of a tree outside his bedroom window, staring at him. Freud suggested that the impact of the dream was derived from a much earlier impression, although key aspects of that event are reversed and filtered through fairytale scenarios. As an infant he had woken and stared, transfixed, at a scene of violent motion—his parents copulating "in the manner of animals." The unconscious recollection of such a scene would have confirmed the reality of castration once that eventuality had become, with the onset of the Oedipus complex, a burning issue for the boy. The traumatic primal scene can hardly be said to have taken place, because the trauma lags so far behind the event. Lacan adds to this that the trauma is real in so far as it remains unsymbolizable—a kernel of nonsense at the heart of the subject. *Camera Lucida* is structured around the idea of the trauma. The recent death of the mother, we may suppose, had reactivated in Barthes the original wound of separation. In one of the fragments of *A Lover's Discourse,* he recalls his intense suffering as a child: "interminable days, abandoned days, when the mother was working away."[23] His search for her authentic photographic image, then, is tinged with this original bereavement.

As Brown rightly points out, there is a close connection between the theory of the trauma and the aesthetics of shock.[24] For Benjamin, traditional art was for the most part ego-sustaining; it kept its distance, and this constituted its aura. But now

28

David Octavius Hill and Robert Adamson, *Elizabeth Johnson, The Beauty of Newhaven,* c. 1844-48

that we are bombarded from all sides by the unassimilable shocks of modern life, our psyches require something beyond the pleasure principle. We subject ourselves to the shock effects of violent cinema images, for example, as a way of "binding" threatening stimuli and of building up a protective "crust" (Freud's terms). For instance, the short strip of amateur film that records John F. Kennedy's assassination or the video images of the attack on the World Trade Center are endlessly replayed to a nation unable to overcome its trauma. Yet it would be very misleading to assimilate the shock effects of Benjamin's anti-auratic art to Barthes's traumatic photographs. The sections of "Little History of Photography" that clearly attracted Barthes were those that dealt with auratic, early photography, with its atmospheric effect of "light struggling out of darkness."[25] Barthes seems interested in restoring the shock of precisely those portrait photographs. Photography is particularly susceptible to this treatment because, as Barthes points out, it has an inherently "traumatic" structure: I witness something in the past by "deferred action" (*CL*, 10). Brown draws attention to a passage from Freud's *Moses and Monotheism* that offers an analogy between photographic and psychic deferred action: the latter may be made "more comprehensible by comparing it with a photographic exposure which can be developed after any interval of time and transformed into a picture."[26] In order to assess what is distinctive about Barthes's notion of the traumatic photograph, we have to understand his theory of the punctum.

The first half of *Camera Lucida* is taken up with a discussion of the distinction Barthes makes between two fundamentally different types of interest we take in photography. The generalized interest, pleasure, or concern a photograph gives us indicates its possession of a studium. Photographs with a studium we judge "good." But in some photographs, there also lurks a detail, a punctum, which takes the viewer by surprise. It "pricks" him or her and completely alters the sense of the image. The detail does not prompt a reinterpretation that would subsume it dialectically and integrate it into the whole; it shares with the trauma, and Lacan's anamorphic stain, an uncoded, unassimilable quality. It is unnamable and, writes Barthes, "what I can name cannot really prick me. The incapacity to name is a good symptom of disturbance" (*CL*, 51). In a discussion of one photograph that has this lacerating detail for him, Barthes first lights on a woman's strapped shoes (43), and then, like an analysand working through screen memories toward the original trauma, he shifts to her necklace, which reminds him of one worn by his maiden aunt. It has been kept shut up in a jewelry box since the aunt's death (53). In her discussion of Barthes's argument, Jane Gallop emphasizes the way in which a photograph with only a studium stays within the confines of the picture. Its coherence is entirely internal. In contrast, the punctum breaks up that coherence, bursting through the frame and plane. As a consequence, the photograph endowed with a punctum has a "blind field," something equivalent to what is masked on the edges of the cin-

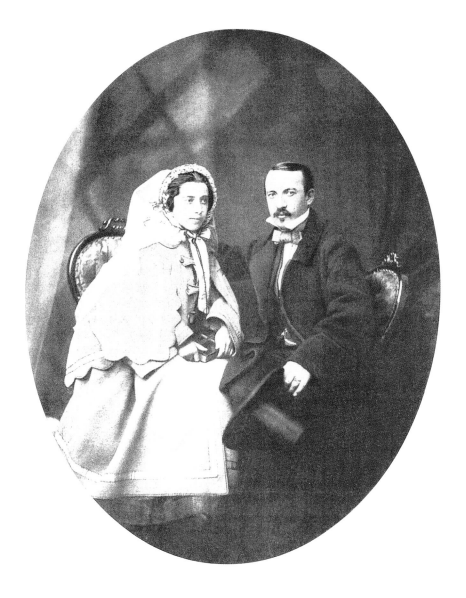

29

Karl Dauthendey,
*The Photographer
Karl Dauthendey
with his betrothed
Miss Friedrich after
their first atten-
dance at church,*
1857

ema image.[27] There is, then, a kind of symmetry between the photograph's and the subject's openness to alterity.[28]

Barthes's studium/punctum distinction recalls aspects of his earlier essay on stills from Sergei Eisenstein's films. In "The Third Meaning" (1970), he pointed to the presence in these stills of an "obtuse" meaning, one that exceeds the "obvious" signification of symbolism and narrative. Certain details "hold" or touch him, but without his being able to say why.[29] They remain mute signifiers and open onto the

field of *signifiance* as understood by Kristeva.[30] Although there may be some overlap between the obtuse meaning and the punctum, we should also be alerted to the difference between them by the fact that the concepts have exactly opposite connotations—blunt versus sharp. The saving bluntness of the third meaning, its ungraspable resistance to conceptual consumption, preserves the image from any fixity of interpretation. The sharpness of the punctum, on the other hand, cuts through the deliberate decorum of the pose and reactivates a trauma.

The Gaze

Barthes's opposition between the studium and the punctum of photographs can be further elucidated by reference to Lacan's critique, in *The Four Fundamental Concepts*, of classical optics and perspective construction. The critique is aimed at the idealist illusion of "seeing oneself seeing oneself" (*FFC*, 83), that is, the optical equivalent of the illusion of self-reflective consciousness ("I think, therefore I am"). More than once Lacan here acknowledges his indebtedness to Maurice Merleau-Ponty, particularly to a posthumous work that had just appeared, *The Visible and the Invisible* (1964). He makes specific reference to a chapter of that book called "The Intertwining—the Chiasm," where the philosopher is trying to show that our own corporeality, making us objects of sight in the world, is the necessary condition of our being subjects of sight.[31] While I look at things, I am looked at. My activity, then, is equally a passivity. Visual perception, tied to the body, is necessarily partial. As Lacan observes, "I see only from one point, but in my existence I am looked at from all sides" (72). Merleau-Ponty's reflections on vision helped Lacan formulate his sense of the necessary preexistence of the gaze, which, in a visual register, shows the subject not as an autonomous, rational subject, but as constituted by the desire of the Other. The subject is thus decentered in relation to any originary point of sight. It should be noted in this context that the traffic between the two thinkers was two-way: Merleau-Ponty used Lacan's 1949 essay on the mirror stage in formulating his conception of the "visible seer."

A key characteristic of our relation to the studium of a photograph is our confident self-possession: "I invest the field of the Studium with my sovereign consciousness" (*CL*, 26). This sort of perception conforms to geometral perspective, in which a single point of sight inaugurates and organizes the field. For Lacan, this system is the optical equivalent of the classical concept of consciousness formulated by Descartes. The Cartesian subject, he notes, "is itself a sort of geometral point" (*FFC*, 86). And, he urges, this conception of self-reflective consciousness is founded on a misrecognition, which in the visual register would be called a "scotoma"—that is, a blanking out of something that is traumatic. What is blanked out is, in either case, the fact that the subject is not just a subject of consciousness but also a subject of unconscious desire. This latter subject, who can only be heard in the lacunae of discourse, can only

be glimpsed in the gaze. My suggestion is that Barthes's punctum is equivalent to Lacan's gaze or, in other words, to that which is elided in classical optics. Because, as Lacan argues, desire is constituted by a lack (separation from the mother, symbolic castration), that lack as gaze inevitably looms up in the visual field and disorganizes it (89). The punctum, as we have seen, also reverses the direction of the lines of sight and disorganizes the visual field, irrupting into the network of signifiers that constitute "reality." Barthes writes, "This time it is not I who seek it out, it is this element which rises from the scene, shoots out of it like an arrow, and pierces me" (*CL*, 26).[32] The terms Barthes uses to describe this experience (prick, wound, hole) clearly suggest their relation to lack.

Lacan's discussion of anamorphosis, to which I alluded in my Introduction, serves to illustrate the disparity between one's position as sovereign subject of sight (studium) and as object of the gaze (or the punctum). From an orthodox position, the viewer of Holbein's *Ambassadors* shares their confidence and vanity; he is master of all he surveys. But something incomprehensible, a shadowy phallic shape, floats in the foreground. Only when one starts to leave the room, casting an oblique glance backward, does the shape resolve itself into a human skull: "It reflects our own nothingness, in the figure of the death's head" (*FFC*, 92). In other words, only when the position of illusory mastery is vacated does the gaze come into full view. The two positions are mutually exclusive: I gain the world of representation only when I sacrifice the immediacy of the real, and conversely, I glimpse the real only when I renounce the vanity of the world conceived as my representation. In the orthodox perceptual field there is, then, a blind spot, which Lacan calls the stain (*la tache*), defined, like the gaze, as "that which always escapes from the grasp of that form of vision that is satisfied with itself in imagining itself as consciousness" (*FFC*, 75). Barthes takes up this term in one of his definitions of the punctum: "For punctum is also sting, speck (*petite tache*), cut, little hole—and also a cast of the die. A photograph's punctum is the accident which pricks me."[33] This same "spot," it seems, also makes an appearance in a passage from the book *Working Space* (1986) by the American artist Frank Stella, helpfully cited by Malcolm Bowie: the painter "worries that there is something that he cannot see, something that is eluding him . . . a dark spot."[34] It would seem that this stain, or spot, must be approached indirectly, viewed awry, glancingly, without conscious deliberation. One requires visual equivalents of the strategies of indirection invented by Freud to approach the unconscious—dreams, free association, transference. As Lacan notes, "It is not, after all, for nothing that analysis is not carried out face to face" (78).

The gaze as spot or stain stresses the opacity and negativity of that which is both object and cause of the scopic drive. This contrasts with the transparency and fullness of vision normally associated with the imaginary register's specular mirroring of the ego.[35] The difference is attributable to the fact that the gaze does not represent

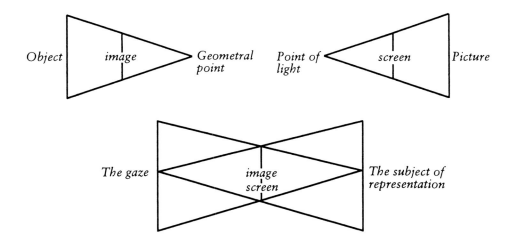

the ego, but rather gestures toward the unrepresentable subject. It reflects not the body image as idealized, coherent, and coordinated, but the subject as castrated and in the grip of desire.[36] In order to understand better the way in which this subject can be shown, we must return to a consideration of Lacan's formulation of the *objet petit a*. His account of the subject's constitution involves a series of painful self-alienations that are described almost as bodily auto-mutilations. One's very birth involves the casting off of a vital part of the organism, the placenta. Then one is weaned from the breast, understood by the infant as coextensive with its own body. One "gives up" urine and feces. Finally, symbolic castration seals one's fate as a desiring subject haunted by lack, retrospectively turning all the other infantile experiences of loss into forms of castration. In each case, a cut is made that initiates both an erotogenic zone (lips, rim of anus, tip of penis, slit of eyelids) and an object (nipple, feces, urinary flow, phallus as imaginary object, "the phoneme, the gaze, the voice—the nothing").[37] The "part objects" formed by the cut are the *objets*

petit a. Lacan argues, "The *objet a* is something from which the subject, in order to constitute itself, has separated itself off as organ. This serves as a symbol of lack, that is to say, of the phallus, not as such, but in so far as it is lacking" (*FFC,* 103). The gaze as *objet petit a* must refer to the lost parental gaze from which the infant so ardently sought recognition. Or, since entry into the symbolic order, the acquisition of language, involves a sacrifice of being for meaning, a residue of one's "pre-Oedipal" vision may emerge between the cracks in the symbolic as though from outside. These lost morsels of flesh, hollowed-out bits of one's being, play a critical role in Lacan's understanding of the subject's relation to the world. If not for them, we would be caught between the specular idealizations of the imaginary and the impersonal law of the symbolic.

Lacan's references to visual art in *The Four Fundamental Concepts* are mostly taken from the history of painting. He does mention photography once, however—admittedly in a context that indicates that we are not supposed to take his comment literally. Here, he insists on the externality of the gaze that has the effect of turning one into a picture: "What determines me, at the most profound level, in the visible, is the gaze that is outside. It is through the gaze that I enter light and it is from the gaze that I receive its effects. Hence it comes about that the gaze is the instrument through which light is embodied and through which—if you will allow me to use the word, as I often do, in a fragmented form—I am photo-graphed" (*FFC,* 106). If traditional optics can be represented by a triangular diagram showing an eye at the geometral point from which it views an image correlated to an object, then the geometral point is where the ego's eye is installed (fig. 30). It is essentially an Albertian model of representation transposed into a Kantian model of experience; phenomena are correlated with (unknowable) noumena. This is the story consciousness tells itself about vision. But the unconscious also sees. It throws its projected desires, fantasies, and fears onto a screen. The diagram of geometral perspective must be intersected accordingly, then, by an inverted triangle showing a point of light projecting a picture onto a screen. While the subject of representation is figured as a single point, from the perspective of the gaze (point of light), the subject is represented as the base of a triangle, anamorphically distorted and blurred. If the subject is to appear in the picture, it must be as a screen casting a shadow, creating a blind spot, a hole, in the passing spectacle.

Lacan insists that the point of light is outside: "In the scopic field, the gaze is outside, I am looked at, that is to say, I am a picture" (106). This insistence is consistent with Lacan's conception of the unconscious as an intersubjective relation (desire is the desire of the Other) and his view of the subject as radically split by the castrating intervention of the register of the symbolic. Lacan suggests that we can observe this fracturing even in the animal kingdom: in the phenomenon of display, an animal swells or grimaces, turning itself into a semblance to ward off its predator (107).

30
Diagrams from Jacques Lacan, *The Four Fundamental Concepts of Psycho-Analysis,* 1977

But this split can also be observed in animal camouflage. An insect, for example, can accommodate itself so well to its environment that it becomes invisible. Roger Caillois's 1935 essay on mimicry in the surrealist magazine *Minotaure*—and in *Méduse et Cie,* much admired by Lacan—proposed that this activity amounts to a kind of death drive in which the organism loses its integrity and is swallowed up by space. Lacan's double dihedral diagram is a modified version of one described by Caillois in "Mimicry and Legendary Psychasthenia," in which he discusses the dangerous "temptation by space" evidenced in mimicry. Caillois describes a diagram formed by the intersection of two dihedrals—a "dihedral of action," the vertical base of which is formed by a standing person, and a "dihedral of representation," whose base is set at the distance where the object appears. It becomes clear that the latter dimension of space carries the same force as Lacan's point of light, or gaze. In this space, writes Caillois, "the living creature, the organism, is no longer the origin of the coordinates, but one point among others." Further, "the feeling of personality, considered as the organism's feeling of distinction from its surroundings, of the connection between consciousness and a particular point in space, cannot fail in these conditions to be seriously undermined."[38]

The composite diagram of visuality, first proposed by Caillois, also makes clear the reversibility of the positions of object and subject produced by this intersubjectivity and splitting. Lacan illustrates this point with an amusing anecdote about his student days, when he joined working fishermen for the summer. One of the fishermen had pointed to a floating sardine can glinting in the sun and joked, "See that sardine can? Well, it doesn't see you!" But it did; Lacan has been photo-graphed and suddenly feels very ill at ease in the picture (*FFC,* 95). This reversal of subject and object is facilitated by the phenomenological fact that "I see outside," or, to put it another way, "perception is on the objects that it apprehends" (88).

Barthes often acknowledges this externality and passivity in relation to the punctum. We have already seen how, for him, "it fills the sight by force" (*CL,* 91). There is also a discussion, useful in this context, about posing in front of the camera. Posing involves putting on a look drawn from the repertoire of images: "I transform myself in advance into an image" (10). But then, suddenly, something intervenes, which shatters this ego-protecting shield. The shutter clicks and "I then experience a micro-version of death," the sound "breaking through the mortiferous layer of the pose" (14–15). Here is perhaps an example of an aural punctum finding a chink in the armor of the imaginary. If assuming the pose involves the negation of myself as unique subject, then this "micro-version of death" is paradoxically revivifying.[39]

Another discussion that bears on Lacan's sense of being photo-graphed comes when Barthes stresses the greater importance of chemistry for photography over that of its relation to the camera obscura, which, after all, it shares with painting.

The optical device does not fix the image. It is the magic of light-sensitive paper that gives the photograph its essential nature as a "that-has-been": "The photograph is literally an emanation of the referent. From a real body, which was there, proceed radiations which ultimately touch me, who am here. . . . A sort of umbilical cord links the body of the photographed thing to my gaze: light, though impalpable, is here a carnal medium, a skin I share with anyone who has been photographed" (*CL*, 80–81). This passage also connects with the chapter in Lacan's book called "The Line and Light." Here again geometral optics is the target of criticism, but now its inadequacy as a theory of vision is attributed to the fact that what it calls rays of light can easily be figured as threads or sticks. It is really a spatial mapping that even a blind person could comprehend, and so it would seem to miss entirely what is essential about vision. As Krauss points out, Lacan juxtaposes a tactile visuality that is palpably obvious and easily mastered with an optical visuality, or "atmospheric surround," in which the viewer, no longer a surveyor, is "caught within the onrush of light."[40] As Lacan observes, "Light may travel in a straight line, but it is refracted, diffused, it floods, it fills—the eye is a sort of bowl—it flows over, too" (*FFC*, 94). What both Lacan and Barthes wish to express is the chiasm of vision. I may see objects, but I am also enveloped by a light or gaze that unsettles the position I want to occupy as the source of the coordinates of sight.

Tame or Mad?

In the chapters called "The Line and Light" and "What Is a Picture?" Lacan broaches the question of the function of art from the point of view of psychoanalysis. The artist, he says, wants to present himself as subject, as gaze—and the gaze is there, even in paintings with no pair of eyes, in what we call style. There is "something so specific to each of the painters that you will feel the presence of the gaze" (*FFC*, 101). If, as I have suggested, the *objet petit a* is that (missing) morsel of one's being outside of symbolic matrixes and public images, then it follows that the *objet petit a* as gaze would inhere in that individuality of style. Lacan also considers the function of art from the spectator's side. Painting, he says, is an opportunity "to lay down one's gaze," and he calls this effect the *dompte-regard,* the tamed gaze. He adds, "This is the pacifying, Apollonian, effect of painting" (101). Art offers something for the eye, and it gives the spectator a sense of mastery in relation to the visual field and a sublimated pleasure that compensates for instinctual renunciation (111). Yet, he continues, there is a whole field of painting—Expressionist, for example—that answers the scopic drive. It offers something for the gaze. The difference between these two functions is illustrated by the retelling of the classical tale of the competition between Zeuxis and Parrhasios. Zeuxis deceived the eye of a bird that flew down to peck on his painted grapes, but Parrhasios, in reply, painted a veil that incited Zeuxis to ask, "What have you painted behind it?" For Lacan, the latter is the true case of *trompe l'oeil*—a triumph of the

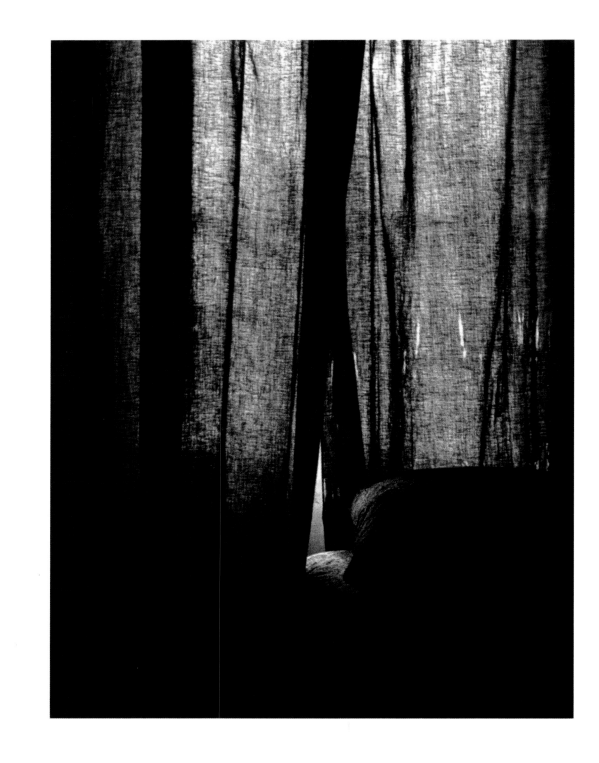

gaze over the eye (103, 111–12). The veil animates the desire of the viewer, and its full effect is only felt when one realizes that nothing lies behind it.[41]

Do *dompte-regard* and *trompe l'oeil* correspond to what Barthes calls tame and mad receptions of photography? I think so, but with the difference that Lacan seems to accept the legitimacy or psychic value of both functions. Barthes challenges us to choose between two incompatible possibilities, tame or mad: "Such are the two ways of the Photograph. The choice is mine: to subject its spectacle to the civilized code of perfect illusions, or to confront in it the wakening of intractable reality" (*CL*, 119). These are the last lines of the book. A retrospective glance through the plates reminds one that the frontispiece (fig. 31) reproduces a strange color photograph of an interior, showing only thin curtains drawn against a brilliant light.[42]

31

Daniel Boudinet, *Polaroid*, 1979

8 Conclusion

After *Camera Lucida*

I decided to arrange the chapters of this book in roughly chronological order, although I did consider starting with "What Is a Photograph?" and working backwards. This alternative arrangement had the merit of tracking the actual development of my thinking on the subject of aesthetics beyond pleasure. Reading *Camera Lucida* had persuaded me to question a structuralist or semiological understanding of the image as a concatenation of signs and to explore further Barthes's idea of the photograph as an encounter with the indexical trace of a past reality, a "that-has-been." I then discovered that a key source for the concept of the photographic punctum was Lacan's discussion of the anamorphic stain in his Seminar XI of 1964, and I was led from there to Lacan's association with the Surrealists in the 1930s. Of course, Freud's *Beyond the Pleasure Principle* and "The 'Uncanny'" of circa 1920 form the background to this whole tradition. While I decided not to present a retrospective history, it is nonetheless fair to say that I have read this material through the prism of *Camera Lucida*.

Although I began my inquiry with a text devoted to photography as a specific medium, I saw no reason why the lessons learned there could not be generalized. That is, I thought I could extract from *Camera Lucida* the basis of an aesthetic beyond the pleasure principle unfettered by Barthes's exclusive attention to photography. But again and again, as I worked on the book, photography as a medium or metaphor

returned. For example, I found that the cropped photographic framing of Hopper's paintings and their "film still" suspended narratives produced an acute sense of spatial and temporal blind fields. The idea of the simulacral image and its relation to the photograph arose in connection with Dalí's attempt to give his paintings the reality effect of color photography. Breton's found objects were presented photographically in *Mad Love,* together with a conception of the photograph as a precipitate of reality. What emerged from my study of *Spiral Jetty* was the importance of the relation of its filmic and photographic forms to the lost object of the earthwork. And my reading of Maya Lin's design for the Vietnam Veterans Memorial related it to the dominant theme in *Camera Lucida* of anti-mourning: the shadowy revenants reflected in the Wall create a missed encounter with the real, very like Barthes's encounter with the winter garden photograph of his lost mother. I now realize that photography was destined to return in the context of my thinking not just because it was implicit in my starting point but, more important, because photography is not an isolated medium. Rather, photography has changed the whole configuration of the visual arts and our thinking about them. Rosalind Krauss gives Walter Benjamin credit for this thought. In his "Work of Art in the Age of Its Technological Reproducibility," Benjamin treated photography not as a medium but as a "theoretical object" that, along with Dada, film montage, and the readymade, has had certain cultural effects.[1] One of those cultural effects, I will argue, is a structural ambivalence in art theory and practice between regarding visual imagery as simulacral or real.

Camera Lucida was undoubtedly the most important study of photography as a theoretical object to have appeared since 1936—that is, since the publication of Walter Benjamin's Artwork essay. And in some ways it is a delayed response. If Benjamin showed how photographic reproduction has the power to turn the unique into the similar by extracting the work from its protective, auratic shell, then Barthes stressed its indexical relation to the particular. As we saw in the last chapter, he did so partly by reviving those moments in Benjamin's writing where he conceived of the possibility of an auratic aesthetic experience, demystified and shorn of its association with social privilege, even in the land of standardized technological reproduction.[2] Benjamin and Barthes established the terms of a dialectic that now inevitably colors our thinking not just about photography but about all forms of visual art. Barthes described the nature of his study as "ontological": "I wanted to learn at all costs what photography was 'in itself,' by what essential feature it was to be distinguished from the community of images" (*CL,* 3). On its face, then, it is an emphatically medium-specific study. Yet photography can no longer be understood as a distinct medium. Rather, it must be seen as a key term in the system of the visual arts, and so the ideas elaborated by Barthes are not exclusively relevant to photography.[3] In Chapter 7, I argued that the real value of *Camera Lucida* lies not in its excavating "the essential nature of photography" but in its communicating to a large audience a particular

idea of our fascination with the image that was formulated by Lacan in *The Four Fundamental Concepts*. I now want to inquire into the implications of Barthes's intervention for art theory and practice. Published in 1980, *Camera Lucida* both signaled and effected a crucial change in our thinking about photography and visual art more generally.

We have seen how Barthes opened his book by summarily dismissing sociology, semiotics, and psychoanalysis as "reductive systems." But this post-structuralist body of theory is negatively present in the text as the foil against which he produced an alternative approach. Indeed, the book targets precisely the thinness and transparency of post-structuralist theories of both image and subject. Lacan's idea of the traumatic real, figured as *objet petit a*, was adapted by Barthes to restore to both the photographic image and the subject a degree of density or opacity. Strangely, photography is the paradigmatic medium of both moments in the history I am going to outline—that is, both before and after *Camera Lucida*. First, photography appears as the medium of the depthless simulacrum, and then, thanks to Barthes, as the privileged site of the return of the real.

This conjunction of the phrases "depthless simulacrum" and "return of the real" will recall Hal Foster's important rereading of Andy Warhol's Death in America series, from the early 1960s, in terms of what he calls "traumatic realism."[4] Foster argues that the competing views of Warhol's work—as pure simulacrum, on the one hand, and referential document of the ills of late capitalist civilization, on the other—can be reconciled. For Foster, Warhol's work suggests a shocked subjectivity. The work repeats a traumatic image in order to defend against the real by draining it of significance, but the real nevertheless pokes through in the form of a repeated galling detail or technical flaw that Foster compares to Barthes's punctum. Repetition in the first instance signals the present impossibility of what Benjamin called "experience," which involves a weaving of past and present; instead, we depend on an automatic defensive reflex in which consciousness parries the blows to prevent their leaving the permanent trace of trauma. Similarly, Foster argues that Warhol's use of the commodity and mass-produced sign should be interpreted as a "mimetic defense." The second form of repetition, the technical flaw, breaks through the numbing shield of consciousness and touches the real.[5] I will first prize apart these moments before returning to Warhol's ingenious synthesis.

The radical difference between these two conceptions of the photograph, which I am calling the simulacral and the traumatic, can best be appreciated by setting them in relation to the Lacanian models of the subject's relation to the image, which I introduced in Chapter 1: the mirror and the anamorphosis. In this concluding chapter, I return to these two Lacanian figures. This time I articulate them with a pair of terms more familiar in art theory and practice—the simulacrum and the traumatic real.

Simulacrum

As we saw in the Introduction, the received view of Lacan's mirror stage is that the ego's stability is an illusion originally precipitated by the impression of bodily coherence that a small child sees reflected back to him- or herself in the mirror. He identifies with another, an ideal-I, who is more coordinated and spatially coherent, and this becomes the template for all future objectifications and identifications. Obviously, a ready-made theory of the subject's relation to photography nestles in this account, even if the spatial image it returns is delayed rather than instantaneous. (As we have seen, it is just that delay that makes all the difference, crossing the photograph with absence and loss.) But film theorists influenced by the French Marxist philosopher Louis Althusser first appropriated Lacan's mirror stage for a critique of cinema. In the latter half of the Sixties, Althusser drew political theorists' attention to the potential of Lacan's formulation of the mirror stage for understanding the workings of ideology.[6] He argued that the subject of ideology assumes an imaginary identity of one who is autonomous, the origin of his own actions. Ideology fosters the same illusory ideal as the mirror: "The 'obviousness' that you and I are subjects . . . is an ideological effect."[7] Film theorists then developed what had been a rather insignificant part of Althusser's political theory into an elaborate account of the role that images in popular culture play in the formation of subjects. The idea of a specular "misrecognition" inaugurated by the mirror stage gave a psychoanalytic underpinning to their critique of the image and of Hollywood cinema in particular.

Two French film theorists were primarily responsible for this transposition. Jean-Louis Baudry published "Ideological Effects of the Basic Cinematic Apparatus" in 1970. Although there is no mention of Althusser in the text, the use of the term "apparatus" (*l'appareil*) in the title alludes to Althusser's article from the same year on "Ideology and Ideological State Apparatuses." There are, however, several references in it to Lacan and the mirror stage. Interestingly, Baudry founds his critique of the cinematic apparatus on its inheritance of Quattrocento perspective construction, which, he says, constitutes a viewing subject as center and origin of meaning.[8] Cinematic camera movement only serves to augment this feeling of power and control. Yet like the helpless infant in thrall to the mirror image, the fascinated viewer of cinema is physically immobilized. For Baudry, though, the spectator identifies less with what is represented on the screen than with the apparatus that stages the spectacle. The crucial illusion that cinema fosters is that of a "transcendental subject." Just as the mirror assembled the fragmented and uncoordinated body in an imaginary unity, the imaginary transcendental self of cinema unites the discontinuous fragments of film into a unifying meaning. Baudry closes the essay with a hymn of praise to an early example of counter-cinema, Dziga Vertov's *Man with a Movie Camera* (1929), in which "both specular tranquility and the assurance of one's own identity collapse simultaneously with the revealing of the mechanism, that is, of the inscription of the

film work."[9] The film theorist Christian Metz is the other key figure in the cultural transmission of Lacan and Althusser. "The Imaginary Signifier," published in French in 1975 and translated in *Screen* the same year, saw the mirror stage as the model for later cinematic identifications. The mirror, he wrote, "alienates man in his own reflection and makes him the double of his double."[10] Although Metz pays some attention to the spectator's identification with figures on the screen, he also claims that the most powerful identification is with the look of the camera—the "all-perceiving" other. In this way the cinematic apparatus gives the spectator an illusion of perceptual mastery.[11]

This model of a subject's captivation by the image underpinned much film and art theory in the 1970s. As an antidote to these fascinating images dispensed mainly by popular culture, an avant-garde practice was promoted that would impede perception and fracture the illusion of an autonomous ego precipitated and reinforced by the image. Structuralist-materialist film aimed to eliminate the spectator's imaginary relation to the film.[12] Distancing strategies—which looked back to the artistic strategies of the avant-garde and the theories of the Russian Formalists and Bertolt Brecht—often took the form of a textual overlay that, in effect, set up a symbolic screen as protection against the lure of the imaginary. This accorded with Lacan's view that psychoanalysis must intervene at the level of the symbolic in order to shift imaginary fixations. Film theorists looked admiringly to the example of early avant-garde painting. Peter Wollen, for instance, noted how Cubism achieved an epistemological break with illusionist representational practices by foregrounding and pointing to its own semiotic constructions. Ironically, art practice of the 1970s, some of it directly influenced by film theory, reintroduced the imaginary register of popular imagery so that it could then be critiqued. I believe this is one of the conditions that favored the rise of so-called appropriation art in the late 1970s and 1980s. Although this moment of film theory recommended an avant-garde, anti-realist aesthetic, its actual effect on art practice was a revival of mass-cultural imagery. Cindy Sherman, Barbara Kruger, Richard Prince, and Laurie Anderson were among those artists who critically appropriated media imagery. Their work, however, was more inflected by an earlier generation of Conceptual Art than by Pop.

Cindy Sherman's Untitled Film Stills series is unusual in that a critical discourse apparently tailored to the work was in place before it appeared. Laura Mulvey's "Visual Pleasure and Narrative Cinema," which introduced gender difference and the ideology of patriarchy to Althusserian film theory, was published in 1975.[13] She argued that the cinematic illusion of specular mastery was part of a masculine regime of "looking" that was dominant in our culture and was dependent on, as well as troubled by, the image of woman. By making this move, Mulvey added to the general apparatus theory an account of psychic investments in various kinds of imagery (identification with an idealized like, scopophilia and fetishism in relation to the

showgirl, voyeurism and sadism toward the *femme fatale*). But she also stressed how the "cinema builds the way she is to be looked at into the spectacle itself." In other words, "cinematic codes create a gaze."[14]

Sherman's Film Noir series and the Film Stills were initiated in 1976–77 (fig. 32). Her work (which seems to have developed independently of the concurrent theoretical trends) and the work of her contemporaries recycled movie and advertising imagery. Appropriation art provided an ideal object for the critical deployment of a set of concepts given currency by the prestige of film theory: identification and objectification, the male gaze and the female spectator, identity and masquerade. The apparent ready-made fit of feminist film discourse with her work accounts in some measure for Sherman's success: her work became a "theoretical object." She pushed the debate around these issues further, however, by implicitly raising questions not addressed by Mulvey about the female artist's agency and the position of the female spectator.

Of course, Sherman's Film Stills series is not the equivalent of Hollywood film. It parodically weaves together references to a range of Hollywood and New Wave films that perform an auto-critique. Her photographs are simulacra of film stills, masks

of femininity that invite, undercut, and sometimes repel the identification of the spectator. The photographs mime other photographs, creating an infinite regress of simulacra.[15] As Douglas Crimp put it in his "Pictures" essay of 1979, "underneath each picture is always another picture."[16] In a subsequent essay, "The Photographic Activity of Postmodernism" (1980), Crimp elaborates on this infinite regress: "Her photographs show that the supposed autonomous and unitary self . . . is nothing other than a discontinuous series of representations, copies, fakes. . . . For though Sherman is literally self-created in these works, she is created in the image of already known stereotypes. . . . [Her photographs] show the self as an imaginary construct."[17]

From Crimp's point of view, the work signals the long-overdue demise of idealist ideologies of the autonomous self—and of the artist as sole origin of the artwork.[18] Krauss agrees that the characters in the Film Stills are only "a concatenation of signifiers . . . making 'her' a pure function of framing, lighting, distance, camera angle."[19] Amelia Jones, tracing the history of body art, places Sherman in the context of the younger generation of artists set on undermining the authentic bodily self projected by performance art of the 1960s and 1970s. These artists project instead a "simulacral self, where ironic disillusionment replaces the self-proclaimed belief in 'authenticity.'"[20] The Film Stills are most often understood as a compression of a cultural stereotype together with its critique (in a manner subtler than Barbara Kruger's work of the same period, for example). As Krauss puts it, myth, in Barthes's sense, "is what Sherman is analyzing and projecting."[21] Sherman repeatedly demonstrates the artificial confection that is "the woman" in cinema. The value of appropriation art, according to this line of argument, is that it shows us that identity is really only an identity effect, just as reality is actually a reality effect. From another point of view, however, this kind of work stages photography's utter depletion and implies a conception of the self as thin and lifeless as a paper doll.[22]

In their determination to dispose of the "autonomous and unitary self," Crimp and other critics of this period seem to have jettisoned the subject altogether. Lacan's model of the ego as an illusory palimpsest of identifications appears to be the only conception of the self on offer. In a curious reversal, spurred on mainly by Derrida's critique of the metaphysics of presence, the simulacral self (as modeled by Cindy Sherman) became the epitome of postmodern subjecthood. But does the decentering of the subject necessitate its abolition? Throughout his career, Lacan insisted that there was something about the subject not captured in the articulations of language or a series of imaginary captivations. The allusions in his early writings to personality and to the style of the subject, noted in the chapter on Dalí, attest to this, as does the following remark from Seminar III, *The Psychoses:* "There is, in effect, something radically unassimilable to the signifier. It's quite simply the subject's singular existence."[23] The philosopher Peter Dews has stressed this aspect of Lacan's thought against those who would enlist him in the post-structuralist project of dismantling

32
Cindy Sherman,
*Untitled Film Still
#2,* 1978

the unique subject. He writes: "The introduction of object a at the end of the 1950s was indeed the result of Lacan's growing realization that something fundamental to the subject cannot be expressed by the collectively shared, and thus universal, 'treasure of the signifier.'"[24]

Dews is at pains to point out that although Lacan often figures this object in terms of the brute contingency of trauma or death, it also features as the stake in an intersubjective relation, that is, as the object of the other's desire: it is that unspecifiable part of the subject, *objet petit a,* that is desired by the other. That is, the lover cherishes what in the other makes him or her a unique being. Dews contrasts the two kinds of "other" encountered in Lacan's work in terms that parallel the difference between the simulacral and traumatic works of art: "The imaginary other, as support of the ego, is characterized by arbitrariness and reproducibility, whereas the object a is a paradoxical, unique, specified object."[25] Yet, since *objet petit a* cannot become an object of consciousness and is unspecularizable, it is not susceptible to the criticism that it revives a nostalgia for lost immediacy or presence. Treading carefully, Malcolm Bowie remarks that with the introduction of *objet petit a,* Lacan allowed "the ghost of referentiality to regain admission to his scheme."[26]

The relevance of this philosophy of the self for art theory is clear. Just as we seek this elusive object (stain or punctum) in every self-representation as an indicator of our unique being, so we also seek it in the work of art as a marker of its irreducible singularity. Postmodernists, following on Duchamp, Pop Art, and post-structuralist theory (including Barthes's own important text "The Death of the Author" of 1968), used every artistic means at their disposal to demonstrate the fallacies of the singularity, originality, and inexhaustible richness of the work of art.[27] This was seen as politically imperative, partly because traditional notions of artistic "genius" encouraged the illusion of absolute personal autonomy and partly because the aura of the work of art was so prone to exploitation by the art market. But the critics would soon discover that the commodity form's lack of aura, which appropriation art mimicked, is just as easily exploited.

The high-water mark of the first phase of post-structuralism in France was 1968. After the near revolution on the streets of Paris, the question of what it is that rebels against social structures had to be addressed. At that time, writes Dews, discourse itself began "to be seen as patterned and disrupted by non-discursive forms."[28] This new concern prompted a reassessment of the work of Merleau-Ponty, a philosopher who always attended to the pressure of an extradiscursive reality on discourse. "Merleau-Ponty sought the "primordial silence" beneath the chatter of words and to "describe the action which breaks the silence."[29] He understood that action as a gesture, as a movement closely bound to the body. The influence of this notion on Barthes's art theory can be seen in essays on André Masson and Cy Twombly (1973, 1979), where Barthes emphasized how the trace of the gesture in their work points

back to the unique body of the artist.[30] By 1980, the year *Camera Lucida* was published, Barthes had turned to Lacan to support his revised conception of the artwork. In the same year he published an article on Pop Art, "That Old Thing, Art . . . ," in which he claimed that Pop's attempted evacuations—of meaning, of artistry, of the subject—all make unexpected returns: "However much pop art has depersonalized the world, platitudinized objects, dehumanized images, replaced traditional craftsmanship of the canvas by machinery, some 'subject' remains. What subject? The one who looks."[31]

The Traumatic Real

The other Lacanian figure that, as I have argued, distills a certain conception of the subject's relation to the image is the anamorphic stain in the foreground of Holbein's *Ambassadors*—or, more accurately, the juxtaposition of the ambassadors' composed world with an incomprehensible smear. The spectator's satisfaction in the painting is troubled by a blind spot. It is as though, with this second figure, Lacan wanted to draw attention to the precariousness of the imaginary domain and to reveal its underside. In *The Four Fundamental Concepts*, he, too, found support in certain aspects of Merleau-Ponty's phenomenology of perception, especially the idea of the chiasm of vision that makes the viewer always an object of sight.[32] Despite this suggestive analysis of the scopic field, post-structuralist art theorists largely ignored Lacan's stress on the real residue of this splitting. Only after a lengthy process of critical dissemination of *The Four Fundamental Concepts* and its mediation in *Camera Lucida* did a different way of thinking about the subject's relation to the image finally emerge.[33] This striking image of the anamorphic death's head has its counterpart in Barthes's book: the unreproduced photograph of his mother as a child, together with the thought that she is going to die, and has died already.

In the preceding chapter, we saw how Barthes invented the idea of the traumatic photograph with one hand in the pages of Lacan's book. Lacan's anamorphic stain inspired the notion of the wounding punctum of a photograph, and they function in exactly the same way—agitating and muddying the clear waters of the narcissistic imaginary. Because film and photography theory were at the cutting edge of post-structuralist cultural theory, it is perhaps not coincidental that Barthes's critique of it took up photography. His invocation of André Bazin's ontology of film, a key target of post-structuralist film theory, also indicates the object of his critique. Against the idea of photography as thoroughly cultural, coded, and conventional, Barthes noted Bazin's comparisons of photography with the shroud of Turin or the fly in amber.[34] But as we have seen, Barthes's position is more complicated than this simple opposition of culture and nature would suggest.

A British film theorist, caught up in contemporary experimental film practice and familiar with both film and psychoanalytic theory in France, made the first hesi-

tant gesture in the direction of anamorphic art theory, I believe.[35] In "Narrative Space" (1976), Stephen Heath made explicit reference to anamorphosis and to Holbein's *Ambassadors,* but curiously, he did not cite *The Four Fundamental Concepts.*[36] The piece begins with a brilliant analysis of a sequence from Hitchcock's *Suspicion* (1941) that, I suggest, is the cinematic equivalent of Lacan's description of the spectator's experience of the *Ambassadors.* Two police officers, ambassadors of the law, visit Lina's home to report to her the murder of a friend. The news heightens her growing suspicion of her husband's probity. The *mise-en-scène* is dominated by a portrait of her authoritarian father, General MacKinlaw, in uniform, and by the deep recessional space of the grand entrance hall. The event takes place in the space of classical perspective and the complex narrative space of cinema. But there is a disturbance within this otherwise homogenous space; another painting, to the side, catches the attention of one of the officers, nearly pulling him out of the frame. It is a cubist-style still life, itself a challenge to orthodox perspectival space. This pull of a peripheral and, within the narrative, useless painting points to the artifice of the dominant space's organization, and it suggests, to Heath, the possibility of "another scene, another story, another space."[37] Heath does not relate this otherness to trauma or Lacan's *objet petit a,* but he does stress the way in which the constant binding of the spectator within cinema's narrative space forecloses something outside of its coherent address: "heterogeneity, contradiction, history."[38] Heath contrasts this binding and the pleasure associated with it with a transgressive impulse disrupting the codes.[39] In *Suspicion,* this fleeting moment of disruption is quickly smoothed over, and this is Heath's point: classical film works to contain anything potentially disruptive. Nevertheless, by highlighting this moment, the film can be seen to reflect on the precariousness of its narrative space. Heath's "Narrative Space" gives us a glimpse of a theory of art beyond pleasure. Moreover, his analysis makes anamorphosis its key figure.

By the early 1980s, the tide was starting to turn in art practice as well. At this point, Cindy Sherman apparently left the imaginary behind and delved into its excluded other (fig. 33). Like a female Dorian Gray, her image became more and more grotesque. In her excellent article on Sherman's work, Mulvey traces this development, but she reads it as if it were an individual artistic trajectory rather than a cultural turn: "The female body's metamorphoses, in Sherman's 'narrative trajectory,' traces a collapse of surface."[40] On Mulvey's account, around 1980, Sherman made a transition from critically recycling the simulacra of femininity to rendering the real of castration and death. The fetishized femininity projected in the Film Stills is a fantasy screen covering over the wound that men project onto the woman's body when this screen is lifted. Within patriarchal culture, "woman" is made to represent death, castration, abject substance. And because of this projected "iconography of misogyny," she is also forced to paper over her body with a cosmetic façade—a smooth surface—and turn herself into a picture. Rosalind Krauss's survey of Sherman's work,

33
Cindy Sherman,
Untitled #168, 1987

although written in explicit opposition to Mulvey's, traces a similar trajectory. Krauss replaces Mulvey's psychoanalytic pair of terms, fetishism/abjection, with terms referring to regimes of representation, simulacrum/*informe,* on the grounds that they are less susceptible to consumption as stable, naturalized signifieds. This shift, unfortunately, also severs the work from any connection with representations of femininity.[41] Writing in the same volume, Norman Bryson sees Sherman's later work as symptomatic of the disappearance of the body under the accretion of codes of representation characteristic of her early work: "Once the world is declared to have become representation, and the real drops out of the system, the cultural sphere should be at peace, orbiting in the serene spaces of virtual reality. But the surprising consequence of the conversion of reality into spectacle is its obverse: a tremendous sensitivity to the real, an acute awareness of the moments when the virtual reality is disturbed, when it comes up against and hits that which it has notionally expelled from the system."[42]

Comparing the Film Stills with Sherman's series of photographs "after" paintings, Bryson notes the "effortless mimesis of the film stills": "The sitter seems entirely, and 'serenely' composed of social stereotypes. This was the postmodern subject, a tissue of quotations, a complete elision of image and identity. By contrast, the historical portraits show 'idealization's price': the rejection, the abjection, of actual flesh from the system."[43] Despite the radical change noted by all commentators in the content of her work, Sherman's procedure remains, in many respects, remarkably constant.

Although her subject matter has turned toward the abjected real, she continues to photograph staged *tableaux vivants*. As a result, her images lack the essential "that-has-been" character of Barthes's ideal of photography. They hold up simulacra of horror and disgust derived from horror films, pornography, and surrealist art, but their self-conscious use of quotation and overall artifice make them, for me, pictures without a punctum.[44]

Photography in the Post-Medium Age

I have argued that photography was the paradigmatic medium, as a "theoretical object," during both the simulacral and traumatic moments of this history—first as the space of the depthless simulacrum, and then as the site of the return of the real. The simulacrum emphasized photography's subversion of the outmoded values of uniqueness and originality. The return of the real foregrounded photography's indexical nature and traumatic quality.[45] Yet simulacra need not be photographic (as, for instance, Jeff Koons's *oeuvre* demonstrates), and art in media other than photography can have the qualities that Barthes ascribed exclusively to photography. Barthes mobilized the idea of the indexical trace in order to give back to the photographic sign some opacity, density, or thickness. But, as he rightly observed, not all photographs preserve an indexical character. At the close of *Camera Lucida,* Barthes railed against the stereotypical repertoire of photographic images that surrounds us: when generalized, the image "completely de-realizes the human world of conflicts and desires" (118).[46] He reflects sadly on the inevitable banalization of the photograph in a society where they come so thin and fast that none can have the special force he values. With an apparent glance sideways at Baudrillard, he describes the United States as a society so dominated by images that the relation of image to subject is reversed; people tailor themselves to the stereotypical image repertoire. Yet in this very passage, Barthes parenthetically praises Robert Mapplethorpe's photographic *tableaux vivants* of the stereotypes of sadomasochistic eroticism, indicating another way around the image repertoire that might also provide an alternative interpretation of Sherman's later work.

The absorption of the subject in the image, described by Barthes, is what Lacan called "imaginary capture." In his discussion of it, Lacan alluded to Roger Caillois's observations in *The Mask of the Medusa* (1960). The patterns on some insects, such as the ocelli on butterfly wings, hypnotize and frighten their small bird predators. The birds become the objects of a sightless gaze.[47] All creatures are subject to this fascination, but, Lacan notes, only the human subject evades being completely caught up in it. Rather, "He maps himself in it. How? In so far as he isolates the function of the screen and plays with it. Man, in effect, knows how to play with the mask as that beyond which there is the gaze. The screen is here as a locus of mediation" (*FFC,* 107). The screen in Lacan's topology of vision is interposed between the gaze and the

subject. It has been interpreted by Kaja Silverman, Hal Foster, and others as the cultural image repertoire. Foster writes: "I understand it to refer to the cultural reserve of which each image is one instance. Call it the conventions of art, the schemata of representation, the codes of visual culture, the screen mediates the object-gaze for the subject, but it also protects the subject from this object-gaze."[48] In a similar vein, Silverman suggests that "playing with the screen," or mask, has political implications for those "attempts at a collective self-redefinition which rely upon masquerade, parody, inversion and bricolage."[49] Both interpretations suggest that playing with the screen involves an art practice that manipulates conventions or stereotypes in order to denaturalize them and so heighten our awareness of them.

But I think Lacan had something stranger in mind. The idea of playing with a screen, or mask, occurs in Caillois's text as well.[50] While Caillois made connections between the animal and human kingdoms, he also set them in opposition. The key difference is the domination of animals and insects by immediate instinctual response, as opposed to humans' imaginative capacity. We live in "a world where the individual has acquired the power to refuse immediate and blind response to a mechanical stimulus. Instinct does not act except through the interposed image." The interposed image is a fantasy, a frightening imago or "hereditary myth." By instinct, writes Caillois, the female praying mantis devours her mate after copulation. Humans are released from the automatism of the insect, but stories of dangerous, cannibalistic females persist: "the terror released by this dark fantasy replaced an implacable and fatal reflex." Or again, men are not hypnotized by ocelli, but nevertheless harbor a belief in the evil eye and paint giant ocelli on their boats or shields. For Caillois, the waning of instinct leaves behind a shadow "world of obsessive dreams and stubborn fears." These dark fantasies and their representation in cultural forms reach back to an archaic, instinctual life, but also point forward to one of resistance, control, and freedom. Caillois concludes: "For the last time I maintain that there is an opposition between the insect world and man's: on the one hand the 'mask,' immovable, formed for all time in the morphology of the species, and on the other, the fragile, external and movable simulacrum used by the officiant to cover his face at the celebration."[51]

In sum, man "introduced a little play into the rigid machinery."[52] If Lacan was following Caillois's lead, then playing with the screen might have something to do with the manipulation of mass-cultural stereotypes, but more exactly involves the production of simulacra as a defense against unconscious automatism. He writes, "The being breaks up, in an extraordinary way, between its being and its semblance, between its self and that paper tiger it shows to others" (*FFC*, 109).[53] Seen in the perspective of Caillois's anthropological *longue durée,* the de-realizing effect of the simulacrum is our salvation. The mask may be terrifying, but as Caillois said, "it is only an image, an external representation, that can be struggled against, modified

or driven out."[54] Rather than being trapped like the bird in the ocelli's sightless gaze and paralyzed by fear, we produce semblances of what we dread that serve to shield us. Cindy Sherman's later work and much of Dalí's seem to me to catalogue these simultaneously frightening and salutary simulacra.[55]

Yet even if this interpretation is correct, Lacan still primarily envisages intercepting imaginary capture, as we have seen, via the missed encounter with the real. Barthes also emphasized this latter strategy, calling for a photographic practice—or perhaps an art practice more generally—that cuts through the generalized image repertoire, the de-realizing simulacra, to touch the real normally excluded from cultural forms. The photographer is called upon to "mediate the real." The camera lens is here imagined as an eye wide open, without the buffer against shock that we call consciousness.[56] The indexical character of the medium, the light-sensitive paper rather than the lens, is emphasized. But there is an alternative strategy to "mediating the real" that might be called "working the simulacrum." This involves a great deal of artifice, and it approaches, or indeed becomes, painting. The artist starts with some depleted mass-cultural image, a photographic readymade, and folds it in on itself with irony, exaggeration, repetition, or flaws, until it has some density and opacity. I would put Sherman's earlier work in this category, as well as Andy Warhol's (which, as we saw when discussing Hal Foster's interpretation of the Death in America series, is based on the photographic readymade but crossed with the accidental, yet unique, tear or punctum).

It is important not to lose sight of the motive that drives this effort to restore the signifier's opacity. In *Camera Lucida,* Barthes remarks that most photographs have "difficulty in existing"; they are banal. He cites a passage from Sartre's *Psychology of Imagination,* where this sentiment is expressed: "Newspaper photographs can very well 'say nothing to me.' In other words, I look at them without assuming a posture of existence."[57] For Sartre, what is required in this case is a spontaneous act of imaginative consciousness: "We become aware, somehow, of *animating* the photo, of lending it life in order to make an image of it."[58] Barthes echoed the idea of animating the photograph, but he inverted it. He stressed the way certain photographs pricked an unconscious nerve and so animated him and his response. "By the mark of *something* the photograph is no longer 'anything whatever,'" he wrote (*CL,* 49).

I want to close with a few reflections on some non-photographic practices that mediate the absent real. These involve indexical procedures without light-sensitive paper. Rachel Whiteread's casts have been extensively discussed in these terms. We noted in Chapter 2 that, as with photography, the presence of the cast of an interior space implies the absence—or, more precisely, the destruction—of the object that formed the mold. Although he does not invoke *Camera Lucida,* Benjamin Buchloh has written about the sculpture of the Mexican artist Gabriel Orozco in terms of an

indexical art practice resisting the simulacrum. The situation is complicated for Orozco by the fact that the metropolitan centers of art in the United States and Europe turn to the art of developing countries to provide an alternative to their own "now generally governing principles of simulation and political instrumentalization of artistic practices." We desire "silent objects" in order to restore the "opacity of the signifier." He continues, "Typical of the desire to establish an opaque, irreducible and indivisible material experience with artistic means is the recurrence of the indexical procedure, an operation that claims the material trace as strictly non-transcendable, as a pure material causality."[59]

Orozco's challenge is to respond to this need without being relegated to the position of a primitive other or negating the specificity of his Mexican cultural formation. Buchloh's analysis of *Mis manos son mi corazón* (*My Hands Are My Heart*) from 1991 illustrates how the artist manages this. Orozco squeezed a lump of brick clay in his hands, making a negative imprint of his fingers (fig. 34). The resulting heart-shaped object simultaneously makes reference to late-1960s casts of body parts, such as Bruce Nauman's, and to a specifically Latin American iconography

of the heart. By crossing these heterogeneous traditions, he cancels out the susceptibility for mystification latent in both. Even more pertinent for my argument is his *Pedra que cede* (*The Yielding Stone)*. Orozco formed a ball of soft, gray plasticine and then rolled it through the streets to collect whatever fragments and marks it encountered. As Buchloh says, this is an example of "transforming a surface into a purely passive receptacle of merely accidental pictorial and indexical marks."[60] Buchloh does not explicitly connect this practice to photography, but the suggestion is there.[61]

Mary Kelly is typically incisive in her thinking about the issues around photography, simulation, indexicality, and trauma that I have raised here. The photo-positives of articles of clothing that make up part of her monumental work *Interim, Part ɪ: Corpus* (1984–85) document a ready-made image repertoire of femininity—leather jacket, summer dress, black negligee, soulful boots, and so on (fig. 35). We are in the realm of the automatism of fashion and mimicry.[62] But the "imaginary capture" implied here is undercut by the fact that they are photographs of Kelly's own clothes, which, particularly in the case of the leather jacket and shoes, bear the indexical marks and folds of long use. They are thereby partially redeemed from the domain of fashion and become traces of a personal style.[63] In her more recent work, indexicality is more prominent. The curious gray waves of *Mea Culpa* (1999) that festoon the walls of the gallery turn out, on closer inspection, to be repeated modules of compacted lint carefully harvested from her tumble dryer (fig. 36). In effect, she turned the machine into a primitive printmaking device, using it to "silk-screen," with a dark load of laundry, tersely written short stories of torture and atrocity around the globe. Fragments of news reports and images of distant disasters are transmitted into our homes as we do the laundry. The lint residue suggests some soft, vulnerable substance in which the traumatic information is filtered and inscribed. The work attempts to give "mediatized," de-realized news stories the texture of the real—a soft monument. There is no photography in *Mea Culpa,* but it invokes photography's two-sided cultural significance: its digitalized ubiquity in the total information world, and its precious residue of a "that-has-been."

I began by stressing the radical difference between the simulacral and real as models of the photographic image. Yet we have seen in this chapter cases where they come into close proximity—in the work of Warhol, Sherman, and Kelly, for example. We are thus led to consider the possibility that these are not freestanding concepts, but rather ones that can only be understood in relation to one another. We have encountered this kind of conceptual proximity, or dependence, before. In Chapter 2, we noted that the familiar, conventional, or banal provides the scene for the emergence of uncanny strangeness. This is so because the "familiar" is constituted by the repression of childhood traumatic experience or the real of unconscious fantasy. In other

MENACÉ

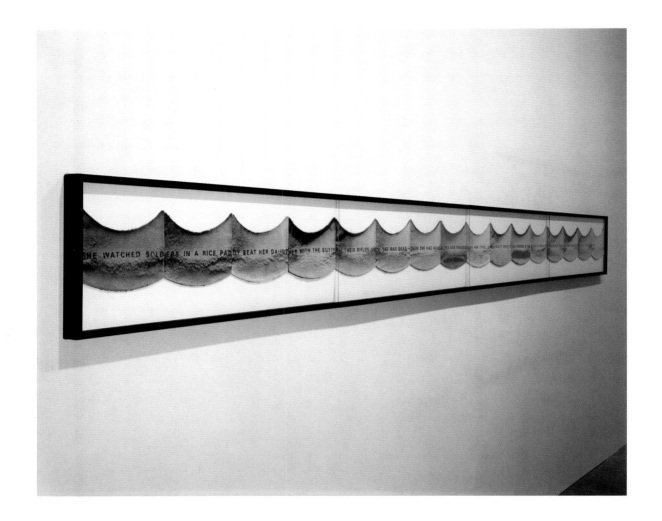

words, what is familiar must inevitably have a simulacral quality, because the real has been expelled. David Lynch beautifully demonstrated this mutual dependence in his film *Blue Velvet* (1986). The white-picket-fenced world of Lumberton, shown in the opening sequence, has such stereotypical clarity that one's gaze slides right off the image, unable to get any purchase.[64] Lynch makes it very clear that the bourgeois residential area has this two-dimensional simulacral quality precisely because reality (here, a criminal underworld) has been marginalized, banished to the other side of the tracks. The nearly indecipherable close-up of the severed ear, crawling with ants, discovered by the protagonist, Jeffrey, functions like an anamorphic stain, forcing him to shift his perspective and investigate the town's excluded other.[65] Lynch intends this geographical division and proximity as a model of the conscious mind's relation to the unconscious. Or, to exchange this Freudian topography for a Laca-

nian model, the ego's imaginary sense of coherence and control is constituted and sustained by the expulsion of whatever does not fit the picture. There is an intrinsic connection, then, between simulacral surface or masquerade and uncanniness.[66] This is why Lacan insists that reality is marginal (*FFC*, 90). In an article called "The Index and the Uncanny," Laura Mulvey implicitly confirms the interdependence of the simulacral and the indexical when she suggests that the current revival of interest in photography's indexicality is related to the development of digital photographic technologies. Mulvey concludes that the uncanniness of the photograph has to do with its "resurrection" of the dead and its apparently uncoded emanation of the real.[67] But because the uncanny is founded on ambivalence, it would be fairer to say that the photograph is uncanny because we know that its simulacral familiarity is so easily broken by a troubling irruption of the real.

36
Detail (*Beirut 1982*) of Mary Kelly, *Mea Culpa*, 1999

Notes

Chapter 1

1. Immanuel Kant, *Critique of Judgment,* trans. Werner S. Pluhar (Indianapolis: Hackett, 1997), 25.245. For an introductory account of this book, see Eva Schaper, "Taste, Sublimity, and Genius: The Aesthetics of Nature and Art," in *The Cambridge Companion to Kant,* ed. Paul Guyer (Cambridge: Cambridge University Press, 1992), 367–93.

2. Immanuel Kant, *Critique of Practical Reason,* trans. Lewis White Beck (Indianapolis: Hackett, 1956), 161–62. There has been a recent revival of the discourse of the beautiful. See especially Thierry de Duve, *Kant After Duchamp* (Cambridge: MIT Press, 1996); Jeremy Gilbert-Rolfe, *Beauty and the Contemporary Sublime* (New York: Allworth Press, 1999); Elaine Scarry, *On Beauty and Being Just* (London: Duckworth, 2000); and Bill Beckly and David Schapiro, *Uncontrollable Beauty: Towards a New Aesthetics* (New York: Allworth Press, 1998).

3. See Thomas Puttfarken, "Aristotle, Titian, and Tragic Painting," in *Art and Thought,* ed. Dana Arnold and Margaret Iversen (Oxford: Blackwell, 2003), 9–27.

4. In *Civilization and Its Discontents* (1930 [1929]), Freud says that aesthetics has failed to explain the nature and origin of beauty, and that it hides this failure "beneath a flood of resounding and empty words." In Sigmund Freud, *The Standard Edition of the Complete Psychological Works of Sigmund Freud,* trans. James Strachey (London: The Hogarth Press, 1953–74), 21:82–83. Hereafter this edition is referred to as *Standard Edition.* The date in square brackets refers to the date on the manuscript, rather than the publication date.

5. Sigmund Freud, "Formulations on the Two Principles of Mental Functioning" (1911), in *Standard Edition,* 12:215–26. There is a long editorial footnote about these complications in Freud, "Instincts and Their Vicissitudes" (1915), in *Standard Edition,* 14:21. Also very helpful, for all the technical terms, is Jean Laplanche and J.-B. Pontalis, *The Language of Psychoanalysis* (London: The Hogarth Press, 1980).

6. Jean Laplanche, *Life and Death in Psychoanalysis,* trans. Jeffrey Mehlman (Baltimore: Johns Hopkins University Press, 1976), 116ff.

7. See Freud's discussion of Dora's *tussis nervosa* in Sigmund Freud, "Fragment of an Analysis of a Case of Hysteria" (1905 [1901]), in *Standard Edition,* 7:7–122.

8. See Sigmund Freud, "Psychopathic Characters on the Stage" (1942 [1905 or 1906]), in *Standard Edition,* 7:308–10.

9. See Sigmund Freud, *Three Essays on the Theory of Sexuality* (1905), in *Standard Edition,* 7:125–34.

10. Jean Laplanche writes, "Sublimation thus forestalls the formation of symptoms arising from repression." See "To Situate Sublimation," *October* 28 (Spring 1984): 21.

11. Sigmund Freud, "Leonardo da Vinci and a Memory of His Childhood" (1910), in *Standard Edition,* 11:57–137 (also in the Pelican Freud Library, vol. 14, *Art and Literature* [Harmondsworth: Penguin, 1985], 143–232). For useful commentaries, see Sarah Kofman, *The Childhood of Art: An Interpretation of Freud's Aesthetics,* trans. Winifred Woodhull (New York: Columbia University Press, 1988), chap. 4; Laurie Schneider Adams, *Art and Psychoanalysis* (New York: HarperCollins, 1993), chap. 2; Meyer Schapiro, "Leonardo and Freud: An Art Historical Study," *Journal of the History of Ideas* 17, no. 2 (1956): 147–78. Introduc-

tions to Freudian psychoanalysis and art abound. To mention a few more: Jack Spector, *The Aesthetics of Freud: A Study in Psychoanalysis and Art* (New York: McGraw-Hill, 1974); Mary Matthews Gedo, *Psychoanalytic Perspectives on Art,* 3 vols. (Hillsdale, N.J.: Analytic Press, 1985–88); and Ellen Handler Spitz, *Art and Psyche: A Study in Psychology and Aesthetics* (New Haven: Yale University Press, 1985).

12. Freud, *Civilization and Its Discontents,* 57–145.

13. For an interesting defense of Freud, see Steven Z. Levine, "Between Art History and Psychoanalysis: I/eyeing Monet with Freud and Lacan," in *The Subjects of Art History: Historical Objects in Contemporary Perspective,* ed. M. Cheetham, M. Holly, and K. Moxey (Cambridge: Cambridge University Press, 1998), 197–212.

14. See, for example, "'Civilized' Sexual Morality" (1908), in *Standard Edition,* 9:189ff.

15. Rosalind Krauss, *The Optical Unconscious* (Cambridge: MIT Press, 1993), 243ff. See Hubert Damisch, *The Judgment of Paris,* trans. John Goodman (Chicago: University of Chicago Press, 1996), for a robust defense of Freud's view that beauty is a sublimation of erotic interest. Other writers have been developing Lacan's notion of sublimation, which ties it closely to the death drive. See especially Parveen Adams, ed., *Art: Sublimation or Symptom* (London: Karnac, 2003), and Joan Copjec, *Imagine There's No Woman: Ethics and Sublimation* (Cambridge: MIT Press, 2002).

16. Yve-Alain Bois and Rosalind Krauss, *Formless: A User's Guide* (Cambridge: MIT Press, 1997).

17. See the editorial introduction to Sigmund Freud, *Beyond the Pleasure Principle* (1920), in *Standard Edition,* 18:164. (*Beyond the Pleasure Principle* is also in the Pelican Freud Library, vol. 11, *On Metapsychology* [Harmondsworth: Penguin, 1984], 269–338.)

18. Cathy Caruth, *Unclaimed Experience in Trauma, Narrative, and History* (Baltimore: Johns Hopkins University Press, 1996), 62.

19. Freud, *Beyond the Pleasure Principle,* 292.

20. Sigmund Freud, "The 'Uncanny'" (1919), in *Standard Edition,* 17:217–52.

21. Jacques Lacan, *The Four Fundamental Concepts of Psycho-Analysis,* ed. Jacques-Alain Miller, trans. Alan Sheridan (Harmondsworth: Penguin, 1977). This work is a translation of *Les quatre concepts fondamentaux de la psychanalyse* (Paris: Seuil, 1973), the published version of Lacan's Seminar XI, delivered in 1964.

22. In the fields of art theory and criticism, see Douglas Crimp, "Pictures," *October* 8 (Spring 1979); Crimp, "The Photographic Activity of Postmodernism," *October* 15 (Winter 1980): 99; and Rosalind Krauss, "A Note on Photography and the Simulacral," *October* 31 (Winter 1984): 49–68.

23. See Jean Baudrillard, "The Precession of Simulacra," in *Simulations,* trans. Paul Foss, Paul Patton, and Philip Beitchman (New York: Semiotext[e], 1983); Gilles Deleuze, "Plato and the Simulacrum," *October* 27 (Winter 1983): 45–56; and Deleuze, *The Logic of Sense,* trans. Mark Lester with Charles Stivale, ed. Constantin V. Boundes (London: Athlone Press, 1989). *Simulacres et simulation* was originally published in 1981; *Logique du sens,* in 1969.

24. Slavoj Žižek, *Looking Awry: An Introduction to Jacques Lacan Through Popular Culture* (Cambridge: MIT Press, 1991); Krauss, *The Optical Unconscious;* Hal Foster, *Compulsive Beauty* (Cambridge: MIT Press, 1993); Foster, *The Return of the Real* (Cambridge: MIT Press, 1996); Parveen Adams, *The Emptiness of the Image: Psychoanalysis and Sexual Differences* (London: Routledge, 1996); Briony Fer, *On Abstract Art* (New Haven: Yale University Press, 1997); and Fer, *The Infinite Line: Re-making Art After Modernism* (New Haven: Yale University Press, 2004).

25. See Jacques Lacan, "The Mirror Stage as Formative of the Function of the I as Revealed in Psychoanalytic Experience" (1949), in *Écrits: A Selection,* trans. Alan Sheridan (London: Tavistock Publications, 1977), 1–7.

26. Ibid., 1–2.

27. Mikkel Borch-Jacobsen, *Lacan: The Absolute Master,* trans. Douglas Brick (Stanford: Stanford University Press, 1991), 46.

28. For Lacan, the entry into the symbolic order coincides with the resolution of the Oedipus crisis, when the paternal prohibition of incest with the mother is internalized and symbolic castration is accepted.

29. I owe this formulation to Alenka Zupančič, "Philosophers' Blind Man's Bluff," in *Gaze and Voice as Love Objects,* ed. Renata Salecl and Slavoj Žižek (Durham, N.C.: Duke University Press, 1996), 32–58.

30. Louis Althusser, "Ideology and Ideological State Apparatuses" (1970) and "Freud and Lacan" (1964), in *Essays on Ideology* (London: Verso, 1984). See also Paul Hirst, "Althusser's Theory of Ideology," *Economy and Society* 5 (November 1976): 385–412. Some important texts for the development of psychoanalytic film theory are *Communications* 23 (1975), the special issue titled "Cinéma et psychanalyse"; Teresa de Lauretis and Stephen Heath, eds., *The Cinematic Apparatus* (London: Macmillan, 1980);

Christian Metz, *Psychoanalysis and Cinema: The Imaginary Signifier* (London: Macmillan, 1982); Jean-Louis Baudry, "Ideological Effects of the Basic Cinematographic Apparatus," in *Narrative, Apparatus, Ideology: A Film Reader,* ed. Philip Rose (New York: Columbia University Press, 1986); and Laura Mulvey, "Visual Pleasure and Narrative Cinema" (1975), in *Visual and Other Pleasures* (London: Macmillan, 1989). For a useful anthology, see Mary Ann Doane, Patricia Mellencamp, and Linda Williams, eds., *Re-vision: Essays in Feminist Film Theory* (Frederick, Md.: University Publications of America, 1984). Margaret Iversen, "The Discourse of Perspective in the Twentieth Century: Panofsky, Lacan, Damisch," *Oxford Art Journal* 28, no. 2 (2005): 191–202.

31. See Chapter 8 for a more detailed discussion of this topic.

32. References to treatises on perspective from Alberti to Panofsky can be found in contributions to *Cahiers du cinéma* in the 1970s. See the excellent volumes of translated essays from this journal published by Routledge and the British Film Institute (London: Routledge and Kegan Paul with the British Film Institute, 1985–2000).

33. Lacan, "Some Reflections on the Ego," *International Journal of Psychoanalysis* 34 (1953): 22, 15. Lacan's term *corps morcelé* (15) is given here as "body in bits and pieces."

34. Ibid., 12.

35. See Michael Baxandall, *Painting and Experience in Fifteenth-Century Italy* (Oxford: Clarendon Press, 1972).

36. Lacan, *The Four Fundamental Concepts,* 81.

37. Lacan, "The Mirror Stage," 4. Norman Bryson follows through the logic of Lacan's essay when he describes the objectifying effect of Albertian per-

spective construction. Whereas prior to this moment, Bryson writes, "the body was never individually interpellated and never saw itself, Albertian space returns the body to itself in its own image, as a measurable, visible, objectified unit." And following Barthes on the effect of having one's photograph taken, Bryson calls it "the transformation of the subject into an object." Hence the uncanniness. Bryson, *Vision and Painting: The Logic of the Gaze* (Basingstoke: Macmillan, 1983), 106–7. Hubert Damisch understands perspective in terms of Lacan's symbolic order in *The Origin of Perspective* (Cambridge: MIT Press, 1994). See also Victor Burgin, "Geometry and Abjection," in *Abjection, Melancholia, and Love: The Work of Julia Kristeva,* ed. John Fletcher and Andrew Benjamin (London: Routledge, 1990), 104–23.

38. Mulvey, "Visual Pleasure and Narrative Cinema." See Mary Kelly, *Imaging Desire* (Cambridge: MIT Press, 1996), and Margaret Iversen, Douglas Crimp, and Homi K. Bhabha, eds., *Mary Kelly* (London: Phaidon, 1998). I discuss Sherman's work in Chapter 8 of this book.

39. Jacques Lacan, *The Seminar of Jacques Lacan, Book II: The Ego in Freud's Theory and in the Technique of Psychoanalysis, 1954–1955,* ed. Jacques-Alain Miller, trans. Sylvana Tomaselli (Cambridge: Cambridge University Press, 1988), 57. Originally published as *Le séminaire, livre II: Le moi dans la théorie de Freud et dans le technique de la psychanalyse, 1954–1955* (Paris: Seuil, 1978).

40. Jacqueline Rose, "The Imaginary," in *Sexuality in the Field of Vision* (London: Verso, 1986), 167–98.

41. Joan Copjec, "The Orthopsychic Subject: Film Theory and the Reception of Lacan" (1989), in *Read My Desire: Lacan Against the Historicists* (Cam-

bridge: MIT Press, 1994). See my chapter on Dalí, Lacan, and paranoia for a full account of the ambivalence of the mirror image.

42. See Lacan's Ph.D. dissertation on paranoia, *De la psychose paranoïaque dans ses rapports avec la personnalité, suivi de Premiers écrits sur la paranoïa* (1932; repr., Paris: Seuil, 1980).

43. See Lacan, *The Four Fundamental Concepts,* 79–90, 92.

44. Lacan, *The Seminar of Jacques Lacan, Book VII: The Ethics of Psychoanalysis, 1959–1960,* ed. Jacques-Alain Miller, trans. Dennis Porter (Cambridge: Cambridge University Press, 1992), 136.

45. Ibid., 140.

46. For introductions to this concept, see Dylan Evans, ed., *An Introductory Dictionary of Lacanian Psychoanalysis* (London: Routledge, 1966), and Žižek, *Looking Awry.*

47. The primal scene is the child's interpretation of the parents' sexual intercourse, which is often construed as violent.

48. Lacan, *The Ethics of Psychoanalysis,* 135.

49. Ibid., 273.

50. Ibid., 248.

51. See Luke Thurston, "Meaning on Trial: Sublimation and *The Reader,*" in *Art: Sublimation or Symptom,* ed. Adams, 42. Other essays in this volume are also relevant.

52. See Slavoj Žižek, *Enjoy Your Symptom! Jacques Lacan in Hollywood and Out,* rev. ed. (London: Routledge, 2001), 49. For a discussion of the many readings of *Antigone,* including Lacan's, see Judith Butler, *Antigone's Claim* (Cambridge: Cambridge University Press, 2000).

53. Lacan, *The Ethics of Psychoanalysis,* 141.

Chapter 2

1. See especially *Rachel Whiteread: Shedding Life,* exh. cat., Tate Gallery Liverpool (New York: Thames and Hudson, [1997]); Briony Fer, "Postscript: Vision and Blindness," in *On Abstract Art,* 153–68, and Fer, "Treading Blindly, or the Excessive Presence of the Object," *Art History* 20, no. 2 (1997): 268–87. Additional sources are cited below.

2. Trevor Fairbrother, "Ghost," *Parkett* 42 (1994): 91. See also David Batchelor, "A Strange Familiarity," in *Rachel Whiteread: Plaster Sculpture* (London: Karsten Schubert Gallery, 1993).

3. Freud, "The 'Uncanny,'" 220 (also in the Pelican Freud Library, vol. 14, *Art and Literature,* 335–76). The rather appropriate scare quotes around "uncanny" in the title were added by the English translator, who clearly had some misgivings about the exactness of the translation from the German *unheimlich.* See also the new translation of "The Uncanny" in *The Uncanny,* trans. David McLintock (London: Penguin, 2003), 121–62.

4. Mike Kelley, *The Uncanny,* exh. cat., Tate Gallery Liverpool and Museum Moderner Kunst Stiftung Ludwig Wien (Cologne: Verlag der Buchhandlung Walther König, 2004), 9–12. First published in Kelley, *The Uncanny,* exh. cat., Gemeentemuseum Arnhem (Arnhem, The Netherlands: Gemeentemuseum, 1993).

5. Relevant to this characterization is Jacques-Alain Miller's discussion of the Lacanian category of *extimité* in *Lacanian Theory of Discourse,* ed. Mark Bracher et al. (New York: New York University Press, 1994), especially where he notes that "the most intimate is not a point of transparency but a point of opacity" (76).

6. Rachel Whiteread in conversation with Iwona Blazwick, in *Rachel Whiteread* (Eindhoven: Van Abbemuseum, 1992–93), 8, 11. Note her use of the word "familiar."

7. See, for example, Neville Wakefield, "Separation Anxiety and the Art of Release," *Parkett* 42 (1994): 81.

8. See especially Krauss, *The Optical Unconscious,* and Foster, *Compulsive Beauty.*

9. Kelley, *The Uncanny.* See, in that volume, Mike Kelley's "New Introduction to *The Uncanny*" (9–12) and "Playing with Dead Things: On the Uncanny" (24–38) as well as John C. Welchman, "On the Uncanny in Visual Culture," 39–56, and Christoph Grunenberg, "Life in a Dead Circus: The Spectacle of the Real," 57–64.

10. Anthony Vidler, *The Architectural Uncanny: Essays in the Modern Unhomely* (Cambridge: MIT Press, 1992).

11. Freud, "The 'Uncanny,'" 224, 249.

12. Gail Levin, *Edward Hopper: The Art and the Artist* (New York: W. W. Norton in association with the Whitney Museum of American Art, 1980), 40. Levin is also author of *Edward Hopper: The Complete Prints* and *Edward Hopper as Illustrator,* both published in 1979 by Norton in association with the Whitney Museum of American Art. See also Gail Levin, *Edward Hopper: A Catalogue Raisonné* (New York: Whitney Museum of American Art with W. W. Norton, 1995). Particularly relevant for this chapter is the section called "Death" in her exploration of themes (1:83–87), where she rightly points to the association in his work between death and waiting.

13. Foster, *Compulsive Beauty,* 164.

14. Brian O'Doherty, *American Masters: The Voice and the Myth* (London: Thames and Hudson, 1988), 22.

15. Lloyd Goodrich, *Edward Hopper* (New York: Abrams, 1976), 164.

16. The curator of the Tate Modern's Hopper exhibition and editor of the catalogue seemed determined to introduce a less sentimental reading. See Sheena Wagstaff, ed., *Edward Hopper* (London: Tate Publishing, 2004), and my contribution to the catalogue, "Hopper's Melancholic Gaze" (52–67).

17. Pascal Bonitzer, "Hitchcockian Suspense," in *Everything You Always Wanted to Know About Lacan (But Were Afraid to Ask Hitchcock),* ed. S. Žižek (London: Verso, 1992), 23. See also Laura Mulvey, "Death Drives: Hitchcock's *Psycho,*" *Film Studies* 2 (Spring 2000): 5–14, and Mulvey, "Alfred Hitchcock's *Psycho* (1960)," in *Death 24x a Second: Stillness and the Moving Image* (London: Reaktion Books, 2006), 85–103.

18. Freud, "The 'Uncanny,'" 241.

19. Jean Laplanche and J.-B. Pontalis, "Fantasy and the Origins of Sexuality" (1964), in *Formations of Fantasy,* ed. V. Burgin, J. Donald, and C. Kaplan (London: Methuen, 1986), 22.

20. Reference has been made to Hopper's interest in cinema by Peter Wollen, in "Two or Three Things I Know About Edward Hopper," and Brian O'Doherty, "Hopper's Look," both in *Edward Hopper,* ed. Wagstaff, 68–81 and 82–99 respectively.

21. John Updike, "Hopper's Polluted Silence," *New York Review of Books,* August 10, 1995.

22. Goodrich, *Edward Hopper,* 31.

23. John Hollander, "Hopper and the Figure of Room," *Art Journal* 41 (Summer 1981): 158–59.

24. Ibid., 159, 160.

25. Freud, "The 'Uncanny,'" 291.

26. Freud, *Beyond the Pleasure Principle,* 219.

27. Freud, "The 'Uncanny,'" 371.

28. Ibid., 340. Hélène Cixous comments on the novelistic, provocative quality of the text, which at times seems to catch its author off guard. See "Fiction

and Its Phantoms: A Reading of Freud's *Das Unheimliche* (The 'Uncanny')," *New Literary History* 7 (1975–76). See also Sarah Kofman, "The Double Is/And the Devil," in *Freud and Fiction*, trans. Sarah Wykes (Oxford: Polity Press, 1990), and Nicholas Royle, *The Uncanny* (Manchester: Manchester University Press, 2003).

29. Jacques Lacan praised this bold speculation in *The Ego in Freud's Theory*, 69. See also Chapter 5 on this point.

30. Edward Hopper, "Charles Burchfield: American," *The Arts* 14 (July 1928): 6. The reference is to Ralph Waldo Emerson, "Self-Reliance," *Essays* (Boston: J. Munroe, 1841).

31. Sigmund Freud, "The Moses of Michelangelo" (1914), in *Standard Edition*, 13:222 (also in the Pelican Freud Library, vol. 14, *Art and Literature*, 249–80).

32. Hopper, "Charles Burchfield," 6–7.

33. Ibid., 7.

34. Freud, "The 'Uncanny,'" 237.

35. Ibid., 238.

36. Freud, *Beyond the Pleasure Principle*, section 5. Curiously, Freud never used the term "Thanatos" to mean the death drive, although he did use the corresponding term "Eros" for the life instinct.

37. Freud, *Civilization and Its Discontents*, 120 (also in the Pelican Freud Library, vol. 12, *Civilization, Society, and Religion* [London: Penguin, 1985], 311).

38. Sigmund Freud, "Delusions and Dreams in Jensen's 'Gradiva'" (1907), in *Standard Edition*, 9:1–96 (also in the Pelican Freud Library, vol. 14, *Art and Literature*, 27–118).

39. For an excellent account of the close cultural connection between feminine beauty and death, see Elisabeth Bronfen, *Over Her Dead Body: Death, Femininity, and the Aesthetic* (Manchester: Manchester University Press, 1992).

40. David Anfam, "Edward Hopper—Recent Studies," *Art History* 4, no. 4 (1981): 459.

41. Hollander, "Hopper and the Figure of Room," 160.

42. Mark Strand, *Hopper* (Hopewell, N.J.: Ecco Press, 1994), 14–15.

43. Ernst Jentsch, "On the Psychology of the Uncanny" (1906), in "Home and Family," ed. Sarah Wood, special issue, *Angelaki* 2, no. 1 (1995): 15.

44. Freud, "The 'Uncanny,'" 253. Freud was indebted to the work of his friend Otto Rank, whose book *Der Doppelgänger* was published in 1914. Rank was, in turn, indebted to Freud's "On Narcissism: An Introduction" (1914), in *Standard Edition*, 14:67–104. See Otto Rank, *The Double: A Psychoanalytic Study*, trans. Harry Tucker Jr. (Chapel Hill: University of North Carolina Press, 1971).

45. "Six Who Knew Edward Hopper," *Art Journal* 41 (Summer 1981): 132.

46. See, for instance, Neil Hertz, *The End of the Line: Essays on Psychoanalysis and the Sublime* (New York: Columbia University Press, 1985), on the brilliant surface of Hoffmann's narrative.

47. André Bazin, *What Is Cinema?* (Berkeley and Los Angeles: University of California Press, 1967), 1:166. The reference is to the discussion of the "blind field," but that particular expression is not used by Bazin. Roland Barthes uses it in *Camera Lucida: Reflections on Photography*, trans. Richard Howard (New York: Hill and Wang, 1981), 55–66, where he refers to Bazin and puts the phrase in quotation marks ("le champ aveugle"), implying that it is Bazin's phrase. A blind field is created by the "punctum" of a photograph—that is, a detail triggering a particular affective response. For example, referring to a family portrait by James Van der Zee, he writes: "on

account of her necklace, the black woman in her Sunday best has had, for me, a whole life external to her portrait" (57). The punctum, so to speak, breaks through the confines of the frame and at the same time, like trauma, punctures the spectator's psychic protective shield.

48. Pascal Bonitzer, *Le champ aveugle: Essais sur le cinéma* (Paris: Gallimard, 1982). Bonitzer cites both Barthes's *La chambre claire* and Lacan's *Le séminaire* XI. I am grateful to Laura Mulvey for drawing my attention to this book.

49. Meyer Schapiro, "On Some Problems in the Semiotics of Visual Art: Field and Vehicle in Image-Signs" (1969), in *Theory and Philosophy of Art: Style, Artist, and Society* (New York: George Braziller, 1994), 4:7.

50. Edward Hopper, letter to Charles H. Sawyer, October 29, 1939, repr. in Goodrich, *Edward Hopper*, 152.

51. Edward Hopper, letter to Norman A. Geske (Director, Walker Art Center, Minneapolis), repr. in Robert Hobbs, *Edward Hopper* (New York: Abrams, 1987), 16.

52. Sigmund Freud, "Dream of the Botanical Monograph," in *The Interpretation of Dreams* (1900), in *Standard Edition*, 4:282–84 (also in the Pelican Freud Library, vol. 4, *The Interpretation of Dreams* [London: Penguin, 1976], 254ff). André Breton, *Mad Love*, trans. Mary Ann Caws (Lincoln: University of Nebraska Press, 1987), 30.

53. Goodrich, *Edward Hopper*, 129.

54. Linda Nochlin, "Edward Hopper and the Imagery of Alienation," *Art Journal* 41 (Summer 1981): 138.

55. Victor Burgin, *Between* (Oxford: Basil Blackwell in association with the ICA, 1986), 183. See also his 1986 photographic work based on *Office at Night*.

56. Ellen Wiley Todd, "Will (S)he Stoop to Conquer? Preliminaries Toward a Reading of Edward Hopper's *Office at Night*," in *Visual Theory,* ed. Norman Bryson, Michael Ann Holly, and Keith Moxey (Oxford: Polity Press, 1991), 47–53.

57. Christopher Bollas, *Cracking Up: The Work of Unconscious Experience* (London: Routledge, 1995), 53.

58. Ibid.

59. Alois Riegl, *Das holländische Gruppenporträt* (1902; Vienna, 1931), 210–14, translated as *The Group Portraiture of Holland,* trans. E. M. Kain and D. Britt (Los Angeles: The Getty Research Institute Publications, 1999), 282–96. See also my discussion in *Alois Riegl: Art History and Theory* (Cambridge: MIT Press, 1993).

60. T. J. Clark, *The Painting of Modern Life: Paris in the Art of Manet and His Followers* (London: Thames and Hudson, 1985), 250–52.

61. The idea of the "effacement" of the spectator was introduced by Briony Fer to characterize the experience of Carl Andre's floor pieces. See "Carl Andre and the Fall of Sculpture," in *Carl Andre and the Sculptural Imagination,* ed. Ian Cole (Oxford: Museum of Modern Art, 1996). See also Fer's book *On Abstract Art.*

62. Žižek, *Looking Awry,* 117–18. The sequence is also analyzed by Stephen Rebello, *Alfred Hitchcock and the Making of "Psycho"* (London: Boyars, 1990). See also Mulvey, "Death Drives."

63. Sigmund Freud, "Screen Memories" (1899), in *Standard Edition,* 3:301–22.

64. Doreen Massey, "Space-time and the Politics of Location," in *Rachel Whiteread: House,* ed. James Lingwood (London: Phaidon, 1995), 34–49.

65. Mladen Dolar, "'I Shall Be with You on Your Wedding-Night': Lacan and the Uncanny," in "Rendering the Real,"
ed. Parveen Adams, special issue, *October* 58 (Fall 1991): 5–24.

66. Terry Castle, *The Female Thermometer: Eighteenth-Century Culture and the Inventing of the Uncanny* (New York: Oxford University Press, 1995).

67. Freud, "The 'Uncanny,'" 226.

Chapter 3

1. Dalí, *Le mythe tragique de l'Angélus de Millet: Interprétation "paranoïaque-critique"* (Paris: Jean-Jacques Pauvert, 1963), translated as *The Tragic Myth of Millet's Angelus: Paranoiac-Critical Interpretation, Including The Myth of William Tell,* trans. Eleanor R. Morse (St. Petersburg, Fla.: The Salvador Dalí Museum, 1986), and hereafter abbreviated *TM*. My references in parentheses in the text refer first to the French and then to the English translation. I give the page reference to the French only, if my translation differs from Morse's. Paranoia-criticism of art was first described as early as 1930 in "L'âne pourri," *Le surréalisme au service de la révolution* 1 (1930): 9–12. This and other texts, including excerpts from *The Tragic Myth,* are available in English in *The Collected Writings of Salvador Dalí,* ed. and trans. Haim Finkelstein (Cambridge: Cambridge University Press, 1998), 223.

2. The first mention of Lacan in surrealist literature was made by René Crével in "Notes en vue d'une psycho-dialectique," *Le surréalisme au service de la révolution* 6 (1933): 48–52, which contained a synopsis of the contents of Lacan's 1932 Ph.D. thesis.

3. Sigmund Freud, "Construction in Analysis" (1937), in *Standard Edition,* 23:268.

4. Jacques Lacan, "Aggressivity in Psychoanalysis" (1948), in *Écrits: A Selection,* ed. Sheridan, 15. Lacan's admiration of Klein's work is well documented.
In 1949, he asked her for permission to translate *The Psychoanalysis of Children* into French, but he never accomplished the task. See Phyllis Grosskurth, *Melanie Klein: Her World and Her Work* (London: Hodder and Stoughton, 1986).

5. Lacan, "Aggressivity in Psychoanalysis," 11.

6. Lacan, *The Four Fundamental Concepts,* 83. For a discussion of Dalí's *Metamorphosis of Narcissus* along these lines, see Hanjo Berressem, "Dalí and Lacan: Painting the Imaginary Landscapes," in *Lacan, Politics, Aesthetics,* ed. Willy Apollon and Richard Feldstein (Albany: State University of New York, 1996), 263–96.

7. Jacques Lacan, "Le problème du style et la conception psychiatrique des formes paranoïaques de l'expérience," *Minotaure* 1 (1933): 68–69, repr. in *De la psychose paranoïaque,* 383–88. It is worth noting that Freud's study of a case of paranoia, the so-called Schreber case, was translated into French in 1932. See Freud, "Remarques psychanalytiques sur l'autobiographie d'un cas de paranoïa: Dementia paranoïdes," *Revue française de psychanalyse* 5, no. 1 (1932).

8. Jacques Lacan, *Écrits* (Paris: Seuil, 1966), 84.

9. Although Dalí is not exactly a reliable source, the original text from 1933 has been located by Dawn Ades, who will soon publish her findings. Steven Harris has suggested to me that the nonpublication of *The Tragic Myth* may have something to do with Dalí's break with the Surrealists. See Harris, *Surrealist Art and Thought in the 1930s: Art, Politics, and the Psyche* (Cambridge: Cambridge University Press, 2004). Finkelstein argues that it was heavily rewritten in the early 1960s on the grounds that its autobiographical revelations are out of

character with his earlier prose (*Collected Writings,* 274).

10. The best is Naomi Schor, "Dalí's Freud," in *Reading in Detail: Aesthetics and the Feminine* (New York: Methuen, 1987), 101–9. A recent article takes up the theme of Dalí's engagement with popular culture and mass production: Jordana Mendelson, "Of Politics, Postcards, and Pornography: Salvador Dalí's *Le mythe tragique de l'Angélus de Millet,*" in *Surrealism, Politics, and Culture,* ed. Raymond Spiteri and Donald LaCoss (Aldershot: Ashgate, 2003), 161–78.

11. Salvador Dalí, "Objets psycho-atmosphériques-anamorphiques," *Le surréalisme au service de la révolution* 5 (1933): 45–48. Translated in *Oui: The Paranoid-Critical Revolution: Writings, 1927–33,* ed. Robert Descharnes, trans. Yvonne Shafir (Boston: Exact Change, 1998), 153–58, and in *Salvador Dalí's Art and Writing, 1927–1942: The Metamorphosis of Narcissus,* ed. and trans. Haim Finkelstein (Cambridge: Cambridge University Press, 1996), 244–48.

12. *Dalí's Art and Writing,* ed. Finkelstein, 220. See also Dawn Ades, *Dalí* (London: Thames and Hudson, 1982); Ades, "Morphologies of Desire," in *Salvador Dalí: The Early Years,* ed. Michael Raeburn (London: The South Bank Centre, 1994); Dawn Ades and Fiona Bradley, eds., *Salvador Dalí: A Mythology* (London: Tate Gallery Publishing, 1999); Ades, ed., *Dalí's Optical Illusions* (Hartford: Wadsworth Atheneum Museum of Art and New Haven: Yale University Press, 2000); Patrice Schmitt, "De la psychose paranoïaque dans ses rapports avec Salvador Dalí," *Salvador Dalí Retrospective, 1920–1981* (Paris: Centre Georges Pompidou, 1980); David Vilaseca, *The Apocryphal Subject: Masochism, Identification, and Paranoia in Salvador Dalí's Autobiographical Writing,* Catalan Studies 17 (New York: Peter Lang, 1995); Robert S. Lubar, *Dalí: The Salvador Dalí Museum Collection* (Boston: Bulfinch Press, 2000). For an interesting expansion of the concept of paranoia in political and aesthetic dimensions, see Victor Burgin, "Paranoiac Space," *New Formations* 12 (Winter 1990): 61–75.

13. Freud, *The Interpretation of Dreams,* vols. 4 and 5 in the *Standard Edition* (vol. 4 in the Pelican Freud Library). The book was published in French as *La science des rêves* (Paris: Payot, 1926).

14. Salvador Dalí, "The Conquest of the Irrational" (1935), in *The Secret Life of Salvador Dalí,* trans. Haakon M. Chevalier (London: Vision, 1948), 418. See also *Collected Writings,* ed. Finkelstein, 262–72.

15. The word *informe* appears in Dalí's text in quotation marks, indicating that Dalí meant the reader to pick up his reference to Georges Bataille's entry in the "Critical Dictionary" under that heading. See *Documents* 7 (December 1929): 382. The English translation appears as "Formless," in Georges Bataille, *Visions of Excess: Selected Writings, 1927–1939,* trans. Allan Stoekl (Manchester: Manchester University Press, 1985), 31.

16. Salvador Dalí, *The Unspeakable Confessions of Salvador Dalí,* as told to André Parinaud, trans. Harold J. Salemson (London: W. H. Allen, 1976), 152. This is the English translation of *Comment on devient Dalí,* as told to André Parinaud (Paris: Laffont, 1973).

17. Roger Caillois, "La mante réligieuse: De la biologie à la pychanalyse," *Minotaure* 5 (May 1934): 20.

18. Sigmund Freud, *The Psychopathology of Everyday Life* (1901), in *Standard Edition,* 6:255. I shall later refer to Lacan's conception of mimetic rivalry, which is equally evident here. This kind of collision is quite different from the missed encounter introduced in the next chapter. In *The Four Fundamental Concepts,* however, Lacan says that the collision in the real has to do with "the fact that things don't work out straight away, as the hand which reaches towards external objects would like" (167), suggesting a link with parapraxis.

19. Sigmund Freud, "From the History of an Infantile Neurosis" (The "Wolf Man") (1918 [1914]), in *Standard Edition,* 17:37–38 (also in the Pelican Freud Library, vol. 9, *Case Histories II* [Harmondsworth: Penguin, 1979], 227–366).

20. Salvador Dalí, "De la beauté terrifiante et comestible de l'architecture modern style," *Minotaure* 3–4 (1933): 69–80. Translated in *Collected Writings,* ed. Finkelstein, 193–200.

21. Freud, "The Moses of Michelangelo." Its first appearance under Freud's name was in his collected papers in 1924, and in English translation, it appeared in his *Collected Papers,* an authorized translation under the supervision of Joan Riviere, vol. 4 (London, 1925). See also the Pelican Freud Library, vol. 14, *Art and Literature,* 249–82.

22. Freud, "The Moses of Michelangelo," 211.

23. Ibid., 213.

24. Ernest Jones, *Sigmund Freud: Life and Work* (London: The Hogarth Press, 1953–58), 3:360.

25. Freud, "The Moses of Michelangelo," 214ff.

26. This point is also made by Schor in her perceptive "Dalí's Freud," 105.

27. Freud, "The Moses of Michelangelo," 229.

28. Ibid., 221.

29. Ibid., 233.

30. For an interesting discussion of Dalí's inquiry into paternal imagoes,

see Robin Adèle Greeley, "Dalí's Fascism; Lacan's Paranoia," *Art History* 24, no. 4 (2001): 465–92.

31. Freud, "Leonardo da Vinci," 87–88.

32. Julia Kristeva, *Powers of Horror: An Essay on Abjection*, trans. Leon S. Roudiez (New York: Columbia University Press, 1982), especially chap. 1, "Approaching Abjection." Curiously, the skin on the surface of milk features as an emblem of what must be abjected in Kristeva's account (2–3).

33. Sigmund Freud, "Psychoanalytic Notes on an Autobiographical Account of a Case of Paranoia (Schreber)" (1911), in *Standard Edition*, 12:201. See also Freud, "Some Neurotic Mechanisms in Jealousy, Paranoia, and Homosexuality" (1922), in *Standard Edition*, 18:221–34.

34. Salvador Dalí, "Interprétation paranoïaque-critique de l'image obsédante *L'Angélus* de Millet," *Minotaure* 1 (1933): 66.

35. Freud, *The Psychopathology of Everyday Life*, 255 (also in the Pelican Freud Library, vol. 5, *The Psychopathology of Everyday Life* [Harmondsworth: Penguin, 1976], 317). This book was published in French as *La psychopathologie de la vie quotidienne* (Paris: Payot, 1922).

36. Ibid., 256.

37. Dalí, *Secret Life*, 18. See also José Ferreira, *Dalí-Lacan: La rencontre: Ce que le psychanalyste doit au peintre* (Paris: L'Harmatten, 2003). He calls attention to the imprecision of the dates and the disagreements among Dalí's and Lacan's biographers. He settles on a meeting in 1930, and he takes the text that Lacan refers to as "L'âne pourri."

38. I do not know how often the two met after this initial encounter, but Dalí does refer to Lacan as a friend in *The Tragic Myth*. Lacan was among those who spontaneously imagined that it would be the male figure of the *Angelus* who would be plunged in a bucket of warm milk (*TM*, 53/83).

39. Elisabeth Roudinesco, *Jacques Lacan and Co.: A History of Psychoanalysis in France, 1925–1985*, trans. Jeffrey Mehlman (Chicago: University of Chicago Press, 1990), 110. Unfortunately, it is unclear whether Roudinesco has independent confirmation of the story or, more likely, she just retells Dalí's version.

40. In 1932, Lacan published his dissertation on paranoia for his M.D. in psychiatry, and a year later he published his article in *Minotaure* alongside Dalí's first attempt at a paranoiac-critical interpretation of Millet's *Angelus*. Lacan subsequently published another essay in *Minotaure* on the famous Papin sisters, the maids who savagely murdered their employer and her daughter. The first version of Lacan's "Mirror Stage" paper was delivered in 1936 at the International Psychoanalytical Congress held that year in Marienbad, although the version in his *Écrits* (1966) was delivered at the Zurich Congress in 1949. Dalí claims that *The Tragic Myth* was completed in 1938. Lacan's article on "Aggressivity in Psychoanalysis" appeared somewhat later (1948), but its themes cohere with this group of works.

41. Dalí, "L'âne pourri," 10. Also printed in *La femme visible* (Paris: Éditions surrealistes, 1930), 18. Translated in *Collected Writings*, ed. Finkelstein, 223.

42. Dalí, "L'âne pourri," 10.

43. Salvador Dalí, "La conquête de l'irrationnel" (1935), in *Oui: Méthode paranoïaque critique et autres texts* (Paris: Denoël/Gonthier, 1971), 16–17, translated as *Oui: The Paranoid-Critical Revolution: Writings, 1927–33*, ed. Descharnes. See also Dalí, "The Conquest of the Irrational."

44. For an excellent account of this view, see Deleuze, "Plato and the Simulacrum."

45. Salvador Dalí, "The Moral Position of Surrealism" (1930), in *Collected Writings*, ed. Finkelstein, 221. Also cited in Arthur Terry, "Introduction to Selection of Texts by Salvador Dalí," in *Salvador Dalí: The Early Years*, ed. Raeburn, 209–13.

46. David Lomas postions Dalí's simulacral painting in relation to Clement Greenberg's attack on kitsch and to the contemporary British artist Glenn Brown (paper delivered at the annual conference of the Association of Art Historians, London, 2001). These issues are also aired in Lomas's book, *The Haunted Self: Surrealism, Psychoanalysis, Subjectivity* (New Haven: Yale University Press, 2000), especially chap. 2, "Seductions of Hysteria."

47. André Breton and Paul Éluard, *L'immaculée conception* (Paris: Éditions surréalistes, 1930). The section on the "Delirium of Interpretation" is translated in Breton, *What Is Surrealism? Selected Writings*, ed. and intro. Franklin Rosemont (London: Pluto Press, 1978), 54–55. The categories of mental illness are pre-Freudian and derive from Emil Kraepelin, *Lectures on Clinical Psychiatry*, ed. T. Johnstone (London: Baillière, 1906).

48. Jacques Lacan, "Écrits 'inspirées': Schizographie," repr. in *De la psychose paranoïaque*, 365–82.

49. Lacan, *De la psychose paranoïaque*, 177.

50. Dalí, "Interprétation paranoïaque-critique," 65–66.

51. The image was first printed and commented on by Dalí in "Communication, visage paranoïaque," *Le surréalisme au service de la révolution* 3 (1931): 40.

52. Dalí, *Unspeakable Confessions*, 142.

53. Lacan, "Le problème du style," 68, 69.

54. Ibid., 69.

55. For more on this subject, see my concluding chapter.

56. See Alexandre Kojève, *Introduction to the Reading of Hegel: Lectures on the Phenomenology of Spirit*, ed. Allan David Bloom (Ithaca, N.Y.: Cornell University Press, 1980). The lectures were delivered at the École des hautes études, Paris, between 1933 and 1939.

57. Lacan, "The Mirror Stage." As noted above, this paper was first delivered in 1936, but it was not published until 1949.

58. Peter Dews, *Logics of Disintegration: Post-Structuralist Thought and the Claims of Critical Theory* (London: Verso, 1987), 58.

59. Jacqueline Rose, "Paranoia and the Film System," in *Feminism and Film Theory*, ed. Constance Penley (New York: Methuen, 1988), 144.

60. Chapters 2 and 3 of Borch-Jacobsen, *Lacan*, offer particularly illuminating commentary on the mirror stage.

61. Anika Lemaire, *Jacques Lacan*, trans. David Macey (London: Routledge and Kegan Paul, 1977), 179.

62. Lacan, "Some Reflections on the Ego," 17.

63. Lacan, *The Four Fundamental Concepts*, 107, and Roger Caillois, *The Mask of the Medusa*, trans. George Ordish (London: Victor Gollancz, 1964). Translation of *Méduse et Cie* (Paris: Gallimard, 1960).

64. Dalí, *Secret Life*, 9. The unambiguous loathing for the abject substance spinach is unusual for Dalí. In fact, his love for shellfish derives, in part, from what lurks underneath—the slimy, gelatinous indeterminate or ignominious. It

is, as Dawn Ades argues, the conjunction of the hard and the soft that is so appealing; see her "Morphologies of Desire."

65. Dalí, "Love," in *Collected Writings*, ed. Finkelstein, 190–91; translation of Dalí, "L'amour," repr. in *La femme visible*, 65–69. See also Georges Bataille, "The Big Toe," in *Visions of Excess*, 20.

66. Dalí, "Love," 191.

67. Dalí, *Unspeakable Confessions*, 23. The detailed information he gives in this book is wrong. He says that his brother was seven years old and died three years before his own birth.

68. Ibid., 23. Fiona Bradley touches on this issue in her article "Doubling and Dédoublement: Gala in Dalí," *Art History* 17, no. 4 (1994): 612–30. She cites an apposite passage: the circumstances of his birth meant that Dalí felt himself to be "not a solid, compact and hard reality, but a reply, a double, an absence." The line appears in *Dalí par Dalí* (Paris: Draeger, 1970), v, translated as *Dalí by Dalí*, trans. Eleanor R. Morse (New York: Abrams, 1970).

69. Borch-Jacobsen, *Lacan*, 23–24.

70. Dalí, *Unspeakable Confessions*, 33.

71. Lacan, "Aggressivity in Psychoanalysis," 17.

Chapter 4

1. See Walter Benjamin on the aesthetics of "shock," particularly in "On Some Motifs in Baudelaire" (1939) in *Selected Writings*, vol. 4, ed. Howard Eiland and Michael Jennings (Cambridge: Belknap Press of Harvard University Press, 2003), 313–35, and *Illuminations*, ed. Hannah Arendt, trans. Harry Zohn (London: Fontana Collins, 1973), 157–203. See also "Benjamin Reading the Rencontre," in Margaret Cohen, *Profane Illumination: Walter Benjamin and the Paris of the Surrealist Revolution* (Berkeley

and Los Angeles: University of California Press, 1993).

2. Breton, *Mad Love*, 8 (hereafter abbreviated *ML*). Translation of *L'amour fou* (Paris: Gallimard, 1937).

3. Lacan, *The Four Fundamental Concepts*, 7 (hereafter abbreviated *FFC*).

4. Cited by Breton in *ML*, 9. The phrase is from Lautréamont, *Les chants de Maldoror*, canto VI.

5. Jane Gallop, "Psychoanalytic Criticism: Some Intimate Questions," *Art in America* (November 1984): 10.

6. For an exemplary account of a "transferential" interpretation of a work of art, see Parveen Adams, "The Art of Analysis: Mary Kelly's *Interim* and the Discourse of the Analyst," in *The Emptiness of the Image*, 71–90.

7. The first French translation of *Beyond the Pleasure Principle* appeared in 1927.

8. Foster, *Compulsive Beauty*, 44.

9. The *objet petit a(utre)* has a long history in Lacan's thought. I am interested in its formulation in *The Four Fundamental Concepts* and after. Perhaps the best explication of it is Borch-Jacobsen, *Lacan*, 197ff.

10. The image of "knocking on the window" is used by Breton to describe a phrase that came to him in a half-waking state in "Manifesto of Surrealism" (1924), *Manifestoes of Surrealism*, trans. Richard Seaver and Helen R. Lane (Ann Arbor: University of Michigan Press, 1972), 21. The episode of finding the slipper spoon is in Breton, *ML*, 25ff.

11. Freud, *Beyond the Pleasure Principle*, 14–17.

12. Foster, *Compulsive Beauty*, 45.

13. Ibid., 44.

14. Breton, *ML*, 25. I have modified the translation to bring out the syntactical compression in the original

of "comes, doesn't come." See Breton, *L'amour fou*, 33.

15. Roger Cardinal, *Breton/Nadja* (London: Grant and Cutler, 1986), 22. He claims that Freud's model of the relation of wish and reality as antagonistic is simply inverted by Breton. Mary Ann Caws is also inclined to an optimistic reception of the encounter in her book, *The Surrealist Look: An Erotics of Encounter* (Cambridge: MIT Press, 1997). For an excellent account that particularly brings out the Surrealists' political utopianism, see Harris, *Surrealist Art and Thought in the 1930s*.

16. Cohen is guided in her reading by Walter Benjamin, another close reader of Freud and Breton.

17. Cohen, *Profane Illumination*, 147, 148.

18. Richard Feldstein, Bruce Fink, and Marie Jaanus, eds., *Reading Seminar XI: Lacan's Four Fundamental Concepts of Psychoanalysis* (Albany: State University of New York Press, 1995). References to Surrealism and Breton's *Nadja* are in Marie Jaanus, "The Démontage of the Drive," in *Reading Seminar XI*, 122.

19. Freud, *The Interpretation of Dreams*, 5:509–11 (also in the Pelican Freud Library, vol. 4, *The Interpretation of Dreams*, 652–55).

20. Ibid., 5:726.

21. Cohen, *Profane Illumination*, 138.

22. Freud, *Beyond the Pleasure Principle*, 26; Cohen, *Profane Illumination*, 138.

23. The reference is to André Breton, "Introduction to the Discourse on the Paucity of Reality" (1924), trans. Richard Sieburth and Jennifer Gordon, *October* 69 (Summer 1994): 133–44. From André Breton, *Point du jour* (Paris: Gallimard, 1970), 5–35.

24. Freud, *Beyond the Pleasure Principle*, 22.

25. Walter Benjamin, "Little History of Photography" (1931), in *Selected Writings*, vol. 2, ed. Michael Jennings, Howard Eiland, and Gary Smith, trans. Rodney Livingstone et al. (Cambridge: Belknap Press of Harvard University Press, 1999), 510. See Chapter 7 on Lacan, Barthes, and photography, which includes an account of Barthes's debt to Benjamin.

26. See the entry under "Deferred Action" for a definition and pertinent references to Freud texts in Laplanche and Pontalis, *The Language of Psychoanalysis*, 111–14.

27. Jane Gallop, *Reading Lacan* (Ithaca, N.Y.: Cornell University Press, 1985), 178–80. Ellie Ragland also argues that, for Lacan, the horror for the father came before the death—"in little haunting incests, murders, or other *jouissances*." See Ragland, "Lacan, the Death Drive, and the Dream of the Burning Child," in *Death and Representation*, ed. Sarah Webster Goodwin and Elisabeth Bronfen (Baltimore: Johns Hopkins University Press, 1993), 80–102.

28. Translation modified.

29. Foster, *Compulsive Beauty*, 44.

30. Jacques Lacan, "On the Structure of Inmixing of an Otherness Prerequisite to Any Subject Whatever," in *The Structuralist Controversy: The Languages of Criticism and the Sciences of Man*, ed. Richard Macksey and Eugenio Donato (Baltimore: Johns Hopkins University Press, 1971), 189. This was a lecture delivered at Johns Hopkins University in 1966 (186–200).

31. Paul Verhaeghe points out that this makes Lacan's conception of the subject exactly the opposite of the Cartesian cogito, the "I think, therefore I exist." He writes, "For Lacan, each time conscious thinking arises [the subject's] being disappears under the signifier."

See Verhaeghe, "Causation and Destitution of a Pre-ontological Non-entity: On the Lacanian Subject," in *Key Concepts of Lacanian Psychoanalysis*, ed. Dany Nobus (New York: Other Press, 1999), 179.

32. Lacan, "On the Structure of Inmixing," 195.

33. David Macey, *Lacan in Contexts* (London: Verso, 1988), 45.

Chapter 5

1. Lacan, *The Ego in Freud's Theory*, 69.

2. Sigmund Freud, *An Outline of Psychoanalysis* (1940 [1938]), in *Standard Edition*, 23:149. For the first formulation of this distinction, see *Beyond the Pleasure Principle*. Unfortunately, the German "*der Trieb*" (drive) is rendered as "instinct" in the *Standard Edition*.

3. For an account of the ego and aggressivity, see Chapter 3 on Dalí and paranoia.

4. Freud, "Project for a Scientific Psychology" (1950 [1895]), in *Standard Edition*, 1:295.

5. Freud, *Beyond the Pleasure Principle*, 27.

6. Ibid., 38.

7. Ibid., 36.

8. The passage where Freud really muddies the waters runs as follows: "The dominating tendency of mental life, and perhaps of nervous life in general, is the effort to reduce, to keep constant or to remove internal tension due to stimuli (the 'Nirvana Principle' . . .)—a tendency which finds expression in the pleasure principle; and our recognition of that fact is one of our strongest reasons for believing in the existence of death instincts" (ibid., 55–56).

9. Joan Copjec, "The Tomb of Perseverance: On *Antigone*," in *Giving Ground: The Politics of Propinquity*, ed. Joan Copjec and Michael Sorkin

(London: Verso, 1999), 253. "Das Ding," German for "the Thing," is an allusion to Kant's thing-in-itself and is Lacan's earlier formulation of *objet petit a* (see Lacan, *The Ethics of Psychoanalysis*). See also Richard Boothby, *Death and Desire: Psychoanalytic Theory in Lacan's Return to Freud* (New York: Routledge, 1992), and Laplanche, *Life and Death in Psychoanalysis*. For a fascinating overview of the cultural significance of death, see Jonathan Dollimore, *Death, Desire, and Loss in Western Culture* (London: Allen Lane, 1998).

10. Jean Laplanche, "Why the Death Drive?" in *Life and Death in Psychoanalysis*, 105ff.

11. Rob Weatherill, *The Sovereignty of Death* (London: Rebus Press, 1998), 85.

12. For a discussion of this essay in the context of a study of Louise Bourgeois's work, see Mignon Nixon, *Fantastic Reality: Louise Bourgeois and the Study of Modern Art* (Cambridge: MIT Press, 2005), 204–8. This book is an excellent contribution to art history and criticism "beyond pleasure" that appeared just as my book was going to press.

13. Marion Milner, "The Role of Illusion in Symbol Formation," in *The Suppressed Madness of Sane Men* (London: Tavistock Publications, 1987), 96.

14. Ibid., 96.

15. In a pre-psychoanalytic book called *An Experiment in Leisure* (1938), Milner explored the theme of the dying god (the subject of J. G. Frazer's book, *The Dying God, The Golden Bough: A Study of Magic and Religion*, 3rd ed. (London: Macmillan, 1911), part 3.

16. For more on this topic, see Claire Bishop, *The Subject of Installation Art: A Typology* (Ph.D. diss., University of Essex, 2002), especially chap. 3. See also

Claire Bishop, *Installation Art: A Critical History* (London: Tate Publishing, 2005).

17. Milner, "The Role of Illusion in Symbol Formation," 97.

18. Anton Ehrenzweig, *The Hidden Order of Art: A Study in the Psychology of Artistic Imagination* (London: Paladin, 1970). See page 204 for his account of Milner's essay. Milner paid generous tribute to her friend in a lecture she gave shortly after he died: see her "Hidden Order of Art," in *The Suppressed Madness of Sane Men*, 241–45. The circle of artists frequented by Ehrenzweig included Richard Hamilton, Henry Moore, Eduardo Paolozzi, and Bridget Riley.

19. Smithson said of Ehrenzweig's book, "We had some good discussions about that in particular. It's very meaningful to artists." Smithson, "Four Conversations Between Dennis Wheeler and Robert Smithson (1969–70)," in *Robert Smithson: The Collected Writings*, ed. Jack Flam (Berkeley and Los Angeles: University of California Press, 1996), 207.

20. For a good selection of essays and helpful commentary on Klein, see Juliet Mitchell, ed., *The Selected Melanie Klein* (London: Penguin, 1986).

21. Ehrenzweig, *The Hidden Order of Art*, 103.

22. Ibid., 121.

23. Ibid., 296.

24. Milner, "The Hidden Order of Art," 243.

25. Ibid., 219.

26. Smithson remarks on this in "Four Conversations," 207.

27. Robert Morris, "Notes on Sculpture, Part 1 (1966)," in *Continuous Project Altered Daily: The Writings of Robert Morris* (Cambridge: MIT Press, 1993), 6–7, hereafter referred to as *Writings*. For an excellent reading of these texts that sets them in relation to Merleau-Ponty's *Phenomenology of Perception*, see Alex

Potts, *The Sculptural Imagination: Figurative, Modernist, Minimalist* (New Haven: Yale University Press, 2000), especially chap. 6, "The Phenomenological Turn." See also James Meyer, *Minimalism: Art and Polemics in the Sixties* (New Haven: Yale University Press, 2001), chap. 6, especially note 44, where Meyer reports an interview with the artist, who recalled reading Kurt Koffka and Wolfgang Köhler at Reed College in Oregon.

28. Donald Judd, "Specific Objects," *Arts Yearbook* 8 (1965), repr. in Donald Judd, *Complete Writings, 1959–1975* (1975; Halifax: Press of the Nova Scotia College of Art and Design; New York: New York University Press, 2005), 187.

29. The subtitle of Morris's 1970 essay "Some Notes on the Phenomenology of Making" is "The Search for the Motivated," indicating his desire to find a causal, physical determination of forms. He wants motivated as opposed to arbitrary forms and, at the same time, forms that eliminate the personal touch. See *Writings*, 71–94.

30. Morris, "Anti Form," in *Writings*, 41.

31. Morris, "Notes on Sculpture, Part 2," in *Writings*, 17.

32. Morris, "Some Notes on the Phenomenology of Making," 91.

33. Ibid., 41. Alex Potts sees this turn to anti-form as part of a wider Romantic refusal of the mediation between artist or artwork and audience. See Potts, *The Sculptural Imagination*, 252. James Meyer makes the same point in *Minimalism*, 267.

34. Morris, "Notes on Sculpture, Part 4: Beyond Objects" (1969), in *Writings*, 61–62.

35. Smithson, "A Sedimentation of the Mind: Earth Projects" (1968), in *Collected Writings*, ed. Flam, 102.

36. Morris, "Notes on Sculpture, Part 4," 61. Jon Bird discusses Morris's interest in Ehrenzweig in "Minding the Body: Robert Morris's 1971 Tate Gallery Retrospective," in *Rewriting Conceptual Art,* ed. Michael Newman and Jon Bird (London: Reaktion Books, 1999). The most ambitious reading of Morris's early work is still Annette Michelson's introductory essay, "Robert Morris: An Aesthetics of Transgression," in *Robert Morris* (Washington, D.C.: Corcoran Gallery of Art, 1969), repr. in *Minimalism,* ed. James Meyer (London: Phaidon, 2000), 247–50.

37. Morris, "Notes on Sculpture, Part 4," 68–69.

38. Bois and Krauss, *Formless.* See, in particular, the entries under the headings "Horizontality" and "Entropy."

39. Morris, "The Present Tense of Space" (1978), in *Writings,* 197.

40. Ibid., 201.

41. This is the burden of Allan Kaprow's trenchant critique of Morris's anti-form article. Kaprow, "The Shape of the Art Environment," *Artforum* 6, no. 10 (1968): 32–33, repr. in Kaprow, *Essays on the Blurring of Art and Life,* ed. Jeff Kelly (Berkeley and Los Angeles: University of California Press, 1993). Kaprow's 1958 piece, "The Legacy of Jackson Pollock," also makes interesting reading in this connection (1–9).

42. Smithson, "A Sedimentation of the Mind," 104.

43. Ibid., 111.

44. Ibid., 107.

45. Lacan, "Some Reflections on the Ego," 11–17.

46. Lacan, "The Mirror Stage," 17.

47. Smithson, "A Sedimentation of the Mind," 102. For an interesting account of the Non-Site pieces in terms of Freud's *Totem and Taboo,* see Ann Reynolds, *Robert Smithson: Learning from New Jersey and Elsewhere* (Cambridge: MIT Press, 2003), 201–7.

48. The ambivalent attitude artists of this generation had to photographic documentation partly derives from their fear of commodification, that is, of the work's becoming merchandise. Virginia Dwan, the gallery owner who pioneered Earth Art, refers to the documentation of Michael Heizer's *Double Negative* (1970) as "program notes" that could be bought. Walter de Maria didn't allow any drawings or photographs of his *Las Vegas Piece.* See the transcript of the interview by Charles Stucky with Virginia Dwan, especially on May 10, 1984 (papers held in the Archives of American Art, Washington, D.C.).

49. These exchanges can be found in Samuel Wagstaff Jr., "Talking with Tony Smith," and Michael Fried, "Art and Objecthood," both in *Minimal Art: A Critical Anthology,* ed. Gregory Battcock (New York: E. P. Dutton, 1968). See Robert Smithson, "A Tour of the Monuments of Passaic, New Jersey" (1967), "A Sedimentation of the Mind," and "Letter to the Editor" (1967), a response to Fried's article, all in *Collected Writings,* ed. Flam.

50. Smithson, "A Sedimentation of the Mind," 103.

51. Smithson, "A Tour of the Monuments," 71.

52. Smithson, "Interview with Robert Smithson for the Archives of American Art/Smithsonian Institution" (interview by Paul Cummings in Washington, D.C., 1972), in *Collected Writings,* ed. Flam, 295.

53. For an analysis and an account of the genesis of "A Tour of the Monuments," see Reynolds, *Robert Smithson,* 100–121. Reynolds notes the "chaos of encounter" that enters the prose when Smithson recounts his personal experience of the trip to Passaic (104).

54. For a primer on Bataille, see Colin MacCabe's introduction to Bataille's *Eroticism,* trans. Mary Dalwood (London: Penguin, 2001). He stresses the point that Lacan's intellectual indebtedness to Bataille "ran very deep" (vii).

55. Smithson, "Four Conversations," 230.

56. Georges Bataille, *Eroticism,* trans. Mary Dalwood (London: Boyars, 1987). *Eroticism* was originally published in French in 1957; first English translation, 1962. For the library inventory, see *Robert Smithson: Une rétrospective: Le paysage entropique, 1960–1973* (Marseilles: Musées de Marseilles, 1994), and Reynolds, *Robert Smithson,* 297–345.

57. Bataille, *Eroticism* (1987), 15.

58. For further discussion of this point with regard to Lacan (who married Bataille's former wife), see the end of Chapter 4 on the encounter.

59. Bataille, *Eroticism,* 22.

60. Ibid., 90.

61. Ibid., 25.

62. Suzann Boettger sets Smithson's Yucatan essay in relation to Ehrenzweig's theories in "In the Yucatan: Mirroring Presence and Absence," in *Robert Smithson,* ed. Eugenie Tsai, exh. cat. (Berkeley and Los Angeles: University of California Press, 2004), 201–5.

63. Smithson, "Incidents of Mirror-Travel in the Yucatan" (1969), in *Collected Writings,* ed. Flam, 120.

64. Ibid., 123. "Death is also in Arcadia."

65. Erwin Panofsky, "Et in Arcadia Ego: Poussin's Arcadian Shepherds," in *Meaning in the Visual Arts* (Harmondsworth: Penguin, 1970).

66. Smithson, "The Spiral Jetty" (1972), in *Collected Writings,* ed. Flam, 143. Most helpful secondary sources for my reading of the *Spiral Jetty* are Eva Schmidt, "Et in Utah ego: Robert

Smithson's 'Entropologic' Cinema," in *Robert Smithson: Drawings from the Estate* (Munster: Westfälisches Landesmuseum, 1989), 42–65; Eugenie Tsai, *Robert Smithson Unearthed: Drawings, Collages, Writings* (New York: Columbia University Press, 1991); Robert Hobbs, *Robert Smithson's Sculpture* (Ithaca, N.Y.: Cornell University Press, 1981); *Robert Smithson: Early Works* (London: Marlene Eleini Gallery, 1988), with catalogue essay by Paul Wood; Gary Schapiro, *Earthwards: Robert Smithson and Art After Babel* (Berkeley and Los Angeles: University of California Press, 1995); and Elizabeth Childs, "Robert Smithson and Film: The Spiral Jetty Reconsidered," *Arts Magazine*, October 1981, 68–81. (The whole September 1978 issue of *Arts Magazine* is devoted to Smithson's work.) See also a clutch of recent publications, including Ron Graziani, *Robert Smithson: The American Landscape* (Cambridge: MIT Press, 2004), and Jennifer L. Roberts, *Mirror-Travels: Robert Smithson and History* (New Haven: Yale University Press, 2004.

Eva Schmidt was thinking along similar lines to my own when she wrote, in "Et in Utah ego," about the metaphor of the spiral: "As a metaphor for the passage to the netherworld, it embodies the mythological idea of death" (53).

67. Smithson, "The Spiral Jetty," 145.

68. Ibid., 146.

69. Roberts, *Mirror-Travels*, 138, suggests an alternative literary source: Edgar Allan Poe's "A Descent into the Maelström," in *The Complete Tales and Poems of Edgar Allan Poe* (New York: Vintage, 1975), 127–40.

70. Smithson, "The Spiral Jetty," 148.

71. Luis Buñuel and Salvador Dalí, *Un chien andalou* (1929). A more pertinent filmic reference for the conception of *Spiral Jetty* is Chris Marker's extraordi-

nary 1964 film about trauma and death, *La jetée*.

72. Frank O'Hara, *Jackson Pollock* (New York: George Braziller, 1959), 23.

73. Georges Bataille, "Sacrificial Mutilation and the Severed Ear of Vincent Van Gogh," in *Visions of Excess*, 67.

74. It is worth noting that the labyrinth of the Minotaur is usually represented as a circular maze and was thought to lead to the underworld. It became a Christian symbol of hell.

75. This is how I understand Lacan's linking of the death drive and ethics; see *The Ethics of Psychoanalysis*.

76. Lawrence Alloway was quick to note the importance of this moment: "When he gets to the center he pauses, then starts to walk back, a factual, deflationary detail, typical of Smithson's laconic but undeviating anti-idealism." In "Robert Smithson's Development," *Artforum* 11, no. 3 (1973): 52–61; repr. in Alloway, *Topics in American Art Since 1945* (New York: W. W. Norton, 1975).

77. I borrow this phrase from Kaprow's account of "The Legacy of Jackson Pollock."

78. Reynolds persuasively argues that the viewer is supposed to be returned to real time and an awareness of the film's "physical and mechanical framework to produce a filmic version of the 'alienation effect'" (*Robert Smithson*, 223).

79. Craig Owens, "Earthwords," *October* 10 (Fall 1979): 128, repr. in Owens, *Beyond Recognition: Representation, Power, and Culture* (Berkeley and Los Angeles: University of California Press, 1992), 47. See also Schapiro, *Earthwards*, and Lynne Cooke, ed., *Robert Smithson's Spiral Jetty: True Fictions, False Realities* (New York: Dia Art Foundation; Berkeley and Los Angeles: University of California Press, 2005).

80. Schmidt, "Et in Utah ego," 53.

81. Kaprow, "The Legacy of Jackson Pollock."

82. Lacan, "Some Reflections on the Ego," 17.

83. *Rites of Passage: Art at the End of the Century* (London: Tate Gallery, 1995), 23.

Chapter 6

1. I am indebted to lectures given by Mark Cousins at the Architectural Association, London, called "The Psychoanalysis of Architecture" (1990–91). One lecture in the series was titled "Fetishism and Monuments."

2. Sigmund Freud, "Fetishism" (1927), in *Standard Edition*, 21:153 (also in the Pelican Freud Library, vol. 7, *On Sexuality* [Harmondsworth: Penguin, 1977], 345–58).

3. Ibid., 154.

4. Neil Hertz, "Medusa's Head: Male Hysteria Under Political Pressure," *Representations* 4 (Fall 1983): 27, repr. in Hertz, *The End of the Line*. He makes use of Freud's short essay "Medusa's Head" (1940 [1922]) in *Standard Edition*, 18:273–74. Some of the most interesting literature has addressed Holocaust memorials. See James E. Young, *The Texture of Memory: Holocaust Memorials and Meaning* (New Haven: Yale University Press, 1993).

5. O. Mannoni, "Je sais, mais quand même . . . ," in *Clefs pour l'imaginaire, ou l'autre scène* (Paris: Seuil, 1969), 12.

6. Ibid., 11.

7. Ibid., 12.

8. Laura Mulvey, *Fetishism and Curiosity* (Bloomington: Indiana University Press; London: BFI Publications, 1996), 5.

9. See, for example, Mary Kelly's development of the theory of maternal fetishism in *Post-Partum Document*

(London: Routledge and Kegan Paul, 1983). See also Kelly, *Imaging Desire*.

10. This is a one-line synopsis of Mark Cousins's "Fetishism and Monuments" lecture cited above.

11. Slavoj Žižek, *The Sublime Object of Ideology* (London: Verso, 1989), 71.

12. See Freud, "Medusa's Head," 273.

13. Tag Gronberg calls the *Titanic* "a failed symbol of security" in her essay "The Titanic: An Object Manufactured for Exhibition at the Bottom of the Sea." She also has interesting things to say about the film. See Gronberg, *Material Memories: Design and Education,* ed. Marius Kwint and Christopher Breward (Oxford: Berg Publishers, 1999).

14. Scruggs served in the U.S. Army Light Infantry Brigade. Half of the brigade was killed or wounded during 1969–70; Scruggs himself had to be hospitalized for two months. Seeing Michael Cimino's film *The Deer Hunter* (1978) apparently precipitated the nightmare.

15. Thomas Carhart, "The Final Insult," *Houston Chronicle,* October 28, 1981. He recommends, in place of Maya Lin's design, "something white and traditional" and raises the call to "fill the trench in, then plant flowers on top and install the flag and statue." He concludes, "It is time for America to recover the courage of her convictions, to come out of the shadows of Vietnam and reassume her rightful place as the true beacon of liberty in the world today."

16. Marita Sturken, "The Wall, the Screen, and the Image: The Vietnam Veterans Memorial," *Representations* 35 (Summer 1991): 123. See also her book *Tangled Memories: The Vietnam War, the AIDS Epidemic, and the Politics of Remembering* (Berkeley and Los Angeles: University of California Press, 1997), especially chap. 2. See also Robin Wagner-Pacifici and Barry Schwartz,

"The Vietnam Veterans Memorial: Commemorating a Difficult Past," *American Journal of Sociology* 97, no. 2 (1981): 376–420.

17. Jan C. Scruggs and Joel L. Swerdlow, *To Heal a Nation: The Vietnam Veterans Memorial* (New York: Harper and Row, 1985).

18. Jan Scruggs, address to Senate Sub-committee Promoting Counseling Program for Vietnam Veterans, 1976 (VVMF Archive, Library of Congress, Washington, D.C.). The bill was enacted in 1980.

19. Archibald MacLeish, "The Young Dead Soldier," cited in Scruggs and Swerdlow, *To Heal a Nation,* 18.

20. "Design Competition: Judging Criteria," *VVMF News* (Vietnam Veterans Memorial Fund, Inc.). See "What Were the Criteria Required for the Design?" at http://thewall-usa.com/information.asp (accessed October 5, 2006).

21. "Design Competition: Winning Designer's Statement," *VVMF News* (Vietnam Veterans Memorial Fund, Inc.). Repr. in Maya Lin, *Boundaries* (New York: Simon and Schuster, 2000), 4.05.

22. Ibid.

23. Ibid.

24. Maya Lin, letter to VVMF, September 20, 1982 (VVMF Archive, Library of Congress, Washington, D.C.).

25. See Harriet F. Senie, *Contemporary Public Sculpture: Tradition, Transformation, and Controversy* (Oxford: Oxford University Press, 1992), and Harriet F. Senie and Sally Webster, eds., *Critical Issues in Public Art: Content, Context, and Controversy* (New York: HarperCollins, 1992).

26. Cited in Scruggs and Swerdlow, *To Heal a Nation,* 69.

27. Ibid., 147.

28. Donald Kunze, "Architecture as Reading, Virtuality, Secrecy, Monstros-

ity," *Journal of Architectural Education* 41 (Summer 1988): 28.

29. Maya Lin quoted in "Vietnam Veterans Memorial: America Remembers," *National Geographic,* May 1985, 557.

30. Kent Bloomer and Charles Moore, *Body, Memory, Architecture* (New Haven: Yale University Press, 1977), 34.

31. Vincent Scully, "The Terrible Art of Designing a War Memorial," *New York Times,* July 14, 1991, Arts and Leisure section, 28. See also his *The Earth, the Temple, and the Gods: Greek Sacred Architecture,* rev. ed. (New Haven: Yale University Press, 1979).

32. Thomas W. Laqueur, "Memory and Naming in the Great War," in *Commemorations: The Politics of National Identity,* ed. John Gilles (Princeton: Princeton University Press, 1994), 160.

33. Lin, *Boundaries,* 4.12.

34. Laqueur, "Memory and Naming in the Great War," 164. See also Jenny Edkins, "War Memorials: The Cenotaph and the Vietnam Wall," in *Trauma and the Memory of Politics* (Cambridge: Cambridge University Press, 2003), 20–56. She argues that they are exceptional monuments "in that they seem to respond to some desire other than the need to celebrate and re-narrate national glory in the aftermath of the trauma" (108).

35. Maya Lin quoted in Robert Campbell, "An Emotive Place Apart," *American Institute of Architects Journal* 72 (May 1983): 151.

36. Julia Kristeva, *Black Sun: Depression and Melancholia,* trans. Leon S. Roudiez (New York: Columbia University Press, 1989), 9.

37. Robert Smithson, "Fredrick Law Olmsted and the Dialectical Landscape," in *Collected Writings,* ed. Flam, 159.

38. Scruggs, address to Senate, 4. I suspect that Daniel Libeskind's decision to leave a portion of the "slurry wall" exposed as part of the memorial on the site of the World Trade Center was influenced by the example of the Vietnam Veterans Memorial.

39. Smithson, "Fredrick Law Olmsted," 159. The correct reference for this quotation is Uvedale Price, *Essays on the Picturesque as Compared with the Sublime and the Beautiful* (London: Mawman, 1810), 1:195.

40. This has also been noted by Daniel Abramson, "Maya Lin and the 1960s: Monuments, Time Lines, and Minimalism," *Critical Inquiry* 22 (Summer 1996): 703–4.

41. Rosalind Krauss, *Passages in Modern Sculpture* (London: Thames and Hudson, 1977), 282–83. See also Richard Serra, *Writings/Interviews* (Chicago: University of Chicago Press, 1994), for instance: "Changing the content of perception by having viewer and sculpture coexist in the same behavioral space implies movement, time, anticipation, etc." ("Interview with Peter Eisenman," 146).

42. Explaining her initial skepticism about the possibility of working unhindered in the capital, Lin mentions the case of Robert Venturi's and Richard Serra's collaboration on an artwork for L'Enfant Plaza in Washington, D.C., that came to grief (*Boundaries*, 4.12).

43. Jean Fisher, "The Revenants of Time," in *Susan Hiller* (London: Matts Gallery, 1990).

44. Abramson, "Maya Lin and the 1960s," 704.

45. Anna Chave, "Minimalism and the Rhetoric of Power," *Arts Magazine*, January 1990, repr. in Holliday T. Day, ed., *Power: Its Myths and Mores in American Art, 1961–91* (Indianapolis: Indianapolis Museum of Art, 1991), 126.

Also repr. in F. Frascina and J. Harris, *Art in Modern Culture: An Anthology of Critical Texts* (London: Phaidon in association with the Open University, 1992). For readings of Minimalism more in keeping with Fisher's remarks, see Fer, *On Abstract Art*.

46. See the index of Smithson, *Collected Writings*, ed. Flam, 159, and my Chapter 5 on Smithson and the death drive. Morris, "Some Notes on the Phenomenology of Making," 81.

47. Serra, *Writings/Interviews*, 112.

48. Freud, "Mourning and Melancholia" (1917 [1915]), in *Standard Edition*, 14:255 (also in the Pelican Freud Library, vol. 11, *On Metapsychology*, 265).

49. Ibid., 258. Martin Jay makes some interesting comments on this topic in "Against Consolation: Walter Benjamin and the Refusal to Mourn," in *War and Remembrance in the Twentieth Century*, ed. Jay Winter and Emmanuel Sivan (Cambridge: Cambridge University Press, 1999).

50. Barthes, *Camera Lucida*.

51. Žižek, *The Sublime Object of Ideology*, 49.

52. See Chapter 4 on the missed encounter and trauma.

53. Phil McCombs, "Maya Lin and the Great Call of China: The Fascinating Heritage of the Student Who Designed the Vietnam Memorial," *Washington Post*, January 3, 1982, F9.

54. Žižek, *The Sublime Object of Ideology*, 49.

55. Gillian Rose, *Mourning Becomes the Law: Philosophy and Representation* (Cambridge: Cambridge University Press, 1996), 103.

56. G. W. F. Hegel, *The Phenomenology of Mind* (1801), trans. J. B. Baillie (London: George Allen and Unwin; New York: Humanities Press, 1971), 667–67.

57. Lin quoted in "Vietnam Veterans Memorial: America Remembers," 557.

58. Abramson, "Maya Lin and the 1960s," 702.

59. Sturken, "The Wall, the Screen, and the Image," 12.

60. Sigmund Freud, "A Note upon the 'Mystic Writing-Pad'" (1925), in *Standard Edition*, 19:227–34.

61. An interesting critique of Freud's view of the ideal of mourning can be found in Kathleen Woodward, "Freud and Barthes: Theorizing Mourning and Sustaining Grief," *Discourse* 13, no. 1 (1990–91). Michael Ann Holly is developing a way of thinking about the practice of art history as a kind of anti-mourning or melancholia. See, for example, her essay "Mourning and Method," *The Art Bulletin* 84 (December 2002): 660–69.

62. Freud, *Five Lectures on Psychoanalysis* (1910), in *Standard Edition*, 11:16–17.

63. This passage from Freud is discussed by Peter Homans in *The Ability to Mourn: Disillusionment and the Social Origins of Psychoanalysis* (Chicago: University of Chicago Press, 1989).

64. See the wide-ranging discussion of this issue and useful references provided by the introduction to Young, *The Texture of Memory*.

65. Jay Winter, *Sites of Memory, Sites of Mourning: The Great War in European Cultural History* (Cambridge: Cambridge University Press, 1995), 115. See also *Memory and Oblivion: Proceedings of the 29th International Congress of the History of Art*, ed. Wessell Reinink and Jeroen Stumpl (Boston: Kluwer, 1999).

66. See especially "Infantile Anxiety Situations Reflected in a Work of Art" and "Mourning and Its Relation to Manic-Depressive States," in *Selected Melanie Klein*, ed. Mitchell. For a development of this idea in relation to the art

of the 1960s, see Briony Fer, "Bordering on Blank: Eva Hesse and Minimalism," in "Psychoanalysis in Art History," ed. Margaret Iversen, special issue, *Art History* 17, no. 3 (1994), repr. in chap. 6 of Fer, *On Abstract Art*. See also Nixon, *Fantastic Reality*.

67. Hanna Segal, "A Psychoanalytical Approach to Aesthetics," in *New Directions in Psychoanalysis*, ed. Melanie Klein et al. (London: Tavistock Publications, 1955).

68. Martin Golding, "Memory, Commemoration, and the Photograph," *Modern Painters* 12, no. 1 (1999): 95. This essay, principally about the work of Christian Boltanski, contrasts the anonymity of his "memorials" to the victims of the Holocaust with Maya Lin's monument.

69. Jacques Lacan, "Desire and the Interpretation of Desire in Hamlet," in *Literature and Psychoanalysis: The Question of Reading: Otherwise,* ed. Shoshana Felman (Baltimore: Johns Hopkins University Press, 1982), 38. Originally published as *Yale French Studies* 55–56 (1977).

70. Ibid., 38, 40.

Chapter 7

1. Barthes, *Camera Lucida*. Subsequent page references to *Camera Lucida* (hereafter abbreviated *CL*) will appear in the text.

2. The text is in the Institut mémoires de l'édition contemporaine, Paris. It is inscribed by Lacan as follows: "Plaisir du texte: vous connaissez, —*moi* j'aime. À l'occasion de qui j'envoi mon 'truc' à Roland Barthes. Le 20 II 73. Jacques Lacan" (Pleasure of the text: you know—I love it. On the occasion when I send my "thing" to Roland Barthes). The clusters of marginal marks Barthes made in this copy fall on pages 64–68, 81–86, 118–19, and 133–34.

3. Jean-Paul Sartre, *L'imaginaire: Psychologie phénoménologique de l'imagination* (Paris: Gallimard, 1940), translated as *The Psychology of the Imagination* (London: Methuen, 1972). *Camera Lucida* (19–20) quotes a long passage from this book, the burden of which is that it is quite possible to regard the things represented as unreal. For Barthes, photographs with a punctum escape this fate. Jean-Michel Rabaté regards this text as the "philosophical foundation" of *Camera Lucida*. See Rabaté, ed., *Writing the Image After Roland Barthes* (Philadelphia: University of Pennsylvania Press, 1997).

4. This point is stressed in Derrida's homage to Barthes, written shortly after his death, titled "The Deaths of Roland Barthes," in *Philosophy and Non-Philosophy,* ed. Hugh J. Silverman (New York: Routledge, 1988), 281. See also Johnnie Gratton, who stresses the illogical conjunction, or paradox, of "here" and "past" characteristic of Barthes's understanding of the photograph. Reference, he says, "can never be separated from a certain loss or absence" in *Camera Lucida*. See Gratton, "Text, Images, Reference in Roland Barthes's *La chambre claire*," *Modern Language Review* 91 (1996): 356. Michael Fried's interesting essay "Barthes' Punctum" puts stress on the photographer's lack of intentionality with respect to the punctum, and he connects this with his own concept of absorptive painting. The essay appeared in *Critical Inquiry* 31 (Spring 2005): 539–74.

5. Roland Barthes, *The Pleasure of the Text,* trans. Richard Miller (New York: Hill and Wang, 1975). See also Bataille, *Eroticism*, and J. Mitchell and J. Rose, eds., *Feminine Sexuality: Jacques Lacan and the École freudienne,* trans. J. Rose (London: Macmillan, 1982). The conception of *jouissance* was also Lacanian, but owed much to Bataille's theories of eroticism.

6. Freud, *Beyond the Pleasure Principle*. See also helpful discussions of the pleasure principle, the death drive, and related concepts in Laplanche and Pontalis, *The Language of Psychoanalysis*.

7. Freud, *Beyond the Pleasure Principle*, 42–43.

8. "Le réel est *au-delà* de l'automaton," he writes, echoing the French term for "beyond" in the French translation of *Beyond the Pleasure Principle*. Several writers make the connection between the punctum and the Lacanian real but do not develop the idea: see Victor Burgin, "Re-reading *Camera Lucida*," in *The End of Art Theory: Criticism and Postmodernity* (London: Macmillan, 1986), 71–95, and Michael Moriarty, *Roland Barthes* (London: Polity, 1991), 204ff. Some commentators do not make any reference to Lacan: Nancy M. Shawcross, *Roland Barthes on Photography: The Critical Tradition in Perspective* (Gainesville: University Press of Florida, 1997); Gilles Mora, ed., *Roland Barthes et la photo: Le pire des signes* (Paris: Contrejour, 1990). See also Ulrich Baer, *Spectral Evidence: The Photography of Trauma* (Cambridge: MIT Press, 2002); Carol Armstrong, *Scenes in a Library: Reading the Photograph in the Book* (Cambridge: MIT Press, 1998); and Eduardo Cadava, *Words of Light: Theses on the Photography of History* (Princeton: Princeton University Press, 1997), all of which are about or influenced by Barthes's book.

9. Jacques Lacan, "The Subversion of the Subject," in *Écrits: A Selection*, ed. Sheridan, 130.

10. Freud, "The 'Uncanny.'" See Chapter 2.

11. Freud, *The Interpretation of Dreams,* 4:509–11, 533–34, and Lacan, *FFC,* 34, 56–60.

12. I discuss the dream of the burning child in Chapter 4.

13. Freud, *Beyond the Pleasure Principle,* 14–17. The child was his daughter Sophie's son, who tragically died around the time of his writing this book. On the effects of this loss, see Bronfen, *Over Her Dead Body,* 15ff.

14. Hal Foster has dubbed this "traumatic realism." See his "Death in America," *October* 75 (Winter 1996): 37–60, and "The Return of the Real," in *The Return of the Real,* 127–70.

15. Also see Benjamin, "A Small History of Photography," in *One-Way Street and Other Writings,* trans. Edmund Jephcott and Kingsley Shorter (London: Verso, 1979), 240–57. Barthes does mention Benjamin's "premonitory" "Work of Art" essay on photography in an interview from the late 1970s: see "On Photography" (1980), in Barthes, *The Grain of the Voice: Interviews, 1962–1980,* trans. Linda Coverdale (Berkeley and Los Angeles: University of California Press, 1985), 354. "Little History" was first translated into French in 1971. Another text important for Barthes, but not discussed here, was Susan Sontag, *On Photography* (London: Penguin, 1978).

16. The pictures were, in fact, the product of collaboration between Hill and Robert Adamson. See Mary Price, *The Photograph: A Strange Confined Space* (Stanford: Stanford University Press, 1994), 37.

17. Benjamin, "Little History," 510.

18. Ibid. "Little History" is translated as "Petite histoire de la photographie" in *Études photographiques* 1 (November 1996) at http://etudesphotographiques.

revues.org/document99.html (accessed October 5, 2006). The scholarly footnotes (15 and 16) point out that the woman in the picture is in fact Karl Dauthendey's second wife, so it would seem that Benjamin has projected something quite "fantasmatic" onto the young woman's expression.

19. Ibid., 510.

20. Krauss, *The Optical Unconscious,* 178–79. See particularly her chap. 2 for a critical use of Lacan's theory of visuality. Her sense of the phrase, like mine, has to do with the way in which artists find, in the visual field, an unconscious reality repressed or foreclosed in conscious thought.

21. Andrew Brown, *Roland Barthes: The Figures of Writing* (Oxford: Clarendon Press, 1992), 236–84. There are many monographs devoted to Barthes. I will mention only Annette Lavers, *Roland Barthes: Structuralism and After* (London: Methuen, 1982); Moriarty, *Roland Barthes;* Steven Ungar, *Roland Barthes: The Professor of Desire* (Lincoln: University of Nebraska Press, 1983). See also Martin Jay, *Downcast Eyes: The Denigration of Vision in Twentieth-Century French Thought* (Berkeley and Los Angeles: University of California Press, 1993), which has chapters devoted to Lacan and Barthes. For an excellent collection of critical essays, see Diana Knight, ed., *Critical Essays on Roland Barthes* (New York: G. K. Hall, 2000).

22. Freud, "From the History of an Infantile Neurosis."

23. Roland Barthes, *A Lover's Discourse: Fragments,* trans. Richard Howard (New York: Hill and Wang, 1978).

24. Brown, *Roland Barthes,* 275–77.

25. Benjamin, "Little History of Photography," 517; Benjamin, "A Small History of Photography," 248.

26. Brown, *Roland Barthes,* 270; Sigmund Freud, *Moses and Monotheism: Three Essays* (1939), in *Standard Edition,* 23:3–132 (also in the Pelican Freud Library, vol. 13, *The Origins of Religion* [London: Penguin, 1990], 237–386).

27. Barthes uses the term "blind field" on page 57 of *CL*. For an extended discussion of the concept, see Bonitzer, *Le champ aveugle.* See my Chapter 2 on Hopper and the blind field of painting. I originally wrote on the blind field in Edward Hopper's work in "In the Blind Field: Hopper and the Uncanny," *Art History* 21, no. 3 (1998): 409–29.

28. Jane Gallop, *Thinking Through the Body* (New York: Columbia University Press, 1980), 151–55. See Norman Bryson's distinction in the chapter called "The Gaze and the Glance" of his *Vision and Painting,* which has affinities with Barthes's studium/punctum.

29. Roland Barthes, "The Third Meaning: Research Notes on Some Eisenstein Stills," *Image/Music/Text,* trans. Stephen Heath (London: Fontana, 1977), 52–68. The theory of the punctum is more nearly approximated in a still earlier essay on photography, "The Photographic Message" (1961), where Barthes considers the possibility of a photograph without connotation: "If such a [pure] denotation exists, it is perhaps not at the level of what ordinary language calls the insignificant, the neutral, the objective, but, on the contrary, at the level of absolutely traumatic images" (in *Image/Music/Text,* 30).

30. Julia Kristeva, *Revolution in Poetic Language* (1974), trans. Margaret Waller (New York: Columbia University Press, 1984), 17. See Burgin, "Re-reading Camera Lucida," and his discussion of photography and *significance* (71–95).

31. Maurice Merleau-Ponty, *The Visible and the Invisible,* ed. Claude Lefort,

trans. Alphonso Lingis (Evanston, Ill.: Northwestern University Press, 1968), 130–55.

32. This is why the punctum is so volatile and subject to displacements. See Margaret Olin, "Touching Photographs: Roland Barthes's 'Mistaken' Identification," *Representations* 80 (Fall 2002): 99–118.

33. *CL*, 27; *La chambre claire*, 49.

34. Malcolm Bowie, *Lacan* (London: Fontana, 1991), 169; Frank Stella, *Working Space* (Cambridge: Harvard University Press, 1986), 6–9. Bataille's notion of "la tache aveugle" is also relevant here. See Denis Hollier's illuminating discussion of it in *Against Architecture: The Writings of Georges Bataille*, trans. Betsy Wing (Cambridge: MIT Press, 1989), 94–98. See also Hollier's article on surrealist indexicality in "Surrealist Precipitates: Shadows Don't Cast Shadows," *October* 69 (Summer 1994): 111–32.

35. See my critique of this one-sided reception of the mirror stage in Chapter 3 on Dalí and paranoia.

36. Joan Copjec reads the analysis of vision (and particularly the "sardine can" anecdote) in *The Four Fundamental Concepts* as a revised version of the mirror stage, which in some ways it clearly is. I am concerned, however, to preserve as distinct moments the mirror stage and the subject's relation to the real in the visible, even if there are overlaps. Copjec, "The Orthopsychic Subject," 15–38. The anecdote is an interesting variation on the famous one told by Sartre in *Being and Nothingness* (to which Lacan refers), where a voyeur bent over a keyhole thinks he hears footsteps and is covered in shame. Jean-Paul Sartre, *Being and Nothingness: An Essay on Phenomenological Ontology*, trans. Hazel Barnes (London: Methuen, 1957), pt. 3, chap. 1, IV, "The Look," 252–302.

On this, see Stephen Melville, "Division of the Gaze, or, Remarks on the Color and Tenor of Contemporary 'Theory,'" in *Seams: Art as a Philosophical Context* (Amsterdam: G&B Arts International, 1996), 111–29.

37. Lacan, *Écrits*, 315.

38. Roger Caillois, "Mimicry and Legendary Psychasthenia," trans. John Shepley, *October* 31 (Winter 1984): 17–32, repr. in *October: The First Decade, 1976–1986*, ed. Annette Michelson, Rosalind Krauss, Douglas Crimp, and Joan Copjec (Cambridge: MIT Press, 1987), 58–75 (citation on 70). Originally published as "Mimétisme et psychasthénie légendaire," *Minotaure* 7 (June 1935). See also Caillois, *Méduse et Cie*. For an interesting commentary, see Denis Hollier, "Mimesis and Castration, 1937," *October* 31 (1984): 3–15. Rosalind Krauss also makes this connection in her essay "Corpus Delicti" in *L'amour fou: Photography and Surrealism* (London: Hayward Gallery, 1986), 57–144.

39. This strand of thought is part of Barthes's Lacanian inheritance, which in turn is informed by Heidegger's conception of authentic being as being toward death. See Dollimore's excellent *Death, Desire, and Loss*.

40. Krauss, *The Optical Unconscious*, 33.

41. For a quite different interpretation of Lacan on painting, which confines it to the Apollonian function, see Jonathan Scott Lee, *Jacques Lacan* (Boston: Twayne Publishers, 1990), 159–61.

42. I am sorry to see that recent English editions of the book do not include the photograph by Daniel Boudinet from 1979 called *Polaroid*.

Chapter 8

1. Rosalind Krauss, "Reinventing 'Photography,'" in *The Promise of Pho-*

tography: The DG Bank Collection, ed. Liminita Sabau (Munich: Prestel, 1998).

2. Walter Benjamin, "The Work of Art in the Age of Its Technological Reproducibility: Second Version" (1936), in *Selected Writings*, vol. 3, ed. Howard Eiland and Michael W. Jennings, trans. Edmund Jephcott, Howard Eiland, et al. (Cambridge: Belknap Press of Harvard University Press, 2002), 101–33. For a reading of the Artwork essay that emphasizes Benjamin's ambivalence in relation to aura, see Miriam Hansen, "Benjamin, Cinema, and Experience: 'The Blue Flower in the Land of Technology,'" *New German Critique* 40 (Winter 1987): 179–224. I also recommend Diarmuid Costello, "Aura, Face, Photography: Re-reading Benjamin Today," in *Walter Benjamin and Art*, ed. Andrew Benjamin (London: Continuum, 2005), 164–84.

3. Barthes was well aware of this. In a late interview, he observed: "Photography displaces, shifts the notion of art" (Barthes, "On Photography," 360).

4. Foster, "Return of the Real," 127–70. This is an extended version of an essay devoted to Warhol: Foster, "Death in America." For an interesting critique of Foster, see Peggy Phelan, "Andy Warhol: Performances of *Death in America*," in *Performing the Body, Performing the Text*, ed. Amelia Jones and Andrew Stephenson (London: Routledge, 1999), 223–37.

5. For a commentary on Benjamin's aesthetics of shock, see Susan Buck-Morss, "Aesthetics and Anaesthetics: Walter Benjamin's Artwork Essay Reconsidered," *October* 62 (1992): 3–41.

6. Louis Althusser, *Lenin and Philosophy and Other Essays*, trans. Ben Brewster (London: New Left Books, 1971). See particularly "Freud and Lacan" (originally published in the French Communist Party journal *La nouvelle*

critique) and "Ideology and Ideological State Apparatuses." For a helpful overview of film theorists' appropriation of Althusserian critique of ideology, see David N. Rodowick, *The Crisis of Political Modernism: Criticism and Ideology in Contemporary Film Theory* (Berkeley and Los Angeles: University of California Press, 1994).

7. Althusser, *Lenin and Philosophy*, 161.

8. Baudry, "Ideological Effects," 286. This work was first published in *Cahiers du cinéma* in 1970. See the four volumes of translated essays from *Cahiers du cinéma* published by Routledge and the British Film Institute.

9. Baudry, "Ideological Effects," 292, 294, 295, 296.

10. Christian Metz, "The Imaginary Signifier," in *Psychoanalysis and Cinema: The Imaginary Signifier*, trans. Celia Britton (London: Macmillan, 1982), 4; first English publication in *Screen* 16, no. 2 (1975): 14–76.

11. Ibid., 53.

12. See Constance Penley, *The Future of an Illusion: Film, Feminism, and Psychoanalysis* (Minneapolis: University of Minnesota Press, 1989), especially chap. 1.

13. Mulvey, "Visual Pleasure and Narrative Cinema," 14–26.

14. Ibid., 25.

15. See Baudrillard, "The Precession of Simulacra." Baudrillard comments on Warhol's work as follows: "The multiple replicas of Marilyn's face are there to show at the same time the death of the original and the end of representation" ("The Orders of the Simulacrum," *Simulations*, 136). Krauss aims to drive a wedge between the reception of Sherman's Film Stills in terms of simulacral images and Mulvey's psychoanalytic reading, but as this brief history of film theory demonstrates, the idea of the imaginary and its pleasures links them. The imaginary in Lacan can be interpreted as a tissue of already known stereotypes. Lacan's later reference to Joan Riviere's idea of the "masquerade" of femininity offers another bridge between the idea of simulation and the psychoanalytic-feminist reading.

16. Crimp, "Pictures," 87.

17. Crimp, "Photographic Activity of Postmodernism," 99. It is interesting to note that this key text on the simulacral image was published in the same year as Barthes's *Camera Lucida*.

18. Crimp raised doubts about the critical effectiveness of this kind of photographic practice in his essay "Appropriating Appropriation" in *Image Scavengers* (Philadelphia: Institute of Contemporary Art, University of Pennsylvania, 1982). See also Abigail Solomon-Godeau's analysis of the institutional and commercial absorption of a critical postmodernist photographic practice in "Living with Contradictions: Critical Practices in the Age of Supply-Side Aesthetics," in *Photography at the Dock: Essays on Photographic History, Institutions, and Practices* (Minneapolis: University of Minnesota Press, 1991), 124–48, and Carol Squires, ed., *The Critical Image: Essays on Contemporary Photography* (Seattle: Bay Press, 1990), 59–79.

19. Rosalind Krauss, *Cindy Sherman, 1975–1993*, with an essay by Norman Bryson (New York: Rizzoli, 1993), 32. See also her "Note on Photography and the Simulacral."

20. Amelia Jones, "Survey," in Tracy Warr and Amelia Jones, *The Artist's Body* (London: Phaidon, 2000), 37.

21. Krauss, *Cindy Sherman*, 20.

22. Peggy Phelan ties the surface pose of femininity to the very nature of photography: "neither admit to the singular." "Developing the Negative: Mapplethorpe, Schor, and Sherman," in *Unmarked: The Politics of Performance* (London: Routledge, 1993), 34–70.

23. Jacques Lacan, *The Seminar of Jacques Lacan, Book III: The Psychoses, 1955–1956*, ed. Jacques-Alain Miller, trans. Russell Grigg (London: Routledge, 1993), 179.

24. Peter Dews, "The Tremor of Reflection: Slavoj Žižek's Lacanian Dialectics," *Radical Philosophy* 72 (July–August 1995): 29, repr. in *The Limits of Disenchantment: Essays on Contemporary European Philosophy* (London: Verso, 1995), 236–58.

25. Dews, *Logics of Disintegration*, 110.

26. Bowie, *Lacan*, 168.

27. Roland Barthes, "The Death of the Author," in *Image, Music, Text*, 142–48.

28. Dews, *Logics of Disintegration*, 90. Dews gives particular emphasis to Jean-François Lyotard, especially his *Discours, figure* (Paris: Klincksieck, 1978).

29. Merleau-Ponty, *The Phenomenology of Perception*, trans. Colin Smith (London: Routledge and Kegan Paul, 1962), 184.

30. In Roland Barthes, *The Responsibility of Forms: Critical Essays on Music, Art, and Representation*, trans. Richard Howard (New York: Hill and Wang, 1985), see "Masson's Semiography," 153–56; "Cy Twombly: Works on Paper," 157–76; and "The Wisdom of Art," 177–94. Also see Margaret Iversen, "Barthes on Art," in *A Companion to Art Theory*, ed. Paul Smith and Carolyn Wilde (Oxford: Blackwell, 2002), 327–36.

31. Roland Barthes, "That Old Thing, Art . . . ," in *The Responsibility of Forms*, 204–5. Foster cites this text as an exemplary simulacral reading of Warhol,

but Barthes sets forth that view only in order to critique it. See Foster, "Death in America," and Foster, "Return of the Real."

32. Merleau-Ponty, *The Visible and the Invisible*. See especially chap. 4, "The Intertwining—The Chiasm."

33. Although delivered in 1964, Seminar XI, *The Four Fundamental Concepts*, was not published in French until 1973 and remained untranslated into English until 1977.

34. André Bazin, "The Ontology of the Photographic Image," in *Classic Essays on Photography*, ed. Alan Trachtenberg (New Haven: Yale University Press, 1980), 237–44, and in Bazin, *What Is Cinema?* 1:9–6. Barthes refers to Bazin on page 15 of *CL*. See for example, Peter Wollen, "'Ontology' and 'Materialism' in Film," *Screen* 17, no. 1 (1976): 19–75, repr. in *Readings and Writings: Semiotic Counter-strategies* (London: Verso, 1982). Victor Burgin discusses the strange omission of Bazin's article in Barthes's bibliography. See "Barthes's Discretion" in *Writing the Image*, ed. Rabaté, 19–31.

35. *Communications* 23 (1975), a special issue devoted to "Psychanalyse et cinéma," contains no reference to Seminar XI. Freud's *Interpretation of Dreams* and Lacan's "Mirror Stage," however, are frequently cited.

36. Stephen Heath, "Narrative Space," in *Questions of Cinema* (Bloomington: Indiana University Press, 1981). Originally published in *Screen* 17, no. 1 (1976). For a discussion of this article, see Rodowick, *The Crisis of Political Modernism*, 1994), especially 180–220. Heath does refer to Seminar XI in "Screen Images, Film Memory," *Edinburgh '76 Magazine* 1 (1976): 33–44.

37. Heath, "Narrative Space," 24.

38. Ibid., 100.

39. Rodowick, *Crisis of Political Modernism*, stresses Heath's point that the discontinuities and asymmetries are used by classical cinema to reinforce stability. He also argues for the importance of Julia Kristeva's work for Heath, which I am sure is right, but he does not indicate the relevance of Lacan's discussion of perspective and anamorphosis for reading "Narrative Space."

40. Laura Mulvey, "Cosmetics and Abjection: Cindy Sherman, 1977–87," in *Fetishism and Curiosity*, 76.

41. See Krauss, *Cindy Sherman*.

42. Bryson, "House of Wax," in ibid., 220–21.

43. Norman Bryson, "The Ideal and the Abject: Cindy Sherman's Historical Portraits," *Parkett* 29 (1991): 92.

44. The recent Clown series from 2003 pushes overall artifice to a new level, as the backdrops are digitally generated.

45. This transition is, in some ways, a recapitulation of the one outlined by Rosalind Krauss in her "Notes on the Index: Parts I and II" (1977), repr. in Krauss, *The Originality of the Avant-Garde and Other Modernist Myths* (Cambridge: MIT Press, 1985), 196–220. The artistic conditions were also similar. In the early 1970s, Pop and Minimalism gave way to a range of works exploring the indexical dimension of signification. Krauss utilizes the Lacanian distinction between the imaginary and symbolic, aligning the index with the regressive imaginary realm. Indexical modes of representation like the photograph are, she says, "sub- or pre-symbolic, ceding the language of art back to the imposition of things" (203). My argument aligns the index with the Lacanian real and the (missed) encounter. Yet this connection with Post-Minimalism explains why the later generation of artists found

inspiration in the work of some of the artists Krauss discusses, notably Gordon Matta-Clark. Krauss also relates the work to the photographic "having-been-there," citing Barthes's "Rhetoric of the Image" (217).

46. Fredric Jameson writes of Duane Hansen's hyperrealist wax figures in terms of the simulacrum and invokes Sartre's sense of "the *derealization* of the whole surrounding world of everyday reality." In *Postmodernism, or, The Cultural Logic of Late Capitalism* (London: Verso, 1991), 34.

47. Caillois, *The Mask of the Medusa*.

48. Foster, "Return of the Real," 140.

49. Kaja Silverman, *The Threshold of the Visible World* (New York: Routledge, 1996). She is admittedly attempting to introduce a historical element into Lacan's schema (135). Her chap. 6, "The Screen," also turns on analyses of Sherman's Film Stills.

50. "Play" is a loaded term in the history of aesthetics. Friedrich Schiller's *On the Aesthetic Education of Man*, trans. Reginald Snell (London: Routledge and Kegan Paul, 1954), turns on the ideas of semblance, play, and freedom from natural constraint. Caillois cites Schiller approvingly in *Les jeux et les hommes: Le masque et le vertige*, rev. ed. (Paris: Gallimard, 1967), 311–12.

51. Roger Caillois, *Méduse et Cie*, 23, 97, 21, 121.

52. Ibid., 127.

53. Several commentators relate these passages to Caillois's "Mimicry and Legendary Psychasthenia" rather than *The Mask of the Medusa*, which has a distorting effect upon their interpretations.

54. Caillois, *Méduse et Cie*, 23.

55. Another source for Lacan's idea of the screen was Merleau-Ponty, who

writes of the impossibility of separating the physical manifestation of art from the idea that a certain arrangement of colors evokes: "There is no vision without the screen." Merleau-Ponty, *The Visible and the Invisible*, 150.

56. In an early essay, Dalí praises "the anaesthetic gaze of the naked, lashless eye of Zeiss." Salvador Dalí, "Photography: Pure Creation of the Mind," in *Oui: The Paranoid-Critical Revolution*, ed. Descharnes, 13.

57. The relevant passage in Sartre is in *The Psychology of Imagination*. Barthes cites it on page 19 of *CL*. Brian Grosskurth comments interestingly on Sartre and Barthes on the image in "Lartigue and the Politics of Enchantment," in *The Aesthetics of Enchantment in the Fine Arts*, ed. M. Kronegger and A. T. Tymieniecka, Analecta Husserliana 65 (Dordrecht: Kluwer, 2000), 101–12.

58. Sartre, *The Psychology of Imagination*, 34.

59. Benjamin H. D. Buchloh, "Refuse and Refuge," in *Gabriel Orozco*, ed. M. Catherine de Zegher (Kortrijk, Belgium: The Kanaal Art Foundation, 1993), 43.

60. Ibid., 51. In the same catalogue, Jean Fisher notes Orozco's insistence on the sentient body, which "goes against the grain of the dominant Euro-American aesthetic debates of the past decade, in which 'reality' disappeared into Jean Baudrillard's 'hyperreal' to emerge as the infinity of mirrors that is simulation." See Fisher, "The Sleep of Wakefulness," 16.

61. Molly Nesbit discussed precisely this point at a conference called "Photography in the Post-Medium Age," organized by Margaret Iversen and Briony Fer (Tate Modern, June 2001), where this chapter was also originally read. See her article and others in *Gabriel Orozco* (Los Angeles: The Museum of Contemporary Art, 2000). She has also written a catalogue essay, "Walking to Work," for an Orozco exhibition called Trabajo (Paris: Galerie Chantal Crousel, 2003). See the catalogue of Photogravity, an Orozco exhibition at the Philadelphia Museum of Art from 1999, that reproduces pages of his journal. See also the interview conducted by Buchloh printed in the exhibition catalogue *Clinton Is Innocent* (Paris: Musée de l'art moderne de la ville de Paris, 1998).

62. Caillois linked fashion and mimicry in *The Mask of the Medusa*, describing it as "an obscure contagion of fascination with a model which is imitated for no real reason" (75).

63. For an extended account of this piece, see my "Visualizing the Unconscious: Mary Kelly's Installations," in *Mary Kelly*, ed. Iversen, Crimp, and Bhabha, 32–85. See also Kelly, *Imaging Desire*.

64. Michel Chion describes Lumberton as "a surface, but with only one side, not a recto with a verso. It is a façade with nothing to hide, not even nothingness." In Chion, *David Lynch*, trans. Robert Julien (London: British Film Institute, 1995), 83.

65. The reference here to surrealist, specifically Dalían, imagery is patent.

66. See Kelley, *The Uncanny*, and my review in the online journal *Papers of Surrealism* 3 (2005) at http://www.surrealismcentre.ac.uk/publications/papers/journal3/index.htm.

67. Laura Mulvey, "The Index and the Uncanny," in *Time and the Image*, ed. Carolyn Gill (Manchester: Manchester University Press, 2001), repr. in Mulvey, *Death 24x a Second*, 54–67. See also her psychoanalytic reading of *Blue Velvet* in "Netherworlds of the Unconscious: Oedipus and *Blue Velvet*," in *Fetishism and Curiosity*, 54–67.

Bibliography

Abramson, Daniel. "Maya Lin and the 1960s: Monuments, Time Lines, and Minimalism." *Critical Inquiry* 22 (Summer 1996).

Adams, Laurie Schneider. *Art and Psychoanalysis.* New York: HarperCollins, 1993.

Adams, Parveen. "The Art of Analysis: Mary Kelly's *Interim* and the Discourse of the Analyst." In *The Emptiness of the Image: Psychoanalysis and Sexual Differences.* London: Routledge, 1996.

———, ed. *Art: Sublimation or Symptom.* London: Karnac, 2003.

———. *The Emptiness of the Image: Psychoanalysis and Sexual Differences.* London: Routledge, 1996.

Ades, Dawn. *Dalí.* London: Thames and Hudson, 1982.

———, ed. *Dalí's Optical Illusions.* Hartford: Wadsworth Atheneum Museum of Art; New Haven: Yale University Press, 2000.

———. "Morphologies of Desire." In *Salvador Dalí: The Early Years,* edited by Michael Raeburn. London: The South Bank Centre, 1994.

Ades, Dawn, and Fiona Bradley, eds. *Salvador Dalí: A Mythology.* London: Tate Publishing, 1999.

Alloway, Lawrence. "Robert Smithson's Development." *Artforum* 11, no. 3 (1973).

———. *Topics in American Art Since 1945.* New York: W. W. Norton, 1975.

Althusser, Louis. *Essays on Ideology.* London: Verso, 1984.

———. *Lenin and Philosophy and Other Essays.* Translated by Ben Brewster. London: New Left Books, 1971.

Anfam, David. "Edward Hopper—Recent Studies." *Art History* 4, no. 4 (1981).

Armstrong, Carol. *Scenes in a Library: Reading the Photograph in the Book.* Cambridge: MIT Press, 1998.

Arnheim, Rudolf. *Art and Visual Perception: A Psychology of the Creative Eye.* London: Faber and Faber, 1956.

Baer, Ulrich. *Spectral Evidence: The Photography of Trauma.* Cambridge: MIT Press, 2002.

Barthes, Roland. *Camera Lucida: Reflections on Photography.* Translated by Richard Howard. New York: Hill and Wang, 1981.

———. *La chambre claire.* Paris: Gallimard, 1992.

———. *The Grain of the Voice: Interviews, 1962–1980.* Translated by Linda Coverdale. Berkeley and Los Angeles: University of California Press, 1985.

———. *Image/Music/Text.* Translated by Stephen Heath. London: Fontana, 1977.

———. *A Lover's Discourse: Fragments.* Translated by Richard Howard. New York: Hill and Wang, 1978.

———. *The Pleasure of the Text.* Translated by Richard Miller. New York: Hill and Wang, 1975.

———. *The Responsibility of Forms: Critical Essays on Music, Art, and Representation.* Translated by Richard Howard. New York: Hill and Wang, 1985.

Bataille, Georges. *Eroticism.* Translated by Mary Dalwood. London: Boyars, 1987.

———. *Eroticism.* Translated by Mary Dalwood. With an introduction by Colin MacCabe. London: Penguin, 2001.

———. *Visions of Excess: Selected Writings, 1927–1939.* Translated by Allan Stoekl. Manchester: Manchester University Press, 1985.

Batchelor, David. "A Strange Familiarity." In *Rachel Whiteread: Plaster Sculpture.* London: Karsten Schubert Gallery, 1993.

Baudrillard, Jean. "The Precession of Simulacra." In *Simulations,* translated by Paul Foss, Paul Patton, and Philip Beitchman. New York: Semiotext(e), 1983.

Baudry, Jean-Louis. "Ideological Effects of the Basic Cinematographic Apparatus." In *Narrative, Apparatus, Ideology: A Film Reader,* edited by Philip Rose. New York: Columbia University Press, 1986.

Baxandall, Michael. *Painting and Experience in Fifteenth-Century Italy.* Oxford: Clarendon Press, 1972.

Bazin, André. "The Ontology of the Photographic Image." In *Classic Essays on Photography,* edited by Alan Trachtenberg. New Haven: Yale University Press, 1980.

———. *What Is Cinema?* Berkeley and Los Angeles: University of California Press, 1967.

Beckly, Bill, and David Schapiro. *Uncontrollable Beauty: Towards a New Aesthetics.* New York: Allworth Press, 1998.

Benjamin, Walter. *Illuminations.* Edited by Hannah Arendt. Translated by Harry Zohn. London: Fontana Collins, 1973.

———. "Little History of Photography." In *Selected Writings,* vol. 2, edited by Michael W. Jennings, Howard Eiland, and Gary Smith, translated by Rodney Livingstone et al. Cambridge: Belknap Press of Harvard University Press, 1999.

———. "On Some Motifs in Baudelaire." In *Selected Writings,* vol. 4, edited by Howard Eiland and Michael W. Jennings. Cambridge: Belknap Press of Harvard University Press, 2003.

———. "A Small History of Photography." In *One-Way Street and Other Writings,* translated by Edmund Jephcott and Kingsley Shorter. London: Verso, 1979.

———. "The Work of Art in the Age of Its Technological Reproducibility: Second Version." In *Selected Writings,* vol. 3, edited by Howard Eiland and Michael W. Jennings, translated by Edmund Jephcott, Howard Eiland, et al. Cambridge: Belknap Press of Harvard University Press, 2002.

Berressem, Hanjo. "Dalí and Lacan: Painting the Imaginary Landscapes." In *Lacan, Politics, Aesthetics,* edited by Willy Apollon and Richard Feldstein. Albany: State University of New York, 1996.

Bird, Jon. "Minding the Body: Robert Morris's 1971 Tate Gallery Retrospective." In *Rewriting Conceptual Art,* edited by Michael Newman and Jon Bird. London: Reaktion Books, 1999.

Bishop, Claire. *Installation Art: A Critical History.* London: Tate Publishing, 2005.

———. "The Subject of Installation Art: A Typology." Ph.D. diss., University of Essex, 2002.

Bloomer, Kent, and Charles Moore. *Body, Memory, Architecture.* New Haven: Yale University Press, 1977.

Boettger, Suzann. "In the Yucatan: Mirroring Presence and Absence." In *Robert Smithson,* edited by Eugenie Tsai. Exh. cat. Berkeley and Los Angeles: University of California Press, 2004.

Bois, Yve-Alain, and Rosalind Krauss. *Formless: A User's Guide.* Cambridge: MIT Press, 1997.

Bollas, Christopher. *Cracking Up: The Work of Unconscious Experience.* London: Routledge, 1995.

Bonitzer, Pascal. *Le champ aveugle: Essais sur le cinéma.* Paris: Gallimard, 1982.

———. "Hitchcockian Suspense." In *Everything You Always Wanted to Know About Lacan (But Were Afraid to Ask Hitchcock),* edited by S. Žižek. London: Verso, 1992.

Boothby, Richard. *Death and Desire: Psychoanalytic Theory in Lacan's Return to Freud.* New York: Routledge, 1992.

Borch-Jacobsen, Mikkel. *Lacan: The Absolute Master.* Translated by Douglas Brick. Stanford: Stanford University Press, 1991.

Bowie, Malcolm. *Lacan.* London: Fontana, 1991.

Bradley, Fiona. "Doubling and Dédoublement: Gala in Dalí." *Art History* 17, no. 4 (1994).

Breton, André. *L'amour fou.* Paris: Gallimard, 1937.

———. "Introduction to the Discourse on the Paucity of Reality." Translated by Richard Sieburth and Jennifer Gordon. *October* 69 (Summer 1994).

———. *Mad Love.* Translated by Mary Ann Caws. Lincoln: University of Nebraska Press, 1987.

———. "Manifesto of Surrealism." In *Manifestoes of Surrealism,* translated by Richard Seaver

and Helen R. Lane. Ann Arbor: University of Michigan Press, 1972.

———. *Nadja.* Translated by Richard Howard. London: Penguin Books, 1999.

———. *Nadja.* Paris: Gallimard, 1964.

———. *Point du jour.* Paris: Gallimard, 1970.

———. *What Is Surrealism? Selected Writings.* Edited and with an introduction by Franklin Rosemont. London: Pluto Press, 1978.

Breton, André, and Paul Éluard. *L'immaculée conception.* Paris: Éditions surréalistes, 1930.

Bronfen, Elisabeth. *Over Her Dead Body: Death, Femininity, and the Aesthetic.* Manchester: Manchester University Press, 1992.

Brown, Andrew. *Roland Barthes: The Figures of Writing.* Oxford: Clarendon Press, 1992.

Bryson, Norman. "The Gaze and the Glance." In *Vision and Painting: The Logic of the Gaze.* Basingstoke: Macmillan, 1983.

———. "House of Wax." In *Cindy Sherman, 1975–1993,* edited by Rosalind Krauss. New York: Rizzoli, 1993.

———. "The Ideal and the Abject: Cindy Sherman's Historical Portraits." *Parkett* 29 (1991).

———. *Vision and Painting: The Logic of the Gaze.* Basingstoke: Macmillan, 1983.

Buchloh, Benjamin H. D. Interview with Gabriel Orozco. In *Clinton Is Innocent.* Exh. cat. Paris: Musée de l'art moderne de la ville de Paris, 1998.

———. "Refuse and Refuge." In *Gabriel Orozco,* edited by M. Catherine de Zegher. Kortrijk, Belgium: The Kanaal Art Foundation, 1993.

Buck-Morss, Susan. "Aesthetics and Anaesthetics: Walter Benjamin's Artwork Essay Reconsidered." *October* 62 (1992).

Burgin, Victor. "Barthes's Discretion." In *Writing the Image After Roland Barthes,* edited by Jean-Michel Rabaté. Philadelphia: University of Pennsylvania Press, 1997.

———. *Between.* Oxford: Basil Blackwell in association with the ICA, 1986.

———. "Geometry and Abjection." In *Abjection, Melancholia, and Love: The Work of Julia Kristeva,* edited by John Fletcher and Andrew Benjamin. London: Routledge, 1990.

———. "Paranoiac Space." *New Formations* 12 (Winter 1990).

———. "Re-reading *Camera Lucida.*" In *The End of Art Theory: Criticism and Postmodernity.* London: Macmillan, 1986.

Butler, Judith. *Antigone's Claim.* Cambridge: Cambridge University Press, 2000.

Cadava, Eduardo. *Words of Light: Theses on the Photography of History.* Princeton: Princeton University Press, 1997.

Caillois, Roger. *Les jeux et les hommes: Le masque et le vertige.* Rev. ed. Paris: Gallimard, 1967.

———. "La mante réligieuse: De la biologie à la pychanalyse." *Minotaure* 5 (May 1934).

———. *The Mask of the Medusa.* Translated by George Ordish. London: Victor Gollancz, 1964. Originally published as *Méduse et Cie* (Paris: Gallimard, 1960).

———. "Mimicry and Legendary Psychasthenia." Translated by John Shepley. *October* 31 (1984). Reprinted in *October: The First Decade, 1976–1986,* edited by Annette Michelson, Rosalind Krauss, Douglas Crimp, and Joan Copjec (Cambridge: MIT Press, 1987).

Campbell, Robert. "An Emotive Place Apart." *American Institute of Architects Journal* 72 (May 1983).

Cardinal, Roger. *Breton/Nadja.* London: Grant and Cutler, 1986.

Carhart, Thomas. "The Final Insult." *Houston Chronicle,* October 28, 1981.

Caruth, Cathy. *Unclaimed Experience in Trauma, Narrative, and History.* Baltimore: Johns Hopkins University Press, 1996.

Castle, Terry. *The Female Thermometer: Eighteenth-Century Culture and the Inventing of the Uncanny.* New York: Oxford University Press, 1995.

Caws, Mary Ann. *The Surrealist Look: An Erotics of Encounter.* Cambridge: MIT Press, 1997.

Chave, Anna. "Minimalism and the Rhetoric of Power." *Arts Magazine,* January 1990.

Childs, Elizabeth. "Robert Smithson and Film: The Spiral Jetty Reconsidered." *Arts Magazine,* October 1981.

Chion, Michel. *David Lynch.* Translated by Robert Julien. London: British Film Institute, 1995.

"Cinéma et psychanalyse." Special issue, *Communications* 23 (1975).

Cixous, Hélène. "Fiction and Its Phantoms: A Reading of Freud's *Das Unheimliche* (The 'Uncanny')."

New Literary History 7 (1975–76).

Clark, T. J. *The Painting of Modern Life: Paris in the Art of Manet and His Followers.* London: Thames and Hudson, 1985.

Cohen, Margaret. "Benjamin Reading the Rencontre." In *Profane Illumination: Walter Benjamin and the Paris of the Surrealist Revolution.* Berkeley and Los Angeles: University of California Press, 1993.

Cooke, Lynne, and Karen Kelly, eds. *Robert Smithson's Spiral Jetty: True Fictions, False Realities.* New York: Dia Art Foundation; Berkeley and Los Angeles: University of California Press, 2005.

Copjec, Joan. *Imagine There's No Woman: Ethics and Sublimation.* Cambridge: MIT Press, 2002.

———. "The Orthopsychic Subject: Film Theory and the Reception of Lacan." In *Read My Desire: Lacan Against the Historicists.* Cambridge: MIT Press, 1994.

———. "The Tomb of Perseverance: On *Antigone.*" In *Giving Ground: The Politics of Propinquity,* edited by Joan Copjec and Michael Sorkin. London: Verso, 1999.

Costello, Diarmuid. "Aura, Face, Photography: Re-reading Benjamin Today." In *Walter Benjamin and Art,* edited by Andrew Benjamin. London: Continuum, 2005.

Crével, René. "Notes en vue d'une psycho-dialectique." *Le surréalisme au service de la révolution* 6 (1933).

Crimp, Douglas. *Image Scavengers.* Philadelphia: Institute of Contemporary Art, University of Pennsylvania, 1982.

———. "The Photographic Activity of Postmodernism." *October* 15 (Winter 1980).

———. "Pictures." *October* 8 (Spring 1979).

Dalí, Salvador. *The Collected Writings of Salvador Dalí.* Edited and translated by Haim Finkelstein. Cambridge: Cambridge University Press, 1998.

———. *Comment on devient Dalí.* Paris: Laffont, 1973. Translated by Harold J. Salemson as *The Unspeakable Confessions of Salvador Dalí* (London: W. H. Allen, 1976).

———. "Communication, visage paranoïaque." *Le surréalisme au service de la révolution* 3 (1931).

———. "The Conquest of the Irrational." In *The Secret Life of Salvador Dalí,* translated by Haakon M. Chevalier. London: Vision, 1948.

———. "La conquête de l'irrationnel." In *Oui: Méthode paranoïaque critique et autres texts.* Paris: Denoël/Gonthier, 1971. Translated in *Oui: The Paranoid-Critical Revolution: Writings, 1927–33,* edited by Robert Descharnes, translated by Yvonne Shafir (Boston: Exact Change, 1998).

———. *Dalí par Dalí.* Paris: Draeger, 1970. Translated by Eleanor R. Morse as *Dalí by Dalí* (New York: Abrams, 1970).

———. "Interprétation paranoïaque-critique de l'image obsédante *L'Angélus* de Millet." *Minotaure* 1 (1933).

———. *Le mythe tragique de l'Angélus de Millet: Interprétation "paranoïaque-critique."* Paris: Jean-Jacques Pauvert, 1963. Translated by Eleanor R. Morse as *The Tragic Myth of Millet's Angelus: Paranoiac-Critical Interpretation, Including The Myth of William Tell* (St. Petersburg, Fla.: The Salvador Dalí Museum, 1986).

———. "Objets psycho-atmosphériques-anamorphiques." *Le surréalisme au service de la révolution* 5 (1933).

———. "Photography: Pure Creation of the Mind." In *Oui: The Paranoid-Critical Revolution: Writings, 1927–33,* edited by Robert Descharnes, translated by Yvonne Shafir. Boston: Exact Change, 1998.

Damisch, Hubert. *The Judgment of Paris.* Translated by John Goodman. Chicago: University of Chicago Press, 1996.

———. *The Origin of Perspective.* Cambridge: MIT Press, 1994.

de Lauretis, Teresa, and Stephen Heath, eds. *The Cinematic Apparatus.* London: Macmillan, 1980.

Deleuze, Gilles. *The Logic of Sense.* Edited by Constantin V. Boundes. Translated by Mark Lester with Charles Stivale. London: Athlone Press, 1989.

———. "Plato and the Simulacrum." *October* 27 (Winter 1983).

Derrida, Jacques. "The Deaths of Roland Barthes." In *Philosophy and Non-Philosophy,* edited by Hugh J. Silverman. New York: Routledge, 1988.

Dews, Peter. *Logics of Disintegration: Post-Structuralist Thought and the Claims of Critical Theory.* London: Verso, 1987.

———. "The Tremor of Reflection: Slavoj Žižek's Lacanian Dialectics."

Radical Philosophy 72 (July–August 1995).

Doane, Mary Ann, Patricia Mellencamp, and Linda Williams, eds. *Re-vision: Essays in Feminist Film Theory.* Frederick, Md.: University Publications of America, 1984.

Dolar, Mladen. "'I Shall Be with You on Your Wedding-Night': Lacan and the Uncanny." In "Rendering the Real," ed. Parveen Adams. Special issue, *October* 58 (Fall 1991).

Dollimore, Jonathan. *Death, Desire, and Loss in Western Culture.* London: Allen Lane, 1998.

Duve, Thierry de. *Kant After Duchamp.* Cambridge: MIT Press, 1996.

Edkins, Jenny. "War Memorials: The Cenotaph and the Vietnam Wall." In *Trauma and the Memory of Politics.* Cambridge: Cambridge University Press, 2003.

Ehrenzweig, Anton. *The Hidden Order of Art: A Study in the Psychology of Artistic Imagination.* London: Paladin, 1970.

Emerson, Ralph Waldo. "Self-Reliance." In *Essays.* Boston: J. Munroe, 1841.

Evans, Dylan, ed. *An Introductory Dictionary of Lacanian Psychoanalysis.* London: Routledge, 1966.

Fairbrother, Trevor. "Ghost." *Parkett* 42 (1994).

Feldstein, Richard, Bruce Fink, and Marie Jaanus, eds. *Reading Seminar XI: Lacan's Four Fundamental Concepts of Psychoanalysis.* Albany: State University of New York Press, 1995.

Fer, Briony. "Bordering on Blank: Eva Hesse and Minimalism." In "Psychoanalysis in Art History," ed. Margaret Iversen. Special issue, *Art History* 17, no. 3 (1994).

———. "Carl Andre and the Fall of Sculpture." In *Carl Andre and the Sculptural Imagination,* edited by Ian Cole. Oxford: Museum of Modern Art, 1996.

———. *The Infinite Line: Re-making Art After Modernism.* New Haven: Yale University Press, 2004.

———. *On Abstract Art.* New Haven: Yale University Press, 1997.

———. "Postscript: Vision and Blindness." In *On Abstract Art.* New Haven: Yale University Press, 1997.

———. "Treading Blindly, or the Excessive Presence of the Object." *Art History* 20, no. 2 (1997).

Ferreira, José. *Dalí-Lacan: La rencontre: Ce que le psychanalyste doit au peintre.* Paris: L'Harmatten, 2003.

Finkelstein, Haim, ed. and trans. *Salvador Dalí's Art and Writing, 1927–1942: The Metamorphosis of Narcissus.* Cambridge: Cambridge University Press, 1996.

Fisher, Jean. "The Revenants of Time." In *Susan Hiller.* London: Matts Gallery, 1990.

———. "The Sleep of Wakefulness." In *Gabriel Orozco,* edited by M. Catherine de Zegher. Kortrijk, Belgium: The Kanaal Art Foundation, 1993.

Foster, Hal. *Compulsive Beauty.* Cambridge: MIT Press, 1993.

———. "Death in America." *October* 75 (Winter 1996).

———. *The Return of the Real.* Cambridge: MIT Press, 1996.

Frazer, J. G. *The Dying God, The Golden Bough: A Study of Magic and Religion.* 3rd ed. London: Macmillan, 1911.

Freud, Sigmund. *La psychopathologie de la vie quotidienne.* Paris: Payot, 1922.

———. *La science des rêves.* Paris: Payot, 1926.

———. *The Standard Edition of the Complete Psychological Works of Sigmund Freud.* Edited and translated by James Strachey. 24 vols. London: The Hogarth Press, 1953–74.

———. *The Uncanny.* Edited by Adam Phillips. Translated by David McLintock. London: Penguin, 2003.

Fried, Michael. "Art and Objecthood." In *Minimal Art: A Critical Anthology,* edited by Gregory Battcock. New York: E. P. Dutton, 1968.

———. "Barthes' Punctum." *Critical Inquiry* 31 (Spring 2005).

Gallop, Jane. "Psychoanalytic Criticism: Some Intimate Questions." *Art in America* (November 1984).

———. *Reading Lacan.* Ithaca, N.Y.: Cornell University Press, 1985.

———. *Thinking Through the Body.* New York: Columbia University Press, 1980.

Gedo, Mary Matthews. *Psychoanalytic Perspectives on Art.* 3 vols. Hillsdale, N.J.: Analytic Press, 1985–88.

Gilbert-Rolfe, Jeremy. *Beauty and the Contemporary Sublime.* New York: Allworth Press, 1999.

Golding, Martin. "Memory, Commemoration, and the Photograph." *Modern Painters* 12, no. 1 (1999).

Goodrich, Lloyd. *Edward Hopper.* New York: Abrams, 1976.

Gratton, Johnnie. "Text, Images, Reference in Roland Barthes's *La chambre claire.*" *Modern Language Review* 91 (1996).

Graziani, Ron. *Robert Smithson: The American Landscape.* Cambridge: MIT Press, 2004.

Greeley, Robin Adèle. "Dalí's Fascism; Lacan's Paranoia." *Art History* 24, no. 4 (2001).

Gronberg, Tag. "The Titanic: An Object Manufactured for Exhibition at the Bottom of the Sea." In *Material Memories: Design and Education,* edited by Marius Kwint and Christopher Breward. Oxford: Berg Publishers, 1999.

Grosskurth, Brian. "Lartigue and the Politics of Enchantment." In *The Aesthetics of Enchantment in the Fine Arts,* edited by M. Kronegger and A. T. Tymieniecka. Analecta Husserliana 65. Dordrecht: Kluwer, 2000.

Grosskurth, Phyllis. *Melanie Klein: Her World and Her Work.* London: Hodder and Stoughton, 1986.

Grunenberg, Christoph. "Life in a Dead Circus: The Spectacle of the Real." In *The Uncanny,* edited by Mike Kelley. Exh. cat. Cologne: Verlag der Buchhandlung Walther König, 2004.

Hansen, Miriam. "Benjamin, Cinema, and Experience: 'The Blue Flower in the Land of Technology.'" *New German Critique* 40 (Winter 1987).

Harris, Steven. *Surrealist Art and Thought in the 1930s: Art, Politics, and the Psyche.* Cambridge: Cambridge University Press, 2004.

Heath, Stephen. "Narrative Space." In *Questions of Cinema.* Bloomington: Indiana University Press, 1981.

———. "Screen Images, Film Memory." *Edinburgh '76 Magazine* 1 (1976).

Hegel, G. W. F. *The Phenomenology of Mind.* Translated by J. B. Baillie. London: George Allen and Unwin; New York: Humanities Press, 1971.

Hertz, Neil. *The End of the Line: Essays on Psychoanalysis and the Sublime.* New York: Columbia University Press, 1985.

———. "Medusa's Head: Male Hysteria Under Political Pressure." *Representations* 4 (Fall 1983).

Hirst, Paul. "Althusser's Theory of Ideology." *Economy and Society* no. 5 (November 1976).

Hobbs, Robert. *Robert Smithson's Sculpture.* Ithaca, N.Y.: Cornell University Press, 1981.

Hollander, John. "Hopper and the Figure of Room." *Art Journal* 41 (Summer 1981).

Hollier, Denis. *Against Architecture: The Writings of Georges Bataille.* Translated by Betsy Wing. Cambridge: MIT Press, 1989.

———. "Mimesis and Castration, 1937." *October* 31 (1984).

———. "Surrealist Precipitates: Shadows Don't Cast Shadows." *October* 69 (Summer 1994).

Holly, Michael Ann. "Mourning and Method." *The Art Bulletin* 84 (December 2002).

Homans, Peter. *The Ability to Mourn: Disillusionment and the Social Origins of Psychoanalysis.* Chicago: University of Chicago Press, 1989.

Hopper, Edward. "Charles Burchfield: American." *The Arts* 14 (July 1928).

———. Edward Hopper to Charles H. Sawyer, October 29, 1939. In *Edward Hopper,* by Lloyd Goodrich. New York: Abrams, 1976.

———. Edward Hopper to Norman A. Geske. In *Edward Hopper,* by Robert Hobbs. New York: Abrams, 1987.

Iversen, Margaret. *Alois Riegl: Art History and Theory.* Cambridge: MIT Press, 1993.

———. "Barthes on Art." In *A Companion to Art Theory,* edited by Paul Smith and Carolyn Wilde. Oxford: Blackwell, 2002.

———. "The Discourse of Perspective in the Twentieth Century: Panofsky, Lacan, Damisch." *Oxford Art Journal* 28, no. 2 (2005).

———. "Hopper's Melancholic Gaze." In *Edward Hopper,* edited by Sheena Wagstaff. London: Tate Publishing, 2004.

———. "In the Blind Field: Hopper and the Uncanny." *Art History* 21, no. 3 (1998).

———. "Visualizing the Unconscious: Mary Kelly's Installations." In *Mary Kelly,* edited by Margaret Iversen, Douglas Crimp, and Homi K. Bhabha, 32–85. London: Phaidon, 1998.

Iversen, Margaret, Douglas Crimp, and Homi K. Bhabha, eds. *Mary Kelly.* London: Phaidon, 1998.

Jaanus, Marie. "The Démontage of the Drive." In *Reading Seminar XI: Lacan's Four Fundamental Concepts of Psychoanalysis,* edited by Richard Feldstein, Bruce Fink, and Marie Jaanus. Albany: State University of New York Press, 1995.

Jameson, Fredric. *Postmodernism, or, The Cultural Logic of Late Capitalism.* London: Verso, 1991.

Jay, Martin. "Against Consolation: Walter Benjamin and the Refusal to Mourn." In *War and Remembrance in the Twentieth*

Century, edited by Jay Winter and Emmanuel Sivan. Cambridge: Cambridge University Press, 1999.

———. *Downcast Eyes: The Denigration of Vision in Twentieth-Century French Thought.* Berkeley and Los Angeles: University of California Press, 1993.

Jentsch, Ernst. "On the Psychology of the Uncanny." In "Home and Family," ed. Sarah Wood. Special issue, *Angelaki* 2, no. 1 (1995).

Jones, Amelia. "Survey." In Tracy Warr and Amelia Jones, *The Artist's Body.* London: Phaidon, 2000.

Jones, Ernest. *Sigmund Freud: Life and Work.* London: The Hogarth Press, 1953–58.

Judd, Donald. *Complete Writings, 1959–1975.* Halifax: Press of the Nova Scotia College of Art and Design; New York: New York University Press, 2005.

———. "Specific Objects." *Arts Yearbook* 8 (1965).

Kant, Immanuel. *Critique of Judgment.* Translated by Werner S. Pluhar. Indianapolis: Hackett, 1997.

———. *Critique of Practical Reason.* Translated by Lewis White Beck. Indianapolis: Hackett, 1956.

Kaprow, Allan. *Essays on the Blurring of Art and Life.* Edited by Jeff Kelly. Berkeley and Los Angeles: University of California Press, 1993.

———. "The Legacy of Jackson Pollock." In *Essays on the Blurring of Art and Life,* edited by Jeff Kelly. Berkeley and Los Angeles: University of California Press, 1993.

———. "The Shape of the Art Environment." *Artforum* 6, no. 10 (1968).

Kelley, Mike. *The Uncanny.* Exh. cat. Arnhem, The Netherlands: Gemeentemuseum, 1993.

———. *The Uncanny.* Exh. cat. Cologne: Verlag der Buchhandlung Walther König, 2004.

Kelly, Mary. *Imaging Desire.* Cambridge: MIT Press, 1996.

———. *Post-Partum Document.* London: Routledge and Kegan Paul, 1983.

Klein, Melanie. *The Selected Melanie Klein.* Edited by Juliet Mitchell. London: Penguin, 1986.

Knight, Diana, ed. *Critical Essays on Roland Barthes.* New York: G. K. Hall, 2000.

Kofman, Sarah. *The Childhood of Art: An Interpretation of Freud's Aesthetics.* Translated by Winifred Woodhull. New York, 1988.

———. "The Double Is/And the Devil." In *Freud and Fiction,* translated by Sarah Wykes. Oxford: Polity Press, 1990.

Kojève, Alexandre. *Introduction to the Reading of Hegel: Lectures on the Phenomenology of Spirit.* Edited by Allan David Bloom. Ithaca, N.Y.: Cornell University Press, 1980.

Kraepelin, Emil. *Lectures on Clinical Psychiatry.* Edited by T. Johnstone. London: Baillière, 1906.

Krauss, Rosalind, ed. *Cindy Sherman, 1975–1993.* New York: Rizzoli, 1993.

———. "Corpus Delicti." In *L'amour fou: Photography and Surrealism.* London: Hayward Gallery, 1986.

———. "A Note on Photography and the Simulacral." *October* 31 (Winter 1984).

———. "Notes on the Index: Parts I and II." In *The Originality of the Avant-Garde and Other Modernist Myths.* Cambridge: MIT Press, 1985.

———. *The Optical Unconscious.* Cambridge: MIT Press, 1993.

———. *Passages in Modern Sculpture.* London: Thames and Hudson, 1977.

———. "Reinventing 'Photography.'" In *The Promise of Photography: The DG Bank Collection,* edited by Liminita Sabau. Munich: Prestel, 1998.

Kristeva, Julia. *Black Sun: Depression and Melancholia.* Translated by Leon S. Roudiez. New York: Columbia University Press, 1989.

———. *Powers of Horror: An Essay on Abjection.* Translated by Leon S. Roudiez. New York: Columbia University Press, 1982.

———. *Revolution in Poetic Language.* Translated by Margaret Waller. New York: Columbia University Press, 1984.

Kunze, Donald. "Architecture as Reading, Virtuality, Secrecy, Monstrosity." *Journal of Architectural Education* 41 (Summer 1988).

Lacan, Jacques. *De la psychose paranoïaque dans ses rapports avec la personnalité, suivi de Premiers écrits sur la paranoïa.* Paris: Seuil, 1980.

———. "Desire and the Interpretation of Desire in Hamlet." In *Literature and Psychoanalysis: The Question of Reading: Otherwise,* edited by Shoshana Felman. Baltimore: Johns Hopkins University Press, 1982.

———. *Écrits.* Paris: Seuil, 1966.

———. "Écrits 'inspirées': Schizographie." In *De la psychose paranoïaque dans ses rapports avec la personnalité, suivi de Premiers écrits sur la paranoïa.* Paris: Seuil, 1980.

———. *The Four Fundamental Concepts of Psycho-Analysis.* Edited by Jacques-Alain Miller. Translated by Alan Sheridan. Harmondsworth: Penguin, 1977.

———. "The Mirror Stage as Formative of the Function of the I as Revealed in Psychoanalytic Experience." In *Écrits: A Selection,* translated by Alan Sheridan. London: Tavistock Publications, 1977.

———. "On the Structure of Inmixing of an Otherness Prerequisite to Any Subject Whatever." In *The Structuralist Controversy: The Languages of Criticism and the Sciences of Man,* edited by Richard Macksey and Eugenio Donato. Baltimore: Johns Hopkins University Press, 1971.

———. "Le problème du style et la conception psychiatrique des formes paranoïaques de l'expérience." *Minotaure* 1 (1933).

———. *Les quatre concepts fondamentaux de la psychanalyse.* Paris: Seuil, 1973.

———. *Le séminaire, livre II: Le moi dans la théorie de Freud et dans le technique de la psychanalyse, 1954–1955.* Paris: Seuil, 1978.

———. *The Seminar of Jacques Lacan, Book II: The Ego in Freud's Theory and in the Technique of Psychoanalysis, 1954–1955.* Edited by Jacques-Alain Miller. Translated by Sylvana Tomaselli. Cambridge: Cambridge University Press, 1988.

———. *The Seminar of Jacques Lacan, Book III: The Psychoses, 1955–1956.* Edited by Jacques-Alain Miller. Translated by Russell Grigg. London: Routledge, 1993.

———. *The Seminar of Jacques Lacan, Book VII: The Ethics of Psycho-analysis, 1959–1960.* Edited by Jacques-Alain Miller. Translated by Dennis Porter. Cambridge: Cambridge University Press, 1992.

———. "Some Reflections on the Ego." *International Journal of Psychoanalysis* 34 (1953).

Laplanche, Jean. *Life and Death in Psychoanalysis.* Translated by Jeffrey Mehlman. Baltimore: Johns Hopkins University Press, 1976.

———. "To Situate Sublimation." *October* 28 (Spring 1984).

———. "Why the Death Drive?" In *Life and Death in Psychoanalysis,* translated by Jeffrey Mehlman. Baltimore: Johns Hopkins University Press, 1976.

Laplanche, Jean, and J.-B. Pontalis. "Fantasy and the Origins of Sexuality." In *Formations of Fantasy,* edited by V. Burgin, J. Donald, and C. Kaplan. London: Methuen, 1986.

———. *The Language of Psychoanalysis.* London: The Hogarth Press, 1980.

Laqueur, Thomas W. "Memory and Naming in the Great War." In *Commemorations: The Politics of National Identity,* edited by John Gilles. Princeton: Princeton University Press, 1994.

Lavers, Annette. *Roland Barthes: Structuralism and After.* London: Methuen, 1982.

Lee, Jonathan Scott. *Jacques Lacan.* Boston: Twayne Publishers, 1990.

Lemaire, Anika. *Jacques Lacan.* Translated by David Macey. London: Routledge and Kegan Paul, 1977.

Levin, Gail. *Edward Hopper: A Catalogue Raisonné.* New York: Whitney Museum of American Art with W. W. Norton, 1995.

———. *Edward Hopper as Illustrator.* New York: W. W. Norton in association with the Whitney Museum of American Art, 1979.

———. *Edward Hopper: The Art and the Artist.* New York: W. W. Norton in association with the Whitney Museum of American Art, 1980.

———. *Edward Hopper: The Complete Prints.* New York: W. W. Norton in association with the Whitney Museum of American Art, 1979.

Levine, Steven Z. "Between Art History and Psychoanalysis: I/eye-ing Monet with Freud and Lacan." In *The Subjects of Art History: Historical Objects in Contemporary Perspective,* edited by M. Cheetham, M. Holly, and K. Moxey. Cambridge: Cambridge University Press, 1998.

Lin, Maya. *Boundaries.* New York: Simon and Schuster, 2000.

Lomas, David. *The Haunted Self: Surrealism, Psychoanalysis, Subjectivity.* New Haven: Yale University Press, 2000.

Lubar, Robert S. *Dalí: The Salvador Dalí Museum Collection.* Boston: Bulfinch Press, 2000.

Lyotard, Jean-François. *Discours, figure.* Paris: Klincksieck, 1978.

Macey, David. *Lacan in Contexts.* London: Verso, 1988.

Mannoni, O. "Je sais, mais quand même" In *Clefs pour l'imaginaire, ou l'autre scène.* Paris: Seuil, 1969.

Massey, Doreen. "Space-time and the Politics of Location." In *Rachel*

Whiteread: House, edited by James Lingwood. London: Phaidon, 1995.

McCombs, Phil. "Maya Lin and the Great Call of China: The Fascinating Heritage of the Student Who Designed the Vietnam Memorial." *Washington Post,* January 3, 1982.

Melville, Stephen. "Division of the Gaze, or, Remarks on the Color and Tenor of Contemporary 'Theory.'" In *Seams: Art as a Philosophical Context.* Amsterdam: G&B Arts International, 1996.

Mendelson, Jordana. "Of Politics, Postcards, and Pornography: Salvador Dali's *Le mythe tragique de l'Angélus de Millet.*" In *Surrealism, Politics, and Culture,* edited by Raymond Spiteri and Donald LaCoss. Aldershot: Ashgate, 2003.

Merleau-Ponty, Maurice. *The Phenomenology of Perception.* Translated by Colin Smith. London: Routledge and Kegan Paul, 1962.

———. *The Visible and the Invisible.* Edited by Claude Lefort. Translated by Alphonso Lingis. Evanston, Ill.: Northwestern University Press, 1968.

Metz, Christian. "The Imaginary Signifier." In *Psychoanalysis and Cinema: The Imaginary Signifier.* Translated by Celia Britton. London: Macmillan, 1982.

———. *Psychoanalysis and Cinema: The Imagery Signifier.* Translated by Celia Britton. London: Macmillan, 1982.

Meyer, James, ed. *Minimalism.* London: Phaidon, 2000.

———. *Minimalism: Art and Polemics in the Sixties.* New Haven: Yale University Press, 2001.

Miller, Jacques-Alain. *Lacanian Theory of Discourse.* Edited by Mark Bracher et al. New York: New York University Press, 1994.

Milner, Marion. *The Suppressed Madness of Sane Men.* London: Tavistock Publications, 1987.

Mitchell, Juliet, and Jacqueline Rose, eds. *Feminine Sexuality: Jacques Lacan and the École freudienne.* Translated by Jacqueline Rose. London: Macmillan, 1982.

Mora, Gilles, ed. *Roland Barthes et la photo: Le pire des signes.* Paris: Contrejour, 1990.

Moriarty, Michael. *Roland Barthes.* London: Polity, 1991.

Morris, Robert. *Continuous Project Altered Daily: The Writings of Robert Morris.* Cambridge: MIT Press, 1993.

Mulvey, Laura. "Death Drives: Hitchcock's *Psycho.*" *Film Studies* 2 (Spring 2000).

———. *Death 24x a Second: Stillness and the Moving Image.* London: Reaktion Books, 2006.

———. *Fetishism and Curiosity.* Bloomington: Indiana University Press; London: BFI Publications, 1996.

———. "The Index and the Uncanny." In *Time and the Image,* edited by Carolyn Gill. Manchester: Manchester University Press, 2001.

———. "Visual Pleasure and Narrative Cinema." In *Visual and Other Pleasures.* London: Macmillan, 1989.

Nesbit, Molly. "Walking to Work." In *Trabajo.* Exh. cat. Paris: Galerie Chantal Crousel, 2003.

Nixon, Mignon. *Fantastic Reality: Louise Bourgeois and the Study of Modern Art.* Cambridge: MIT Press, 2005.

Nochlin, Linda. "Edward Hopper and the Imagery of Alienation." *Art Journal* 41 (Summer 1981).

O'Doherty, Brian. *American Masters: The Voice and the Myth.* London: Thames and Hudson, 1988.

O'Hara, Frank. *Jackson Pollock.* New York: George Braziller, 1959.

Olin, Margaret. "Touching Photographs: Roland Barthes's 'Mistaken' Identification." *Representations* 80 (Fall 2002).

Owens, Craig. "Earthwords." *October* 10 (Fall 1979).

Panofsky, Erwin. "Et in Arcadia Ego: Poussin's Arcadian Shepherds." In *Meaning in the Visual Arts.* Harmondsworth: Penguin, 1970.

Penley, Constance. *The Future of an Illusion: Film, Feminism, and Psychoanalysis.* Minneapolis: University of Minnesota Press, 1989.

Phelan, Peggy. "Andy Warhol: Performances of *Death in America.*" In *Performing the Body, Performing the Text,* edited by Amelia Jones and Andrew Stephenson. London: Routledge, 1999.

———. "Developing the Negative: Mapplethorpe, Schor, and Sherman." In *Unmarked: The Politics of Performance.* London: Routledge, 1993.

Poe, Edgar Allan. "A Descent into the Maelström." In *The Complete Tales and Poems of Edgar Allan Poe.* New York: Vintage, 1975.

Potts, Alex. "The Phenomenological Turn." In *The Sculptural Imagination: Figurative, Modernist, Minimalist.* New Haven: Yale University Press, 2000.

———. *The Sculptural Imagination: Figurative, Modernist, Minimalist.* New Haven: Yale University Press, 2000.

Price, Mary. *The Photograph: A Strange Confined Space.* Stanford: Stanford University Press, 1994.

Price, Uvedale. *Essays on the Picturesque as Compared with the Sublime and the Beautiful.* London: Mawman, 1810.

Puttfarken, Thomas. "Aristotle, Titian, and Tragic Painting." In *Art and Thought,* edited by Dana Arnold and Margaret Iversen. Oxford: Blackwell, 2003.

Rabaté, Jean-Michel, ed. *Writing the Image After Roland Barthes.* Philadelphia: University of Pennsylvania Press, 1997.

Rachel Whiteread: Shedding Life. Exh. cat. New York: Thames and Hudson, 1997.

Ragland, Ellie. "Lacan, the Death Drive, and the Dream of the Burning Child." In *Death and Representation,* edited by Sarah Webster Goodwin and Elisabeth Bronfen. Baltimore: Johns Hopkins University Press, 1993.

Rank, Otto. *The Double: A Psychoanalytic Study.* Translated by Harry Tucker Jr. Chapel Hill: University of North Carolina Press, 1971.

Rebello, Stephen. *Alfred Hitchcock and the Making of "Psycho."* London: Boyars, 1990.

Reinink, Wessell, and Jeroen Stumpl. *Memory and Oblivion: Proceedings of the 29th International Congress of the History of Art.* Boston: Kluwer, 1999.

Reynolds, Ann. *Robert Smithson: Learning from New Jersey and Elsewhere.* Cambridge: MIT Press, 2003.

Riegl, Alois. *Das holländische Gruppenporträt.* Vienna, 1931. Translated by E. M. Kain and D. Britt as *The Group Portraiture of Holland* (Los Angeles: The Getty Research Institute Publications, 1999).

Roberts, Jennifer L. *Mirror-Travels: Robert Smithson and History.* New Haven: Yale University Press, 2004.

Robert Smithson: Early Works. Exh. cat. London: Marlene Eleini Gallery, 1988.

Robert Smithson: Une rétrospective: Le paysage entropique, 1960–1973. Marseilles: Musées de Marseilles, 1994.

Rodowick, David N. *The Crisis of Political Modernism: Criticism and Ideology in Contemporary Film Theory.* Berkeley and Los Angeles: University of California Press, 1994.

Rose, Gillian. *Mourning Becomes the Law: Philosophy and Representation.* Cambridge: Cambridge University Press, 1996.

Rose, Jacqueline. "The Imaginary." In *Sexuality in the Field of Vision.* London: Verso, 1986.

———. "Paranoia and the Film System." In *Feminism and Film Theory,* edited by Constance Penley. New York: Methuen, 1988.

Roudinesco, Elisabeth. *Jacques Lacan and Co.: A History of Psychoanalysis in France, 1925–1985.* Translated by Jeffrey Mehlman. Chicago: University of Chicago Press, 1990.

Royle, Nicholas. *The Uncanny.* Manchester: Manchester University Press, 2003.

Sartre, Jean-Paul. *Being and Nothingness: An Essay on Phenomenological Ontology.* Translated by Hazel Barnes. London: Methuen, 1957.

———. *L'imaginaire: Psychologie phénoménologique de l'imagination.* Paris: Gallimard, 1940. Translated as *The Psychology of the Imagination* (London: Methuen, 1972).

Scarry, Elaine. *On Beauty and Being Just.* London: Duckworth, 2000.

Schaper, Eva. "Taste, Sublimity, and Genius: The Aesthetics of Nature and Art." In *The Cambridge Companion to Kant,* edited by Paul Guyer. Cambridge: Cambridge University Press, 1992.

Schapiro, Gary. *Earthwards: Robert Smithson and Art After Babel.* Berkeley and Los Angeles: University of California Press, 1995.

Schapiro, Meyer. "Leonardo and Freud: An Art Historical Study." *Journal of the History of Ideas* 17, no. 2 (April 1956).

———. "On Some Problems in the Semiotics of Visual Art: Field and Vehicle in Image-Signs." In *Theory and Philosophy of Art: Style, Artist, and Society.* New York: George Braziller, 1994.

Schiller, Friedrich. *On the Aesthetic Education of Man.* Translated by Reginald Snell. London: Routledge and Kegan Paul, 1954.

Schmidt, Eva. "Et in Utah ego: Robert Smithson's 'Entropologic' Cinema." In *Robert Smithson: Drawings from the Estate.* Munster: Westfälisches Landesmuseum, 1989.

Schmitt, Patrice. "De la psychose paranoïaque dans ses rapports avec Salvador Dalí." In

Salvador Dalí Retrospective, 1920–1981. Paris: Centre Georges Pompidou, 1980.

Schor, Naomi. "Dalí's Freud." In *Reading in Detail: Aesthetics and the Feminine.* New York: Methuen, 1987.

Scruggs, Jan C., and Joel L. Swerdlow. *To Heal a Nation: The Vietnam Veterans Memorial.* New York: Harper and Row, 1985.

Scully, Vincent. *The Earth, the Temple, and the Gods: Greek Sacred Architecture.* Rev. ed. New Haven: Yale University Press, 1979.

———. "The Terrible Art of Designing a War Memorial." *The New York Times,* July 14, 1991.

Segal, Hanna. "A Psychoanalytical Approach to Aesthetics." In *New Directions in Psychoanalysis,* edited by Melanie Klein et al. London: Tavistock Publications, 1955.

Senie, Harriet F. *Contemporary Public Sculpture: Tradition, Transformation, and Controversy.* Oxford: Oxford University Press, 1992.

Senie, Harriet F., and Sally Webster, eds. *Critical Issues in Public Art: Content, Context, and Controversy.* New York: HarperCollins, 1992.

Serra, Richard. *Writings/Interviews.* Chicago: University of Chicago Press, 1994.

Shawcross, Nancy M. *Roland Barthes on Photography: The Critical Tradition in Perspective.* Gainesville: University Press of Florida, 1997.

Sherman, Cindy. *The Complete Untitled Film Stills: Cindy Sherman.* New York: Museum of Modern Art, 2003.

Silverman, Kaja. *The Threshold of the Visible World.* New York: Routledge, 1996.

"Six Who Knew Edward Hopper." *Art Journal* 41 (Summer 1981).

Smithson, Robert. *Robert Smithson: The Collected Writings.* Edited by Jack Flam. Berkeley and Los Angeles: University of California Press, 1996.

Solomon-Godeau, Abigail. "Living with Contradictions: Critical Practices in the Age of Supply-Side Aesthetics." In *Photography at the Dock: Essays on Photographic History, Institutions, and Practices.* Minneapolis: University of Minnesota Press, 1991.

Sontag, Susan. *On Photography.* London: Penguin, 1978.

Spector, Jack. *The Aesthetics of Freud: A Study in Psychoanalysis and Art.* New York: McGraw-Hill, 1974.

Spitz, Ellen Handler. *Art and Psyche: A Study in Psychology and Aesthetics.* New Haven: Yale University Press, 1985.

Squires, Carol, ed. *The Critical Image: Essays on Contemporary Photography.* Seattle: Bay Press, 1990.

Stella, Frank. *Working Space.* Cambridge: Harvard University Press, 1986.

Strand, Mark. *Hopper.* Hopewell, N.J.: Ecco Press, 1994.

Sturken, Marita. *Tangled Memories: The Vietnam War, the AIDS Epidemic, and the Politics of Remembering.* Berkeley and Los Angeles: University of California Press, 1997.

———. "The Wall, the Screen, and the Image: The Vietnam Veterans Memorial." *Representations* 35 (Summer 1991).

Terry, Arthur. "Introduction to Selection of Texts by Salvador Dalí." In *Salvador Dalí: The Early Years,* edited by Michael Raeburn. London: Thames and Hudson, 1994.

Thurston, Luke. "Meaning on Trial: Sublimation and *The Reader."* In *Art: Sublimation or Symptom,* edited by Parveen Adams. London: Karnac, 2003.

Todd, Ellen Wiley. "Will (S)he Stoop to Conquer? Preliminaries Toward a Reading of Edward Hopper's *Office at Night."* In *Visual Theory,* edited by Norman Bryson, Michael Ann Holly, and Keith Moxey. Oxford: Polity Press, 1991.

Tsai, Eugenie. *Robert Smithson Unearthed: Drawings, Collages, Writings.* New York: Columbia University Press, 1991.

Ungar, Steven. *Roland Barthes: The Professor of Desire.* Lincoln: University of Nebraska Press, 1983.

Updike, John. "Hopper's Polluted Silence." *New York Review of Books,* August 10, 1995.

Verhaeghe, Paul. "Causation and Destitution of a Pre-ontological Non-entity: On the Lacanian Subject." In *Key Concepts of Lacanian Psychoanalysis,* edited by Dany Nobus. New York: Other Press, 1999.

Vidler, Anthony. *The Architectural Uncanny: Essays in the Modern Unhomely.* Cambridge: MIT Press, 1992.

"Vietnam Veterans Memorial: America Remembers." *National Geographic,* May 1985.

Vilaseca, David. *The Apocryphal Subject: Masochism, Identification, and Paranoia in Salvador Dalí's Autobiographical Writing.* Catalan Studies 17. New York: Peter Lang, 1995.

Wagner-Pacifici, Robin, and Barry Schwartz. "The Vietnam Veterans Memorial: Commemorating a Difficult Past." *American Journal of Sociology* 97, no. 2 (1981).

Wagstaff, Samuel, Jr. "Talking with Tony Smith." In *Minimal Art: A Critical Anthology,* edited by Gregory Battcock. New York: E. P. Dutton, 1968.

Wagstaff, Sheena, ed. *Edward Hopper.* London: Tate Publishing, 2004.

Wakefield, Neville. "Separation Anxiety and the Art of Release." *Parkett* 42 (1994).

Walker, Ian. *City Gorged with Dreams: Surrealism and Documentary Photography in the Interwar Years.* Manchester: Manchester University Press, 2002.

Weatherill, Rob. *The Sovereignty of Death.* London: Rebus Press, 1998.

Welchman, John C. "On the Uncanny in Visual Culture." In *The Uncanny,* ed. Mike Kelley. Exh. cat. Cologne: Verlag der Buchhandlung Walther König, 2004.

Winter, Jay. *Sites of Memory, Sites of Mourning: The Great War in European Cultural History.* Cambridge: Cambridge University Press, 1995.

Wollen, Peter. "'Ontology' and 'Materialism' in Film." *Screen* 17, no. 1 (1976). Reprinted in *Readings and Writings: Semiotic Counter-Strategies* (London: Verso, 1982).

Woodward, Kathleen. "Freud and Barthes: Theorizing Mourning and Sustaining Grief." *Discourse* 13, no. 1 (1990–91).

Young, James E. *The Texture of Memory: Holocaust Memorials and Meaning.* New Haven: Yale University Press, 1993.

Žižek, Slavoj. *Enjoy Your Symptom! Jacques Lacan in Hollywood and Out.* Rev. ed. London: Routledge, 2001.

———. *Looking Awry: An Introduction to Jacques Lacan Through Popular Culture.* Cambridge: MIT Press, 1991.

———. *The Sublime Object of Ideology.* London: Verso, 1989.

Zupančič, Alenka. *Ethics of the Real: Kant, Lacan.* London: Verso, 2000.

———. "Philosophers' Blind Man's Bluff." In *Gaze and Voice as Love Objects,* edited by Renata Salecl and Slavoj Žižek. Durham, N.C.: Duke University Press, 1996.

Index

Margaret Iversen is Professor of Art History and Theory at the University of Essex.